D0676002

The Location of Culture

'The work being done in my field, African and African-American Studies, is unimaginably richer because of Homi Bhabha's stunning contribution to literary, historical, and cultural studies. The breadth and depth of his analysis, and the razor precision of his writing, push us all to be better, more innovative scholars, and I thank him for it.'

Henry Louis Gates, JR

'*The Location of Culture* has been extraordinarily fertile for work in a variety of fields: literature, geography, architecture, politics among them. Homi Bhabha is at once radical and subtle in his method of argument and his insights have been fundamental to the flourishing of post-colonial studies.'

Gillian Beer, University of Cambridge

'*The Location of Culture* is an exuberantly intelligent voyage of discovery and disorientation. Supple, subtle, and unafraid, its power lies in its remarkable openness to all that is challenging and unsettling in the contemporary world.'

Stephen Greenblatt, Harvard University

'Bhabha is that rare thing, a reader of enormous subtlety and wit, a theorist of uncommon power. His work is a landmark in the exchange between ages, genres and cultures; the colonial, post-colonial, modernist and postmodern.'

Edward Said

'Homi Bhabha is one of that small group occupying the front ranks of literary and cultural theoretical thought. Any serious discussion of post-colonial/postmodern scholarship is inconceivable without referencing Mr Bhabha.'

Toni Morrison

Routledge Classics contains the very best of Routledge publishing over the past century or so, books that have, by popular consent, become established as classics in their field. Drawing on a fantastic heritage of innovative writing published by Routledge and its associated imprints, this series makes available in attractive, affordable form some of the most important works of modern times.

For a complete list of titles visit
www.routledgeclassics.com

Homi K.
Bhabha

The Location of Culture

With a new preface by the author

 London and New York

First published 1994 by Routledge

First published in Routledge Classics 2004
by Routledge
2 Park Square, Milton Park, Abingdon, Oxon, OX14 4RN

270 Madison Avenue, New York, NY 10016

Routledge is an imprint of the Taylor & Francis Group

© 1994 Homi K. Bhabha

Typeset in Joanna by RefineCatch Limited, Bungay, Suffolk
Printed and bound in Great Britain by TJ International Ltd,
Padstow, Cornwall

All rights reserved. No part of this book may be reprinted or reproduced or
utilised in any form or by any electronic, mechanical, or other means, now
known or hereafter invented, including photocopying and recording, or in
any information storage or retrieval system, without permission in writing
from the publishers.

British Library Cataloguing in Publication Data
A catalogue record for this book is available from the British Library

Library of Congress Cataloging in Publication Data
A catalog record for this book has been requested

ISBN 0–415–33639–2

For Naju and Kharshedji Bhabha

Contents

PREFACE TO THE ROUTLEDGE CLASSICS EDITION [1]

LOOKING BACK, MOVING FORWARD: NOTES ON VERNACULAR COSMOPOLITANISM

I was not one of midnight's children.[2] My belated birth, some years after the midnight hour that marked India's tryst with freedom, absented me from that epochal narrative. I was not there to witness the emergence of India and Pakistan, born together from a cleft womb, still as restless in relation to each other as the day they stepped into the harsh light of nationhood. But great events persist beyond their happening, leaving a sense of expectation in the air like the telling vacancy of weather, the silence, that often follows a spectacular storm, never letting you forget that it happened. My childhood was filled with accounts of India's struggle for Independence, its complicated histories of subcontinental cultures caught in that deadly embrace of Imperial power and domination that always produces an uncomfortable residue of enmity and amity. In a small way, my early life was caught on the crossroads that marked the end of

Empire: the postcolonial drive towards the new horizons of a Third World of free nations, the Bandung spirit, embroiled, at times, with a desire for the wayward modernist art and literature of Europe that was so much a part of the world of the westernized Indian bourgeoisie. Growing up in Bombay as a middle-class Parsi – a member of a small Zoroastrian-Persian minority in a predominantly Hindu and Muslim context – I never imagined that I would live elsewhere. Years later, I ask myself what it would be like to live without the unresolved tensions between cultures and countries that have become the narrative of my life, and the defining characteristic of my work.

Setting out from Bombay in the 1970s to study English at Oxford was, in many ways, the culmination of an Indian middle class trajectory where formal education and 'high' culture colluded in emulating the canons of elite 'English' taste (or what we knew of it) and conforming to its customs and comforts. My everyday life, however, provided quite a different inheritance. It was lived in that rich cultural mix of languages and lifestyles that most cosmopolitan Indian cities celebrate and perpetuate in their vernacular existence – 'Bombay' Hindustani, 'Parsi' Gujarati, mongrel Marathi, all held in a suspension of Welsh-missionary-accented English peppered with an Anglo-Indian *patois* that was sometimes cast aside for American slang picked up from the movies or popular music.

Learning to work with the contradictory strains of languages *lived*, and languages *learned*, has the potential for a remarkable critical and creative impulse. At times, the English language had the archaic feel of a carved almirah that engulfed you in the faded smell of moth-balls and beautiful brittle linens; at other times it had the mix-and-match quality of a moveable feast, like Bombay street food, spicy, cheap, available in all kinds of quantities and combinations, subtle delicacies with a street-wise savour. I went to Oxford to embellish the antique charms of the armoire; I ended up realizing how much I desired street food.

Why was I intellectually fascinated but unmoved, when I found myself at the academic acme of the literary culture that I had chosen to follow?

Fumbling towards an answer to that question brings me closer to the critical lesson that I was to learn in my early years as an apprentice academic working in the West. It was this: what one expects to find at the very center of life or literature – the summation of a Great Tradition, a touchstone of Taste – may only be the dream of the deprived, or the illusion of the powerless. The canonical 'center' may, indeed, be most interesting for its elusiveness, most compelling as an enigma of authority. What was missing from the traditionalist world of English literary study, as I encountered it, was a rich and paradoxical engagement with the pertinence of what lay in an oblique or alien relation to the forces of centering. Writers who were off-center; literary texts that had been passed by; themes and topics that had lain dormant or unread in great works of literature – these were the angles of vision and visibility that enchanted me.

I do not mean, in any sense, to glorify margins and peripheries. However, I do want to make graphic what it means to survive, to produce, to labor and to create, within a world-system whose major economic impulses and cultural investments are pointed in a direction away from you, your country or your people. Such neglect can be a deeply negating experience, oppressive and exclusionary, and it spurs you to resist the polarities of power and prejudice, to reach beyond and behind the invidious narratives of center and periphery. Remember the awful realization endured by Rahul Singh, V. S. Naipaul's central character in his novel *The Mimic Men*, when it begins to dawn on him that the great stone walls of London don't contain a unique weight and an unsurpassable resonance; they are like stones elsewhere and everywhere; other stones are not pale shadows of them. What he had earlier dismissed as the insignificant stones

and shells of his small postcolonial island of Isabella suddenly, belatedly, develop their own historical presence.

My search for a subject of my own did not emerge directly from the English authors that I avidly read, nor from the Indian writers with whom I deeply identified. It was the Indo-Caribbean world of V. S. Naipaul's fiction that was to become the diversionary, exilic route that led me to the historical themes and theoretical questions that were to form the core of my thinking. For reasons still obscure to me, the detour through Naipaul's milieu brought back the world, and the words, of my Bombay life, even as Naipaul's journey from Trinidad to his ancestral home in India passed through his English experiences. You could say that our paths crossed somewhere between Oxford and London, although we belonged to different generations and social geographies. Naipaul's novels, *A House for Mr. Biswas*, *The Mimic Men* and *In a Free State* have been celebrated for achieving a cast of characters whose unpromising lives were turned by him into the most memorable portraits of individuals striving for their independence, attempting to establish their autonomy, against all the odds. The odds in this case were very high; nothing less than the conservative melancholy of the author's own attitude to his own characters and to the postcolonial countries of the South.

What I found intriguing about Naipaul's novels was the way in which the fiction was capable of being read against the author's intention and ideology. His characters made their way in the world while acknowledging its fragmented structures, its split imperatives, and a prevailing sense of a loss of cultural authority. In Naipaul's view, of course, this was nothing more than the fated condition of the Caribbean – 'History is built around achievement and creation; and nothing was created in the West Indies'[3] – and his unrelenting despair led him to create characters that seemed hopelessly bereft, half-made peoples, who turned into the most consummate literary creations. I took a different view from his. It was the ability of Naipaul's

characters to forbear their despair, to work through their anxieties and alienations towards a life that may be radically incomplete but continues to be intricately communitarian, busy with activity, noisy with stories, garrulous with grotesquerie, gossip, humor, aspirations, fantasies – these were signs of a culture of survival that emerges from the other side of the colonial enterprise, the darker side. Naipaul's people are vernacular cosmopolitans of a kind, moving in-between cultural traditions, and revealing hybrid forms of life and art that do not have a prior existence within the discrete world of any single culture or language. Naipaul makes this point himself.

> The Trinidadian is a cosmopolitan,' he writes. 'He is a natural anarchist, who has never been able to take the eminent at their own valuation. . .[He] is without the greater corruption of sanctimoniousness, and can never make pleas for *intolerance* in the name of piety. He can never achieve the society-approved nastiness of the London landlord, say, who turns a dwelling-house into a boarding-house, charges exorbitant rents, and is concerned that his tenants live in sin. Everything that makes the Trinidadian an unreliable, exploitable citizen makes him a quick, civilised person whose values are always human ones, whose standards are those of wit and style.[4]

There is more to Naipaul's comparison than the contrast between Trinidadian wit and style, and London's sanctimonious piety. The locale that informs his judgment is, in part, the world of extortionate boarding-houses ruled over by prurient, even racially prejudiced, landlords – a world of migrant life that features prominently in Naipaul's early fiction. The cosmopolitan ethic that emerges from the colonized Trinidadian's embattled existence – ironic style, tolerance, a refusal to take the eminent at their own estimation – now delivers a withering judgment on the masked intolerance and posed piety of the

supposedly 'advanced' metropolitan world. Naipaul's early intimation of what a 'vernacular cosmopolitanism' might be is extremely useful in discriminating between two forms of cosmopolitical thinking that are deeply ingrained in contemporary discourses of globalization.

There is a kind of global cosmopolitanism, widely influential now, that configures the planet as a concentric world of national societies extending to global villages. It is a cosmopolitanism of relative prosperity and privilege founded on ideas of progress that are complicit with neo-liberal forms of governance, and free-market forces of competition. Such a concept of global 'development' has faith in the virtually boundless powers of technological innovation and global communications. It has certainly made useful interventions into stagnant, state-controlled economies and polities and has kick-started many societies which were mired in bureaucratic corruption, inefficiency and nepotism. Global cosmopolitans of this ilk frequently inhabit 'imagined communities' that consist of silicon valleys and software campuses; although, increasingly, they have to face up to the carceral world of call-centres, and the sweat-shops of outsourcing. A global cosmopolitanism of this sort readily celebrates a world of plural cultures and peoples located at the periphery, so long as they produce healthy profit margins within metropolitan societies. States that participate in such multicultural multinationalism affirm their commitment to 'diversity', at home and abroad, so long as the demography of diversity consists largely of educated economic migrants – computer engineers, medical technicians, and entrepreneurs, rather than refugees, political exiles, or the poor. In celebrating a 'word culture' or 'world markets' this mode of cosmopolitanism moves swiftly and selectively from one island of prosperity to yet another terrain of technological productivity, paying conspicuously less attention to the persistent inequality and immiseration produced by such unequal and uneven development.

Globalization, I want to suggest, must always begin at home. A just measure of global progress requires that we first evaluate how globalizing nations deal with 'the difference within' – the problems of diversity and redistribution at the local level, and the rights and representations of minorities in the regional domain. What is the status of the Aboriginal peoples of Australia, or the Muslims in India in the midst of the transformational myths and realities of global connectivity? In the United States, for instance, the American dream is sustained by the 'wave theory' of migration – the Irish, followed by the Italians, Jews, Koreans and South Asians. There is, however, an ingrained insouciance, a structural injustice, shown towards African Americans or First Nations Peoples whose ethical and political demands for equality and fairness are based on issues of reparations and land-rights. These rights go beyond 'welfare' or 'opportunity' and make claims to recognition and redistribution in the process of questioning the very sovereignty of national traditions and territories. And it is because of their interrogations and interventions at this foundational level, that such movements are often considered to be 'against the American grain.' Or, for that matter, against the Australian grain too. Kim Scott writes:

> Insecurity, uncertainty, doubt. I still often hear that phrase surrounding Native title discussions, and purportedly its use in reference to economic contract. No, it's insecurity, uncertainty and doubt about something more important than that. Much deeper.
>
> About the foundations of the nation. About who belongs. About who we are.[5]

The hegemonies that exist at 'home' provide us with useful perspectives on the predatory effects of global governance however philanthropic or ameliorative the original intention might

have been. The economic 'solutions' to national and inter-national inequality and poverty as practiced by the IMF and the World Bank, for instance, have 'the feel of the colonial ruler,'[6] according to Joseph Stiglitz, once Senior Vice-President and Chief Economist of the World Bank – 'they help to create a dual economy in which there are pockets of wealth . . . **But a dual economy is not a developed economy**.'[my emphasis] It is the *re-production* of dual, unequal economies as *effects* of globalization that render poorer societies more vulnerable to the 'culture of conditionality' through which what is purportedly the granting of loans turn into the peremptory enforcement of policy:

> If the IMF wanted a nation to liberalise its financial markets, for instance, it might pay out the loan in installments, tying sub-sequent installments to verifiable steps to liberalisation. [And] such *conditions* are seen as intrusions by the new colonial power on the country's own sovereignty.[7]

An economic world-order based on such practices of 'con-ditionality' facilitates peremptory postures of political power that conduct global politics by setting 'conditions' to the rest of the world – 'you are with us or against us' – that are in danger of being unilateral and may not comply with International law or seek consensus amongst representative bodies of the Inter-national community. When global government is conducted in terms of coercive conditionality, it is difficult to enter into equitable negotiations with one's allies or one's enemies.

There is, however, another cosmopolitanism of the Trini-dadian variety, figuratively speaking, that emerges from the world of migrant boarding-houses and the habitations of national and diasporic minorities. Julia Kristeva, in a different context, calls it a wounded cosmopolitanism. In my view, it is better described as a vernacular cosmopolitanism which meas-ures global progress from the minoritarian perspective. Its

claims to freedom and equality are marked by 'a "right to differ-ence in equality,"[8]' rather than a diversity founded on a 'dual economy'.[9] Such a 'right to difference', as Etienne Balibar sug-gests, does not require the restoration of an original [or essentialist] cultural or group identity; nor does it consider equality to be a neutralization of differences in the name of the 'universality' of rights where implementation is often subject to ideological and institutional definitions of what counts as 'human' in any specific cultural or political context. A right to difference-in-equality can be articulated from the perspective of both national minorities and global migrants; and in each case such a right represents a desire to revise the customary com-ponents of citizenship – political, legal and social citizenship (T.H. Marshall) – by extending them to include the realm of 'symbolic citizenship' (Avishai Margalit). The symbolic aspect raises affective and ethical issues connected with cultural differ-ences and social discrimination – the problems of inclusion and exclusion, dignity and humiliation, respect and repudiation. In the context of the world dis-order in which we are mired, sym-bolic citizenship is now principally defined by a surveillant cul-ture of 'security' – how do we tell the good migrant from the bad migrant? Which cultures are safe? Which unsafe?

Our nation-centered view of sovereign citizenship can only comprehend the predicament of minoritarian 'belonging' as a problem of ontology – a question of belonging to a race, a gender, a class, a generation becomes a kind of 'second nature,' a prim-ordial identification, an inheritance of tradition, a naturalization of the problems of citizenship. The vernacular cosmopolitan takes the view that the commitment to a 'right to difference in equal-ity' as a process of constituting emergent groups and affiliations has less to do with the affirmation or authentication of origins and 'identities,' and more to do with political practices and ethical choices. Minoritarian affiliations or solidarities arise in response to the failures and limits of democratic representation,

creating new modes of agency, new strategies of recognition, new forms of political and symbolic representation – NGOs, anti-globalization groups, Truth Commissions, International courts, local agencies of transitional justice (the gacaca courts in rural Rwanda). Vernacular cosmopolitanism represents a political process that works *towards* the shared goals of democratic rule, rather than simply acknowledging already constituted 'marginal' political entities or identities.

If I have argued that the success and failure of globalization begins at home, then the great African–American vernacular cosmopolitan, W.E.B. Du Bois, understood this only too well. In a lecture on Human Rights delivered in 1945, he suggested that the essence of the global predicament is to be found in 'the problem of minorities':

> We must conceive of colonies in the nineteenth and twentieth centuries as . . . [part of] the local problems of London, Paris and New York. [Here in America,] in the organized and dominant states of the world, there are groups of people who occupy the *quasi-colonial status*: laborers who are settled in the slums of large cities; groups like Negroes in the United States who are segregated physically and discriminated spiritually in law and custom . . . All these people occupy what is really a [quasi] colonial status and make the kernel and substance of the problem of minorities.[10]

The poet Adrienne Rich explores the kernel and substance of global minorities in *An Atlas of the Difficult World* (1991), one of the most striking series of poems dealing with the contemporary cosmopolitical world. Rich takes a global measure – a measure that is both moral and poetic – by decentering the place from which she speaks, and the location in which she lives. There is no ventriloquism of victimage here; no consensual cartography. Rich's resistance to such facile forms of identification and

resolution comes from the relentless, repetitive power of her verse to reveal the profound 'unsatisfaction' that dwells in our 'shared' history of human civilization and barbarism. Anxiety links us to the memory of the past while we struggle to choose a path through the ambiguous history of the present. Such a restless apprehension about who one is – as an individual, a group or a community – and the complexities of forming a global perspective, are beautifully evoked in these few lines:

> Memory says, want to do it right? Don't count on me . . .
> I'm a canal in Europe where bodies are floating
> I'm a mass grave I'm the life that returns
> I'm a table set with room for the Stranger
> I'm a field with corners left for the landless
> I'm a man-child praising God he's a man,
> I'm a woman who sells for a boat ticket
> ***********************************
>
> I'm an immigrant tailor who says A coat
> is not a piece of cloth only
>
>
> I have dreamed of Zion I've dreamed of world revolution
> I'm a corpse dredged from a canal in Berlin
> A river in Mississippi. I am a woman standing
> I am standing here in your poem. Unsatisfied.[11]

The insistent repetition of the phrase – 'I'm a /I'm a . . . I am' – as in some bleak counting-song of a monstrous child of our times, finds itself both implicated in the traumatic events of global histories – slavery, war, migration, diaspora, peasant rebellions, revolution – and yet unsatisfied in its attempt to imagine how one might stage a relationship to a world rendered restless by its transhistorical memories. Each line contains its own encrypted narrative: Rosa Luxembourg may be the corpse dredged from the Landswehr canal in Berlin; the civil rights

moment of the American South is invoked in the burning Mississippi. Rich struggles to find a way of establishing a narrative of human interest, in the sense that Arendt gives to the term: an exploration of what lies in-between (inter-est) these distinct, even disjunct moments that allow them to become affiliated with one another in the spirit of a 'right to difference in equality.' The repeated phrase – 'I am – *a table* . . . *a field* . . . *a man-child* . . . *a woman* . . . *an immigrant*' – does not seek to establish the sovereignty of a 'representative' world-subject who can speak for all peoples.

In keeping with the spirit of the 'right to narrate' as a means to achieving our own national or communal identity in a global world, demands that we revise our sense of symbolic citizenship, our myths of belonging, by identifying ourselves with the 'starting-points' of other national and international histories and geographies. It is by placing herself at the intersections (and in the interstices) of these narratives that Rich emphasizes the importance of historical and cultural re-visioning: the process of being subjected to, or the subject of, a particular history 'of one's own' – a *local* history – leaves the poet 'unsatisfied' and anxious about who she is, or what her community can be, in the larger flow of a transnational history. If we look at the relation of cultures in this way, then we see them as part of a complex process of 'minoritarian' modernity, not simply a polarity of majority and minority, the center and the periphery. Rich does not merely string together the woes of the 'wretched of the earth'; she turns the abjection of modern history into the productive and creative history of the minority as a social agent. Out of a spirit of resistance and forbearance emerges the minoritarian will to live, to *make*, to introduce the act of *poesis* into the imagined life of the migrant or the minority as part of civic and civil society: 'I'm an immigrant tailor who says A coat/is not a piece of cloth only.'

Is 'unsatisfaction' the pessimism of the idealist or the

aspiration of the utopian? Is Rich's evocation of an ethic and poetic of 'unsatisfaction' a subtle warning against the stance of the 'informed bystander,' or of the political realist who acts largely on the grounds of enlightened self-interest?

> I am standing here in your poem. Unsatisfied.

The emphasis, in the last line, on 'standing' – I am a woman standing/ I am standing here in your poem – should not be passed over. For this is a peculiar kind of political stance, the 'standing of citizenship' as a measure of public 'good', as respect and recognition, upon which Judith Shklar founds her theory of American citizenship.[12] Citizenship as 'standing' is testimony to her insistence that as active citizens we must vigilantly guard against the state's strategies of exclusion and discrimination in the midst of its promises of formal equality and procedural democracy. As a woman, whose effective elision from the polity becomes a 'negative' condition for the empowerment of the male citizen, Rich now stands with those who are in the minoritarian position on a global scale.

In the wake of these voices, we are led to a philosophical and political responsibility for conceiving of minoritization and globalization as the quasi-colonial, a condition at once old and new, a dynamic, even dialectical relation that goes beyond the polarizations of the local and the global, the center and the periphery, or, indeed, the 'citizen' and the 'stranger.' A recent UNESCO report of the World Commission of Culture and Development suggests that a minoritarian condition is, indeed, a kind of global citizenship. The last two or three decades have seen more people living across or between national borders than ever before – on a conservative estimate, 40 million foreign workers, 20 million refugees, 20–25 million internally displaced peoples as a result of famines and civil wars. Immigrants, refugees or minorities who live in the midst of the metropolitan

centers in the North and South represent the most tangible and proximate presence of the global or transnational world as it exists within 'national' societies. When we talk of the ever-expanding boundaries and territories of the global world, we must not fail to see how our own intimate, indigenous landscapes should be remapped to include those who are its new citizens; or those whose citizenly presence has been annihilated or marginalized. Regional movements of peoples within nation-states, and the financial and cultural impact of migrants upon their 'home' communities and societies, should not be neglected in favor of a celebration of diasporic communities. In my home state of Maharashtra the Shiv Sena party turned against the Muslim minority as 'foreigners' in the riots of the late 1980s, only after they had targeted 'economic refugees' from Southern India who came to seek jobs in Bombay a decade earlier.

Article 27, one of the two main implementing conventions of the Universal Declaration of Human Rights, supports 'the right of minorities, in community with the other members of their group, to enjoy their own culture, to profess and practice their own religion, or to use their own language.' However, Article 27 emphasizes the need for minorities to 'preserve' their cultural identities, rather than to affiliate across emergent minority communities. For all its good intentions, such rights neglect the 'inter-cultural' political existence and ethical imperative that Rich and Du Bois direct us towards. For Rich the speaking 'I,' the location and locution of poetic voice must repeat and reverberate across historically specific moments of the minority predicament. For Du Bois, a minority only discovers its political force and its aesthetic form when it is articulated *across* and alongside communities of difference, in acts of affiliation and contingent coalitions. Many member states proposed an amendment that immigrants, for instance, should not be considered minorities. It was held that 'the very existence of *unassimilated* minorities would be a threat to national unity; and

hence, the provisions relating to the rights of minorities should not be so applied to encourage the emergence of new minority groups, or to thwart the process of assimilation and so threaten the unity of the State.'[13] Minorities are part of that on-going process of 'human artifice,' as Arendt describes it, where 'we are not born equal, but *become* equal as members of a group on the strength of our decision to guarantee ourselves mutually equal rights.'[14]

As I end this exploration of the artifice and agency of the national and global minority, I want to go home. Home, to the Bombay where I started my story. But it is now difficult to return to *Mumbai* without passing through that many-mirrored gateway to the city, Salman Rushdie's *Midnight's Children*, Bombay's *Buddenbrooks*. The fetish of profuse and desperate description that characterizes the style of *Midnight's Children* signifies a desire to preserve, in minute and quotidian detail, the enlightened cosmopolitanism long associated with the city. But Rushdie knowingly placed a ticking time-bomb under that belief.

> Fission of Saleem, I am the bomb in Bombay, watch me explode, bones splitting breaking beneath the awful pressure of the crowd, bag of bones falling down and down ... only a broken creature spilling pieces into the street, because I have been too-many persons. Life unlike syntax allows one more than three, and at last somewhere the striking of a clock, twelve chimes, release. ...[15]

The fission of syntax that blows up Bombay – the **bomb** in Bombay – is a wonderful image of this city of 'too-many persons' and too many stories. But it is also a prophetic vision of the bombs that tore through Bombay in 1993, burning down at least five skyscrapers in a matter of as many hours. The world's media, busily searching for historical precedents after 9/11, did

not spare a thought for that day in Bombay. '*Bones splitting breaking beneath the awful pressure of the crowd.*'[16]

Attacks of terror, and incidents of communal rioting have tragically left their mark on a city that seems, on the surface, to work busily against, and across, such ethnic and religious boundaries. Rushdie most often takes the coastal road, along Marine Drive, as he makes his way from the South to the North of the island. But if you turn off Marine Drive into the city's old interior, you enter a different world. You drive past Azad maidan, just the other side of the Anglo-Scottish Cathedral school, past the Goan-Roman Catholic communities around Girgaum, then around the Parsi settlements in Grant Road and towards the Muslim areas in Mohamedalli Road. If you take a sharp left before getting to the poorer Anglo-Indian communities of Byculla, you would enter the once-Jewish quarters of Nagpada with pale wraith-like women selling string-cheese and flat Iraqi-Jewish sesame breads. This teeming hinterland of the city with its layered communities is where the communal riots of the early nineties, left their most lasting and devastating memories.

But in this multi-storied world of Mumbai, now caught in communal fears and the fires of fundamentalism, there lives a poet named Prakash Jadhav, who comes from the Dalit community and writes of the homeless underclass who survive on the pavements of Bombay. In *Under Dadar Bridge* he takes a view of the city from beneath the arches of one of its landmarks; and he has an interesting Hindu-Muslim story to tell:

> Hey, Ma, tell me my religion. Who am I?
> What am I?
> You are not a Hindu or a Muslim!
> You are an abandoned spark of the
> World's lusty fires.
> Religion? This is where I stuff religion!

Whores have only one religion, my son.
If you want a hole to fuck in, keep
Your cock in your pocket!¹⁷

Suddenly a bridge in Bombay becomes a place from which a Marathi poem is translated into English by a poet who speaks both the ornate language of a devotional dialect – *an abandoned spark of the world's lusty fires* – and the demotic slang reminiscent of the Black Panther poets who had a lasting influence on Dalit poetry – *if you want a hole to fuck in, keep your cock in your pocket*. The language of the poem catches something of the spark of vernacular cosmopolitanism that I have been trying to explore. And the poem's refusal to identify with the Hindu-Muslim polarization, either communal or doctrinal, draws this small 'spark of the World' into the wider realm of Du Bois's quasi-colonial status – 'those settled in the slums of great cities; groups who are segregated physically and discriminated spiritually in law and custom.' These are now the local problems of Mumbai, Paris, London, Hong Kong, *because globalization begins at home*.

In the unsatisfied voice of Adrienne Rich – *I am . . . I am . . . I am* – and in the insistent questioning of Prakash Jadhav – *Who am I? What am I?* – we hear a right to narrate, a desire for 'a collective, ethical, right to difference in equality.'¹⁸ No name is yours until you speak it; somebody returns your call and suddenly, the circuit of signs, gestures, gesticulations is established and you enter the territory of the right to narrate. You are part of a dialogue that may not, at first, be heard or heralded – you may be ignored – but your personhood cannot be denied. In another's country that is also your own, your person divides, and in following the forked path you encounter yourself in a double movement . . . once as stranger, and then as friend.

ACKNOWLEDGEMENTS

The memory of gratitude is not best served by the neat lists of people and places that acknowledgements can accommodate. The help we receive is a more haphazard affair. It gives me particular pleasure to note that most of those mentioned below have sat at our kitchen table. In that spirit academic acquaintance has often turned into enduring friendship.

The evolution of this book owes a personal debt to a group of interrogators and co-conspirators: Stephan Feuchtwang for asking the unthought question; James Donald for the pleasures of precision, without saying 'precisely'; Robert Young for his fine readings and his tolerance for telephone theory; and Gyan Prakash for insisting that scholarship must be leavened with style.

I want here to acknowledge the pioneering *oeuvre* of Edward Said which provided me with a critical terrain and an intellectual project; Gayatri Spivak's courage and brilliance, which has set high standards of excitement; and Stuart Hall's work which has been exemplary for me in combining political acuity with an

inspiring vision of inclusion. Ranajit Guha and the subaltern scholars have provided me with the most stimulating recent example of historical revision. Terry Eagleton's early exhortations at Oxford to stay tuned to the materialist mode have proved to be sturdy advice.

The work of Toni Morrison has been formative in my thinking on narrative and historical temporality; many of my ideas on 'migrant' and minority space have been sparked off by the novels of Salman Rushdie. I owe these remarkable writers a significant personal and intellectual debt. In allowing me to quote from two of his inspirational poems Derek Walcott has shown great generosity. So too has Anish Kapoor, whose profound exploration of sculptural space has provided an image for the cover. (Used for the cover image of the 1994 edition of The Location of Culture.)

Stephen Greenblatt has been exemplary in his ability, over the years, to forge a shared project through a subtle and sympathetic dialogue. Gillian Beer and John Barrell opened up the eighteenth and nineteenth centuries to postcolonial questions. Joan Copjec instantly grasped what I meant by 'mimicry' and helped me to read Lacan. The Essex Conference Collective and Peter Hulme, in particular, are responsible for creating some of the most productive and collaborative events that I have participated in. Henry Louis Gates and W. J. T. Mitchell invited me to contribute to Race, Writing and Difference, providing the sense of a new community of scholarship. At an early stage, Joan Scott, Elizabeth Weed, Kaja Silverman, Rey Chow and Evelyn Higginbotham gave my work a most useful 'going over' at the Pembroke Center Seminar, Brown University. Houston Baker generously invited me to deliver the Richard Wright lectures at the Center for Black Literature and Culture at the University of Pennsylvania, a unique intellectual opportunity and responsibility.

My 'home' institution during a visit to Australia was the University of Queensland; and I thank John Frow, Helen Tiffin, Alan

Lawson, Jeff Minson and the participants of the Advanced Theory seminar. The National Humanities Centre, Canberra, was also generous with its support. David Bennett, Terry Collits and Dipesh Chakrabarty mix the perfect conference cocktail: two parts pleasure to one part business, lots of stirring (up) and shaking (down)! Meaghan Morris and Sneja Gunew have, over the years, helped me to rethink perspectives and priorities.

My tenure at the universities of Pennsylvania and Princeton provided me with the time I needed to complete this work. The contribution of my graduate students in both places was invaluable.

The English Department and the Center for Black Literature at Penn invited me to take up the Steinberg Visiting Professorship. My thanks to John Richetti, Houston Baker, Wendy Steiner, Stephen Nicholls, Marjorie Levinson, Arjun Appadurai, Carol Breckenridge, Deidre David, Manthia Diawara and Peter Stallybrass.

At Princeton, Elaine Showalter was a most generous host who made possible an exciting year. Victor Brombert who could turn, without missing a beat, from *bel canto* to the Gauss seminars, was an invaluable support. Natalie Zemon Davis provided insightful and constructive critiques. Arcadio Diaz-Quiñones never failed to temper instruction with delight. Arnold Rampersad was generous with his time and advice. Cornel West's presence was an inspiration to re-think 'race'; I learned much from attending Nell Painter and Cornel West's seminars on the African American Intellectual tradition.

I owe a great debt to a group of scholars and friends in the English department at Princeton who contributed in unchartable ways to the development of these ideas: Andrew Ross, Wahneema Lubiano, Eduardo Cadava, Diana Fuss, Tom Keenan and Barbara Browning.

It gives me particular pleasure to acknowledge the crucial influence of ideas that come from outside (or beside) the Academy. David Ross and Elisabeth Sussman of the Whitney

Museum in New York have provided me with challenging opportunities. Alberta Arthurs, Tomas Ybarra Frausto and Lynn Szwaja at the Rockefeller Foundation have taught me to think of cultural studies in new intellectual and social environments.

Other than specific events and institutions, the contingent development of ideas and dialogues provides a skein of people and places. My students at the University of Sussex were active participants in the developments of many themes and ideas. Amongst many supportive colleagues, Laura Chrissman, Jonathan Dollimore, Frank Gloversmith, Tony Inglis, Gabriel Josipovici, Cora Kaplan, Stuart Laing, Partha Mitter, Jacqueline Rose, Alan Sinfield, Jenny Taylor, Cedric Watts and Nancy Wood have been particularly generous with their help at various times. There are others, close friends and intellectual companions, who deserve both the gratitude of the daily grind and the shared pleasure of many epiphanies:

Parveen Adams, Lisa Appignanesi, Emily Apter, Dorothy Bednarowska, Ellice Begbie, Andrew Benjamin, Lauren Berlant, Jan Brogden, Benjamin Buchloh, Victor Burgin, Abena Busia, Judith Butler, Bea Campbell, Iain Chambers, Ron Clark, Lidia Curti, Nick Dirks, Maud Ellmann, Grant Farred, John Forrester, David Frankel, Tschome Gabriel, Cathy Gallagher, Paul Gilroy, Sepp Gumbrecht, Abdul Janmohamed, Isaac Julian, Adil Jussawalla, Ann Kaplan, Mary Kelly, Ernesto Laclau, David Lloyd, Lisa Lowe, Ann McClintock, Phil Mariani, Pratap Mehta, Liz Moore, Rob Nixon, Nicos Papastergiadis, Benita Parry, Ping hui Liao, Helena Reckitt, Bruce Robbins, Irene Sheard, Stephen Sleaman, Val Smith, Jennifer Stone, Mitra Tabrizian, Mathew Teitelbaum, Tony Vidler, Gauri Viswanathan, Yvonne Wood. Zareer Masani has weathered many storms with me and Julian Henriques has often brought good weather. John Phillips and Rebecca Walkowitz helped prepare the manuscript for publication with efficiency and understanding.

I have enjoyed a most cooperative relationship with my publishers. Janice Price has been a friend and discussant at all stages of this work. Her foresight has meant an enormous amount to me. The elegance of Talia Rodgers' style extends from the cover to the content; working with her has been most pleasurable. Sue Bilton has shown resources of patience and perseverance that have taught me a lesson in perfectibility.

Although our lives are now lived in different countries my parents have been a source of the deepest sustenance. To Hilla and Nadir Dinshaw I offer my heartfelt thanks for countless considerations during the period of writing. I am deeply indebted to Anna MacWhinnie for making possible many opportunities for work and play. My children Ishan, Satya and Leah have been true companions. They have never respected the sanctity of the study. Their interruptions have been frequent and irreplaceable. Beyond this book or any other, I thank Jacqueline for sharing in the dissatisfaction that is the spur to thought, and for bearing the anxiety of incompletion that accompanies the act of writing.

HOMI BHABHA
LONDON, 1993

The author and publishers would like to thank the following for permission to reproduce copyrighted material:

'The commitment to theory' is reprinted from Questions of Third Cinema edited by J. Pines and P. Willemen (1989) with the kind permission of the British Film Institute.

'Interrogating identity' is reprinted from The Anatomy of Racism edited by David Goldberg (1990) with the kind permission of The University of Minnesota Press.

'The other question' is reprinted from The Sexual Subject: A Screen Reader in Sexuality edited by M. Merck (1992) with the kind permission of Routledge.

'Of mimicry and man' (*October: Anthology*, Boston, Mass.: MIT Press, 1987) and 'Sly civility' (*October*, Winter 1985, MIT Press) are reprinted with kind permission from *October*.

'Signs taken for wonders' is reprinted with the kind permission of Chicago University Press from *Race, Writing and Difference: Special Issue of the Journal* edited by Henry Louis Gates Jnr, *Critical Inquiry* (1985).

'Articulating the archaic' is reprinted from *Literary Theory Today* edited by Peter Collier and Helga Gaya-Ryan (1990: Polity Press) with the kind permission of Blackwell.

'The postcolonial and the postmodern' is reprinted from *Redrawing the Boundary of Literary Study in English* edited by Giles Gunn and Stephen Greenblatt (1992) with the kind permission of the Modern Languages Association.

' "Race", time and revision of modernity' is reprinted with kind permission from *Neocolonialism*, edited by Robert Young, *Oxford Literary Review* 13 (1991) pp. 193–219. © 1991 *Oxford Literary Review*.

Lines from the song 'Ac-cent-tchu-ate the Positive' are reproduced with the kind permission of International Music Publications Ltd.

The architecture of this work is rooted in the
temporal. Every human problem must be
considered from the standpoint of time.

(Frantz Fanon: *Black Skin, White Masks*)

You've got to
'Ac-cent-tchu-ate the pos-i-tive,
E-li-mi-nate the neg-a-tive',
Latch on to the af-firm-a-tive,
Don't mess with Mister In-be-tween.

(refrain from 'Ac-cent-tchu-ate the Positive' by Johnny
Mercer)

INTRODUCTION

Locations of culture

A boundary is not that at which something stops but, as
the Greeks recognized, the boundary is that from which
something begins its presencing.

Martin Heidegger, 'Building, dwelling, thinking'

BORDER LIVES: THE ART OF THE PRESENT

It is the trope of our times to locate the question of culture in the
realm of the *beyond*. At the century's edge, we are less exercised by
annihilation – the death of the author – or epiphany – the birth
of the 'subject'. Our existence today is marked by a tenebrous
sense of survival, living on the borderlines of the 'present', for
which there seems to be no proper name other than the current
and controversial shiftiness of the prefix 'post': *postmodernism,
postcolonialism, postfeminism.* . . .

The 'beyond' is neither a new horizon, nor a leaving behind

of the past. . . . Beginnings and endings may be the sustaining myths of the middle years; but in the *fin de siècle*, we find ourselves in the moment of transit where space and time cross to produce complex figures of difference and identity, past and present, inside and outside, inclusion and exclusion. For there is a sense of disorientation, a disturbance of direction, in the 'beyond': an exploratory, restless movement caught so well in the French rendition of the words *au-delà* – here and there, on all sides, *fort/da*, hither and thither, back and forth.[1]

The move away from the singularities of 'class' or 'gender' as primary conceptual and organizational categories, has resulted in an awareness of the subject positions – of race, gender, generation, institutional location, geopolitical locale, sexual orientation – that inhabit any claim to identity in the modern world. What is theoretically innovative, and politically crucial, is the need to think beyond narratives of originary and initial subjectivities and to focus on those moments or processes that are produced in the articulation of cultural differences. These 'in-between' spaces provide the terrain for elaborating strategies of selfhood – singular or communal – that initiate new signs of identity, and innovative sites of collaboration, and contestation, in the act of defining the idea of society itself.

It is in the emergence of the interstices – the overlap and displacement of domains of difference – that the intersubjective and collective experiences of *nationness*, community interest, or cultural value are negotiated. How are subjects formed 'in-between', or in excess of, the sum of the 'parts' of difference (usually intoned as race/class/gender, etc.)? How do strategies of representation or empowerment come to be formulated in the competing claims of communities where, despite shared histories of deprivation and discrimination, the exchange of values, meanings and priorities may not always be collaborative and dialogical, but may be profoundly antagonistic, conflictual and even incommensurable?

The force of these questions is borne out by the 'language' of recent social crises sparked off by histories of cultural difference. Conflicts in South Central Los Angeles between Koreans, Mexican-Americans and African-Americans focus on the concept of 'disrespect' – a term forged on the borderlines of ethnic deprivation that is, at once, the sign of racialized violence and the symptom of social victimage. In the aftermath of the *The Satanic Verses* affair in Great Britain, Black and Irish feminists, despite their different constituencies, have made common cause against the 'racialization of religion' as the dominant discourse through which the State represents their conflicts and struggles, however secular or even 'sexual' they may be.

Terms of cultural engagement, whether antagonistic or affiliative, are produced performatively. The representation of difference must not be hastily read as the reflection of *pre-given* ethnic or cultural traits set in the fixed tablet of tradition. The social articulation of difference, from the minority perspective, is a complex, on-going negotiation that seeks to authorize cultural hybridities that emerge in moments of historical transformation. The 'right' to signify from the periphery of authorized power and privilege does not depend on the persistence of tradition; it is resourced by the power of tradition to be reinscribed through the conditions of contingency and contradictoriness that attend upon the lives of those who are 'in the minority'. The recognition that tradition bestows is a partial form of identification. In restaging the past it introduces other, incommensurable cultural temporalities into the invention of tradition. This process estranges any immediate access to an originary identity or a 'received' tradition. The borderline engagements of cultural difference may as often be consensual as conflictual; they may confound our definitions of tradition and modernity; realign the customary boundaries between the private and the public, high and low; and challenge normative expectations of development and progress.

> I wanted to make shapes or set up situations that are kind of open. . . . My work has a lot to do with a kind of fluidity, a movement back and forth, not making a claim to any specific or essential way of being.[2]

Thus writes Renée Green, the African-American artist. She reflects on the need to understand cultural difference as the production of minority identities that 'split' – are estranged unto themselves – in the act of being articulated into a collective body:

> Multiculturalism doesn't reflect the complexity of the situation as I face it daily. . . . It requires a person to step outside of him/ herself to actually see what he/she is doing. I don't want to condemn well-meaning people and say (like those T-shirts you can buy on the street) 'It's a black thing, you wouldn't understand.' To me that's essentialising blackness.[3]

Political empowerment, and the enlargement of the multiculturalist cause, come from posing questions of solidarity and community from the interstitial perspective. Social differences are not simply given to experience through an already authenticated cultural tradition; they are the signs of the emergence of community envisaged as a project – at once a vision and a construction – that takes you 'beyond' yourself in order to return, in a spirit of revision and reconstruction, to the political conditions of the present:

> Even then, it's still a struggle for power between various groups within ethnic groups about what's being said and who's saying what, who's representing who? What is a community anyway? What is a black community? What is a Latino community? I have trouble with thinking of all these things as monolithic fixed categories.[4]

If Renée Green's questions open up an interrogatory, inter-stitial space between the act of representation – who? what? where? – and the presence of community itself, then consider her own creative intervention within this in-between moment. Green's 'architectural' site-specific work, *Sites of Genealogy* (Out of Site, The Institute of Contemporary Art, Long Island City, New York), displays and displaces the binary logic through which identities of difference are often constructed – Black/White, Self/Other. Green makes a metaphor of the museum building itself, rather than simply using the gallery space:

> I used architecture literally as a reference, using the attic, the boiler room, and the stairwell to make associations between certain binary divisions such as higher and lower and heaven and hell. The stairwell became a liminal space, a pathway between the upper and lower areas, each of which was anno-tated with plaques referring to blackness and whiteness.[5]

The stairwell as liminal space, in-between the designations of identity, becomes the process of symbolic interaction, the con-nective tissue that constructs the difference between upper and lower, black and white. The hither and thither of the stairwell, the temporal movement and passage that it allows, prevents identities at either end of it from settling into primordial polarities. This interstitial passage between fixed identifications opens up the possibility of a cultural hybridity that entertains difference without an assumed or imposed hierarchy:

> I always went back and forth between racial designations and designations from physics or other symbolic designations. All these things blur in some way. . . . To develop a genealogy of the way colours and noncolours function is interesting to me.[6]

'Beyond' signifies spatial distance, marks progress, promises

the future; but our intimations of exceeding the barrier or boundary – the very act of going *beyond* – are unknowable, unrepresentable, without a return to the 'present' which, in the process of repetition, becomes disjunct and displaced. The imaginary of spatial distance – to live somehow beyond the border of our times – throws into relief the temporal, social differences that interrupt our collusive sense of cultural contemporaneity. The present can no longer be simply envisaged as a break or a bonding with the past and the future, no longer a synchronic presence: our proximate self-presence, our public image, comes to be revealed for its discontinuities, its inequalities, its minorities. Unlike the dead hand of history that tells the beads of sequential time like a rosary, seeking to establish serial, causal connections, we are now confronted with what Walter Benjamin describes as the blasting of a monadic moment from the homogenous course of history, 'establishing a conception of the present as the "time of the now" '[7]

If the jargon of our times – postmodernity, postcoloniality, postfeminism – has any meaning at all, it does not lie in the popular use of the 'post' to indicate sequentiality – *after*-feminism; or polarity – *anti*-modernism. These terms that insistently gesture to the beyond, only embody its restless and revisionary energy if they transform the present into an expanded and ex-centric site of experience and empowerment. For instance, if the interest in postmodernism is limited to a celebration of the fragmentation of the 'grand narratives' of postenlightenment rationalism then, for all its intellectual excitement, it remains a profoundly parochial enterprise.

The wider significance of the postmodern condition lies in the awareness that the epistemological 'limits' of those ethnocentric ideas are also the enunciative boundaries of a range of other dissonant, even dissident histories and voices – women, the colonized, minority groups, the bearers of policed sexualities. For the demography of the new internationalism is the

history of postcolonial migration, the narratives of cultural and
political diaspora, the major social displacements of peasant and
aboriginal communities, the poetics of exile, the grim prose of
political and economic refugees. It is in this sense that the
boundary becomes the place from which something begins its presenc-
ing in a movement not dissimilar to the ambulant, ambivalent
articulation of the beyond that I have drawn out: 'Always and
ever differently the bridge escorts the lingering and hastening
ways of men to and fro, so that they may get to other banks. . . .
The bridge gathers as a passage that crosses.'[8]

The very concepts of homogenous national cultures, the con-
sensual or contiguous transmission of historical traditions, or
'organic' ethnic communities – as the grounds of cultural comparativism
– are in a profound process of redefinition. The hideous extrem-
ity of Serbian nationalism proves that the very idea of a pure,
'ethnically cleansed' national identity can only be achieved
through the death, literal and figurative, of the complex inter-
weavings of history, and the culturally contingent borderlines of
modern nationhood. This side of the psychosis of patriotic fer-
vour, I like to think, there is overwhelming evidence of a more
transnational and translational sense of the hybridity of
imagined communities. Contemporary Sri Lankan theatre repre-
sents the deadly conflict between the Tamils and the Sinhalese
through allegorical references to State brutality in South Africa
and Latin America; the Anglo-Celtic canon of Australian litera-
ture and cinema is being rewritten from the perspective of Abo-
riginal political and cultural imperatives; the South African
novels of Richard Rive, Bessie Head, Nadine Gordimer, John
Coetzee, are documents of a society divided by the effects of
apartheid that enjoin the international intellectual community to
meditate on the unequal, assymetrical worlds that exist else-
where; Salman Rushdie writes the fabulist historiography of
post-Independence India and Pakistan in Midnight's Children and
Shame, only to remind us in The Satanic Verses that the truest eye may

now belong to the migrant's double vision; Toni Morrison's *Beloved* revives the past of slavery and its murderous rituals of possession and self-possession, in order to project a contemporary fable of a woman's history that is at the same time the narrative of an affective, historic memory of an emergent public sphere of men and women alike.

What is striking about the 'new' internationalism is that the move from the specific to the general, from the material to the metaphoric, is not a smooth passage of transition and transcendence. The 'middle passage' of contemporary culture, as with slavery itself, is a process of displacement and disjunction that does not totalize experience. Increasingly, 'national' cultures are being produced from the perspective of disenfranchised minorities. The most significant effect of this process is not the proliferation of 'alternative histories of the excluded' producing, as some would have it, a pluralist anarchy. What my examples show is the changed basis for making international connections. The currency of critical comparativism, or aesthetic judgement, is no longer the sovereignty of the national culture conceived as Benedict Anderson proposes as an 'imagined community' rooted in a 'homogeneous empty time' of modernity and progress. The great connective narratives of capitalism and class drive the engines of social reproduction, but do not, in themselves, provide a foundational frame for those modes of cultural identification and political affect that form around issues of sexuality, race, feminism, the lifeworld of refugees or migrants, or the deathly social destiny of AIDS.

The testimony of my examples represents a radical revision in the concept of human community itself. What this geopolitical space may be, as a local or transnational reality, is being both interrogated and reinitiated. Feminism, in the 1990s, finds its solidarity as much in liberatory narratives as in the painful ethical position of a slavewoman, Morrison's Sethe, in *Beloved*, who is pushed to infanticide. The body politic can no longer

contemplate the nation's health as simply a civic virtue; it must rethink the question of rights for the entire national, and international, community, from the AIDS perspective. The Western metropole must confront its postcolonial history, told by its influx of postwar migrants and refugees, as an indigenous or native narrative *internal to its national identity*; and the reason for this is made clear in the stammering, drunken words of Mr 'Whisky' Sisodia from *The Satanic Verses*: 'The trouble with the Engenglish is that their hiss hiss history happened overseas, so they dodo don't know what it means.'[9]

Postcoloniality, for its part, is a salutary reminder of the persistent 'neo-colonial' relations within the 'new' world order and the multinational division of labour. Such a perspective enables the authentication of histories of exploitation and the evolution of strategies of resistance. Beyond this, however, postcolonial critique bears witness to those countries and communities – in the North and the South, urban and rural – constituted, if I may coin a phrase, 'otherwise than modernity'. Such cultures of a postcolonial *contra-modernity* may be contingent to modernity, discontinuous or in contention with it, resistant to its oppressive, assimilationist technologies; but they also deploy the cultural hybridity of their borderline conditions to 'translate', and therefore reinscribe, the social imaginary of both metropolis and modernity. Listen to Guillermo Gomez-Peña, the performance artist who lives, amongst other times and places, on the Mexico/ US border:

> hello America
> this is the voice of *Gran Vato Charollero*
> *broadcasting from the hot deserts of Nogales, Arizona*
> zona de libre cogercio
> 2000 megaherz en todas direciones
>
> you are celebrating Labor Day in Seattle
> while the Klan demonstrates

against Mexicans in Georgia
ironia, 100% ironia[10]

Being in the 'beyond', then, is to inhabit an intervening space, as any dictionary will tell you. But to dwell 'in the beyond' is also, as I have shown, to be part of a revisionary time, a return to the present to redescribe our cultural contemporaneity; to re-inscribe our human, historic commonality; *to touch the future on its hither side*. In that sense, then, the intervening space 'beyond', becomes a space of intervention in the here and now. To engage with such invention, and intervention, as Green and Gomez-Peña enact in their distinctive work, requires a sense of the new that resonates with the hybrid chicano aesthetic of '*rasquachismo*' as Tomas Ybarra-Frausto describes it:

> the utilization of available resources for syncretism, juxta-position, and integration. *Rasquachismo* is a sensibility attuned to mixtures and confluence . . . a delight in texture and sensu-ous surfaces . . . self-conscious manipulation of materials or iconography . . . the combination of found material and satiric wit . . . the manipulation of *rasquache* artifacts, code and sens-ibilities from both sides of the border.[11]

The borderline work of culture demands an encounter with 'newness' that is not part of the continuum of past and present. It creates a sense of the new as an insurgent act of cultural translation. Such art does not merely recall the past as social cause or aesthetic precedent; it renews the past, refiguring it as a contingent 'in-between' space, that innovates and interrupts the performance of the present. The 'past–present' becomes part of the necessity, not the nostalgia, of living.

Pepon Osorio's *objects trouvés* of the Nuyorican (New York/ Puerto Rican) community – the statistics of infant mortality, or the silent (and silenced) spread of AIDS in the Hispanic com-

munity – are elaborated into baroque allegories of social alien-
ation. But it is not the high drama of birth and death that cap-
tures Osorio's spectacular imagination. He is the great celebrant
of the migrant act of survival, using his mixed-media works to
make a hybrid cultural space that forms contingently, dis-
junctively, in the inscription of signs of cultural memory and
sites of political agency. *La Cama* (*The Bed*) turns the highly
decorated four-poster into the primal scene of lost-and-found
childhood memories, the memorial to a dead nanny Juana, the
mise-en-scène of the eroticism of the 'emigrant' everyday. Survival,
for Osorio, is working in the interstices of a range of practices:
the 'space' of installation, the spectacle of the social statistic, the
transitive time of the body in performance.

Finally, it is the photographic art of Alan Sekula that takes the
borderline condition of cultural translation to its global limit in
Fish Story, his photographic project on harbours: 'the harbour is
the site in which material goods appear in bulk, in the very flux
of exchange.'[12] The harbour and the stockmarket become the
paysage moralisé of a containerized, computerized world of global
trade. Yet, the non-synchronous time–space of transnational
'exchange', and exploitation, is embodied in a navigational
allegory:

> Things are more confused now. A scratchy recording of the
> Norwegian national anthem blares out from a loudspeaker at
> the Sailor's Home on the bluff above the channel. The con-
> tainer ship being greeted flies a Bahamian flag of convenience.
> It was built by Koreans working long hours in the giant ship-
> yards of Ulsan. The underpaid and the understaffed crew could
> be Salvadorean or Filipino. Only the Captain hears a familiar
> melody.[13]

Norway's nationalist nostalgia cannot drown out the babel on
the bluff. Transnational capitalism and the impoverishment of

the Third World certainly create the chains of circumstance that incarcerate the Salvadorean or the Filipino/a. In their cultural passage, hither and thither, as migrant workers, part of the massive economic and political diaspora of the modern world, they embody the Benjaminian 'present': that moment blasted out of the continuum of history. Such conditions of cultural displacement and social discrimination – where political survivors become the best historical witnesses – are the grounds on which Frantz Fanon, the Martinican psychoanalyst and participant in the Algerian revolution, locates an agency of empowerment:

> As soon as I *desire* I am asking to be considered. I am not merely here-and-now, sealed into thingness. I am for somewhere else and for something else. I demand that notice be taken of my *negating activity* [my emphasis] insofar as I pursue something other than life; insofar as I do battle for the creation of a human world – that is a world of reciprocal recognitions.
>
> I should constantly remind myself that the real *leap* consists in introducing invention into existence.
> In the world in which I travel, I am endlessly creating myself. And it is by going beyond the historical, instrumental hypothesis that I will initiate my cycle of freedom.[14]

Once more it is the desire for recognition, 'for somewhere else and for something else' that takes the experience of history beyond the instrumental hypothesis. Once again, it is the space of intervention emerging in the cultural interstices that introduces creative invention into existence. And one last time, there is a return to the performance of identity as iteration, the re-creation of the self in the world of travel, the resettlement of the borderline community of migration. Fanon's desire for the recognition of cultural presence as 'negating activity' resonates with my breaking of the time-barrier of a culturally collusive 'present'.

UNHOMELY LIVES: THE LITERATURE OF RECOGNITION

Fanon recognizes the crucial importance, for subordinated peoples, of asserting their indigenous cultural traditions and retrieving their repressed histories. But he is far too aware of the dangers of the fixity and fetishism of identities within the calcification of colonial cultures to recommend that 'roots' be struck in the celebratory romance of the past or by homogenizing the history of the present. The negating activity is, indeed, the intervention of the 'beyond' that establishes a boundary: a bridge, where 'presencing' begins because it captures something of the estranging sense of the relocation of the home and the world – the unhomeliness – that is the condition of extra-territorial and cross-cultural initiations. To be unhomed is not to be homeless, nor can the 'unhomely' be easily accommodated in that familiar division of social life into private and public spheres. The unhomely moment creeps up on you stealthily as your own shadow and suddenly you find yourself with Henry James's Isabel Archer, in *The Portrait of a Lady*, taking the measure of your dwelling in a state of 'incredulous terror'.[15] And it is at this point that the world first shrinks for Isabel and then expands enormously. As she struggles to survive the fathomless waters, the rushing torrents, James introduces us to the 'unhomeliness' inherent in that rite of extra-territorial and cross-cultural initiation. The recesses of the domestic space become sites for history's most intricate invasions. In that displacement, the borders between home and world become confused; and, uncannily, the private and the public become part of each other, forcing upon us a vision that is as divided as it is disorienting.

Although the 'unhomely' is a paradigmatic colonial and post-colonial condition, it has a resonance that can be heard distinctly, if erratically, in fictions that negotiate the powers of cultural difference in a range of transhistorical sites. You have

already heard the shrill alarm of the unhomely in that moment when Isabel Archer realizes that her world has been reduced to one high, mean window, as her house of fiction becomes 'the house of darkness, the house of dumbness, the house of suffocation'.[16] If you hear it thus at the Palazzo Roccanera in the late 1870s, then a little earlier in 1873 on the outskirts of Cincinnati, in mumbling houses like 124 Bluestone Road, you hear the undecipherable language of the black and angry dead; the voice of Toni Morrison's Beloved, 'the thoughts of the women of 124, unspeakable thoughts, unspoken'.[17] More than a quarter of a century later in 1905, Bengal is ablaze with the Swadeshi or Home Rule movement when 'home-made Bimala, the product of the confined space', as Tagore describes her in The Home and the World, is aroused by 'a running undertone of melody, low down in the bass . . . the true manly note, the note of power'. Bimala is possessed and drawn forever from the zenana, the secluded women's quarters, as she crosses that fated verandah into the world of public affairs – 'over to another shore and the ferry had ceased to ply.'[18] Much closer to our own times in contemporary South Africa, Nadine Gordimer's heroine Aila in My Son's Story emanates a stilling atmosphere as she makes her diminished domesticity into the perfect cover for gun-running: suddenly the home turns into another world, and the narrator notices that 'It was as if everyone found that he had unnoticingly entered a strange house, and it was hers. . . .'[19]

The historical specificities and cultural diversities that inform each of these texts would make a global argument purely gestural; in any case, I shall only be dealing with Morrison and Gordimer in any detail. But the 'unhomely' does provide a 'non-continuist' problematic that dramatizes – in the figure of woman – the ambivalent structure of the civil State as it draws its rather paradoxical boundary between the private and the public spheres. If, for Freud, the unheimlich is 'the name for everything that ought to have remained . . . secret and hidden but has come

to light,' then Hannah Arendt's description of the public and private realms is a profoundly unhomely one: 'it is the distinction between things that should be hidden and things that should be shown,' she writes, which through their inversion in the modern age 'discovers how rich and manifold the hidden can be under conditions of intimacy'.[20]

This logic of reversal, that turns on a disavowal, informs the profound revelations and reinscriptions of the unhomely moment. For what was 'hidden from sight' for Arendt, becomes in Carole Pateman's *The Disorder of Women* the 'ascriptive domestic sphere' that is *forgotten* in the theoretical distinctions of the private and public spheres of civil society. Such a forgetting – or disavowal – creates an uncertainty at the heart of the generalizing subject of civil society, compromising the 'individual' that is the support for its universalist aspiration. By making visible the forgetting of the 'unhomely' moment in civil society, feminism specifies the patriarchal, gendered nature of civil society and disturbs the symmetry of private and public which is now shadowed, or uncannily doubled, by the difference of genders which does not neatly map on to the private and the public, but becomes disturbingly supplementary to them. This results in redrawing the domestic space as the space of the normalizing, pastoralizing, and individuating techniques of modern power and police: the personal-is-the-political; the world-in-the-home.

The unhomely moment relates the traumatic ambivalences of a personal, psychic history to the wider disjunctions of political existence. Beloved, the child murdered by her own mother, Sethe, is a daemonic, belated repetition of the violent history of black infant deaths, during slavery, in many parts of the South, less than a decade after the haunting of 124 Bluestone Road. (Between 1882 and 1895 from one-third to a half of the annual black mortality rate was accounted for by children under five years of age.) But the memory of Sethe's act of infanticide

emerges through 'the holes – the things the fugitives did not say; the questions they did not ask ... the unnamed, the unmentioned.'[21] As we reconstruct the narrative of child murder through Sethe, the slave mother, who is herself the victim of social death, the very historical basis of our ethical judgement undergoes a radical revision.

Such forms of social and psychic existence can best be represented in that tenuous survival of literary language itself, which allows memory to speak:

> while knowing Speech can (be) at best, a shadow echoing
> the silent light, bear witness
> To the truth, it is not . . .

W. H. Auden wrote those lines on the powers of *poesis* in *The Cave of Making*, aspiring to be, as he put it, 'a minor Atlantic Goethe'.[22] And it is to an intriguing suggestion in Goethe's final 'Note on world literature' (1830) that I now turn to find a comparative method that would speak to the 'unhomely' condition of the modern world.

Goethe suggests that the possibility of a world literature arises from the cultural confusion wrought by terrible wars and mutual conflicts. Nations

> could not return to their settled and independent life again
> without noticing that they had learned many foreign ideas and
> ways, which they had unconsciously adopted, and come to
> feel here and there previously unrecognized spiritual and
> intellectual needs.[23]

Goethe's immediate reference is, of course, to the Napoleonic wars and his concept of 'the feeling of neighbourly relations' is profoundly Eurocentric, extending as far as England and France. However, as an Orientalist who read *Shakuntala* at seventeen

years of age, and who writes in his autobiography of the 'unformed and overformed'[24] monkey god Hanuman, Goethe's speculations are open to another line of thought.

What of the more complex cultural situation where 'previously unrecognized spiritual and intellectual needs' emerge from the imposition of 'foreign' ideas, cultural representations, and structures of power? Goethe suggests that the 'inner nature of the whole nation as well as the individual man works all unconsciously.'[25] When this is placed alongside his idea that the cultural life of the nation is 'unconsciously' lived, then there may be a sense in which world literature could be an emergent, prefigurative category that is concerned with a form of cultural dissensus and alterity, where non-consensual terms of affiliation may be established on the grounds of historical trauma. The study of world literature might be the study of the way in which cultures recognize themselves through their projections of 'otherness'. Where, once, the transmission of national traditions was the major theme of a world literature, perhaps we can now suggest that transnational histories of migrants, the colonized, or political refugees – these border and frontier conditions – may be the terrains of world literature. The centre of such a study would neither be the 'sovereignty' of national cultures, nor the universalism of human culture, but a focus on those 'freak social and cultural displacements' that Morrison and Gordimer represent in their 'unhomely' fictions. Which leads us to ask: can the perplexity of the unhomely, intrapersonal world lead to an international theme?

If we are seeking a 'worlding' of literature, then perhaps it lies in a critical act that attempts to grasp the sleight of hand with which literature conjures with historical specificity, using the medium of psychic uncertainty, aesthetic distancing, or the obscure signs of the spirit-world, the sublime and the subliminal. As literary creatures and political animals we ought to concern ourselves with the understanding of human action

and the social world as a moment when *something is beyond control, but it is not beyond accommodation*. This act of writing the world, of taking the measure of its dwelling, is magically caught in Morrison's description of her house of fiction – art as 'the fully realized presence of a haunting'[26] of history. Read as an image that describes the relation of art to social reality, my translation of Morrison's phrase becomes a statement on the political responsibility of the critic. For the critic must attempt to fully realize, and take responsibility for, the unspoken, unrepresented pasts that haunt the historical present.

Our task remains, however, to show how historical agency is transformed through the signifying process; how the historical event is represented in a discourse that is *somehow beyond control*. This is in keeping with Hannah Arendt's suggestion that the author of social action may be the initiator of its unique meaning, but as agent he or she cannot control its outcome. It is not simply what the house of fiction contains or 'controls' *as content*. What is just as important is the metaphoricity of the houses of racial memory that both Morrison and Gordimer construct – those subjects of the narrative that mutter or mumble like 124 Bluestone Road, or keep a still silence in a 'grey' Cape Town suburb.

Each of the houses in Gordimer's *My Son's Story* is invested with a specific secret or a conspiracy, an unhomely stirring. The house in the ghetto is the house of the collusiveness of the coloureds in their antagonistic relations to the blacks; the lying house is the house of Sonny's adultery; then there is the silent house of Aila's revolutionary camouflage; there is also the nocturnal house of Will, the narrator, writing of the narrative that charts the phoenix rising in his home, while the words must turn to ashes in his mouth. But each 'unhomely' house marks a deeper historical displacement. And that is the condition of being 'coloured' in South Africa, or as Will describes it, 'halfway between . . . being not defined – and it was this lack of definition in itself

that was never to be questioned, but observed like a taboo, something which no one, while following, could ever admit to'.[27]

This halfway house of racial and cultural origins bridges the 'in-between' diasporic origins of the coloured South African and turns it into the symbol for the disjunctive, displaced everyday life of the liberation struggle: 'like so many others of this kind, whose families are fragmented in the diaspora of exile, code names, underground activity, people for whom a real home and attachments are something for others who will come after.'[28]

Private and public, past and present, the psyche and the social develop an interstitial intimacy. It is an intimacy that questions binary divisions through which such spheres of social experience are often spatially opposed. These spheres of life are linked through an 'in-between' temporality that takes the measure of dwelling at home, while producing an image of the world of history. This is the moment of aesthetic distance that provides the narrative with a double edge, which like the coloured South African subject represents a hybridity, a difference 'within', a subject that inhabits the rim of an 'in-between' reality. And the inscription of this borderline existence inhabits a stillness of time and a strangeness of framing that creates the discursive 'image' at the crossroads of history and literature, bridging the home and the world.

Such a strange stillness is visible in the portrait of Aila. Her husband Sonny, now past his political prime, his affair with his white revolutionary lover in abeyance, makes his first prison visit to see his wife. The wardress stands back, the policeman fades, and Aila emerges as an unhomely presence, on the opposite side from her husband and son:

> but through the familiar beauty there was a vivid strangeness. -
> . . . It was as if some chosen experience had seen in her, as a

> painter will in his subject, what she was, what was there to be discovered. In Lusaka, in secret, in prison – who knows where – she had sat for her hidden face. *They had to recognise her.*[29]

Through this painterly distance a vivid strangeness emerges; a partial or double 'self' is framed in a climactic political moment that is also a contingent historical event – 'some chosen experience . . . who knows where . . . or what there was to be discovered.'[30] They had to recognize her, but *what* do they recognize in her?

Words will not speak and the silence freezes into the images of apartheid: identity cards, police frame-ups, prison mug-shots, the grainy press pictures of terrorists. Of course, Aila is not judged, nor is she judgemental. Her revenge is much wiser and more complete. In her silence she becomes the unspoken 'totem' of the taboo of the coloured South African. She displays the unhomely world, 'the halfway between . . . not defined' world of the coloured as the 'distorted place and time in which they – all of them – Sonny, Aila, Hannah – lived'.[31] The silence that doggedly follows Aila's dwelling now turns into an image of the 'interstices', the in-between hybridity of the history of sexuality and race.

> The necessity for what I've done – She placed the outer edge of each hand, fingers extended and close together, as a frame on either sides of the sheets of testimony in front of her. And she placed herself before him, to be judged by him.[32]

Aila's hidden face, the outer edge of each hand, these small gestures through which she speaks describe another dimension of 'dwelling' in the social world. Aila as coloured woman defines a boundary that is at once inside and outside, the insider's outsideness. The stillness that surrounds her, the gaps in her story, her hesitation and passion that speak between the self and its

acts – these are moments where the private and public touch in contingency. They do not simply transform the content of political ideas; the very 'place' from which the political is spoken – the public sphere itself, becomes an experience of liminality which questions, in Sonny's words, what it means to speak 'from the centre of life'.[33]

The central political preoccupation of the novel – till Aila's emergence – focuses on the 'loss of absolutes', the meltdown of the cold war, the fear 'that if we can't offer the old socialist paradise in exchange for the capitalist hell here, we'll have turned traitor to our brothers'.[34] The lesson Aila teaches requires a movement away from a world conceived in binary terms, away from a notion of the people's aspirations sketched in simple black and white. It also requires a shift of attention from the political as a pedagogical, ideological practice to politics as the stressed necessity of everyday life – politics as a performativity. Aila leads us to the unhomely world where, Gordimer writes, the banalities are enacted – the fuss over births, marriages, family affairs with their survival rituals of food and clothing.[35] But it is precisely in these banalities that the unhomely stirs, as the violence of a racialized society falls most enduringly on the details of life: where you can sit, or not; how you can live, or not; what you can learn, or not; who you can love, or not. Between the banal act of freedom and its historic denial rises the silence: 'Aila emanated a stilling atmosphere; the parting jabber stopped. It was as if everyone found he had unnoticingly entered a strange house, and it was hers; she stood there.'[36]

In Aila's stillness, its obscure necessity, we glimpse what Emmanuel Levinas has magically described as the twilight existence of the aesthetic image – art's image as 'the very event of obscuring, a descent into night, an invasion of the shadow'.[37] The 'completion' of the aesthetic, the distancing of the world in the image, is precisely not a transcendental activity. The image – or the metaphoric, 'fictional' activity of discourse – makes

visible 'an interruption of time by a movement going on on the hither side of time, in its interstices'.[38] The complexity of this statement will become clearer when I remind you of the stillness of time through which Aila surreptitiously and subversively interrupts the on-going presence of political activity, using her interstitial role, her domestic world to both 'obscure' her political role and to articulate it the better. Or, as *Beloved*, the continual eruption of 'undecipherable languages' of slave memory obscures the historical narrative of infanticide only to articulate the unspoken: that ghostly discourse that enters the world of 124 'from the outside' in order to reveal the transitional world of the aftermath of slavery in the 1870s, its private and public faces, its historical past and its narrative present.

The aesthetic image discloses an ethical time of narration because, Levinas writes, 'the real world appears in the image as it were between parentheses.'[39] Like the outer edges of Aila's hands holding her enigmatic testimony, like 124 Bluestone Road which is a fully realized presence haunted by undecipherable languages, Levinas's parenthetical perspective is also an ethical view. It effects an 'externality of the inward' as the very enunciative position of the historical and narrative subject, 'introducing into the heart of subjectivity a radical and anarchical reference to the other which in fact constitutes the inwardness of the subject.'[40] Is it not uncanny that Levinas's metaphors for this unique 'obscurity' of the image should come from those Dickensian unhomely places – those dusty boarding schools, the pale light of London offices, the dark, dank second-hand clothes shops?

For Levinas the 'art-magic' of the contemporary novel lies in its way of 'seeing inwardness from the outside', and it is this ethical-aesthetic positioning that returns us, finally, to the community of the unhomely, to the famous opening lines of *Beloved*: '124 was spiteful. The women in the house knew it and so did the children.'

It is Toni Morrison who takes this ethical and aesthetic project

of 'seeing inwardness from the outside' furthest or deepest – right into Beloved's naming of her desire for identity: 'I want you to touch me on my inside part and call me my name.'[41] There is an obvious reason why a ghost should want to be so realized. What is more obscure – and to the point – is how such an inward and intimate desire would provide an 'inscape' of the memory of slavery. For Morrison, it is precisely the signification of the historical and discursive boundaries of slavery that are the issue.

Racial violence is invoked by historical dates – 1876, for instance – but Morrison is just a little hasty with the events 'inthemselves', as she rushes past 'the true meaning of the Fugitive Bill, the Settlement Fee, God's Ways, antislavery, manumission, skin voting'.[42] What has to be endured is the knowledge of doubt that comes from Sethe's eighteen years of disapproval and a solitary life, her banishment in the unhomely world of 124 Bluestone Road, as the pariah of her postslavery community. What finally causes the thoughts of the women of 124 'unspeakable thoughts to be unspoken' is the understanding that the victims of violence are themselves 'signified upon': they are the victims of projected fears, anxieties and dominations that do not originate within the oppressed and will not fix them in the circle of pain. The stirring of emancipation comes with the knowledge that the racially supremacist belief 'that under every dark skin there was a jungle' was a belief that grew, spread, touched every perpetrator of the racist myth, turned them mad from their own untruths, and was then expelled from 124 Bluestone Road.

But before such an emancipation from the ideologies of the master, Morrison insists on the harrowing ethical repositioning of the slave mother, who must be the enunciatory site for seeing the inwardness of the slave world from the outside – when the 'outside' is the ghostly return of the child she murdered; the double of herself, for 'she is the laugh I am the laugher I see her face which is mine.'[43] What could be the ethics of child murder?

What historical knowledge returns to Sethe, through the aesthetic distance or 'obscuring' of the event, in the phantom shape of her dead daughter Beloved?

In her fine account of forms of slave resistance in *Within the Plantation Household*, Elizabeth Fox-Genovese considers murder, self-mutilation and infanticide to be the core psychological dynamic of all resistance. It is her view that 'these extreme forms captured the essence of the slave woman's self-definition'.[44] Again we see how this most tragic and intimate act of violence is performed in a struggle to push back the boundaries of the slave world. Unlike acts of confrontation against the master or the overseer which were resolved within the household context, infanticide was recognized as an act against the system and at least acknowledged the slavewoman's legal standing in the public sphere. Infanticide was seen to be an act against the master's property – against his surplus profits – and perhaps that, Fox-Genovese concludes, 'led some of the more desperate to feel that, by killing an infant they loved, they would be in some way reclaiming it as their own'.[45]

Through the death and the return of Beloved, precisely such a reclamation takes place: the slave mother regaining through the presence of the child, the property of her own person. This knowledge comes as a kind of self-love that is also the love of the 'other': Eros and Agape together. It is an ethical love in the Levinasian sense in which the 'inwardness' of the subject is inhabited by the 'radical and anarchical reference to the other'. This knowledge is visible in those intriguing chapters[46] which lay over each other, where Sethe, Beloved and Denver perform a fugue-like ceremony of claiming and naming through intersecting and interstitial subjectivities: 'Beloved, she my daughter'; 'Beloved is my sister'; 'I am Beloved and she is mine.' The women speak in tongues, from a space 'in-between each other' which is a communal space. They explore an 'interpersonal' reality: a social reality that appears within the poetic image as if

it were in parentheses – aesthetically distanced, held back, and yet historically framed. It is difficult to convey the rhythm and the improvization of those chapters, but it is impossible not to see in them the healing of history, a community reclaimed in the making of a name. We can finally ask ourselves:

Who is Beloved?

Now we understand: she is the daughter that returns to Sethe so that her mind will be homeless no more.

Who is Beloved?

Now we may say: she is the sister that returns to Denver, and brings hope of her father's return, the fugitive who died in his escape.

Who is Beloved?

Now we know: she is the daughter made of murderous love who returns to love and hate and free herself. Her words are broken, like the lynched people with broken necks; disembodied, like the dead children who lost their ribbons. But there is no mistaking what her live words say as they rise from the dead despite their lost syntax and their fragmented presence.

My face is coming I have to have it I am looking for the join I am loving my face so much I want to join I am loving my face so much my dark face is close to me I want to join.[47]

LOOKING FOR THE JOIN

To end, as I have done, with the nest of the phoenix, not its pyre is, in another way, to return to my beginning in the *beyond*. If

Gordimer and Morrison describe the historical world, forcibly entering the house of art and fiction in order to invade, alarm, divide and dispossess, they also demonstrate the contemporary compulsion to move beyond; to turn the present into the 'post'; or, as I said earlier, to touch the future on its hither side. Aila's in-between identity and Beloved's double lives both affirm the borders of culture's insurgent and interstitial existence. In that sense, they take their stand with Renee Green's pathway between racial polarities; or Rushdie's migrant history of the English written in the margins of satanic verses; or Osorio's bed – La Cama – a place of dwelling, located between the unhomeliness of migrancy and the baroque belonging of the metropolitan, New York/Puerto-Rican artist.

When the public nature of the social event encounters the silence of the word it may lose its historical composure and closure. At this point we would do well to recall Walter Benjamin's insight on the disrupted dialectic of modernity: 'Ambiguity is the figurative appearance of the dialectic, the law of the dialectic at a standstill.'[48] For Benjamin that stillness is Utopia; for those who live, as I described it, 'otherwise' than modernity but not outside it, the Utopian moment is not the necessary horizon of hope. I have ended this argument with the woman framed – Gordimer's Aila – and the woman renamed – Morrison's Beloved – because in both their houses great world events erupted – slavery and apartheid – and their happening was turned, through that peculiar obscurity of art, into a second coming.

Although Morrison insistently repeats at the close of Beloved, 'This is not a story to pass on,' she does this only in order to engrave the event in the deepest resources of our amnesia, of our unconsciousness. When historical visibility has faded, when the present tense of testimony loses its power to arrest, then the displacements of memory and the indirections of art offer us the image of our psychic survival. To live in the unhomely world, to

find its ambivalencies and ambiguities enacted in the house of fiction, or its sundering and splitting performed in the work of art, is also to affirm a profound desire for social solidarity: 'I am looking for the join . . . I want to join . . . I want to join.'

1

THE COMMITMENT
TO THEORY

I

There is a damaging and self-defeating assumption that theory is
necessarily the elite language of the socially and culturally privil-
eged. It is said that the place of the academic critic is inevitably
within the Eurocentric archives of an imperialist or neo-colonial
West. The Olympian realms of what is mistakenly labelled 'pure
theory' are assumed to be eternally insulated from the historical
exigencies and tragedies of the wretched of the earth. Must we
always polarize in order to polemicize? Are we trapped in a
politics of struggle where the representation of social antagon-
isms and historical contradictions can take no other form than a
binarism of theory vs politics? Can the aim of freedom of know-
ledge be the simple inversion of the relation of oppressor and
oppressed, centre and periphery, negative image and positive
image? Is our only way out of such dualism the espousal of an
implacable oppositionality or the invention of an originary

counter-myth of radical purity? Must the project of our liber-
ationist aesthetics be forever part of a totalizing Utopian vision
of Being and History that seeks to transcend the contradictions
and ambivalences that constitute the very structure of human
subjectivity and its systems of cultural representation?

Between what is represented as the 'larceny' and distortion of
European 'metatheorizing' and the radical, engaged, activist
experience of Third World creativity,[1] one can see the mirror
image (albeit reversed in content and intention) of that ahistor-
ical nineteenth-century polarity of Orient and Occident which,
in the name of progress, unleashed the exclusionary imperialist
ideologies of self and other. This time round, the term 'critical
theory', often untheorized and unargued, is definitely the Other,
an otherness that is insistently identified with the vagaries of the
depoliticized Eurocentric critic. Is the cause of radical art or
critique best served for instance, by a fulminating professor of
film who announces, at a flashpoint in the argument, 'We are not
artists, we are political activists?' By obscuring the power of his
own practice in the rhetoric of militancy, he fails to draw atten-
tion to the specific value of a politics of cultural production;
because it makes the surfaces of cinematic signification the
grounds of political intervention, it gives depth to the language
of social criticism and extends the domain of 'politics' in a direc-
tion that will not be entirely dominated by the forces of
economic or social control. Forms of popular rebellion and
mobilization are often most subversive and transgressive when
they are created through oppositional cultural practices.

Before I am accused of bourgeois voluntarism, liberal pragma-
tism, academicist pluralism and all the other '-isms' that are
freely bandied about by those who take the most severe excep-
tion to 'Eurocentric' theoreticism (Derrideanism, Lacanianism,
poststructuralism . . .), I would like to clarify the goals of my
opening questions. I am convinced that, in the language of polit-
ical economy, it is legitimate to represent the relations of

exploitation and domination in the discursive division between the First and Third World, the North and the South. Despite the claims to a spurious rhetoric of 'internationalism' on the part of the established multinationals and the networks of the new communications technology industries, such circulations of signs and commodities as there are, are caught in the vicious circuits of surplus value that link First World capital to Third World labour markets through the chains of the international division of labour, and national comprador classes. Gayatri Spivak is right to conclude that it is 'in the interest of capital to preserve the comprador theatre in a state of relatively primitive labour legislation and environmental regulation'.[2]

I am equally convinced that, in the language of international diplomacy, there is a sharp growth in a new Anglo-American nationalism which increasingly articulates its economic and military power in political acts that express a neo-imperialist disregard for the independence and autonomy of peoples and places in the Third World. Think of America's 'backyard' policy towards the Caribbean and Latin America, the patriotic gore and patrician lore of Britain's Falklands Campaign or, more recently, the triumphalism of the American and British forces during the Gulf War. I am further convinced that such economic and political domination has a profound hegemonic influence on the information orders of the Western world, its popular media and its specialized institutions and academics. So much is not in doubt.

What does demand further discussion is whether the 'new' languages of theoretical critique (semiotic, poststructuralist, deconstructionist and the rest) simply reflect those geopolitical divisions and their spheres of influence. Are the interests of 'Western' theory necessarily collusive with the hegemonic role of the West as a power bloc? Is the language of theory merely another power ploy of the culturally privileged Western elite

to produce a discourse of the Other that reinforces its own power–knowledge equation?

A large film festival in the West – even an alternative or counter-cultural event such as Edinburgh's 'Third Cinema' Conference – never fails to reveal the disproportionate influence of the West as cultural forum, in all three senses of that word: as place of public exhibition and discussion, as place of judgement, and as market-place. An Indian film about the plight of Bombay's pavement-dwellers wins the Newcastle Festival which then opens up distribution facilities in India. The first searing exposé of the Bhopal disaster is made for Channel Four. A major debate on the politics and theory of Third Cinema first appears in *Screen*, published by the British Film Institute. An archival article on the important history of neo-traditionalism and the 'popular' in Indian cinema sees the light of day in *Framework*.[3] Among the major contributors to the development of the Third Cinema as precept and practice are a number of Third World film-makers and critics who are exiles or *émigrés* in the West and live problematically, often dangerously, on the 'left' margins of a Eurocentric, bourgeois liberal culture. I don't think I need to add individual names or places, or detail the historical reasons why the West carries and exploits what Bourdieu would call its symbolic capital. The condition is all too familiar, and it is not my purpose here to make those important distinctions between different national situations and the disparate political causes and collective histories of cultural exile. I want to take my stand on the shifting margins of cultural displacement – that confounds any profound or 'authentic' sense of a 'national' culture or an 'organic' intellectual – and ask what the function of a committed theoretical perspective might be, once the cultural and historical hybridity of the postcolonial world is taken as the paradigmatic place of departure.

Committed to what? At this stage in the argument, I do not want to identify any specific 'object' of political allegiance – the

Third World, the working class, the feminist struggle. Although such an objectification of political activity is crucial and must significantly inform political debate, it is not the only option for those critics or intellectuals who are committed to progressive political change in the direction of a socialist society. It is a sign of political maturity to accept that there are many forms of political writing whose different effects are obscured when they are divided between the 'theoretical' and the 'activist'. It is not as if the leaflet involved in the organization of a strike is short on theory, while a speculative article on the theory of ideology ought to have more practical examples or applications. They are both forms of discourse and to that extent they produce rather than reflect their objects of reference. The difference between them lies in their operational qualities. The leaflet has a specific expository and organizational purpose, temporally bound to the event; the theory of ideology makes its contribution to those embedded political ideas and principles that inform the right to strike. The latter does not justify the former; nor does it necessarily precede it. It exists side by side with it – the one as an enabling part of the other – like the recto and verso of a sheet of paper, to use a common semiotic analogy in the uncommon context of politics.

My concern here is with the process of 'intervening ideologically', as Stuart Hall describes the role of 'imagining' or representation in the practice of politics in his response to the British election of 1987.[4] For Hall, the notion of hegemony implies a politics of identification of the imaginary. This occupies a discursive space which is not exclusively delimited by the history of either the right or the left. It exists somehow in-between these political polarities, and also between the familiar divisions of theory and political practice. This approach, as I read it, introduces us to an exciting, neglected moment, or movement, in the 'recognition' of the relation of politics to theory; and confounds the traditional division between them. Such a movement is

initiated if we see that relation as determined by the rule of repeatable materiality, which Foucault describes as the process by which statements from one institution can be transcribed in the discourse of another.[5] Despite the schemata of use and application that constitute a field of stabilization for the statement, any change in the statement's conditions of use and reinvestment, any alteration in its field of experience or verification, or indeed any difference in the problems to be solved, can lead to the emergence of a new statement: the difference of the same.

In what hybrid forms, then, may a politics of the theoretical statement emerge? What tensions and ambivalences mark this enigmatic place from which theory speaks? Speaking in the name of some counter-authority or horizon of 'the true' (in Foucault's sense of the strategic effects of any apparatus or *dispositif*), the theoretical enterprise has to represent the adversarial authority (of power and/or knowledge) which, in a doubly inscribed move, it simultaneously seeks to subvert and replace. In this complicated formulation I have tried to indicate something of the boundary and location of the event of theoretical critique which does not *contain* the truth (in polar opposition to totalitarianism, 'bourgeois liberalism' or whatever is supposed to repress it). The 'true' is always marked and informed by the ambivalence of the process of emergence itself, the productivity of meanings that construct counter-knowledges in *medias res*, in the very act of agonism, within the terms of a negotiation (rather than a negation) of oppositional and antagonistic elements. Political positions are not simply identifiable as progressive or reactionary, bourgeois or radical, prior to the act of *critique engagée*, or outside the terms and conditions of their discursive address. It is in this sense that the historical moment of political action must be thought of as part of the history of the form of its writing. This is not to state the obvious, that there is no knowledge – political or otherwise – outside representation. It is to suggest that the dynamics of writing and textuality require us to

rethink the logics of causality and determinacy through which we recognize the 'political' as a form of calculation and strategic action dedicated to social transformation.

'What is to be done?' must acknowledge the force of writing, its metaphoricity and its rhetorical discourse, as a productive matrix which defines the 'social' and makes it available as an objective of and for, action. Textuality is not simply a second-order ideological expression or a verbal symptom of a pre-given political subject. That the political subject – as indeed the subject of politics – is a discursive event is nowhere more clearly seen than in a text which has been a formative influence on Western democratic and socialist discourse – Mill's essay 'On Liberty'. His crucial chapter, 'On The Liberty of Thought and Discussion', is an attempt to define political judgement as the problem of finding a form of public rhetoric able to represent different and opposing political 'contents' not as a priori preconstituted principles but as a dialogical discursive exchange; a negotiation of terms in the on-going present of the enunciation of the political statement. What is unexpected is the suggestion that a crisis of identification is initiated in the textual performance that displays a certain 'difference' within the signification of any single political system, prior to establishing the substantial differences between political beliefs. A knowledge can only become political through an agnostic process: dissensus, alterity and otherness are the discursive conditions for the circulation and recognition of a politicized subject and a public 'truth':

> [If] opponents of all important truths do not exist, it is indispensable to imagine them. . . . [He] must feel the whole force of the difficulty which the true view of the subject has to encounter and dispose of; *else he will never really possess himself of the portion of truth which meets and removes that difficulty*. . . . Their conclusion may be true, but it might be false for anything they know: they have never thrown themselves into the *mental*

position of those who think differently from them ... and con-
sequently they do not, in any proper sense of the word, *know
the doctrine which they themselves profess.*[6] (My emphases)

It is true that Mill's 'rationality' permits, or requires, such forms
of contention and contradiction in order to enhance his vision of
the inherently progressive and evolutionary bent of human
judgement. (This makes it possible for contradictions to be
resolved and also generates a sense of the 'whole truth' which
reflects the natural, organic bent of the human mind.) It is also
true that Mill always reserves, in society as in his argument, the
unreal neutral space of the Third Person as the representative of
the 'people', who witnesses the debate from an 'epistemological
distance' and draws a reasonable conclusion. Even so, in his
attempt to describe the political as a form of debate and dialogue
– as the process of public rhetoric – that is crucially mediated
through this ambivalent and antagonistic faculty of a political
'imagination', Mill exceeds the usual mimetic sense of the battle
of ideas. He suggests something much more dialogical: the real-
ization of the political idea at the ambivalent point of textual
address, its emergence through a form of political projection.

Rereading Mill through the stategies of 'writing' that I have
suggested, reveals that one cannot passively follow the line of
argument running through the logic of the opposing ideology.
The textual process of political antagonism initiates a contradict-
ory process of reading between the lines; the agent of the dis-
course becomes, in the same time of utterance, the inverted,
projected object of the argument, turned against itself. It is, Mill
insists, only by effectively assuming the mental position of the
antagonist and working through the displacing and decentring
force of that discursive difficulty that the politicized 'portion of
truth' is produced. This is a different dynamic from the ethic of
tolerance in liberal ideology which has to imagine opposition in
order to contain it and demonstrate its enlightened relativism or

humanism. Reading Mill, against the grain, suggests that politics can only become representative, a truly public discourse, through a splitting in the signification of the subject of representation; through an ambivalence at the point of the enunciation of a politics.

I have chosen to demonstrate the importance of the space of writing, and the problematic of address, at the very heart of the liberal tradition because it is here that the myth of the 'transparency' of the human agent and the reasonableness of political action is most forcefully asserted. Despite the more radical political alternatives of the right and the left, the popular, common-sense view of the place of the individual in relation to the social is still substantially thought and lived in ethical terms moulded by liberal beliefs. What the attention to rhetoric and writing reveals is the discursive ambivalence that makes 'the political' possible. From such a perspective, the problematic of political judgement cannot be represented as an epistemological problem of appearance and reality or theory and practice or word and thing. Nor can it be represented as a dialectical problem or a symptomatic contradiction constitutive of the materiality of the 'real'. On the contrary, we are made excruciatingly aware of the ambivalent juxtaposition, the dangerous interstitial relation of the factual and the projective, and, beyond that, of the crucial function of the textual and the rhetorical. It is those vicissitudes of the movement of the signifier, in the fixing of the factual and the closure of the real, that ensure the efficacy of stategic thinking in the discourses of *Realpolitik*. It is this to-and-fro, this *fort/da* of the symbolic process of political negotiation, that constitutes a politics of address. Its importance goes beyond the unsettling of the essentialism or logocentricism of a received political tradition, in the name of an abstract free play of the signifier.

A critical discourse does not yield a *new* political object, or aim, or knowledge, which is simply a mimetic reflection of an a priori political principle or theoretical commitment. We

should not demand of it a pure teleology of analysis whereby the prior principle is simply augmented, its rationality smoothly developed, its identity as socialist or materialist (as opposed to neo-imperialist or humanist) consistently confirmed in each oppositional stage of the argument. Such identikit political idealism may be the gesture of great individual fervour, but it lacks the deeper, if dangerous, sense of what is entailed by the *passage* of history in theoretical discourse. The language of critique is effective not because it keeps forever separate the terms of the master and the slave, the mercantilist and the Marxist, but to the extent to which it overcomes the given grounds of opposition and opens up a space of translation: a place of hybridity, figuratively speaking, where the construction of a political object that is new, *neither the one nor the other*, properly alienates our political expectations, and changes, as it must, the very forms of our recognition of the moment of politics. The challenge lies in conceiving of the time of political action and understanding as opening up a space that can accept and regulate the differential structure of the moment of intervention without rushing to produce a unity of the social antagonism or contradiction. This is a sign that history is *happening* – within the pages of theory, within the systems and structures we construct to figure the passage of the historical.

When I talk of *negotiation* rather than *negation*, it is to convey a temporality that makes it possible to conceive of the articulation of antagonistic or contradictory elements: a dialectic without the emergence of a teleological or transcendent History, and beyond the prescriptive form of symptomatic reading where the nervous tics on the surface of ideology reveal the 'real materialist contradiction' that History embodies. In such a discursive temporality, the event of theory becomes the *negotiation* of contradictory and antagonistic instances that open up hybrid sites and objectives of struggle, and destroy those negative polarities between knowledge and its objects, and between theory and practical-political

reason.[7] If I have argued against a primordial and previsionary division of right or left, progressive or reactionary, it has been only to stress the fully historical and discursive *différance* between them. I would not like my notion of negotiation to be confused with some syndicalist sense of reformism because that is not the political level that is being explored here. By negotiation I attempt to draw attention to the structure of *iteration* which informs political movements that attempt to articulate antagonistic and oppositional elements without the redemptive rationality of sublation or transcendence.[8]

The temporality of negotiation or translation, as I have sketched it, has two main advantages. First, it acknowledges the historical connectedness between the subject and object of critique so that there can be no simplistic, essentialist opposition between ideological miscognition and revolutionary truth. The progressive reading is crucially determined by the adversarial or agonistic situation itself; it is effective because it uses the subversive, messy mask of camouflage and does not come like a pure avenging angel speaking the truth of a radical historicity and pure oppositionality. If one is aware of this heterogeneous emergence (not origin) of radical critique, then – and this is my second point – the function of theory within the political process becomes double-edged. It makes us aware that our political referents and priorities – the people, the community, class struggle, anti-racism, gender difference, the assertion of an anti-imperialist, black or third perspective – are not there in some primordial, naturalistic sense. Nor do they reflect a unitary or homogeneous political object. They make sense as they come to be constructed in the discourses of feminism or Marxism or the Third Cinema or whatever, whose objects of priority – class or sexuality or 'the new ethnicity' – are always in historical and philosophical tension, or cross-reference with other objectives.

Indeed, the whole history of socialist throught which seeks to 'make it new and better' seems to be a different process of

articulating priorities whose political objects can be recalcitrant and contradictory. Within contemporary Marxism, for example, witness the continual tension between the English, humanist, labourist faction and the 'theoreticist', structuralist, new left tendencies. Within feminism, there is again a marked difference of emphasis between the psychoanalytic/semiotic tradition and the Marxist articulation of gender and class through a theory of cultural and ideological interpellation. I have presented these differences in broad brush-strokes, often using the language of polemic, to suggest that each position is always a process of translation and transference of meaning. Each objective is constructed on the trace of that perspective that it puts under erasure; each political object is determined in relation to the other, and displaced in that critical act. Too often these theoretical issues are peremptorily transposed into organizational terms and represented as sectarianism. I am suggesting that such contradictions and conflicts, which often thwart political intentions and make the question of commitment complex and difficult, are rooted in the process of translation and displacement in which the object of politics is inscribed. The effect is not stasis or a sapping of the will. It is, on the contrary, the spur of the negotiation of socialist democratic politics and policies which demand that questions of organization are theorized and socialist theory is 'organized', *because there is no given community or body of the people whose inherent, radical historicity emits the right signs.*

This emphasis on the representation of the political, on the construction of discourse, is the radical contribution of the translation of theory. Its conceptual vigilance never allows a simple identity between the political objective and its means of representation. This emphasis on the necessity of heterogeneity and the double inscription of the political objective is not merely the repetition of a general truth about discourse introduced into the political field. Denying an essentialist logic and a mimetic referent to political representation is a strong, principled

argument against political separatism of any colour, and cuts through the moralism that usually accompanies such claims. There is literally, and figuratively, no space for the unitary or organic political objective which would offend against the sense of a socialist community of interest and articulation.

In Britain, in the 1980s, no political struggle was fought more powerfully, and sustained more poignantly, on the values and traditions of a socialist community than the miners' strike of 1984–5. The battalions of monetarist figures and forecasts on the profitability of the pits were starkly ranged against the most illustrious standards of the British labour movement, the most cohesive cultural communities of the working class. The choice was clearly between the dawning world of the new Thatcherite city gent and a long history of the working man, or so it seemed to the traditional left and the new right. In these class terms the mining women involved in the strike were applauded for the heroic supporting role they played, for their endurance and initiative. But the revolutionary impulse, it seemed, belonged securely to the working-class male. Then, to commemorate the first anniversary of the strike, Beatrix Campbell, in the *Guardian*, interviewed a group of women who had been involved in the strike. It was clear that their experience of the historical struggle, their understanding of the historic choice to be made, was startlingly different and more complex. Their testimonies would not be contained simply or singly within the priorities of the politics of class or the histories of industrial struggle. Many of the women began to question their roles within the family and the community – the two central institutions which articulated the meanings and mores of the *tradition* of the labouring classes around which ideological battle was enjoined. Some challenged the symbols and authorities of the culture they fought to defend. Others disrupted the homes they had struggled to sustain. For most of them there was no return, no going back to the 'good old days'. It would be simplistic to suggest either that this

considerable social change was a spin-off from the class struggle or that it was a repudiation of the politics of class from a socialist-feminist perspective. There is no simple political or social truth to be learned, for there is no unitary representation of a political agency, no fixed hierarchy of political values and effects.

My illustration attempts to display the importance of the hybrid moment of political change. Here the transformational value of change lies in the rearticulation, or translation, of elements that are *neither the One* (unitary working class) *nor the Other* (the politics of gender) *but something else besides*, which contests the terms and territories of both. There is a negotiation between gender and class, where each formation encounters the displaced, differentiated boundaries of its group representation and enunciative sites in which the limits and limitations of social power are encountered in an agonistic relation. When it is suggested that the British Labour Party should seek to produce a socialist alliance among progressive forces that are widely dispersed and distributed across a range of class, culture and occupational forces – without a unifying sense of the class for itself – the kind of hybridity that I have attempted to identify is being acknowledged as a historical necessity. We need a little less pietistic articulation of political principle (around class and nation); a little more of the principle of political *negotiation*.

This seems to be the theoretical issue at the heart of Stuart Hall's arguments for the construction of a counter-hegemonic power bloc through which a socialist party might construct its majority, its constituency; and the Labour Party might (in)conceivably improve its image. The unemployed, semi-skilled and unskilled, part-time workers, male and female, the low paid, black people, underclasses: these signs of the fragmentation of class and cultural consensus represent both the historical experience of contemporary social divisions, and a structure of heterogeneity upon which to construct a theoretical and

political alternative. For Hall, the imperative is to construct a new social bloc of different constituencies, through the production of a form of symbolic identification that would result in a collective will. The Labour Party, with its desire to reinstate its traditionalist image – white, male, working class, trade union based – is not hegemonic enough, Hall writes. He is right; what remains unanswered is whether the rationalism and intentionality that propel the collective will are compatible with the language of symbolic image and fragmentary identification that represents, for Hall and for 'hegemony'/'counter-hegemony', the fundamental political issue. Can there ever be hegemony enough, except in the sense that a two-thirds majority will elect us a socialist government?

It is by intervening in Hall's argument that the necessities of negotiation are revealed. The interest of Hall's position lies in his acknowledgement, remarkable for the British left, that, though influential, 'material interests on their own have no necessary class belongingness.'[9] This has two significant effects. It enables Hall to see the agents of political change as discontinuous, divided subjects caught in conflicting interests and identities. Equally, at the historical level of a Thatcherite population, he asserts that divisive rather than solidary forms of identification are the rule, resulting in undecidabilities and aporia of political judgement. What does a working woman put first? Which of her identities is the one that determines her political choices? The answers to such questions are defined, according to Hall, in the ideological definition of materialist interests; a process of symbolic identification achieved through a political technology of imaging that hegemonically produces a social bloc of the right or the left. Not only is the social bloc heterogeneous, but, as I see it, the work of hegemony is itself the process of iteration and differentiation. It depends on the production of alternative or antagonistic images that are always produced side by side and in competition with each other. It is this side-by-side nature, this

partial presence, or metonymy of antagonism, and its effective significations, that give meaning (quite literally) to a politics of struggle *as the struggle of identifications* and the war of positions. It is therefore problematic to think of it as sublated into an image of the collective will.

Hegemony requires iteration and alterity to be effective, to be productive of politicized populations: the (non-homogeneous) symbolic-social bloc needs to represent itself in a solidary collective will – a modern image of the future – if those populations are to produce a progressive government. Both may be necessary but they do not easily follow from each other, for in each case the mode of representation and its temporality are different. The contribution of negotiation is to display the 'in-between' of this crucial argument; it is *not* self-contradictory but significantly performs, in the process of its discussion, the problems of judgement and identification that inform the political space of its enunciation.

For the moment, the act of negotiation will only be interrogatory. Can such split subjects and differentiated social movements, which display ambivalent and divided forms of identification, be represented in a collective will that distinctively echoes Gramsci's enlightenment inheritance and its rationalism?[10] How does the language of the will accommodate the vicissitudes of its representation, its construction through a symbolic majority where the have-nots identify themselves from the position of the haves? How do we construct a politics based on such a displacement of affect or strategic elaboration (Foucault), where political positioning is ambivalently grounded in an acting-out of political fantasies that require repeated passages across the differential boundaries between one symbolic bloc *and an other*, and the positions available to each? If such is the case, then how do we fix the counter-image of socialist hegemony to reflect the divided will, the fragmented population? If the policy of hegemony is, quite literally, *unsignifiable*

without the metonymic representation of its agonistic and ambivalent structure of articulation, then how does the collective will stabilize and unify its address as an agency of *representation*, as representative of a people? How do we avoid the mixing or overlap of images, the split screen, the failure to synchronize sound and image? Perhaps we need to change the ocular language of the image in order to talk of the social and political identifications or representations of a people. It is worth noting that Laclau and Mouffe have turned to the language of textuality and discourse, to *différance* and enunciative modalities, in attempting to understand the structure of hegemony.[11] Paul Gilroy also refers to Bakhtin's theory of narrative when he describes the performance of black expressive cultures as an attempt to transform the relationship between performer and crowd 'in *dialogic* rituals so that spectators acquire the active role of participants in collective processes which are sometimes cathartic and which may symbolize or even create a community' (my emphasis).[12]

Such negotiations between politics and theory make it impossible to think of the place of the theoretical as a metanarrative claiming a more total form of generality. Nor is it possible to claim a certain familiar epistemological distance between the *time and place* of the intellectual and the activitist, as Fanon suggests when he observes that 'while politicians situate their action in actual present-day events, men of culture take their stand in the field of history.'[13] It is precisely that popular binarism between theory and politics, whose foundational basis is a view of knowledge as totalizing generality and everyday life as experience, subjectivity or false consciousness, that I have tried to erase. It is a distinction that even Sartre subscribes to when he describes the committed intellectual as the theoretician of practical knowledge whose defining criterion is rationality and whose first project is to combat the irrationality of ideology.[14] From the perspective of negotiation and translation, *contra* Fanon and Sartre, there can be no final discursive *closure* of theory. It

does not foreclose on the political, even though battles for power-knowledge may be won or lost to great effect. The corollary is that there is no first or final act of revolutionary social (or socialist) transformation.

I hope it is clear that this erasure of the traditional boundary between theory/politics, and my resistance to the en-closure of the theoretical, whether it is read negatively as elitism or positively as radical supra-rationality, do not turn on the good or bad faith of the activist agent or the intellectual *agent provocateur*. I am primarily concerned with the conceptual structuring of the terms – the theoretical/the political – that inform a range of debates around the place and time of the committed intellectual. I have therefore argued for a certain relation to knowledge which I think is crucial in structuring our sense of what the *object* of theory may be in the act of determining our specific political *objectives*.

II

What is at stake in the naming of critical theory as 'Western'? It is, obviously, a designation of institutional power and ideological Eurocentricity. Critical theory often engages with texts within the familiar traditions and conditions of colonial anthropology either to universalize their meaning within its own cultural and academic discourse, or to sharpen its internal critique of the Western logocentric sign, the idealist subject, or indeed the illusions and delusions of civil society. This is a familiar manoeuvre of theoretical knowledge, where, having opened up the chasm of cultural difference, a mediator or metaphor of otherness must be found to contain the effects of difference. In order to be institutionally effective as a discipline, the knowledge of cultural difference must be made to foreclose on the Other; difference and otherness thus become the fantasy of a certain cultural space or, indeed, the certainty of a form of

theoretical knowledge that deconstructs the epistemological 'edge' of the West.

More significantly, the site of cultural difference can become the mere phantom of a dire disciplinary struggle in which it has no space or power. Montesquieu's Turkish Despot, Barthes's Japan, Kristeva's China, Derrida's Nambikwara Indians, Lyotard's Cashinahua pagans are part of this strategy of containment where the Other text is forever the exegetical horizon of difference, never the active agent of articulation. The Other is cited, quoted, framed, illuminated, encased in the shot/reverse-shot strategy of a serial enlightenment. Narrative and the cultural politics of difference become the closed circle of interpretation. The Other loses its power to signify, to negate, to initiate its historic desire, to establish its own institutional and oppositional discourse. However impeccably the content of an 'other' culture may be known, however anti-ethnocentrically it is represented, it is its location as the closure of grand theories, the demand that, in analytic terms, it be always the good object of knowledge, the docile body of difference, that reproduces a relation of domination and is the most serious indictment of the institutional powers of critical theory.

There is, however, a distinction to be made between the institutional history of critical theory and its conceptual potential for change and innovation. Althusser's critique of the temporal structure of the Hegelian–Marxist expressive totality, despite its functionalist limitations, opens up the possibilities of thinking the relations of production in a time of differential histories. Lacan's location of the signifier of desire, on the cusp of language and the law, allows the elaboration of a form of social representation that is alive to the ambivalent structure of subjectivity and sociality. Foucault's archaeology of the emergence of modern, Western man as a problem of finitude, inextricable from its afterbirth, its Other, enables the linear, progressivist claims of the social sciences – the major imperializing discourses

– to be confronted by their own historicist limitations. These arguments and modes of analysis can be dismissed as internal squabbles around Hegelian causality, psychic representation or sociological theory. Alternatively, they can be subjected to a translation, a transformation of value as part of the questioning of the project of modernity in the great, revolutionary tradition of C. L. R. James – *contra* Trotsky or Fanon, *contra* phenomenology and existentialist psychoanalysis. In 1952, it was Fanon who suggested that an oppositional, differential reading of Lacan's Other might be more relevant for the colonial condition than the Marxisant reading of the master–slave dialectic.

It may be possible to produce such a translation or transformation if we understand the tension within critical theory between its institutional containment and its revisionary force. The continual reference to the horizon of other cultures which I have mentioned earlier is ambivalent. It is a site of citation, but it is also a sign that such critical theory cannot forever sustain its position in the academy as the adversarial cutting edge of Western idealism. What is required is to demonstrate another territory of translation, another testimony of analytical argument, a different engagement in the politics of and around cultural domination. What this other site for theory might be will become clearer if we first see that many poststructuralist ideas are themselves opposed to Enlightenment humanism and aesthetics. They constitute no less than a deconstruction of the moment of the modern, its legal values, its literary tastes, its philosophical and political categorical imperatives. Secondly, and more importantly, we must rehistoricize the moment of 'the emergence of the sign', or 'the question of the subject', or the 'discursive construction of social reality' to quote a few popular topics of contemporary theory. This can only happen if we relocate the referential and institutional demands of such theoretical work in the field of cultural difference – *not cultural diversity*.

Such a reorientation may be found in the historical texts of the

colonial moment in the late eighteenth and early nineteenth centuries. For at the same time as the question of cultural difference emerged in the colonial text, discourses of civility were defining the doubling moment of the emergence of Western modernity. Thus the political and theoretical genealogy of modernity lies not only in the origins of the *idea* of civility, but in this history of the colonial moment. It is to be found in the resistance of the colonized populations to the Word of God and Man – Christianity and the English language. The transmutations and translations of indigenous traditions in their opposition to colonial authority demonstrate how the desire of the signifier, the indeterminacy of intertextuality, can be deeply engaged in the postcolonial struggle against dominant relations of power and knowledge. In the following words of the missionary master we hear, quite distinctly, the oppositional voices of a culture of resistance; but we also hear the uncertain and threatening process of cultural transformation. I quote from A. Duff's influential *India and India Missions* (1839):

> Come to some doctrine which you believe to be peculiar to Revelation; tell the people that they must be regenerated or born again, else they can never 'see God'. Before you are aware, they may go away saying, 'Oh, there is nothing new or strange here; our own Shastras tell us the same thing; we know and believe that we must be born again; it is our fate to be so.' But what do they understand by the expression? It is that they are to be born again and again, in some other form, agreeably to their own system of transmigration or reiterated births. To avoid the appearance of countenancing so absurd and pernicious a doctrine, you vary your language, and tell them that there must be a second birth – that they must be twice-born. Now it so happens that this, and all similar phraseology, is preoccupied. The sons of a Brahman have to undergo various purificatory and initiatory ceremonial rites, before they attain to full

Brahmanhood. The last of these is the investiture with the sac-
red thread; which is followed by the communication of the
Gayatri, or most sacred verse in the Vedas. This ceremonial
constitutes, 'religiously and metaphorically, their second birth';
henceforward their distinctive and peculiar appellation is that
of the twice-born, or regenerated men. *Hence it is your improved
language might only convey the impression that all must become
perfect Brahmans, ere they can 'see God'.*[15] (My emphasis)

The grounds of evangelical certitude are opposed not by the
simple assertion of an antagonistic cultural tradition. The process
of translation is the opening up of another contentious political
and cultural site at the heart of colonial representation. Here the
word of divine authority is deeply flawed by the assertion of
the indigenous sign, and in the very practice of domination the
language of the master becomes hybrid – neither the one thing
nor the other. The incalculable colonized subject – half acqui-
escent, half oppositional, always untrustworthy – produces an
unresolvable problem of cultural difference for the very address
of colonial cultural authority. The 'subtile system of Hinduism',
as the missionaries in the early nineteenth century called it,
generated tremendous policy implications for the institutions of
Christian conversion. The written authority of the Bible was
challenged and together with it a postenlightenment notion of
the 'evidence of Christianity' and its historical priority, which
was central to evangelical colonialism. The Word could no
longer be trusted to carry the truth when written or spoken in
the colonial world by the European missionary. Native catechists
therefore had to be found, who brought with them their own
cultural and political ambivalences and contradictions, often
under great pressure from their families and communities.

This revision of the history of critical theory rests, I have said,
on the notion of cultural difference, not cultural diversity. Cul-
tural diversity is an epistemological object – culture as an object

of empirical knowledge – whereas cultural difference is the process of the *enunciation* of culture as 'knowledge*able*', authoritative, adequate to the construction of systems of cultural identification. If cultural diversity is a category of comparative ethics, aesthetics or ethnology, cultural difference is a process of signification through which statements *of* culture or *on* culture differentiate, discriminate and authorize the production of fields of force, reference, applicability and capacity. Cultural diversity is the recognition of pre-given cultural contents and customs; held in a time-frame of relativism it gives rise to liberal notions of multiculturalism, cultural exchange or the culture of humanity. Cultural diversity is also the representation of a radical rhetoric of the separation of totalized cultures that live unsullied by the intertextuality of their historical locations, safe in the Utopianism of a mythic memory of a unique collective identity. Cultural diversity may even emerge as a system of the articulation and exchange of cultural signs in certain early structuralist accounts of anthropology.

Through the concept of cultural difference I want to draw attention to the common ground and lost territory of contemporary critical debates. For they all recognize that the problem of cultural interaction emerges only at the significatory boundaries of cultures, where meanings and values are (mis)-read or signs are misappropriated. Culture only emerges as a problem, or a problematic, at the point at which there is a loss of meaning in the contestation and articulation of everyday life, between classes, genders, races, nations. Yet the reality of the limit or limit-text of culture is rarely theorized outside of well-intentioned moralist polemics against prejudice and stereotype, or the blanket assertion of individual or institutional racism – that describe the effect rather than the structure of the problem. The need to think the limit of culture as a problem of the enunciation of cultural difference is disavowed.

The concept of cultural difference focuses on the problem of

the ambivalence of cultural authority: the attempt to dominate in the name of a cultural supremacy which is itself produced only in the moment of differentiation. And it is the very authority of culture as a knowledge of referential truth which is at issue in the concept and moment of enunciation. The enunciative process introduces a split in the performative present of cultural identification; a split between the traditional culturalist demand for a model, a tradition, a community, a stable system of reference, and the necessary negation of the certitude in the articulation of new cultural demands, meanings, strategies in the political present, as a practice of domination, or resistance. The struggle is often between the historicist teleological or mythical time and narrative of traditionalism – of the right or the left – and the shifting, strategically displaced time of the articulation of a historical politics of negotiation which I suggested above. The time of liberation is, as Fanon powerfully evokes, a time of cultural uncertainty, and, most crucially, of significatory or representational undecidability:

> But [native intellectuals] forget that the forms of thought and what [they] feed ... on, together with modern techniques of information, language and dress, have dialectically reorganized the people's intelligences and *the constant principles (of national art)* which acted as safeguards during the colonial period are now undergoing extremely radical changes. . . . [We] must join the people in that fluctuating movement which they are *just* giving a shape to ... which will be the signal for everything to be called into question ... it is to the zone of *occult instability* where the people dwell that we must come.[16] (My emphases)

The enunciation of cultural difference problematizes the binary division of past and present, tradition and modernity, at the level of cultural representation and its authoritative address. It is the problem of how, in signifying the present, something comes to

be repeated, relocated and translated in the name of tradition, in the guise of a pastness that is not necessarily a faithful sign of historical memory but a strategy of representing authority in terms of the artifice of the archaic. That iteration negates our sense of the origins of the struggle. It undermines our sense of the homogenizing effects of cultural symbols and icons, by questioning our sense of the authority of cultural synthesis in general.

This demands that we rethink our perspective on the identity of culture. Here Fanon's passage – somewhat reinterpreted – may be helpful. What is implied by his juxtaposition of the constant national principles with his view of culture-as-political-struggle, which he so enigmatically and beautifully describes as 'the zone of occult instability where the people dwell'? These ideas not only help to explain the nature of colonial struggle; they also suggest a possible critique of the positive aesthetic and political values we ascribe to the unity or totality of cultures, especially those that have known long and tyrannical histories of domination and misrecognition. Cultures are never unitary in themselves, nor simply dualistic in the relation of Self to Other. This is not because of some humanistic nostrum that beyond individual cultures we all belong to the human culture of mankind; nor is it because of an ethical relativism which suggests that in our cultural capacity to speak of and judge others we necessarily 'place ourselves in their position', in a kind of relativism of distance of which Bernard Williams has written at length.[17]

The reason a cultural text or system of meaning cannot be sufficient unto itself is that the act of cultural enunciation – the *place of utterance* – is crossed by the *différance* of writing. This has less to do with what anthropologists might describe as varying attitudes to symbolic systems within different cultures than with the structure of symbolic representation itself – not the content of the symbol or its social function, but the structure of symbol-

ization. It is this difference in the process of language that is crucial to the production of meaning and ensures, at the same time, that meaning is never simply mimetic and transparent.

The linguistic difference that informs any cultural perform- ance is dramatized in the common semiotic account of the dis- juncture between the subject of a proposition (*énoncé*) and the subject of enunciation, which is not represented in the statement but which is the acknowledgement of its discursive embedded- ness and address, its cultural positionality, its reference to a pres- ent time and a specific space. The pact of interpretation is never simply an act of communication between the I and the You designated in the statement. The production of meaning requires that these two places be mobilized in the passage through a Third Space, which represents both the general condi- tions of language and the specific implication of the utterance in a performative and institutional strategy of which it cannot 'in itself' be conscious. What this unconscious relation introduces is an ambivalence in the act of interpretation. The pronominal I of the proposition cannot be made to address – in its own words – the subject of enunciation, for this is not personable, but remains a spatial relation within the schemata and strategies of discourse. The meaning of the utterance is quite literally neither the one nor the other. This ambivalence is emphasized when we realize that there is no way that the content of the proposition will reveal the structure of its positionality; no way that context can be mimetically read off from the content.

The implication of this enunciative split for cultural analysis that I especially want to emphasize is its temporal dimension. The splitting of the subject of enunciation destroys the logics of synchronicity and evolution which traditionally authorize the subject of cultural knowledge. It is often taken for granted in materialist and idealist problematics that the value of culture as an object of study, and the value of any analytic activity that is considered cultural, lie in a capacity to produce a

cross-referential, generalizable unity that signifies a progression or evolution of ideas-in-time, as well as a critical self-reflection on their premisses or determinants. It would not be relevant to pursue the detail of this argument here except to demonstrate – via Marshall Sahlins's *Culture and Practical Reason* – the validity of my general characterization of the Western expectation of culture as a disciplinary practice of writing. I quote Sahlins at the point at which he attempts to define the difference of Western bourgeois culture:

> We have to do not so much with functional dominance as with structural – with different structures of symbolic *integration*. And to this gross difference in design correspond differences in symbolic performance: between an *open, expanding* code, responsive by *continuous* permutation to events it has itself staged, and an apparently *static* one that seems to know not events, but only its own preconceptions. The gross distinction between 'hot' societies and 'cold', development and under-development, societies with and without history – and so between large societies and small, expanding and self-contained, colonizing and colonized.[18] (My emphases)

The intervention of the Third Space of enunciation, which makes the structure of meaning and reference an ambivalent process, destroys this mirror of representation in which cultural knowledge is customarily revealed as an integrated, open, expanding code. Such an intervention quite properly challenges our sense of the historical identity of culture as a homogenizing, unifying force, authenticated by the originary Past, kept alive in the national tradition of the People. In other words, the disruptive temporality of enunciation displaces the narrative of the Western nation which Benedict Anderson so perceptively describes as being written in homogeneous, serial time.[19]

It is only when we understand that all cultural statements and

systems are constructed in this contradictory and ambivalent space of enunciation, that we begin to understand why hier-archical claims to the inherent originality or 'purity' of cultures are untenable, even before we resort to empirical historical instances that demonstrate their hybridity. Fanon's vision of revolutionary cultural and political change as a 'fluctuating movement' of occult instability could not be articulated as cul-tural *practice* without an acknowledgement of this indeterminate space of the subject(s) of enunciation. It is that Third Space, though unrepresentable in itself, which constitutes the discursive conditions of enunciation that ensure that the mean-ing and symbols of culture have no primordial unity or fixity; that even the same signs can be appropriated, translated, rehistoricized and read anew.

Fanon's moving metaphor – when reinterpreted for a theory of cultural signification – enables us to see not only the necessity of theory, but also the restrictive notions of cultural identity with which we burden our visions of political change. For Fanon, the liberatory people who initiate the productive instabil-ity of revolutionary cultural change are themselves the bearers of a hybrid identity. They are caught in the discontinuous time of translation and negotiation, in the sense in which I have been attempting to recast these words. In the moment of liberatory struggle, the Algerian people destroy the continuities and con-stancies of the nationalist tradition which provided a safeguard against colonial cultural imposition. They are now free to nego-tiate and translate their cultural identities in a discontinuous intertextual temporality of cultural difference. The native intel-lectual who identifies the people with the true national culture will be disappointed. The people are now the very principle of 'dialectical reorganization' and they construct their culture from the national text translated into modern Western forms of information technology, language, dress. The changed political and historical site of enunciation transforms the meanings of the

colonial inheritance into the liberatory signs of a free people of the future.

> I have been stressing a certain void or misgiving attending every assimilation of contraries – I have been stressing this in order to expose what seems to me a fantastic mythological congruence of elements. . . . And if indeed therefore any real sense is to be made of material change it can only occur with an acceptance of a concurrent void and with a willingness to descend into that void wherein, as it were, one may begin to come into confrontation with a spectre of invocation whose freedom to participate in an alien territory and wilderness has become a necessity for one's reason or salvation.[20]

This meditation by the great Guyanese writer Wilson Harris on the void of misgiving in the textuality of colonial history reveals the cultural and historical dimension of that Third Space of enunciations which I have made the precondition for the articulation of cultural difference. He sees it as accompanying the 'assimilation of contraries' and creating that occult instability which presages powerful cultural changes. It is significant that the productive capacities of this Third Space have a colonial or postcolonial provenance. For a willingness to descend into that alien territory – where I have led you – may reveal that the theoretical recognition of the split-space of enunciation may open the way to conceptualizing an international culture, based not on the exoticism of multiculturalism or the diversity of cultures, but on the inscription and articulation of culture's hybridity. To that end we should remember that it is the 'inter' – the cutting edge of translation and negotiation, the inbetween space – that carries the burden of the meaning of culture. It makes it possible to begin envisaging national, anti-nationalist histories of the 'people'. And by exploring this Third Space, we may elude the politics of polarity and emerge as the others of our selves.

2

INTERROGATING IDENTITY

Frantz Fanon and the postcolonial prerogative

I

To read Fanon is to experience the sense of division that pre-figures – and fissures – the emergence of a truly radical thought that never dawns without casting an uncertain dark. Fanon is the purveyor of the transgressive and transitional truth. He may yearn for the total transformation of Man and Society, but he speaks most effectively from the uncertain interstices of histor-ical change: from the area of ambivalence between race and sexuality; out of an unresolved contradiction between culture and class; from deep within the struggle of psychic representa-tion and social reality. His voice is most clearly heard in the subversive turn of a familiar term, in the silence of sudden rupture: '*The Negro is not. Any more than the white man.*'[1] The awkward division that breaks his line of thought keeps alive the dramatic

and enigmatic sense of change. That familiar alignment of colonial subjects – Black/White, Self/Other – is disturbed with one brief pause and the traditional grounds of racial identity are dispersed, whenever they are found to rest in the narcissistic myths of negritude or white cultural supremacy. It is this palpable pressure of division and displacement that pushes Fanon's writing to the edge of things – the cutting edge that reveals no ultimate radiance but, in his words, 'exposed an utterly naked declivity where an authentic upheaval can be born'.[2]

The psychiatric hospital at Blida-Joinville is one such place where, in the divided world of French Algeria, Fanon discovered the impossibility of his mission as a colonial psychiatrist:

> If psychiatry is the medical technique that aims to enable man no longer to be a stranger to his environment, I owe it to myself to affirm that the Arab, permanently an alien in his own country, lives in a state of absolute depersonalization. . . . The social structure existing in Algeria was hostile to any attempt to put the individual back where he belonged.[3]

The extremity of this colonial alienation of the person – this end of the 'idea' of the individual – produces a restless urgency in Fanon's search for a conceptual form appropriate to the social antagonism of the colonial relation. The body of his work splits between a Hegelian–Marxist dialectic, a phenomenological affirmation of Self and Other and the psychoanalytic ambivalence of the Unconscious. In his desperate, doomed search for a dialectic of deliverance Fanon explores the edge of these modes of thought: his Hegelianism restores hope to history; his existentialist evocation of the 'I' restores the presence of the marginalized; his psychoanalytic framework illuminates the madness of racism, the pleasure of pain, the agonistic fantasy of political power.

As Fanon attempts such audacious, often impossible,

transformations of truth and value, the jagged testimony of colonial dislocation, its displacement of time and person, its defilement of culture and territory, refuses the ambition of any total theory of colonial oppression. The Antillean *évolué* cut to the quick by the glancing look of a frightened, confused, white child; the stereotype of the native fixed at the shifting boundaries between barbarism and civility; the insatiable fear and desire for the Negro: 'Our women are at the mercy of Negroes . . . God knows how they make love';[4] the deep cultural fear of the black figured in the psychic trembling of Western sexuality — it is these signs and symptoms of the colonial condition that drive Fanon from one conceptual scheme to another, while the colonial relation takes shape in the gaps between them, articulated to the intrepid engagements of his style. As Fanon's texts unfold, the scientific fact comes to be aggressed by the experience of the street; sociological observations are intercut with literary artefacts, and the poetry of liberation is brought up short against the leaden, deadening prose of the colonized world.

What is the distinctive *force* of Fanon's vision? It comes, I believe, from the tradition of the oppressed, the language of a revolutionary awareness that, as Walter Benjamin suggests, 'the state of emergency in which we live is not the exception but the rule. We must attain to a concept of history that is in keeping with this insight.'[5] And the state of emergency is also always a state of *emergence*. The struggle against colonial oppression not only changes the direction of Western history, but challenges its historicist idea of time as a progressive, ordered whole. The analysis of colonial depersonalization not only alienates the Enlightenment idea of 'Man', but challenges the transparency of social reality, as a pre-given image of human knowledge. If the order of Western historicism is disturbed in the colonial state of emergency, even more deeply disturbed is the social and psychic representation of the human subject. For the very nature of humanity becomes estranged in the colonial condition and from

that 'naked declivity' it emerges, not as an assertion of will nor as an evocation of freedom, but as an enigmatic questioning. With a question that echoes Freud's *'What does woman want?'*, Fanon turns to confront the colonized world. 'What does a man want?' he asks, in the introduction to *Black Skin, White Masks*; 'What does the black man want?'

To this loaded question where cultural alienation bears down on the ambivalence of psychic identification, Fanon responds with an agonizing performance of self-images:

> I had to meet the white man's eyes. An unfamiliar weight burdened me. In the white world the man of color encounters difficulties in the development of his bodily schema. . . . I was battered down by tom-toms, cannibalism, intellectual deficiency, fetishism, racial defects. . . . I took myself far off from my own presence. . . . What else could it be for me but an amputation, an excision, a haemorrhage that spattered my whole body with black blood?[6]

From within the metaphor of vision complicit with a Western metaphysic of Man emerges the displacement of the colonial relation. The black presence runs the representative narrative of Western personhood: its past tethered to treacherous stereotypes of primitivism and degeneracy will not produce a history of civil progress, a space for the *Socius*; its present, dismembered and dislocated, will not contain the image of identity that is questioned in the dialectic of mind/body and resolved in the epistemology of appearance and reality. The white man's eyes break up the black man's body and in that act of epistemic violence its own frame of reference is transgressed, its field of vision disturbed.

'What does the black man *want?*' Fanon insists, and in privileging the psychic dimension he not only changes what we understand by a *political* demand but transforms the very means by which we recognize and identify its *human agency*. Fanon is not

principally posing the question of political oppression as the violation of a human essence, although he lapses into such a lament in his more existential moments. He is not raising the question of colonial man in the universalist terms of the liberal-humanist (How does colonialism deny the Rights of Man?); nor is he posing an ontological question about Man's being (*Who* is the alienated colonial man?). Fanon's question is addressed not to such a unified notion of history nor to such a unitary concept of man. It is one of the original and disturbing qualities of *Black Skin, White Masks* that it rarely historicizes the colonial experience. There is no master narrative or realist perspective that provides a background of social and historical facts against which emerge the problems of the individual or collective psyche. Such a traditional sociological alignment of Self and Society or History and Psyche is rendered questionable in Fanon's identification of the colonial subject who is historicized in the heterogeneous assemblage of the texts of history, literature, science, myth. The colonial subject is always 'overdetermined from without', Fanon writes.[7] It is through image and fantasy – those orders that figure transgressively on the borders of history and the unconscious – that Fanon most profoundly evokes the colonial condition.

In articulating the problem of colonial cultural alienation in the psychoanalytic language of demand and desire, Fanon radically questions the formation of both individual and social authority as they come to be developed in the discourse of social sovereignty. The social virtues of historical rationality, cultural cohesion, the autonomy of individual consciousness assume an immediate, Utopian identity with the subjects on whom they confer a civil status. The civil state is the ultimate expression of the innate ethical and rational bent of the human mind; the social instinct is the progressive destiny of human nature, the necessary transition from Nature to Culture. The direct access from individual interests to social authority is objectified in the representative structure of a General Will – Law or Culture –

where Psyche and Society mirror each other, transparently trans-
lating their difference, without loss, into a historical totality.
Forms of social and psychic alienation and aggression – mad-
ness, self-hate, treason, violence – can never be acknowledged as
determinate and constitutive conditions of civil authority, or as
the ambivalent effects of the social instinct itself. They are always
explained away as alien presences, occlusions of historical
progress, the ultimate misrecognition of Man.

For Fanon such a myth of Man and Society is fundamentally
undermined in the colonial situation. Everyday life exhibits a
'constellation of delirium' that mediates the normal social rela-
tions of its subjects: 'The Negro enslaved by his inferiority, the
white man enslaved by his superiority alike behave in accord-
ance with a neurotic orientation.'[8] Fanon's demand for a psy-
choanalytic explanation emerges from the perverse reflections of
civil virtue in the alienating acts of colonial governance: the
visibility of cultural mummification in the colonizer's avowed
ambition to civilize or modernize the native that results in
'archaic inert institutions [that function] under the oppressor's
supervision like a caricature of formerly fertile institutions';[9] or
the validity of violence in the very definition of the colonial
social space; or the viability of the febrile, phantasmic images of
racial hatred that come to be absorbed and acted out in the
wisdom of the West. These interpositions, indeed collaborations
of political and psychic violence within civic virtue, alienation
within identity, drive Fanon to describe the splitting of the
colonial space of consciousness and society as marked by a
'Manichaean delirium'.

The representative figure of such a perversion, I want to sug-
gest, is the image of post-Enlightenment man tethered to, not
confronted by, his dark reflection, the shadow of colonized man,
that splits his presence, distorts his outline, breaches his bound-
aries, repeats his action at a distance, disturbs and divides the
very time of his being. The ambivalent identification of the racist

world – moving on two planes without being in the least embar-
rassed by it, as Sartre says of the anti-Semitic consciousness –
turns on the idea of man as his alienated image; not Self and
Other but the otherness of the Self inscribed in the perverse
palimpsest of colonial identity. And it is that bizarre figure of
desire, which splits along the axis on which it turns, that com-
pels Fanon to put the psychoanalytic question of the desire of
the subject to the historic condition of colonial man.

'What is often called the black soul is a white man's artefact,'
Fanon writes.[10] This transference speaks otherwise. It reveals the
deep psychic uncertainty of the colonial relation itself: its split
representations stage the division of body and soul that enacts
the artifice of identity, a division that cuts across the fragile skin
– black and white – of individual and social authority. Three
conditions that underlie an understanding of the *process of
identification* in the analytic of desire emerge.

First: to exist is to be called into being in relation to an other-
ness, its look or locus. It is a demand that reaches outward to an
external object and as Jacqueline Rose writes, 'It is the relation of
this demand to the place of the object it claims that becomes the
basis for identification.'[11] This process is visible in the exchange
of looks between native and settler that structures their psychic
relation in the paranoid fantasy of boundless possession and its
familiar language of reversal: 'When their glances meet he [the
settler] ascertains bitterly, always on the defensive, "They want
to take our place." It is true for there is no native who does not
dream at least once a day of setting himself up in the settler's
place.'[12] It is always in relation to the place of the Other that
colonial desire is articulated: the phantasmic space of possession
that no one subject can singly or fixedly occupy, and therefore
permits the dream of the inversion of roles.

Second: the very place of identification, caught in the tension
of demand and desire, is a space of splitting. The fantasy of the
native is precisely to occupy the master's place while keeping his

place in the slave's *avenging* anger. 'Black skin, white masks' is not a neat division; it is a doubling, dissembling image of being in at least two places at once that makes it impossible for the devalued, insatiable *évolué* (an abandonment neurotic, Fanon claims) to accept the colonizer's invitation to identity: 'You're a doctor, a writer, a student, you're *different*, you're one of *us*.' It is precisely in that ambivalent use of 'different' – to be different from those that are different makes you the same – that the Unconscious speaks of the form of otherness, the tethered shadow of deferral and displacement. It is not the colonialist Self or the colonized Other, but the disturbing distance in-between that constitutes the figure of colonial otherness – the white man's artifice inscribed on the black man's body. It is in relation to this impossible object that the liminal problem of colonial identity and its vicissitudes emerges.

Finally, the question of identification is never the affirmation of a pre-given identity, never a *self*-fulfilling prophecy – it is always the production of an image of identity and the transformation of the subject in assuming that image. The demand of identification – that is, to be *for* an Other – entails the representation of the subject in the differentiating order of otherness. Identification, as we inferred from the preceding illustrations, is always the return of an image of identity that bears the mark of splitting in the Other place from which it comes. For Fanon, like Lacan, the primary moments of such a repetition of the self lie in the desire of the look and the limits of language. The 'atmosphere of certain uncertainty' that surrounds the body certifies its existence and threatens its dismemberment.

II

Listen to my friend, the Bombay poet Adil Jussawalla, writing of the 'missing person' that haunts the identity of the postcolonial bourgeoisie:

> No Satan
> warmed in the electric coils of his creatures
> or Gunga Din
> will make him come before you.
> To see an invisible man or a missing person,
> trust no Eng. Lit. That
> puffs him up, narrows his eyes,
> scratches his fangs. Caliban
> is still not IT.
> But faintly pencilled
> behind a shirt . . .
>
> . . .
>
> savage of no sensational paint,
> fangs cancelled.[13]

As that voice falters listen to its echo in the verse of a black woman, descendant of slaves, writing of the diaspora:

> We arrived in the Northern Hemisphere
> when summer was set in its way
> running from the flames that lit the sky
> over the Plantation.
> We were a straggle bunch of immigrants
> in a lily white landscape.
>
> . . .
>
> One day I learnt
> a secret art,
> Invisible-Ness, it was called.
> I think it worked
> as even now you look
> but never see me . . .
> Only my eyes will remain to watch and to haunt,
> and to turn your dreams
> to chaos.[14]

As these images fade, and the empty eyes endlessly hold their menacing gaze, listen finally to Edward Said's attempt to historicize their chaos of identity:

> One aspect of the electronic, postmodern world is that there has been a reinforcement of the stereotypes by which the Orient is viewed. . . . If the world has become immediately accessible to a Western citizen living in the electronic age, the Orient too has drawn nearer to him, and is now less a myth perhaps than a place criss-crossed by Western, especially American interests.[15]

I use these postcolonial portraits because they seize on the vanishing point of two familiar traditions in the discourse of identity: the philosophical tradition of identity as the process of self-reflection in the mirror of (human) nature; and the anthropological view of the difference of human identity as located in the division of Nature/Culture. In the postcolonial text the problem of identity returns as a persistent questioning of the frame, the space of representation, where the image – missing person, invisible eye, Oriental stereotype – is confronted with its difference, its Other. This is neither the glassy essence of Nature, to use Richard Rorty's image, nor the leaden voice of 'ideological interpellation', as Louis Althusser suggests.

What is so graphically enacted in the moment of colonial identification is the splitting of the subject in its historical place of utterance: 'No Satan . . ./or Gunga Din/will make him come before you/*To see* an invisible man or a missing person,/trust *no* Eng. Lit.' (my emphases). What these repeated negations of identity dramatize, in their elision of the seeing eye that must contemplate what is missing or invisible, is the impossibility of claiming an origin for the Self (or Other) within a tradition of representation that conceives of identity as the satisfaction of a totalizing, plenitudinous object of vision. By disrupting the

stability of the ego, expressed in the equivalence between image and identity, the secret art of invisibleness of which the migrant poet speaks changes the very terms of our recognition of the person.

This change is precipitated by the peculiar temporality whereby the subject cannot be apprehended without the absence or invisibility that constitutes it − 'as even now you look/but never see me' − so that the subject speaks, and is seen, from where it is *not*; and the migrant woman can subvert the perverse satisfaction of the racist, masculinist gaze that disavowed her presence, by presenting it with an anxious absence, a counter-gaze that turns the discriminatory look, which denies her cultural and sexual difference, back on itself.

The familiar space of the Other (in the process of identification) develops a graphic historical and cultural specificity in the splitting of the postcolonial or migrant subject. In place of that 'I' − institutionalized in the visionary, authorial ideologies of Eng. Lit. or the notion of 'experience' in the empiricist accounts of slave history − there emerges the challenge to see what is invisible, the look that cannot 'see me', a certain problem of the object of the gaze that constitutes a problematic referent for the language of the Self. The elision of the eye, represented in a narrative of negation and repetition − *no . . . no . . . never* − insists that the phrase of identity cannot be spoken, except by putting the eye/I in the impossible position of enunciation. To see a missing person, or *to look* at Invisibleness, is to emphasize the subject's *transitive* demand for a *direct* object of self-reflection, a point of presence that would maintain its privileged enunciatory position *qua subject*. To see a *missing person* is to *transgress* that demand; the 'I' in the position of mastery is, at *that same time*, the place of its absence, its re-presentation. We witness the alienation of the eye through the sound of the signifier as the scopic desire (to look/to be looked at) emerges and is erased in the *feint of writing*:

> But faintly pencilled
> behind a shirt,
> a trendy jacket or tie
> *if* he catches your eye,
> he'll come screaming at you like a jet –
> savage of no sensational paint,
> fangs cancelled.

Why does the faintly pencilled person fail to catch your eye? What is the secret of Invisibleness that enables the woman migrant to look without being seen?

What is interrogated is not simply the image of the person, but the discursive and disciplinary place from which questions of identity are strategically and institutionally posed. Through the progress of this poem 'you' are continually positioned in the space between a range of contradictory places that coexist. So that you find yourself at the point at which the Orientalist stereotype is evoked and erased *at the same time*, in the place where Eng. Lit. is *entstellt* in the ironic mimicry of its Indo-Anglican repetition. And this space of reinscription must be thought outside of those metaphysical philosophies of self-doubt, where the otherness of identity is the anguished *presence* within the Self of an existentialist agony that emerges when you look perilously through a glass darkly.

What is profoundly unresolved, even erased, in the discourses of poststructuralism is that *perspective of depth* through which the authenticity of identity comes to be reflected in the glassy metaphorics of the mirror and its mimetic or realist narratives. Shifting the frame of identity from the field of vision to the space of writing interrogates the third dimension that gives profundity to the representation of Self and Other – that depth of perspective that cineastes call the forth wall; literary theorists describe it as the transparency of realist metanarratives. Barthes brilliantly diagnoses this as *l'effet du réel*, the 'profound, geological

dimension'[16] of signification, achieved by arresting the linguistic sign in its *symbolic* function. The bilateral space of the symbolic consciousness, Barthes writes, massively privileges *resemblance*, constructs an *analogical* relation between signifier and signified that ignores the question of form, and creates a vertical dimension within the sign. In this scheme the signifier is always predetermined by the signified – that conceptual or real space that is placed prior to, and outside of, the act of signification.

From our point of view, this verticality is significant for the light it sheds on that *dimension of depth* that provides the language of Identity with its sense of reality – a measure of the 'me', which emerges from an acknowledgement of my inwardness, the depth of my character, the profoundity of my person, to mention only a few of those qualities through which we commonly articulate our self-consciousness. My argument about the importance of *depth* in the representation of a unified image of the self is borne out by the most decisive and influential formulation on personal identity in the English empiricist tradition.

John Locke's famous criteria for the continuity of consciousness could quite legitimately be read in the symbolic register of resemblance and analogy. For the sameness of a rational being requires a consciousness of the past which is crucial to the argument – 'as far as this consciousness can be extended *backwards* to any past action or thought, so far reaches the identity of that person' – and is precisely the unifying third dimension. The agency of *depth* brings together in an analogical relation (dismissive of the differences that construct temporality and signification) 'that same consciousness uniting those distant actions into the same person, *whatever substances contributed to their production*' (my emphasis).[17]

Barthes's description of the sign-as-symbol is conveniently analogous to the language we use to designate identity. At the same time, it sheds light on the concrete linguistic concepts with which we can grasp how the language of personhood comes to

be invested with a visuality or visibility of depth. This makes the moment of self-consciousness at once refracted and transparent; the question of identity always poised uncertainly, tenebrously, between shadow and substance. The symbolic consciousness gives the sign (of the Self) a sense of autonomy or solitariness 'as if it stands by itself in the world' privileging an individuality and a unitariness whose integrity is expressed in a certain richness of agony and anomie. Barthes calls it a mythic prestige, almost totemic in 'its form [which is] constantly exceeded by the power and movement of its content; . . . much less a codified form of communication than an (affective) instrument of participation.'[18]

This image of human identity and, indeed, human identity as image – both familiar frames or mirrors of selfhood that speak from deep within Western culture – are inscribed in the sign of resemblance. The analogical relation unifies the experience of self-consciousness by finding, within the mirror of nature, the symbolic certitude of the sign of culture based 'on an analogy with the compulsion to believe when staring at an object'.[19] This, as Rorty writes, is part of the West's obsession that our primary relation to objects and ourselves is analogous to visual perception. Pre-eminent among these representations has been the reflection of the self that develops in the symbolic consciousness of the sign. It marks out the discursive space from which The real Me emerges (initially as an assertion of the authenticity of the person) and then lingers on to reverberate – The real Me? – as a questioning of identity.

My purpose here is to define the space of the inscription or writing of identity – beyond the visual depths of Barthes's symbolic sign. The experience of the disseminating self-image goes beyond representation as the analogical consciousness of resemblance. This is not a form of dialectical contradiction, the antagonistic consciousness of master and slave, that can be sublated and transcended. The impasse or aporia of consciousness

that seems to be the representative postmodernist experience is a peculiar strategy of doubling.

Each time the encounter with identity occurs at the point at which something exceeds the frame of the image, it eludes the eye, evacuates the self as site of identity and autonomy and – most important – leaves a resistant trace, a stain of the subject, a sign of resistance. We are no longer confronted with an onto-logical problem of being but with the discursive strategy of the moment of interrogation, a moment in which the demand for identification becomes, primarily, a response to other questions of signification and desire, culture and politics.

In place of the symbolic consciousness that gives the sign of identity its integrity and unity, its *depth*, we are faced with a dimension of doubling; a spatialization of the subject, that is occluded in the illusory perspective of what I have called the 'third dimension' of the mimetic frame or visual image of iden-tity. The figure of the double – to which I now turn – cannot be contained within the analogical sign of resemblance; as Barthes said, this developed its totemic, vertical dimension only because 'what interests it in the sign is the signified: the signifier is always a determined element.'[20] For poststructuralist discourse, the priority (and play) of the signifier reveals the space of doub-ling (not depth) that is the very articulatory principle of dis-course. It is through that space of enunciation that problems of meaning and being enter the discourses of poststructuralism, as the problematic of subjection and identification.

What emerges in the preceding poems, as the line drawing of trendy jacket and tie, or the eerie, avengeful disembodied eye, must not be read as a revelation of some suppressed truth of the postcolonial psyche/subject. In the world of double inscriptions that we have now entered, in this space of *writing*, there can be no such immediacy of a visualist perspective, no such face-to-face epiphanies in the mirror of nature. On one level, what confronts you, the reader, in the incomplete portrait of the postcolonial

bourgeois – who looks uncannily like the metropolitan intellectual – is the ambivalence of your desire for the Other: 'You! hypocrite lecteur! – mon semblable, – mon frère!'

That disturbance of your voyeuristic look enacts the complexity and contradictions of your desire to see, to fix cultural difference in a containable, *visible* object. The desire for the Other is doubled by the desire in language, which *splits the difference* between Self and Other so that both positions are partial; neither is sufficient unto itself. As I have just shown in the portrait of the missing person, the very question of identification only emerges *in-between* disavowal and designation. It is performed in the agonistic struggle between the epistemological, visual demand for a knowledge of the Other, and its representation in the act of articulation and enunciation.

> Look, a Negro ... Mama, see the Negro! I'm frightened ... I could no longer laugh, because I already know where there were legends, stories, history, and above all *historicity*. . . . Then, assailed at various points, the corporeal schema crumbled, its place taken by a racial epidermal schema. . . . It was no longer a question of being aware of my body in the third person but in a triple person. . . . I was responsible for my body, for my race, for my ancestors.[21]

Fanon's *Black Skin, White Masks* reveals the doubling of identity: the difference between personal identity as an intimation of reality, or an intuition of being, and the psychoanalytic problem of identification that always begs the question of the subject: 'What does a man want?' The emergence of the human subject as socially and psychically authenticated depends on the *negation* of an originary narrative of fulfilment, or of an imaginary coincidence between individual interest or instinct and the General Will. Such binary, two-part, identities function in a kind of narcissistic reflection of the One in the Other, confronted in the

language of desire by the psychoanalytic process of identification. For identification, identity is never an a priori, nor a finished product; it is only ever the problematic process of access to an image of totality. The discursive conditions of this psychic image of identification will be clarified if we think of the perilous perspective of the concept of the image itself. For the image – as point of identification – marks the site of an ambivalence. Its representation is always spatially split – it makes *present* something that is *absent* – and temporally deferred: it is the representation of a time that is always elsewhere, a repetition.

The image is only ever an *appurtenance* to authority and identity; it must never be read mimetically as the appearance of a reality. The access to the image of identity is only ever possible in the *negation* of any sense of originality or plenitude; the process of displacement and differentiation (absence/presence, representation/repetition) renders it a liminal reality. The image is at once a metaphoric substitution, an illusion of presence, and by that same token a metonym, a sign of its absence and loss. It is precisely from this edge of meaning and being, from this shifting boundary of otherness within identity, that Fanon asks: 'What does a black man want?'

> When it encounters resistance from the other, self-consciousness undergoes the experience of desire. . . . As soon as I desire I ask to be considered. I am not merely here and now, sealed into thingness. I am for somewhere else and for something else. I demand that notice be taken of my negating activity in so far as I pursue something other than life. . . .
>
> I occupied space. I moved towards the other . . . and the evanescent other, hostile, but not opaque, transparent, not there, disappeared. Nausea.[22]

From that overwhelming emptiness of nausea Fanon makes his answer: the black man wants the objectifying confrontation with otherness; in the colonial psyche there is an unconscious

disavowal of the negating, splitting moment of desire. The place of the Other must not be imaged, as Fanon sometimes suggests, as a fixed phenomenological point opposed to the self, that represents a culturally alien consciousness. The Other must be seen as the necessary negation of a primordial identity – cultural or psychic – that introduces the system of differentiation which enables the cultural to be signified as a linguistic, symbolic, historic reality. If, as I have suggested, the subject of desire is never simply a Myself, then the Other is never simply an It-self, a front of identity, truth or misrecognition.

As a principle of identification, the Other bestows a degree of objectivity, but its representation – be it the social process of the Law or the psychic process of the Oedipus – is always ambivalent, disclosing a lack. For instance, the common, conversational distinction between the letter and spirit of the Law displays the otherness of Law itself; the ambiguous grey area between Justice and judicial procedure is, quite literally, a conflict of judgement. In the language of psychoanalysis, the Law of the Father or the paternal metaphor cannot be taken at its word. It is a process of substitution and exchange that inscribes a normative, normalizing place for the subject; but that metaphoric access to identity is exactly the place of prohibition and repression, a conflict of authority. Identification, as it is spoken in the desire of the Other, is always a question of interpretation, for it is the elusive assignation of myself with a one-self, the elision of person and place.

If the differentiating force of the Other is the process of the subject's signification in language and society's objectification in Law, then how can the Other disappear? Can desire, the moving spirit of the subject, ever evanesce?

III

Lacan's excellent, if cryptic, suggestion that 'the Other is a dual entry matrix'[23] should be understood as the partial erasure of the

depth perspective of the symbolic sign; through the circulation of the signifier in its doubling and displacing, the signifier permits the sign no reciprocal, binary division of form/content, super-structure/infrastructure, self/other. It is only by understanding the ambivalence and the antagonism of the desire of the Other that we can avoid the increasingly facile adoption of the notion of a homogenized Other, for a celebratory, oppositional politics of the margins or minorities.

The performance of the doubleness or splitting of the subject is enacted in the writing of the poems I have quoted; it is evident in the play on the metonymic figures of 'missing' and 'invisible-ness' around which their questioning of identity turns. It is articulated in those iterative instances that simultaneously mark the possibility and impossibility of identity, presence through absence. 'Only my eyes will remain to watch and to haunt,' warns Meiling Jin as that threatening part object, the dis-embodied eye − the evil eye − becomes the subject of a violent discourse of *ressentiment*. Here, phantasmic and (pre)figurative rage erases the naturalistic identities of I and We that narrate a more conventional, even realist history of colonial exploitation and metropolitan racism, within the poem.

The moment of seeing that is arrested in the evil eye inscribes a timelessness, or a freezing of time − 'remain/to watch and to haunt' − that can only be represented in the destruction of the *depth* associated with the sign of symbolic consciousness. It is a depth that comes from what Barthes describes as the *analogical* relation between superficial form and massive *Abgrund*: the 'rela-tion of form and content [as] ceaselessly renewed by time (his-tory); the superstructure overwhelmed by the infrastructure, without our ever being able to grasp the structure itself.'[24]

The eyes that remain − the eyes as a kind of *remainder*, pro-ducing an iterative process − cannot be part of this plenitudinous and progressive renewal of time or history. They are the signs of a structure of writing history, a history of the poetics of

postcolonial diaspora, that the symbolic consciousness could never grasp. Most significantly, these partial eyes bear witness to a woman's writing of the postcolonial condition. Their circulation and repetition frustrate both the voyeuristic desire for the fixity of sexual difference and the fetishistic desire for racist stereotypes. The gaze of the evil eye alienates *both* the narratorial I of the slave and the surveillant eye of the master. It unsettles any simplistic polarities or binarisms in identifying the exercise of power – Self/Other – and erases the analogical dimension in the articulation of sexual difference. It is empty of that depth of verticality that creates a totemic resemblance of form and content (*Abgrund*) ceaselessly renewed and replenished by the groundspring of history. The evil eye – like the missing person – is nothing in itself; and it is this *structure of difference* that produces the hybridity of race and sexuality in the postcolonial discourse.

The elision of identity in these tropes of the 'secret art of Invisibleness' from which these writers speak is not an ontology of lack that, on its other side, becomes a nostalgic demand for a liberatory, non-repressed identity. It is the uncanny space and time *between* those two moments of being, their incommensurable differences – if such a place can be imagined – signified in the process of repetition, that give the evil eye or the missing person their meaning. Meaningless in/as themselves, these figures initiate the rhetorical excess of social reality and the psychic reality of social fantasy. Their poetic and political force develops through a certain strategy of duplicity or doubling (not resemblance, in Barthes's sense), which Lacan has elaborated as 'the process of gap' within which the relation of subject to Other is produced.[25] The primary duplicity of the missing person pencilled in before your eyes, or the woman's eyes that watch and haunt, is this: although these images emerge with a certain fixity and finality in the *present*, as if they are the last word on the subject, they cannot identify or interpellate identity as *presence*. This is because they are created in the ambivalence of a double

time of iteration that, in Derrida's felicitous phrase, 'baffles the process of appearing by dislocating any orderly time at the center of the present'.[26] The effect of such baffling, in both poems, is to initiate a principle of undecidability in the signification of part and whole, past and present, self and Other, such that there can be no negation or transcendence of difference.

The naming of the missing person as 'Savage of no sensational paint' is a case in point. The phrase, spoken at the end of Adil Jussawalla's poem, neither simply returns us to the Orientalist discourse of stereotypes and exotica – Gunga Din – enshrined in the history of Eng. Lit., nor allows us to rest with the line drawing of the missing person. The reader is positioned – together with the enunciation of the question of identity – in an undecidable space between 'desire and fulfillment, between perpetration and its recollection. . . . Neither future nor present, but between the two.'[27] The repetition of the Orientalia and their imperialist past are re-presented, made present semantically, within the same time and utterance as that in which their representations are negated syntactically – 'no sensational paint/*Fangs cancelled*.' From that erasure, in the repetition of that 'no', without being articulated at all in the phrase itself, emerges the faintly pencilled presence of the missing person who, *in absentia*, is both present in, and constitutive of, the savagery. Can you tell the postcolonial bourgeois and the Western intellectual elite apart? How does the repetition of a part of speech – no! – turn the image of civility into the double of savagery? What part does the feint of writing play in evoking these faint figures of identity? And, finally, where do *we* stand in that uncanny echo between what may be described as the attenuation of identity and its simulacra?

These questions demand a double answer. In each of them I have posed a theoretical problem in terms of its political and social effects. It is the boundary between them that I have tried to explore in my vacillations between the texture of poetry and a certain textuality of identity. One answer to my questions would

be to say that we now stand at the point in the poststructuralist argument where we can see the doubleness of its own grounds: the uncanny sameness-in-difference, or the alterity of Identity of which these theories speak, and from which, in forked tongues, they communicate with each other to constitute those discourses that we name postmodernist. The rhetoric of repetition or doubling that I have traced displays the art of *becoming* through a certain metonymic logic disclosed in the 'evil eye' or the 'missing person'. Metonymy, a figure of contiguity that substitutes a part for a whole (an eye for an I), must not be read as a form of simple substitution or equivalence. Its circulation of part and whole, identity and difference, must be understood as a *double movement* that follows what Derrida calls the logic or play of the 'supplement':

> If it represents and makes an image, it is by the anterior default of a presence. Compensatory and vicarious, the supplement [evil eye] is an adjunct, a subaltern instance which *takes – the – place*. As substitute . . . [missing person] . . . it produces no relief, its place is assigned in the structure by the mark of an emptiness. Somewhere something can be filled up of itself . . . only by allowing itself to be filled through sign and proxy.[28]

Having illustrated, through my reading of the poems above, the supplementary nature of the subject, I want to focus on the subaltern instance of metonymy, which is the *proxy* of both presence and the present: time (*takes place on*) and space (*takes place of* . . .) at once. To conceptualize this complex doubling of time and space, as the site of enunciation, and the temporal conditionality of social discourse, is both the thrill and the threat of the poststructuralist and postmodernist discourses. How different is this representation of the sign from the symbolic consciousness where, as Barthes said, the relation of form and content is ceaselessly renewed by Time (as the *Abgrund* of the

historical)? The evil eye, which seeks to outstare linear, continuist history and turn its progressive dream into nightmarish chaos, is exemplary once more. What Meiling Jin calls 'the secret art of Invisible-Ness' creates a crisis in the representation of personhood and, at the critical moment, initiates the possibility of political subversion. Invisibility erases the self-presence of that 'I' in terms of which traditional concepts of political agency and narrative mastery function. What takes (the) place, in Derrida's supplementary sense, is the disembodied evil eye, the subaltern instance, that wreaks its revenge by circulating, without being seen. It cuts across the boundaries of master and slave; it opens up a space in-between the poem's two locations, the Southern Hemisphere of slavery and the Northern Hemisphere of diaspora and migration, which then become uncannily doubled in the phantasmic scenario of the political unconscious. This doubling resists the traditional causal link that explains contemporary metropolitan racism as a result of the historical prejudices of imperialist nations. What it does suggest is the possibility of a new understanding of both forms of racism, based on their shared symbolic and spatial structures – Fanon's Manichaean structure – articulated within different temporal, cultural and power relations.

The anti-dialectical movement of the subaltern instance subverts any binary or sublatory ordering of power and sign; it defers the object of the look – 'as even now you look/but never see me' – and endows it with a strategic motion, which we may here, analogously, name the movement of the death drive. The evil eye, which is nothing in itself, exists in its lethal traces or effects as a form of iteration that arrests time – death/chaos – and initiates a space of intercutting that articulates politics/psyche, sexuality/race. It does this in a relation that is differential and strategic rather than originary, ambivalent rather than accumulative, doubling rather than dialectical. The play of the evil eye is camouflaged, invisible in the common, on-going activity of

looking – making present, while it is implicated in the petrify-
ing, unblinking gaze that falls Medusa-like on its victims – deal-
ing death, extinguishing both presence and the present. There is
a specifically feminist re-presentation of political subversion in
this strategy of the evil eye. The disavowal of the position of the
migrant woman – her social and political invisibility – is used by
her in her secret art of revenge, mimicry. In that overlap of signifi-
cation – in that fold of identification as cultural and sexual dif-
ference – the 'I' is the initial, initiatory signature of the subject;
and the 'eye' (in its metonymic repetition) is the sign that
initiates the terminal, arrest, death:

> as even now you look
> but never see me . . .
> Only my eyes will remain to haunt,
> and to turn your dreams
> to chaos.

It is in this overlapping space between the fading of identity
and its faint inscription that I take my stand on the subject,
amidst a celebrated gathering of poststructuralist thinkers.
Although there are significant differences between them, I want
to focus here on their attention to the place from which the
subject speaks or is spoken.

For Lacan – who has used the arrest of the evil eye in his
analysis of the gaze – this is the moment of 'temporal pulsation':
'[The signifier in the field of the Other] petrif[ies] the subject in
the same movement in which it calls the subject to speak as
subject.'[29]

Foucault repeats something of the same uncanny movement
of doubling when he elaborates on the 'quasi-invisibility of the
statement':

> Perhaps it is like the over-familiar that constantly eludes one;

> those familiar transparencies, which although they conceal nothing in their density, are nevertheless not entirely clear. The enunciative level emerges in its very proximity. . . . It has this quasi-invisibility of the 'there is,' which is effaced in the very thing of which one can say: 'there is this or that thing. . . .' Language always seems to be inhabited by the other, the elsewhere, the distant; it is hollowed out by distance.[30]

Lyotard holds on to the pulsating beat of the time of utterance when he discusses the narrative of Tradition:

> Tradition is that which concerns time, not content. Whereas what the West wants from autonomy, invention, novelty, self-determination, is the opposite – to forget time and to preserve, and accumulate contents. To turn them into what we call history and to think that it progresses because it accumulates. On the contrary, in the case of popular traditions . . . nothing gets accumulated, that is the narratives must be repeated all the time because they are forgotten all the time. But what does not get forgotten is the temporal beat that does not stop sending the narratives to oblivion.
>
> . . .
>
> This is a situation of continuous embedding, which makes it impossible to find a first utterer.[31]

IV

I may be accused of a form of linguistic or theoretical formalism, of establishing a rule of metonymy or the supplement and laying down the oppressive, even universalist, law of difference or doubling. How does the poststructuralist attention to *écriture* and textuality influence my experience of myself? Not directly, I would answer, but then, have our fables of identity ever been unmediated by another; have they ever been more (or less) than

a detour through the word of God, or the writ of Law, or the Name of the Father; the totem, the fetish, the telephone, the superego, the voice of the analyst, the closed ritual of the weekly confessional or the ever open ear of the monthly *coiffeuse*?

I am reminded of the problem of self-portraiture in Holbein's *The Ambassadors*, of which Lacan produces a startling reading. The two still figures stand at the centre of their world, surrounded by the accoutrements of *vanitas* – a globe, a lute, books and compasses, unfolding wealth. They also stand in the moment of temporal instantaneity where the Cartesian subject emerges as the subjectifying relation of geometrical perspective, described above as the *depth* of the image of identity. But off-centre, in the foreground (violating the meaningful depths of the *Abgrund*), there is a flat spherical object, obliquely angled. As you walk away from the portrait and turn to leave, you see that the disc is a skull, the reminder (and remainder) of death, that makes visible nothing more than the alienation of the subject, the anamorphic ghost.[32]

Doesn't the logic of the supplement – in its repetition and doubling – produce a historylessness; a 'culture' of theory that makes it impossible to give meaning to historical specificity? This is a large question that I can only answer here by proxy, by citing a text remarkable for its postcolonial specificity and for its questioning of what we might mean by cultural specificity:

A– 's a giggle now
but on it Osiris, Ra.
An अ an er . . . a cough,
once spoking your valleys with light.
But the a's here to stay.
On it St. Pancras station,
the Indian and African railways.
That's why you learn it today.
. . .
'Get back to your language,' they say.

These lines come from an early section of Adil Jussawalla's poem 'Missing Person'. They provide an insight into the fold between the cultural and linguistic conditions articulated in the textual economy that I have described as the metonymic or the supplementary. The discourse of poststructuralism has largely been spelled out in an intriguing repetition of *a*, whether it is Lacan's *petit objet a* or Derrida's *différance*. Observe, then, the agency of this postcolonial *a*.

There is something supplementary about *a* that makes it the initial letter of the Roman alphabet and, at the same time, the indefinite article. What is dramatized in this circulation of the *a* is a double scene on a double stage, to borrow a phrase from Derrida. The A – with which the verse begins – is the sign of a linguistic objectivity, inscribed in the Indo-European language tree, institutionalized in the cultural disciplines of empire; and yet as the Hindi vowel अ, which is the first letter of the Hindi alphabet and is pronounced as 'er', testifies, the object of linguistic science is always already in an enunciatory process of cultural translation, showing up the hybridity of any genealogical or systematic filiation.

Listen: 'An अ an er . . . a cough': in the same time, we hear the *a* repeated in translation, not as an object of linguistics, but in the *act* of the colonial enunciation of cultural contestation. This double scene articulates the ellipsis . . . which marks the *différence* between the Hindi sign अ and the demotic English signifier – 'er, a cough'. It is through the emptiness of ellipsis that the difference of colonial culture is articulated as a *hybridity* acknowledging that all cultural specificity is belated, *different unto itself* – अ . . . er . . . ugh! Cultures come to be represented by virtue of the processes of iteration and translation through which their meanings are very vicariously addressed to – *through* – an Other. This erases any essentialist claims for the inherent authenticity or purity of cultures which, when inscribed in the naturalistic sign of symbolic consciousness frequently become political

arguments for the hierarchy and ascendancy of powerful cultures.[33] It is in this hybrid gap, which produces no relief, that the colonial subject *takes place*, its subaltern position inscribed in that space of iteration where अ *takes (the) place of* '*er*'.

If this sounds like a schematic, poststructuralist joke – 'it's all words, words, words . . .' – then I must remind you of the linguistic insistence in Clifford Geertz's influential statement that the experience of understanding other cultures is 'more like grasping a proverb, catching an illusion, seeing a joke [or as I have suggested reading a poem] than it is like achieving communion.'[34] My insistence on locating the postcolonial subject within the play of the subaltern instance of writing is an attempt to develop Derrida's passing remark that the history of the decentred subject and its dislocation of European metaphysics is concurrent with the emergence of the problematic of cultural difference within ethnology.[35] He acknowledges the political nature of this moment but leaves it to us to specify it in the postcolonial text:

'Wiped out,' they say.
Turn left or right,
there's millions like you up here,
picking their way through refuse,
looking for words they lost.
You're your country's lost property
with no office to claim you back.
You're polluting our sounds. You're so rude.
'Get back to your language,' they say.[36]

Embedded in these statements is a cultural politics of diaspora and paranoia, of migration and discrimination, of anxiety and appropriation, which is unthinkable without attention to those metonymic or subaltern moments that structure the subject of writing and meaning. Without the doubleness that I described in

the postcolonial play of the 'a **अ**', it would be difficult to understand the anxiety provoked by the hybridizing of language, activated in the anguish associated with vacillating *boundaries* – psychic, cultural, territorial – of which these verses speak. Where do you draw the line between languages? between cultures? between disciplines? between peoples?

I have suggested here that a subversive political line is drawn in a certain poetics of 'invisibility', 'ellipsis', the evil eye and the missing person – all instances of the 'subaltern' in the Derridean sense, and near enough to the sense that Gramsci gives the concept: '[not simply an oppressed group] but lacking autonomy, subjected to the influence or hegemony of another social group, not possessing one's own hegemonic position.'[37] It is with this difference between the two usages that notions of autonomy and domination within the hegemonic would have to be carefully rethought, in the light of what I have said about the *proxy*-mate nature of any claim to *presence* or autonomy. However, what is implicit in both concepts of the subaltern, as I read it, is a strategy of ambivalence in the structure of identification that occurs precisely in the elliptical *in-between*, where the shadow of the other falls upon the self.

From that shadow (in which the postcolonial *a* plays) emerges cultural difference as an *enunciative* category; opposed to relativistic notions of cultural diversity, or the exoticism of the 'diversity' of cultures. It is the 'between' that is articulated in the camouflaged subversion of the 'evil eye' and the transgressive mimicry of the 'missing person'. The force of cultural difference is, as Barthes once said of the practice of metonymy, 'the violation of a signifying *limit of space*, it permits on the very level of discourse, a counterdivision of objects, usages, meanings, spaces and properties' (my emphasis).[38]

It is by placing the violence of the poetic sign *within* the threat of political violation that we can understand the powers of language. Then, we can grasp the importance of the imposition of

the imperial *a* as the cultural condition for the very movement of empire, its *logomotion* – the colonial creation of the Indian and African railways as the poet wrote. Now, we can begin to see why the threat of the (mis)translation of **अ** and 'er', among the displaced and diasporic peoples who pick through the refuse, is a constant reminder to the postimperial West, of the hybridity of its mother tongue, and the heterogeneity of its national space.

V

In his analytic mode Fanon explores such questions of the ambivalence of colonial inscription and identification. The state of emergency from which he writes demands insurgent answers, more immediate identifications. Fanon frequently attempts a close correspondence between the *mise-en-scène* of unconscious fantasy and the phantoms of racist fear and hate that stalk the colonial scene; he turns from the ambivalences of identification to the antagonistic identities of political alienation and cultural discrimination. There are times when he is too quick to name the Other, to personalize its presence in the language of colonial racism – 'the real Other for the white man is and will continue to be the black man. And conversely.'[39] Restoring the dream to its proper political time and cultural space can, at times, blunt the edge of Fanon's brilliant illustrations of the complexity of the psychic projections in the pathological colonial relation. Jean Veneuse, the Antillean *évolué*, desires not merely to be in the place of the white man but compulsively seeks to look back and down on himself from that position. Equally, the white racist cannot merely deny what he fears and desires by projecting it on 'them'. Fanon sometimes forgets that social paranoia does not indefinitely authorize its projections. The compulsive, fantasmatic identification with a persecutory 'they' is accompanied, even undermined, by an emptying, an evacuation of the racist 'I' who projects.

Fanon's sociodiagnostic psychiatry tends to explain away the ambivalent turns and returns of the subject of colonial desire, its masquerade of Western Man and the 'long' historical perspective. It is as if Fanon is fearful of his most radical insights: that the politics of race will not be entirely contained within the humanist myth of man or economic necessity or historical progress, for its psychic affects question such forms of determinism; that social sovereignty and human subjectivity are only realizable in the order of otherness. It is as if the question of desire that emerged from the traumatic tradition of the oppressed has to be modified, at the end of *Black Skin, White Masks*, to make way for an existentialist humanism that is as banal as it is beatific:

> Why not the quite simple attempt to touch the other, to feel the other, to explain the other to myself? . . . At the conclusion of this study, I want the world to recognize, with me, the open door of every consciousness.[40]

Despite Fanon's insight into the dark side of man, such a deep hunger for humanism must be an overcompensation for the closed consciousness or 'dual narcissism' to which he attributes the depersonalization of colonial man: 'There one lies body to body, with one's blackness or one's whiteness in full narcissistic cry, each sealed into his own particularity – with, it is true, now and then a flash or so.'[41] It is this flash of recognition – in its Hegelian sense with its transcendental, sublative spirit – that fails to ignite in the colonial relation where there is only narcissistic indifference: 'And yet the Negro knows there is a difference. He wants it. . . . The former slave needs a challenge to his humanity.'[42] In the absence of such a challenge, Fanon argues, the colonized can only imitate, a distinction nicely made by the psychoanalyst Annie Reich: 'It is imitation . . . when the child holds the newspaper *like* his father. It is identification when the child learns to read.'[43] In disavowing the culturally differentiated

condition of the colonial world – in demanding 'Turn white or disappear' – the colonizer is himself caught in the ambivalence of paranoic identification, alternating between fantasies of megalomania and persecution.

However, Fanon's Hegelian dream for a human reality *in-itself-for-itself* is ironized, even mocked, by his view of the Manichaean structure of colonial consciousness and its non-dialectical division. What he says in *The Wretched of the Earth* of the demography of the colonial city reflects his view of the psychic structure of the colonial relation. The native and settler zones, like the juxtaposition of black and white bodies, are opposed, but not in the service of a higher unity. No conciliation is possible, he concludes, for of the two terms one is superfluous.

No, there can be no reconciliation, no Hegelian recognition, no simple, sentimental promise of a humanistic 'world of the You'. Can there be life without transcendence? Politics without the dream of perfectibility? Unlike Fanon, I think the *non-dialectical* moment of Manichaeanism suggests an answer. By following the trajectory of colonial desire – in the company of the bizarre colonial figure, the tethered shadow – it becomes possible to cross, even to shift the Manichaean boundaries. Where there is no human *nature*, hope can hardly spring eternal; but it emerges surely and surreptitiously in the strategic return of that difference that informs and deforms the image of identity, in the margin of otherness that displays identification. There may be no Hegelian negation, but Fanon must sometimes be reminded that the disavowal of the Other always exacerbates the edge of identification, reveals that dangerous place where identity and aggressivity are twinned. For denial is always a retroactive process; a half acknowledgement of that otherness has left its traumatic mark.

In that uncertainty lurks the white-masked black man; and from such ambivalent identification – black skin, white masks – it is possible, I believe, to redeem the pathos of cultural

confusion into a strategy of political subversion. We cannot agree with Fanon that 'since the racial drama is played out in the open the black man has no time to make it unconscious,'[44] but that is a provocative thought. In occupying two places at once – or three in Fanon's case – the depersonalized, dislocated colonial subject can become an incalculable object, quite literally difficult to place. The demand of authority cannot unify its message nor simply identify its subjects. For the strategy of colonial desire is to stage the drama of identity at the point which the black man *slips* to reveal the white skin. At the edge, in-between the black body and the white body, there is a tension of meaning and being, or some would say demand and desire, which is the psychic counterpart to that muscular tension that inhabits the native body:

> The symbols of social order – the police, the bugle calls in the barracks, military parades and waving flags – are at one and the same time inhibitory and stimulating: for they do not convey the message 'Don't dare to budge'; rather, they cry out 'Get ready to attack.'[45]

It is from such tensions – both psychic and political – that a strategy of subversion emerges. It is a mode of negation that seeks not to unveil the fullness of Man but to manipulate his representation. It is a form of power that is exercised at the very limits of identity and authority, in the mocking spirit of mask and image; it is the lesson taught by the veiled Algerian woman in the course of the revolution as she crossed the Manichaean lines to claim her liberty. In Fanon's essay 'Algeria unveiled' the colonizer's attempt to unveil the Algerian woman does not simply turn the veil into a symbol of resistance; it becomes a technique of camouflage, a means of struggle – the veil conceals bombs. The veil that once secured the boundary of the home – the limits of woman – now masks the woman in her

revolutionary activity, linking the Arab city and French quarter, transgressing the familial and colonial boundary. As the veil is liberated in the public sphere, circulation between and beyond cultural and social norms and spaces, it becomes the object of paranoid surveillance and interrogation. Every veiled woman, writes Fanon, became suspect. And when the veil is shed in order to penetrate deeper into the European quarter, the colonial police see everything and nothing. An Algerian woman is only, after all, a woman. But the Algerian *fidai* is an arsenal, and in her handbag she carries her hand grenades.

Remembering Fanon is a process of intense discovery and disorientation. Remembering is never a quiet act of introspection or retrospection. It is a painful re-membering, a putting together of the dismembered past to make sense of the trauma of the present. It is such a memory of the history of race and racism, colonialism and the question of cultural identity, that Fanon reveals with greater profundity and poetry than any other writer. What he achieves, I believe, is something far greater: for in seeing the phobic image of the Negro, the native, the colonized, deeply woven into the psychic pattern of the West, he offers the master and slave a deeper reflection of their interpositions, as well as the hope of a difficult, even dangerous, freedom: 'It is through the effort to recapture the self and to scrutinize the self, it is through the lasting tension of their freedom that men will be able to create the ideal conditions of existence for a human world'.[46]

This leads to a meditation on the experience of dispossession and dislocation – psychic and social – which speaks to the condition of the marginalized, the alienated, those who have to live under the surveillance of a sign of identity and fantasy that denies their difference. In shifting the focus of cultural racism from the politics of nationalism to the politics of narcissism, Fanon opens up a margin of interrogation that causes a subversive slippage of identity and authority. Nowhere is this

subaltern activity more visible than in his work itself, where a range of texts and traditions – from the classical repertoire to the quotidian, conversational culture of racism – vie to utter that last word that remains unspoken.

As a range of culturally and racially marginalized groups readily assume the mask of the black, or the position of the minority, not to deny their diversity, but audaciously to announce the important artifice of cultural identity and its dif-ference, the need for Fanon becomes urgent. As political groups from different directions, refuse to homogenize their oppres-sion, but make of it a common cause, a public image of the identity of otherness, the need for Fanon becomes urgent – urgent, in order to remind us of that crucial engagement between mask and identity, image and identification, from which comes the lasting tension of our freedom and the lasting impression of ourselves as others:

> In case of display . . . the play of combat in the form of intimi-dation, the being gives of himself, or receives from the other, something that is like a mask, a double, an envelope, a thrown-off skin, thrown off in order to cover the frame of a shield. It is through this separated form of himself that the being comes into play in his effects of life and death.[47]

The time has come to return to Fanon; as always, I believe, with a question: how can the human world live its difference; how can a human being live Other-wise?

VI

I have chosen to give poststructuralism a specifically postcolonial provenance in order to engage with an influential objection repeated by Terry Eagleton in his essay, 'The politics of subjectivity':

> We have as yet no political theory, or theory of the subject, which is capable in this dialectical way of grasping social transformation as at once diffusion and affirmation, the death and birth of the subject – or at least we have no such theories that are not vacuously apocalyptic.[48]

Taking my lead from the 'doubly inscribed' subaltern instance, I would argue that it is the *dialectical* hinge between the birth and death of the subject that needs to be interrogated. Perhaps the charge that a politics of the subject results in a vacuous apocalypse is itself a response to the poststructuralist probing of the notion of progressive negation – or sublation – in dialectical thinking. The subaltern or metonymic are *neither* empty nor full, *neither* part nor whole. Their compensatory and vicarious processes of signification are a spur to social translation, the production of something else *besides* which is not only the cut or gap of the subject but also the intercut across social sites and disciplines. This hybridity initiates the project of political thinking by continually facing it with the strategic and the contingent, with the countervailing thought of its own 'unthought'. It has to negotiate its goals through an acknowledgement of differential objects and discursive levels articulated not simply as contents but in their *address* as forms of textual or narrative subjections – be they governmental, judicial or artistic. Despite its firm commitments, the political must always pose as a problem, or a question, the *priority of the place from which it begins*, if its authority is not to become autocratic.

What must be left an open question is how we are to rethink ourselves once we have undermined the immediacy and autonomy of self-consciousness. It is not difficult to question the civil argument that the people are a conjugation of individuals, harmonious *under* the Law. We can dispute the political argument that the radical, vanguardist party and its masses represent a certain objectification in a historical process, or stage, of social

transformation. What remains to be thought is the *repetitious* desire to recognize ourselves doubly, as, at once, decentred in the solidary processes of the political group, and yet, ourself as a consciously committed, even individuated, agent of change – the bearer of belief. What is this ethical pressure to 'account for ourselves' – but only *partially* – within a political theatre of agonism, bureaucratic obfuscation, violence and violation? Is this political desire for partial identification a beautifully human, even pathetic attempt to disavow the realization that, *betwixt and besides* the lofty dreams of political thinking, there exists an acknowledgement, somewhere between fact and fantasy, that the techniques and technologies of politics need not be *humanizing* at all, in no way endorsing of what we understand to be the human – humanist? – predicament. We may have to force the limits of the social as we know it to rediscover a sense of political and personal agency through the unthought within the civic and the psychic realms. This may be no place to end but it may be a place to begin.

3

THE OTHER QUESTION

Stereotype, discrimination and the discourse of colonialism

> To concern oneself with the founding concepts of the entire history of philosophy, to deconstitute them, is not to undertake the work of the philologist or of the classic historian of philosophy. Despite appearances, it is probably the most daring way of making the beginnings of a step outside of philosophy.
>
> Jacques Derrida, 'Structure, sign and play'[1]

An important feature of colonial discourse is its dependence on the concept of 'fixity' in the ideological construction of otherness. Fixity, as the sign of cultural/historical/racial difference in the discourse of colonialism, is a paradoxical mode of representation: it connotes rigidity and an unchanging order as well as disorder, degeneracy and daemonic repetition. Likewise the stereotype, which is its major discursive strategy, is a form of

knowledge and identification that vacillates between what is always 'in place', already known, and something that must be anxiously repeated . . . as if the essential duplicity of the Asiatic or the bestial sexual licence of the African that needs no proof, can never really, in discourse, be proved. It is this process of *ambivalence*, central to the stereotype, that this chapter explores as it constructs a theory of colonial discourse. For it is the force of ambivalence that gives the colonial stereotype its currency: ensures its repeatability in changing historical and discursive conjunctures; informs its strategies of individuation and marginalization; produces that effect of probabilistic truth and predictability which, for the stereotype, must always be in *excess* of what can be empirically proved or logically construed. Yet the function of ambivalence as one of the most significant discursive and psychical strategies of discriminatory power – whether racist or sexist, peripheral or metropolitan – remains to be charted.

The absence of such a perspective has its own history of political expediency. To recognize the stereotype as an ambivalent mode of knowledge and power demands a theoretical and political response that challenges deterministic or functionalist modes of conceiving of the relationship between discourse and politics. The analytic of ambivalence questions dogmatic and moralistic positions on the meaning of oppression and discrimination. My reading of colonial discourse suggests that the point of intervention should shift from the ready recognition of images as positive or negative, to an understanding of the *processes of subjectification* made possible (and plausible) through stereotypical discourse. To judge the stereotyped image on the basis of a prior political normativity is to dismiss it, not to displace it, which is only possible by engaging with its *effectivity*; with the repertoire of positions of power and resistance, domination and dependence that constructs colonial identification subject (both colonizer and colonized). I do not intend to deconstruct the

colonial discourse to reveal its ideological misconceptions or repressions, to exult in its self-reflexivity, or to indulge its liberatory 'excess'. In order to understand the productivity of colonial power it is crucial to construct its regime of truth, not to subject its representations to a normalizing judgement. Only then does it become possible to understand the *productive* ambivalence of the object of colonial discourse – that 'otherness' which is at once an object of desire and derision, an articulation of difference contained within the fantasy of origin and identity. What such a reading reveals are the boundaries of colonial discourse and it enables a transgression of these limits from the space of that otherness.

The construction of the colonial subject in discourse, and the exercise of colonial power through discourse, demands an articulation of forms of difference – racial and sexual. Such an articulation becomes crucial if it is held that the body is always simultaneously (if conflictually) inscribed in both the economy of pleasure and desire and the economy of discourse, domination and power. I do not wish to conflate, unproblematically, two forms of the marking – and splitting – of the subject nor to globalize two forms of representation. I want to suggest, however, that there is a theoretical space and a political place for such an *articulation* – in the sense in which that word itself denies an 'original' identity or a 'singularity' to objects of difference – sexual or racial. If such a view is taken, as Feuchtwang argues in a different context,[2] it follows that the epithets racial or sexual come to be seen as modes of differentiation, realized as multiple, cross-cutting determinations, polymorphous and perverse, always demanding a specific and strategic calculation of their effects. Such is, I believe, the moment of colonial discourse. It is a form of discourse crucial to the binding of a range of differences and discriminations that inform the discursive and political practices of racial and cultural hierarchization.

Before turning to the construction of colonial discourse, I

want to discuss briefly the process by which forms of racial/cultural/historical otherness have been marginalized in theoretical texts committed to the articulation of 'difference', or 'contradiction', in order, it is claimed, to reveal the limits of Western representationalist discourse. In facilitating the passage 'from work to text' and stressing the arbitrary, differential and systemic construction of social and cultural signs, these critical strategies unsettle the idealist quest for meanings that are, most often, intentionalist and nationalist. So much is not in question. What does need to be questioned, however, is the *mode of representation of otherness*.

Where better to raise the question of the subject of racial and cultural difference than in Stephen Heath's masterly analysis of the chiaroscuro world of Welles's classic, *A Touch of Evil*? I refer to an area of its analysis which has generated the least comment, that is, Heath's attention to the structuration of the Mexican/US border that circulates through the text affirming and exchanging some notion of 'limited being'. Heath's work departs from the traditional analysis of racial and cultural differences, which identify stereotype and image and elaborate them in a moralistic or nationalistic discourse that affirms the *origin* and *unity* of national identity. Heath's attentiveness to the contradictory and diverse sites within the textual system, which *construct* national/cultural differences in their deployment of the semes of 'foreignness', 'mixedness', 'impurity', as transgressive and corrupting, is extremely relevant. His attention to the turnings of this much neglected subject as sign (not symbol or stereotype) disseminated in the codes (as 'partition', 'exchange', 'naming', 'character', etc.), gives us a useful sense of the circulation and proliferation of racial and cultural otherness. Despite the awareness of the multiple or cross-cutting determinations in the construction of modes of sexual and racial differentiation there is a sense in which Heath's analysis marginalizes otherness. Although I shall argue that the problem of the Mexican/US

border is read too singularly, too exclusively under the sign of sexuality, it is not that I am not aware of the many proper and relevant reasons for that 'feminist' focus. The 'entertainment' operated by the realist Hollywood film of the 1950s was always also a containment of the subject in a narrative economy of voyeurism and fetishim. Moreover, the displacement that organizes any textual system, within which the display of difference circulates, demands that the play of 'nationalities' should participate in the sexual positioning, troubling the Law and desire. There is, nevertheless, a singularity and reductiveness in concluding that:

> Vargas is the position of desire, its admission and its prohibition. Not surprisingly he has two names: the name of desire is Mexican, Miguel . . . that of the Law American – Mike. . . . The film uses the border, the play between American and Mexican . . . at the same time it seeks to hold that play finally in the opposition of purity and mixture which in turn is a version of Law and desire.[3]

However liberatory it is from one position to see the logic of the text traced ceaselessly between the Ideal Father and the Phallic Mother, in another sense, seeing only one possible articulation of the differential complex 'race–sex', it half colludes with the proffered images of marginality. For if the naming of Vargas is crucially mixed and split in the economy of desire, then there are other mixed economies which make naming and positioning equally problematic 'across the border'. To identify the 'play' on the border as purity and mixture and to see it as an allegory of Law and desire reduces the articulation of racial and sexual difference to what is dangerously close to becoming a circle rather than a spiral of difference. On that basis, it is not possible to construct the polymorphous and perverse collusion between racism and sexism as a *mixed economy* – for instance, the discourses

of American cultural colonialism and Mexican dependency, the fear/desire of miscegenation, the American border as cultural signifier of a pioneering, male 'American' spirit always under threat from races and cultures beyond the border or frontier. If the death of the Father is the interruption on which the narrative is initiated, it is through that death that miscegenation is both possible and deferred; if, again, it is the purpose of the narrative to restore Susan as 'good object', it also becomes its project to deliver Vargas from his racial 'mixedness'.

These questions of race and representation have been pursued in the issue of *Screen* on the problems of 'Racism, colonialism and cinema'.[4] This is a timely and welcome intervention in the debate on realist narrative and its conditions of existence and representability – a debate which has hitherto engaged mainly with the 'subject' of gender and class within the social and textual formations of Western bourgeois society. It would be inappropriate to review this issue of *Screen* here, but I would like to draw attention to Julianne Burton's 'The politics of aesthetic distance: the presentation of representation in *São Bernardo*'. Burton produces an interesting reading of Hirzman's *São Bernardo* as a specific Third World riposte of dualistic metropolitan debates around realism and the possibilities of rupture. Although she doesn't use Barthes, it would be accurate to say that she locates the film as the 'limit-text' of both its own totalitarian social context *as well as* contemporary theoretical debates on representation.

Again, anti-colonialist objectives are admirably taken up by Robert Stam and Louise Spence in 'Colonialism, racism and representation', with a useful Brechtian emphasis on the politicization of the *means* of representation, specifically point-of-view and suture. But despite the shift in political objectives and critical methods, there remains in their essay a limiting and traditional reliance on the stereotype as offering, *at any one time*, *a secure* point of identification. This is not compensated for (nor contradicted

by) their view that, *at other times and places*, the same stereotype may be read in a contradictory way or, indeed, be misread. What is, therefore, a simplification in the process of stereotypical representation has a knock-on effect on their central point about the politics of point-of-view. They operate a passive and unitary notion of suture which simplifies the politics and 'aesthetics' of spectator-positioning by ignoring the ambivalent, psychical process of identification which is crucial to the argument. In contrast I suggest, in a very preliminary way, that the stereotype is a complex, ambivalent, contradictory mode of representation, as anxious as it is assertive, and demands not only that we extend our critical and political objectives but that we change the object of analysis itself.

The difference of other cultures is other than the excess of signification or the trajectory of desire. These are theoretical strategies that are necessary to combat 'ethnocentricism' but they cannot, of themselves, unreconstructed, represent that otherness. There can be no inevitable sliding from the semiotic activity to the unproblematic reading of other cultural and discursive systems.[5] There is in such readings a will to power and knowledge that, in failing to specify the limits of their own field of enunciation and effectivity, proceeds to individualize otherness as the discovery of their own assumptions.

II

The difference of colonial discourse as an apparatus of power[6] will emerge more fully as this chapter develops. At this stage, however, I shall provide what I take to be the minimum conditions and specifications of such a discourse. It is an apparatus that turns on the recognition and disavowal of racial/cultural/historical differences. Its predominant strategic function is the creation of a space for a 'subject peoples' through the production of knowledges in terms of which surveillance is exercised

and a complex form of pleasure/unpleasure is incited. It seeks authorization for its strategies by the production of knowledges of colonizer and colonized which are stereotypical but antithetically evaluated. The objective of colonial discourse is to construe the colonized as a population of degenerate types on the basis of racial origin, in order to justify conquest and to establish systems of administration and instruction. Despite the play of power within colonial discourse and the shifting positionalities of its subjects (for example, effects of class, gender, ideology, different social formations, varied systems of colonization and so on), I am referring to a form of governmentality that in marking out a 'subject nation', appropriates, directs and dominates its various spheres of activity. Therefore, despite the 'play' in the colonial system which is crucial to its exercise of power, colonial discourse produces the colonized as a social reality which is at once an 'other' and yet entirely knowable and visible. It resembles a form of narrative whereby the productivity and circulation of subjects and signs are bound in a reformed and recognizable totality. It employs a system of representation, a regime of truth, that is structurally similar to realism. And it is in order to intervene within that system of representation that Edward Said proposes a semiotic of 'Orientalist' power, examining the varied European discourses which constitute 'the Orient' as a unified racial, geographical, political and cultural zone of the world. Said's analysis is revealing of, and relevant to, colonial discourse:

> Philosophically, then, the kind of language, thought, and vision that I have been calling orientalism very generally is a form or *radical realism*; anyone employing orientalism, which is the habit for dealing with questions, objects, qualities and regions deemed Oriental, will designate, name, point to, fix, what he is talking or thinking about with a word or phrase, which then is considered either to have acquired, or more simply to be,

> reality. . . . The tense they employ is the timeless eternal; they
> convey an impression of repetition and strength. . . . For all
> these functions it is frequently enough to use the simple copula
> *is*.[7]

For Said, the copula seems to be the point at which western
rationalism preserves the boundaries of sense for itself. Of this,
too, Said is aware when he hints continually at a polarity or
division at the very centre of Orientalism.[8] It is, on the one hand,
a topic of learning, discovery, practice; on the other, it is the site
of dreams, images, fantasies, myths, obsessions and require-
ments. It is a static system of 'synchronic essentialism', a know-
ledge of 'signifiers of stability' such as the lexicographic and the
encyclopaedic. However, this site is continually under threat
from diachronic forms of history and narrative, signs of instabil-
ity. And, finally, this line of thinking is given a shape analogical
to the dreamwork, when Said refers explicitly to a distinction
between 'an unconscious positivity' which he terms *latent* Orien-
talism, and the stated knowledges and views about the Orient
which he calls *manifest* Orientalism.

The originality of this pioneering theory could be extended to
engage with the alterity and ambivalence of Orientalist dis-
course. Said contains this threat by introducing a binarism
within the argument which, in initially setting up an opposition
between these two discursive scenes, finally allows them to be
correlated as a congruent system of representation that is unified
through a political–ideological *intention* which, in his words,
enables Europe to advance securely and *unmetaphorically* upon the
Orient. Said identifies the *content* of Orientalism as the
unconscious repository of fantasy, imaginative writings and
essential ideas; and the *form* of manifest Orientalism as the
historically and discursively determined, diachronic aspect. This
division/correlation structure of manifest and latent Orientalism
leads to the effectivity of the concept of discourse being

undermined by what could be called the polarities of intentionality.

This produces a problem with Said's use of Foucault's concepts of power and discourse. The productivity of Foucault's concept of power/knowledge lies in its refusal of an epistemology which opposes essence/appearance, ideology/science. '*Pouvoir/Savoir*' places subjects in a relation of power and recognition that is not part of a symmetrical or dialectical relation – self/other, master/slave – which can then be subverted by being inverted. Subjects are always disproportionately placed in opposition or domination through the symbolic decentring of multiple power relations which play the role of support as well as target or adversary. It becomes difficult, then, to conceive of the *historical* enunciations of colonial discourse without them being either functionally overdetermined or strategically elaborated or displaced by the *unconscious* scene of latent Orientalism. Equally, it is difficult to conceive of the process of subjectification as a placing *within* Orientalist or colonial discourse for the dominated subject without the dominant being strategically placed within it too. The terms in which Said's Orientalism is unified – the intentionality and unidirectionality of colonial power – also unify the subject of colonial enunciation.

This results in Said's inadequate attention to representation as a concept that articulates the historical and fantasy (as the scene of desire) in the production of the 'political' effects of discourse. He rightly rejects a notion of Orientalism as the misrepresentation of an Oriental essence. However, having introduced the concept of 'discourse' he does not face up to the problems it creates for an instrumentalist notion of power/knowledge that he seems to require. This problem is summed up by his ready acceptance of the view that, 'Representations are formations, or as Roland Barthes has said of all the operations of language, they are deformations.'[9]

This brings me to my second point. The closure and coherence

attributed to the unconscious pole of colonial discourse and the unproblematized notion of the subject, restrict the effectivity of both power and knowledge. It is not possible to see how power functions productively as incitement and interdiction. Nor would it be possible, without the attribution of ambivalence to relations of power/knowledge, to calculate the traumatic impact of the return of the oppressed – those terrifying stereotypes of savagery, cannibalism, lust and anarchy which are the signal points of identification and alienation, scenes of fear and desire, in colonial texts. It is precisely this function of the stereotype as phobia and fetish that, according to Fanon, threatens the closure of the racial/epidermal schema for the colonial subject and opens the royal road to colonial fantasy.

There is an underdeveloped passage in *Orientalism* which, in cutting across the body of the text, articulates the question of power and desire that I now want to take up. It is this:

> Altogether an internally structured archive is built up from the literature that belongs to these experiences. Out of this comes a restricted number of typical encapsulations: the journey, the history, the fable, the stereotype, the polemical confrontation. These are the lenses through which the Orient is experienced, and they shape the language, perception, and form of the encounter between East and West. What gives the immense number of encounters some unity, however, is the vacillation I was speaking about earlier. Something patently foreign and dis-tant acquires, for one reason or another, a status more rather than less familiar. One tends to stop judging things either as completely novel or as completely well-known; a new median category emerges, a category that allows one to see new things, things seen for the first time, as versions of a previously known thing. In essence such a category is not so much a way of receiving new information as it is a method of controlling what seems to be a threat to some established view of things. . . .

> The threat is muted, familiar values impose themselves, and in
> the end the mind reduces the pressure upon it by accommodat-
> ing things to itself as either 'original' or 'repetitious'. . . . The
> orient at large, therefore, vacillates between the West's con-
> tempt for what is familiar and its shivers of delight in – or fear
> of – novelty.[10]

What is this other scene of colonial discourse played out
around the 'median category'? What is this theory of encapsula-
tion or fixation which moves between the recognition of cul-
tural and racial difference and its disavowal, by affixing the
unfamiliar to something established, in a form that is repetitious
and vacillates between delight and fear? Does the Freudian fable
of fetishism (and disavowal) circulate within the discourse of
colonial power requiring the articulation of modes of differen-
tiation – sexual and racial – as well as different modes of
theoretical discourse – psychoanalytic and historical?

The strategic articulation of 'coordinates of knowledge' –
racial and sexual – and their inscription in the play of colonial
power as modes of differentiation, defence, fixation, hierarchiza-
tion, is a way of specifying colonial discourse which would be
illuminated by reference to Foucault's poststructuralist concept
of the dispositif or apparatus. Foucault insists that the relation of
knowledge and power within the apparatus are always a strategic
response to an urgent need at a given historical moment. The force
of colonial and postcolonial discourse as a theoretical and
cultural intervention in our contemporary moment represents
the urgent need to contest singularities of difference and to
articulate diverse 'subjects' of differentiation. Foucault writes:

> the apparatus is essentially of a strategic nature, which means
> assuming that it is a matter of a certain manipulation of rela-
> tions of forces, either developing them in a particular direction,
> blocking them, stabilising them, utilising them, etc. The

> apparatus is thus always inscribed in a play of power, but it is also always linked to certain coordinates of knowledge which issue from it but, to an equal degree, condition it. This is what the apparatus consists in: strategies of relations of forces supporting and supported by, types of knowledge.[11]

In this spirit I argue for the reading of the stereotype in terms of fetishism. The myth of historical origination – racial purity, cultural priority – produced in relation to the colonial stereotype functions to 'normalize' the multiple beliefs and split subjects that constitute colonial discourse as a consequence of its process of disavowal. The scene of fetishism functions similarly as, at once, a reactivation of the material of original fantasy – the anxiety of castration and sexual difference – as well as a normalization of that difference and disturbance in terms of the fetish object as the substitute for the mother's penis. Within the apparatus of colonial power, the discourses of sexuality and race relate in a process of *functional overdetermination*, 'because each effect . . . enters into resonance or contradiction with the others and thereby calls for a readjustment or a reworking of the heterogeneous elements that surface at various points.'[12]

There is both a structural and functional justification for reading the racial stereotype of colonial discourse in terms of fetishism.[13] My rereading of Said establishes the *structural* link. Fetishism, as the disavowal of difference, is that repetitious scene around the problem of castration. The recognition of sexual difference – as the precondition for the circulation of the chain of absence and presence in the realm of the Symbolic – is disavowed by the fixation on an object that masks that difference and restores an original presence. The *functional* link between the fixation of the fetish and the stereotype (or the stereotype as fetish) is even more relevant. For fetishism is always a 'play' or vacillation between the archaic affirmation of wholeness/ similarity – in Freud's terms: 'All men have penises'; in ours: 'All

men have the same skin/race/culture' – and the anxiety associ-
ated with lack and difference – again, for Freud 'Some do not
have penises'; for us 'Some do not have the same skin/race/
culture.' Within discourse, the fetish represents the simul-
taneous play between metaphor as substitution (masking
absence and difference) and metonymy (which contiguously
registers the perceived lack). The fetish or stereotype gives access
to an 'identity' which is predicated as much on mastery and
pleasure as it is on anxiety and defence, for it is a form of
multiple and contradictory belief in its recognition of difference
and disavowal of it. This conflict of pleasure/unpleasure,
mastery/defence, knowledge/disavowal, absence/presence, has
a fundamental significance for colonial discourse. For the scene
of fetishism is also the scene of the reactivation and repetition of
primal fantasy – the subject's desire for a pure origin that is
always threatened by its division, for the subject must be
gendered to be engendered, to be spoken.

The stereotype, then, as the primary point of subjectification
in colonial discourse, for both colonizer and colonized, is the
scene of a similar fantasy and defence – the desire for an origin-
ality which is again threatened by the differences of race, colour
and culture. My contention is splendidly caught in Fanon's title
Black Skin, White Masks where the disavowal of difference turns the
colonial subject into a misfit – a grotesque mimicry or 'doub-
ling' that threatens to split the soul and whole, undifferentiated
skin of the ego. The stereotype is not a simplification because it
is a false representation of a given reality. It is a simplification
because it is an arrested, fixated form of representation that, in
denying the play of difference (which the negation through the
Other permits), constitutes a problem for the *representation* of the
subject in significations of psychic and social relations.

When Fanon talks of the positioning of the subject in the
stereotyped discourse of colonialism, he gives further credence
to my point. The legends, stories, histories and anecdotes of a

colonial culture offer the subject a primordial Either/Or.[14] *Either* he is fixed in a consciousness of the body as a solely negating activity *or* as a new kind of man, a new genus. What is denied the colonial subject, both as colonizer and colonized, is that form of negation which gives access to the recognition of difference. It is that possibility of difference and circulation which would liberate the signifier of *skin/culture* from the fixations of racial typology, the analytics of blood, ideologies of racial and cultural dominance or degeneration. 'Wherever he goes', Fanon despairs, 'the Negro remains a Negro'[15] – his race becomes the ineradicable sign of *negative difference* in colonial discourses. For the stereotype impedes the circulation and articulation of the signifier of 'race' as anything other than its fixity as racism. We always already know that blacks are licentious, Asiatics duplicitous. . . .

III

There are two 'primal scenes' in Fanon's *Black Skins, White Masks*: two myths of the origin of the marking of the subject within the racist practices and discourses of a colonial culture. On one occasion a white girl fixes Fanon in a look and word as she turns to identify with her mother. It is a scene which echoes endlessly through his essay 'The fact of blackness': 'Look, a Negro . . . Mama, see the Negro! I'm frightened.' 'What else could it be for me', Fanon concludes, 'but an amputation, an excision, a haemorrhage that spattered my whole body with black blood.'[16] Equally, he stresses the primal moment when the child encounters racial and cultural stereotypes in children's fictions, where white heroes and black demons are proffered as points of ideological and psychical identification. Such dramas are enacted *every day* in colonial societies, says Fanon, employing a theatrical metaphor – the scene – which emphasizes the visible – the seen. I want to play on both these senses which refer at once to the site of fantasy and desire and to the sight of subjectification and power.

The drama underlying these dramatic 'everyday' colonial scenes is not difficult to discern. In each of them the subject turns around the pivot of the 'stereotype' to return to a point of total identification. The girl's gaze returns to her mother in the recognition and disavowal of the Negroid type; the black child turns away from himself, his race, in his total identification with the positivity of whiteness which is at once colour and no colour. In the act of disavowal and fixation the colonial subject is returned to the narcissism of the Imaginary and its identification of an ideal ego that is white and whole. For what these primal scenes illustrate is that looking/hearing/reading as sites of subjectification in colonial discourse are evidence of the importance of the visual and auditory imaginary for the histories of societies.[17]

It is in this context that I want to allude briefly to the problematic of seeing/being seen. I suggest that in order to conceive of the colonial subject as the effect of power that is productive – disciplinary and 'pleasurable' – one has to see the *surveillance* of colonial power as functioning in relation to the regime of the *scopic drive*. That is, the drive that represents the pleasure in 'seeing', which has the look as its object of desire, is related both to the myth of origins, the primal scene, and to the problematic of fetishism and locates the surveyed object within the 'imaginary' relation. Like voyeurism, surveillance must depend for its effectivity on 'the *active consent* which is its real or mythical correlate (but always real as myth) and establishes in the scopic space the illusion of the object relation' (my emphasis).[18] The ambivalence of this form of 'consent' in objectification – real as mythical – is the *ambivalence* on which the stereotype turns and illustrates that crucial bind of pleasure and power that Foucault asserts but, in my view, fails to explain.

My anatomy of colonial discourse remains incomplete until I locate the stereotype, as an arrested, fetishistic mode of representation within its field of identification, which I have identified in my description of Fanon's primal scenes, as the Lacanian schema

of the Imaginary. The Imaginary[19] is the transformation that takes place in the subject at the formative mirror phase, when it assumes a *discrete* image which allows it to postulate a series of equivalences, samenesses, identities, between the objects of the surrounding world. However, this positioning is itself problematic, for the subject finds or recognizes itself through an image which is simultaneously alienating and hence potentially confrontational. This is the basis of the close relation between the two forms of identification complicit with the Imaginary – narcissism and aggressivity. It is precisely these two forms of identification that constitute the dominant strategy of colonial power exercised in relation to the stereotype which, as a form of multiple and contradictory belief, gives knowledge of difference and simultaneously disavows or masks it. Like the mirror phase 'the fullness' of the stereotype – its image *as* identity – is always threatened by 'lack'.

The construction of colonial discourse is then a complex articulation of the tropes of fetishism – metaphor and metonymy – and the forms of narcissistic and aggressive identification available to the Imaginary. Stereotypical racial discourse is a four-term strategy. There is a tie-up between the metaphoric or masking function of the fetish and the narcissistic object-choice and an opposing alliance between the metonymic figuring of lack and the aggressive phase of the Imaginary. A repertoire of conflictual positions constitutes the subject in colonial discourse. The taking up of any one position, within a specific discursive form, in a particular historical conjuncture, is thus always problematic – the site of both fixity and fantasy. It provides a colonial 'identity' that is played out – like all fantasies of originality and origination – in the face and space of the disruption and threat from the heterogeneity of other positions. As a form of splitting and multiple belief, the stereotype requires, for its successful signification, a continual and repetitive chain of other stereotypes. The process by which the metaphoric 'masking' is

inscribed on a lack which must then be concealed gives the stereotype both its fixity and its phantasmatic quality – the *same old* stories of the Negro's animality, the Coolie's inscrutability or the stupidity of the Irish *must* be told (compulsively) again and afresh, and are differently gratifying and terrifying each time.

In any specific colonial discourse the metaphoric/narcissistic and the metonymic/aggressive positions will function simultaneously, strategically poised in relation to each other; similar to the moment of alienation which stands as a threat to Imaginary plenitude, and 'multiple belief' which threatens fetishistic disavowal. The subjects of the discourse are constructed within an apparatus of power which *contains*, in both senses of the word, an 'other' knowledge – a knowledge that is arrested and fetishistic and circulates through colonial discourse as that limited form of otherness that I have called the stereotype. Fanon poignantly describes the effects of this process for a colonized culture:

> a continued agony rather than a total disappearance of the preexisting culture. The culture once living and open to the future, becomes closed, fixed in the colonial status, caught in the yolk of oppression. Both present and mummified, it testifies against its members. . . . The cultural mummification leads to a mummification of individual thinking. . . . As though it were possible for a man to evolve otherwise than within the framework of a culture that recognises him and that he decides to assume.[20]

My four-term strategy of the stereotype tries tentatively to provide a structure and a process for the 'subject' of a colonial discourse. I now want to take up the problem of discrimination as the political effect of such a discourse and relate it to the question of 'race' and 'skin'. To that end it is important to remember that the multiple belief that accompanies fetishism not only has disavowal value; it also has 'knowledge value' and it

is this that I shall now pursue. In calculating this knowledge value it is crucial to consider what Fanon means when he says that:

> There is a quest for the Negro, the Negro is a demand, one cannot get along without him, he is needed, but only if he is made palatable in a certain way. Unfortunately the Negro knocks down the system and breaks the treaties.[21]

To understand this demand and how the native or Negro is made 'palatable' we must acknowledge some significant differences between the general theory of fetishism and its specific uses for an understanding of racist discourse. First, the fetish of colonial discourse – what Fanon calls the epidermal schema – is not, like the sexual fetish, a secret. Skin, as the key signifier of cultural and racial difference in the stereotype, is the most visible of fetishes, recognized as 'common knowledge' in a range of cultural, political and historical discourses, and plays a public part in the racial drama that is enacted every day in colonial societies. Second, it may be said that sexual fetish is closely linked to the 'good object'; it is the prop that makes the whole object desirable and lovable, facilitates sexual relations and can even promote a form of happiness. The stereotype can also be seen as that particular 'fixated' form of the colonial subject which *facilitates* colonial relations, and sets up a discursive form of racial and cultural opposition in terms of which colonial power is exercised. If it is claimed that the colonized are most often objects of hate, then we can reply with Freud that

> affection and hostility in the treatment of the fetish – which run parallel with the disavowal and acknowledgement of castration – are mixed in unequal proportions in different cases, so that the one or the other is more clearly recognisable.[22]

What this statement recognizes is the wide range of the stereo-type, from the loyal servant to Satan, from the loved to the hated; a shifting of subject positions in the circulation of colonial power which I tried to account for through the motility of the metaphoric/narcissistic and metonymic/aggressive system of colonial discourse. What remains to be examined, however, is the construction of the signifier of 'skin/race' in those regimes of visibility and discursivity – fetishistic, scopic, Imaginary – within which I have located the stereotypes. It is only on that basis that we can construct its 'knowledge-value' which will, I hope, enable us to see the place of fantasy in the exercise of colonial power.

My argument relies upon a particular reading of the problem-atic of representation which, Fanon suggests, is specific to the colonial situation. He writes:

> the originality of the colonial context is that the economic sub-structure is also a superstructure . . . you are rich because you are white, you are white because you are rich. This is why Marxist analysis should always be slightly stretched every time we have to do with the colonial problem.[23]

Fanon could either be seen to be adhering to a simple reflection-ist or determinist notion of cultural/social signification or, more interestingly, he could be read as taking an 'anti-repressionist' position (attacking the notion that ideology as miscognition, or misrepresentation, is the repression of the real). For our pur-poses I tend towards the latter reading which then provides a 'visibility' to the exercise of power; gives force to the argument that skin, as a signifier of discrimination, must be produced or processed as visible. As Paul Abbot says, in a very different context,

> whereas repression banishes its object into the unconscious,

forgets and attempts to forget the forgetting, discrimination must constantly invite its representations into consciousness, reinforcing the crucial recognition of difference which they embody and revitalising them for the perception on which its effectivity depends. . . . It must sustain itself on the presence of the very difference which is also its object.[24]

What 'authorizes' discrimination, Abbot continues, is the occlusion of the preconstruction or working-up of difference: 'this repression of production entails that the recognition of difference is procured in an innocence, as a "nature"; recognition is contrived as primary cognition, spontaneous effect of the "evidence of the visible".'[25]

This is precisely the kind of recognition, as spontaneous and visible, that is attributed to the stereotype. The difference of the object of discrimination is at once visible and natural – colour as the cultural/political *sign* of inferiority or degeneracy, skin as its natural '*identity*'. However, Abbot's account stops at the point of 'identification' and strangely colludes with the *success* of discriminatory practices by suggesting that their representations require the repression of the working-up of difference; to argue otherwise, according to him, would be to put the subject in 'an impossible awareness, since it would run into consciousness the heterogeneity of the subject as a place of articulation.'[26]

Despite his awareness of the crucial recognition of difference for discrimination and its problematization of repression, Abbot is trapped in his unitary place of articulation. He comes close to suggesting that it is possible, however momentarily and illusorily, for the *perpetrator* of the discriminatory discourse to be in a position that is *unmarked by the discourse* to the extent to which the *object* of discrimination is deemed natural and visible. What Abbot neglects is the facilitating role of contradiction and heterogeneity in the construction of authoritarian practices and their strategic, discursive fixations.

My concept of stereotype-as-suture is a recognition of the *ambivalence* of that authority and those orders of identification. The role of fetishistic identification, in the construction of discriminatory knowledges that depend on the 'presence of difference', is to provide a process of splitting and multiple/contradictory belief at the point of enunciation and subjectification. It is this crucial splitting of the ego which is represented in Fanon's description of the construction of the colonized subject as effect of stereotypical discourse: the subject primordially fixed and yet triply split between the incongruent knowledges of body, race, ancestors. Assailed by the stereotype, 'the corporeal schema crumbled, its place taken by a racial epidermal schema. - . . . It was no longer a question of being aware of my body in the third person but in a triple person. . . . I was not given one, but two, three places.'[27]

This process is best understood in terms of the articulation of multiple belief that Freud proposes in his essay on fetishism. It is a non-repressive form of knowledge that allows for the possibility of simultaneously embracing two contradictory beliefs, one official and one secret, one archaic and one progressive, one that allows the myth of origins, the other that articulates difference and division. Its knowledge 'value' lies in its orientation as a defence towards external reality, and provides, in Metz's words,

> the lasting matrix, the effective prototype of all those splittings of belief which man will henceforth be capable of in the most varied domains, of all the infinitely complex unconscious and occasionally conscious interactions which he will allow himself between believing and not-believing.[28]

It is through this notion of splitting and multiple belief that, I believe, it becomes easier to see the bind of knowledge and fantasy, power and pleasure, that informs the particular regime of visibility deployed in colonial discourse. The visibility of the

racial/colonial Other is at once a *point* of identity ('Look, a Negro') and at the same time a *problem* for the attempted closure within discourse. For the recognition of difference as 'imaginary' points of identity and origin − such as black and white − is disturbed by the representation of splitting in the discourse. What I called the play between the metaphoric/narcissistic and metonymic/aggressive moments in colonial discourse − that four-part strategy of the stereotype − crucially recognizes the prefiguring of desire as a potentially conflictual, disturbing force in all those regimes of 'originality' that I have brought together. In the objectification of the scopic drive there is always the threatened return of the look; in the identification of the Imaginary relation there is always the alienating other (or mirror) which crucially returns its image to the subject; and in that form of substitution and fixation that is fetishism there is always the trace of loss, absence. To put it succinctly, the recognition and disavowal of 'difference' is always disturbed by the question of its re-presentation or construction.

The stereotype is in that sense an 'impossible' object. For that very reason, the exertions of the 'official knowledges' of colonialism − pseudo-scientific, typological, legal–administrative, eugenicist − are imbricated at the point of their production of meaning and power with the fantasy that dramatizes the impossible desire for a pure, undifferentiated origin. Not itself the object of desire but its setting, not an ascription of prior identities but their production in the syntax of the scenario of racist discourse, colonial fantasy plays a crucial part in those everyday scenes of subjectification in a colonial society which Fanon refers to repeatedly. Like fantasies of the origins of sexuality, the productions of 'colonial desire' mark the discourse as 'a favoured spot for the most primitive defensive reactions such as turning against oneself, into an opposite, projection, negation'.[29]

The problem of origin as the problematic of racist, stereotypical knowledge is a complex one and what I have said about

its construction will come clear in this illustration from Fanon. Stereotyping is not the setting up of a false image which becomes the scapegoat of discriminatory practices. It is a much more ambivalent text of projection and introjection, metaphoric and metonymic strategies, displacement, over-determination, guilt, aggressivity; the masking and splitting of 'official' and phantasmatic knowledges to construct the positionalities and oppositionalities of racist discourse:

> My body was given back to me sprawled out, distorted, recoloured, clad in mourning in that white winter day. The Negro is an animal, the Negro is bad, the Negro is mean, the Negro is ugly; look, a nigger, it's cold, the nigger is shivering, the nigger is shivering because he is cold, the little boy is trembling because he is afraid of the nigger, the nigger is shivering with cold, that cold that goes through your bones, the handsome little boy is trembling because he thinks that the nigger is quivering with rage, the little white boy throws himself into his mother's arms: Mama, the nigger's going to eat me up.[30]

It is the scenario of colonial fantasy which, in staging the ambivalence of desire, articulates the demand for the Negro which the Negro disrupts. For the stereotype is at once a substitute and a shadow. By acceding to the wildest fantasies (in the popular sense) of the colonizer, the stereotyped Other reveals something of the 'fantasy' (as desire, defence) of that position of mastery. For if 'skin' in racist discourse is the visibility of darkness, and a prime signifier of the body and its social and cultural correlates, then we are bound to remember what Karl Abrahams says in his seminal work on the scopic drive.[31] The pleasure-value of darkness is a withdrawal in order to know nothing of the external world. Its symbolic meaning, however, is thoroughly ambivalent. Darkness signifies at once both birth and death; it is in all cases a desire to return to the fullness of the

mother, a desire for an unbroken and undifferentiated line of vision and origin.

But surely there is another scene of colonial discourse in which the native or Negro meets the demand of colonial discourse; where the subverting 'split' is recuperable within a strategy of social and political control. It is recognizably true that the chain of stereotypical signification is curiously mixed and split, polymorphous and perverse, an articulation of multiple belief. The black is both savage (cannibal) and yet the most obedient and dignified of servants (the bearer of food); he is the embodiment of rampant sexuality and yet innocent as a child; he is mystical, primitive, simple-minded and yet the most worldly and accomplished liar, and manipulator of social forces. In each case what is being dramatized is a separation − *between* races, cultures, histories, *within* histories − a separation between *before* and *after* that repeats obsessively the mythical moment or disjunction.

Despite the structural similarities with the play of need and desire in primal fantasies, the colonial fantasy does not try to cover up that moment of separation. It is more ambivalent. On the one hand, it proposes a teleology − under certain conditions of colonial domination and control the native is progressively reformable. On the other, however, it effectively displays the 'separation', makes it more visible. It is the visibility of this separation which, in denying the colonized the capacities of self-government, independence, Western modes of civility, lends authority to the official version and mission of colonial power.

Racist stereotypical discourse, in its colonial moment, inscribes a form of governmentality that is informed by a productive splitting in its constitution of knowledge and exercise of power. Some of its practices recognize the difference of race, culture and history as elaborated by stereotypical knowledges, racial theories, administrative colonial experience, and on that basis institutionalize a range of political and cultural ideologies

that are prejudicial, discriminatory, vestigial, archaic, 'mythical', and, crucially, are recognized as being so. By 'knowing' the native population in these terms, discriminatory and authoritarian forms of political control are considered appropriate. The colonized population is then deemed to be both the cause and effect of the system, imprisoned in the circle of interpretation. What is visible is the *necessity* of such rule which is justified by those moralistic and normative ideologies of amelioration recognized as the Civilizing Mission or the White Man's Burden. However, there coexist within the same apparatus of colonial power, modern systems and sciences of government, progressive 'Western' forms of social and economic organization which provide the manifest justification for the project of colonialism – an argument which, in part, impressed Karl Marx. It is on the site of this coexistence that strategies of hierarchization and marginalization are employed in the management of colonial societies. And if my deduction from Fanon about the peculiar visibility of colonial power is justified, then I would extend that to say that it is a form of governmentality in which the 'ideological' space functions in more openly collaborative ways with political and economic exigencies. The barracks stands by the church which stands by the schoolroom; the cantonment stands hard by the 'civil lines'. Such visibility of the institutions and apparatuses of power is possible because the exercise of colonial power makes their *relationship* obscure, produces them as fetishes, spectacles of a 'natural'/racial pre-eminence. Only the seat of government is always elsewhere – alien and separate by that distance upon which surveillance depends for its strategies of objectification, normalization and discipline.

The last word belongs to Fanon:

> this behaviour [of the colonizer] betrays a determination to objectify, to confine, to imprison, to harden. Phrases such as 'I know them', 'that's the way they are', show this maximum

objectification successfully achieved. . . . There is on the one hand a culture in which qualities of dynamism, of growth, of depth can be recognised. As against this, [in colonial cultures] we find characteristics, curiosities, things, never a structure.[32]

4

OF MIMICRY AND MAN

The ambivalence of colonial discourse

> Mimicry reveals something in so far as it is distinct from what might be called an itself that is behind. The effect of mimicry is camouflage. . . . It is not a question of harmonizing with the background, but against a mottled background, of becoming mottled – exactly like the technique of camouflage practised in human warfare.
>
> Jacques Lacan, 'The line and light', *Of the Gaze*.[1]

It is out of season to question at this time of day, the original policy of a conferring on every colony of the British Empire a mimic representation of the British Constitution. But if the creature so endowed has sometimes forgotten its real significance and under the fancied importance of speakers and maces, and all the paraphernalia and ceremonies of the imperial legislature, has dared to defy the mother country, she has to thank herself for the folly of conferring such privileges on a condition of society that has no earthly claim to so exalted a position. A fundamental principle appears to have been forgotten or overlooked in our system of colonial policy

> – that of colonial dependence. To give to a colony the forms of
> independence is a mockery; she would not be a colony for a
> single hour if she could maintain an independent station.
>> Sir Edward Cust, 'Reflections on West African affairs . . .
>> addressed to the Colonial Office', Hatchard, London 1839

The discourse of post-Enlightenment English colonialism often speaks in a tongue that is forked, not false. If colonialism takes power in the name of history, it repeatedly exercises its authority through the figures of farce. For the epic intention of the civilizing mission, 'human and not wholly human' in the famous words of Lord Rosebery, 'writ by the finger of the Divine'[2] often produces a text rich in the traditions of *trompe-l'œil*, irony, mimicry and repetition. In this comic turn from the high ideals of the colonial imagination to its low mimetic literary effects mimicry emerges as one of the most elusive and effective strategies of colonial power and knowledge.

Within that conflictual economy of colonial discourse which Edward Said[3] describes as the tension between the synchronic panoptical vision of domination – the demand for identity, stasis – and the counter-pressure of the diachrony of history – change, difference – mimicry represents an *ironic* compromise. If I may adapt Samuel Weber's formulation of the marginalizing vision of castration,[4] then colonial mimicry is the desire for a reformed, recognizable Other, *as a subject of a difference that is almost the same, but not quite*. Which is to say, that the discourse of mimicry is constructed around an *ambivalence*; in order to be effective, mimicry must continually produce its slippage, its excess, its difference. The authority of that mode of colonial discourse that I have called mimicry is therefore stricken by an indeterminacy: mimicry emerges as the representation of a difference that is itself a process of disavowal. Mimicry is, thus the sign of a double articulation; a complex strategy of reform, regulation and discipline, which 'appropriates' the Other as it visualizes power. Mimicry is also the sign of the inappropriate, however, a differ-

ence or recalcitrance which coheres the dominant strategic function of colonial power, intensifies surveillance, and poses an immanent threat to both 'normalized' knowledges and disciplinary powers.

The effect of mimicry on the authority of colonial discourse is profound and disturbing. For in 'normalizing' the colonial state or subject, the dream of post-Enlightenment civility alienates its own language of liberty and produces another knowledge of its norms. The ambivalence which thus informs this strategy is discernible, for example, in Locke's Second Treatise which *splits* to reveal the limitations of liberty in his double use of the word 'slave': first simply, descriptively as the locus of a legitimate form of ownership, then as the trope for an intolerable, illegitimate exercise of power. What is articulated in that distance between the two uses is the absolute, imagined difference between the 'Colonial' State of Carolina and the Original State of Nature.

It is from this area between mimicry and mockery, where the reforming, civilizing mission is threatened by the displacing gaze of its disciplinary double, that my instances of colonial imitation come. What they all share is a discursive process by which the excess or slippage produced by the *ambivalence* of mimicry (almost the same, *but not quite*) does not merely 'rupture' the discourse, but becomes transformed into an uncertainty which fixes the colonial subject as a 'partial' presence. By 'partial' I mean both 'incomplete' and 'virtual'. It is as if the very emergence of the 'colonial' is dependent for its representation upon some strategic limitation or prohibition *within* the authoritative discourse itself. The success of colonial appropriation depends on a proliferation of inappropriate objects that ensure its strategic failure, so that mimicry is at once resemblance and menace.

A classic text of such partiality is Charles Grant's 'Observations on the state of society among the Asiatic subjects of Great Britain' (1792)[5] which was only superseded by James Mills's

History of India as the most influential early nineteenth-century account of Indian manners and morals. Grant's dream of an evangelical system of mission education conducted uncompromisingly in the English language, was partly a belief in political reform along Christian lines and partly an awareness that the expansion of company rule in India required a system of subject formation – a reform of manners, as Grant put it – that would provide the colonial with 'a sense of personal identity as we know it'. Caught between the desire for religious reform and the fear that the Indians might become turbulent for liberty, Grant paradoxically implies that it is the 'partial' diffusion of Christianity, and the 'partial' influence of moral improvements which will construct a particularly appropriate form of colonial subjectivity. What is suggested is a process of reform through which Christian doctrines might collude with divisive caste practices to prevent dangerous political alliances. Inadvertently, Grant produces a knowledge of Christianity as a form of social control which conflicts with the enunciatory assumptions that authorize his discourse. In suggesting, finally, that 'partial reform' will produce an empty form of 'the *imitation* [my emphasis] of English manners which will induce them [the colonial subjects] to remain under our protection'.[6] Grant mocks his moral project and violates the Evidence of Christianity – a central missionary tenet – which forbade any tolerance of heathen faiths.

The absurd extravagance of Macaulay's 'Minute' (1835) – deeply influenced by Charles Grant's 'Observations' – makes a mockery of Oriental learning until faced with the challenge of conceiving of a 'reformed' colonial subject. Then, the great tradition of European humanism seems capable only of ironizing itself. At the intersection of European learning and colonial power, Macaulay can conceive of nothing other than 'a class of interpreters between us and the millions whom we govern – a class of persons Indian in blood and colour, but English in tastes,

in opinions, in morals and in intellect'[7] – in other words a mimic man raised 'through our English School', as a missionary educationist wrote in 1819, 'to form a corps of translators and be employed in different departments of Labour'.[8] The line of descent of the mimic man can be traced through the works of Kipling, Forster, Orwell, Naipaul, and to his emergence, most recently, in Benedict Anderson's excellent work on nationalism, as the anomalous Bipin Chandra Pal.[9] He is the effect of a flawed colonial mimesis, in which to be Anglicized is *emphatically* not to be English.

The figure of mimicry is locatable within what Anderson describes as 'the inner compatibility of empire and nation'.[10] It problematizes the signs of racial and cultural priority, so that the 'national' is no longer naturalizable. What emerges between mimesis and mimicry is a *writing*, a mode of representation, that marginalizes the monumentality of history, quite simply mocks its power to be a model, that power which supposedly makes it imitable. Mimicry *repeats* rather than *re-presents* and in that diminishing perspective emerges Decoud's displaced European vision of Sulaco in Conrad's *Nostromo* as:

> the endlessness of civil strife where folly seemed even harder to bear than its ignominy . . . the lawlessness of a populace of all colours and races, barbarism, irremediable tyranny. . . . America is ungovernable.[11]

Or Ralph Singh's apostasy in Naipaul's *The Mimic Men*:

> We pretended to be real, to be learning, to be preparing ourselves for life, we mimic men of the New World, one unknown corner of it, with all its reminders of the corruption that came so quickly to the new.[12]

Both Decoud and Singh, and in their different ways Grant and

Macaulay, are the parodists of history. Despite their intentions and invocations they inscribe the colonial text erratically, eccentrically across a body politic that refuses to be representative, in a narrative that refuses to be representational. The desire to emerge as 'authentic' through mimicry – through a process of writing and repetition – is the final irony of partial representation.

What I have called mimicry is not the familiar exercise of *dependent* colonial relations through narcissistic identification so that, as Fanon has observed,[13] the black man stops being an actional person for only the white man can represent his self-esteem. Mimicry conceals no presence or identity behind its mask: it is not what Césaire describes as 'colonization-thingification'[14] behind which there stands the essence of the *présence Africaine*. The *menace* of mimicry is its *double* vision which in disclosing the ambivalence of colonial discourse also disrupts its authority. And it is a double vision that is a result of what I've described as the partial representation/recognition of the colonial object. Grant's colonial as partial imitator, Macaulay's translator, Naipaul's colonial politician as play-actor, Decoud as the scene setter of the *opéra bouffe* of the New World, these are the appropriate objects of a colonialist chain of command, authorized versions of otherness. But they are also, as I have shown, the figures of a doubling, the part-objects of a metonymy of colonial desire which alienates the modality and normality of those dominant discourses in which they emerge as 'inappropriate' colonial subjects. A desire that, through the repetition of *partial presence*, which is the basis of mimicry, articulates those disturbances of cultural, racial and historical difference that menace the narcissistic demand of colonial authority. It is a desire that reverses 'in part' the colonial appropriation by now producing a partial vision of the colonizer's presence; a gaze of otherness, that shares the acuity of the genealogical gaze which, as Foucault describes it, liberates marginal elements and shatters

the unity of man's being through which he extends his sovereignty.[15]

I want to turn to this process by which the look of surveillance returns as the displacing gaze of the disciplined, where the observer becomes the observed and 'partial' representation rearticulates the whole notion of identity and alienates it from essence. But not before observing that even an exemplary history like Eric Stokes's The English Utilitarians and India acknowledges the anomalous gaze of otherness but finally disavows it in a contradictory utterance:

> Certainly India played no central part in fashioning the distinctive qualities of English civilisation. In many ways it acted as a disturbing force, a magnetic power placed at the periphery tending to distort the natural development of Britain's character.[16] (My emphasis)

What is the nature of the hidden threat of the partial gaze? How does mimicry emerge as the subject of the scopic drive and the object of colonial surveillance? How is desire disciplined, authority displaced?

If we turn to a Freudian figure to address these issues of colonial textuality, that form of difference that is mimicry – almost the same but not quite – will become clear. Writing of the partial nature of fantasy, caught inappropriately, between the unconscious and the preconscious, making problematic, like mimicry, the very notion of 'origins', Freud has this to say:

> Their mixed and split origin is what decides their fate. We may compare them with individuals of mixed race who taken all round resemble white men but who betray their coloured descent by some striking feature or other and on that account are excluded from society and enjoy none of the privileges.[17]

Almost the same but not white: the visibility of mimicry is always produced at the site of interdiction. It is a form of colonial discourse that is uttered *inter dicta*: a discourse at the crossroads of what is known and permissible and that which though known must be kept concealed; a discourse uttered between the lines and as such both against the rules and within them. The question of the representation of difference is therefore always also a problem of authority. The 'desire' of mimicry, which is Freud's 'striking feature' that reveals so little but makes such a big difference, is not merely that impossibility of the Other which repeatedly resists signification. The desire of colonial mimicry – an interdictory desire – may not have an object, but it has strategic objectives which I shall call the *metonymy of presence*.

Those inappropriate signifiers of colonial discourse – the difference between being English and being Anglicized; the identity between stereotypes which, through repetition, also become different; the discriminatory identities constructed across traditional cultural norms and classifications, the Simian Black, the Lying Asiatic – all these are *metonymies* of presence. They are strategies of desire in discourse that make the anomalous representation of the colonized something other than a process of 'the return of the repressed', what Fanon unsatisfactorily characterized as collective catharsis.[18] These instances of metonymy are the non-repressive productions of contradictory and multiple belief. They cross the boundaries of the culture of enunciation through a strategic confusion of the metaphoric and metonymic axes of the cultural production of meaning.

In mimicry, the representation of identity and meaning is rearticulated along the axis of metonymy. As Lacan reminds us, mimicry is like camouflage, not a harmonization of repression of difference, but a form of resemblance, that differs from or defends presence by displaying it in part, metonymically. Its threat, I would add, comes from the prodigious and strategic production of conflictual, fantastic, discriminatory 'identity

effects' in the play of a power that is elusive because it hides no essence, no 'itself'. And that form of *resemblance* is the most terrifying thing to behold, as Edward Long testifies in his *History of Jamaica* (1774). At the end of a tortured, negrophobic passage, that shifts anxiously between piety, prevarication and perversion, the text finally confronts its fear; nothing other than the repetition of its resemblance 'in part': '[Negroes] are represented by all authors as the vilest of human kind, to which they have little more pretension of resemblance *than what arises from their exterior forms*' (my emphasis).[19]

From such a colonial encounter between the white presence and its black semblance, there emerges the question of the ambivalence of mimicry as a problematic of colonial subjection. For if Sade's scandalous theatricalization of language repeatedly reminds us that discourse can claim 'no priority', then the work of Edward Said will not let us forget that the 'ethnocentric and erratic will to power from which texts can spring'[20] is itself a theatre of war. Mimicry, as the metonymy of presence is, indeed, such an erratic, eccentric strategy of authority in colonial discourse. Mimicry does not merely destroy narcissistic authority through the repetitious slippage of difference and desire. It is the process of the *fixation* of the colonial as a form of cross-classificatory, discriminatory knowledge within an interdictory discourse, and therefore necessarily raises the question of the *authorization* of colonial representations; a question of authority that goes beyond the subject's lack of priority (castration) to a historical crisis in the conceptuality of colonial man as an *object* of regulatory power, as the subject of racial, cultural, national representation.

'This culture . . . fixed in its colonial status', Fanon suggests, '[is] both present and mummified, it testified against its members. It defines them in fact without appeal.'[21] The ambivalence of mimicry – almost but not quite – suggests that the fetishized colonial culture is potentially and strategically an insurgent

counter-appeal. What I have called its 'identity-effects' are always crucially *split*. Under cover of camouflage, mimicry, like the fetish, is a part-object that radically revalues the normative knowledges of the priority of race, writing, history. For the fetish mimes the forms of authority at the point at which it deauthorizes them. Similarly, mimicry rearticulates presence in terms of its 'otherness', that which it disavows. There is a crucial difference between this *colonial* articulation of man and his doubles and that which Foucault describes as 'thinking the unthought'[22] which, for nineteenth-century Europe, is the ending of man's alienation by reconciling him with his essence. The colonial discourse that articulates an *interdictory* otherness is precisely the 'other scene' of this nineteenth-century European desire for an authentic historical consciousness.

The 'unthought' across which colonial man is articulated is that process of classificatory confusion that I have described as the metonymy of the substitutive chain of ethical and cultural discourse. This results in the *splitting* of colonial discourse so that two attitudes towards external reality persist; one takes reality into consideration while the other disavows it and replaces it by a product of desire that repeats, rearticulates 'reality' as mimicry.

So Edward Long can say with authority, quoting variously Hume, Eastwick and Bishop Warburton in his support, that: 'Ludicrous as the opinion may seem I do not think that an orang-utang husband would be any dishonour to a Hottentot female.'[23]

Such contradictory articulations of reality and desire – seen in racist stereotypes, statements, jokes, myths – are not caught in the doubtful circle of the return of the repressed. They are the effects of a disavowal that denies the differences of the other but produces in its stead forms of authority and multiple belief that alienate the assumptions of 'civil' discourse. If, for a while, the ruse of desire is calculable for the uses of discipline soon the repetition of guilt, justification, pseudo-scientific theories,

superstition, spurious authorities, and classifications can be seen as the desperate effort to 'normalize' formally the disturbance of a discourse of splitting that violates the rational, enlightened claims of its enunciatory modality. The ambivalence of colonial authority repeatedly turns from mimicry – a difference that is almost nothing but not quite – to menace – a difference that is almost total but not quite. And in that other scene of colonial power, where history turns to farce and presence to 'a part' can be seen the twin figures of narcissism and paranoia that repeat furiously, uncontrollably.

In the ambivalent world of the 'not quite/not white', on the margins of metropolitan desire, the founding objects of the Western world become the erratic, eccentric, accidental objets trouvés of the colonial discourse – the part-objects of presence. It is then that the body and the book lose their part-objects of presence. It is then that the body and the book lose their representational authority. Black skin splits under the racist gaze, displaced into signs of bestiality, genitalia, grotesquerie, which reveal the phobic myth of the undifferentiated whole white body. And the holiest of books – the Bible – bearing both the standard of the cross and the standard of empire finds itself strangely dismembered. In May 1817 a missionary wrote from Bengal:

> Still everyone would gladly receive a Bible. And why? – that he may lay it up as a curiosity for a few pice; or use it for waste paper. Such it is well known has been the common fate of these copies of the Bible. . . . Some have been bartered in the markets, others have been thrown in snuff shops and used as wrapping paper.[24]

5

SLY CIVILITY

> They [the paranoid], too, cannot regard anything in other
> people as indifferent, and they, too, take up minute indica-
> tions with which these other, unknown, people present them,
> and use them in their 'delusions of reference'. The meaning
> of their delusions of reference is that they expect from all
> strangers something like love. But these people show them
> nothing of the kind; they laugh to themselves, flourish their
> sticks, even spit on the ground as they go by – and one really
> does not do such things while a person in whom one takes a
> friendly interest is near. One does them only when one feels
> quite indifferent to the passer-by, when one can treat him like
> air; and, considering, too, the fundamental kinship of the
> concepts of 'stranger' and 'enemy', the paranoic is not so far
> wrong in regarding this indifference as hate, in contrast to his
> claim for love.
>
> Freud, 'Some neurotic mechanisms in jealousy,
> paranoia and homosexuality'[1]

If the spirit of the Western nation has been symbolized in epic
and anthem, voiced by a 'unanimous people assembled in
the self-presence of its speech',[2] then the sign of colonial

government is cast in a lower key, caught in the irredeemable act of writing. Who better to bear witness to this hypothesis than that representative figure of the mid-nineteenth century, J. S. Mill, who divided his life between addressing the colonial sphere as an examiner of correspondence for the East India Company, and preaching the principles of postutilitarian liberalism to the English nation.

'The whole government of India is carried out in writing,' Mill testified to a Select Committee of the House of Lords in 1852.

> All the orders given and all the acts of executive officers are reported in writing. . . . [There] is no single act done in India, the whole of the reasons for which are not placed on record. This appears to me a greater security for good government than exists in almost any other government in the world, because no other has a system of recordation so complete.[3]

Mill's dream of a perfect system of recordation was underwritten by the practice of utilitarian reforms: the union of judicial and executive powers in the tax collector, the codification of the law, the *ryotwar* system of land settlement, and an accurate survey and record of landed rights. But nowhere was this faith in a government of recordation made more problematic than in the dependence of his central concept of 'public discussion' on the fundamental principle of speech[4] as the guarantee of good government. Nobody who has witnessed Mill's vision of the value of individual independence can be blind to that passionate principle of *speech* that makes it so − 'a vivid conception and a strong belief',[5] not learned by rote or written but, as he says, articulated with a direct ' "living feeling power" which spreads from the words spoken to the things signified and forces the mind to take them in and make them conform to the formula'.[6] Nobody who has read Mill's metaphors of authority

can fail to see that for him the sign of civility is not so much the Lockean consent to Property, nor the Hobbesian assent to Law, but the spirited sound of the *vox populi*, engaged as an individual in public discussion, that 'steady communal habit of correcting his own opinion and collating it with those of others'.[7]

Nobody who grasps that for Mill the boundaries of the national culture are open so long as the voices of dissent remain individual and closed when that culture is threatened by collective dissension, can fail to hear him propounding the nationalist ideology of *unisonance*[8] as Benedict Anderson describes it, a contemporaneous cultural cohesion connecting its national subjects through the undifferentiated simultaneity of an 'aural' imaginary. And once this nationalist, authoritarian tone is caught in *speech*, it is possible to see in *writing*, how Mill echoes Cicero's forensic principle 'that individuals must throw themselves into the mental position of those who think differently from them'[9] only to use it ambivalently; both as the principle that preserves the liberty of the Western individualist 'public sphere' as well as a strategy for policing the culturally and racially differentiated colonial space: 'Where you have not the advantage given by representative government of *discussion* [my emphasis] by persons of all partialities, prepossessions and interests,' Mill continues in his testimony before the Lords, 'you *cannot* have a perfect substitute for this, still some substitute [such as recordation] is better than none.'[10]

The political moment of cultural difference emerges within the problematic of colonial governmentality, and eclipses the transparency between legibility and legitimate rule. Mill's 'recordation' now embodies the practice of writing as a strategy of colonialist regulation, and the mimetic adequacy of draft and dispatch is somewhat in doubt.

To know that the embryonic ideas of Mill's essays 'On Liberty' and 'Representative Government' were originally formulated in a draft dispatch on Indian education, written in

response to Macaulay's infamous 'Minute' of 1835, is to realize – in that fine intertextual irony – both the limitations of liberty and the problems of establishing a mode of governmental discourse that requires a colonial substitute for democratic 'public discussion'. Such a process of substitution is precisely Mill's system of recordation: events experienced and inscribed in India are to be read *otherwise*, transformed into the acts of governments and the discourse of authority in *another place*, at *another time*. Such a *syntax of deferral* must not merely be recognized as a theoretical object, the deferral of the space of writing – the sign under erasure – but acknowledged as a specific *colonial* temporality and textuality of that space between enunciation and address. As G. D. Bearce has written, the transaction on paper to take effect at the other side of the globe was not, according to Mill, 'of itself calculated to give much practical knowledge of life'.[11]

Between the Western sign and its colonial signification there emerges a map of misreading that embarrasses the righteousness of recordation and its certainty of good government. It opens up a space of interpretation and misappropriation that inscribes an ambivalence at the very origins of colonial authority, indeed, within the originary documents of British colonial history itself. 'It is probable that writing 15,000 miles from the place where their orders were to be carried into effect', writes Macaulay in his essay on Warren Hastings, the Directors of the East India Company

> never perceived the gross inconsistency of which they were guilty. . . . Whoever examines their letters written at that time, will find there many just and humane sentiments . . . an admirable code of political ethics. . . . Now these instructions, *being interpreted*, mean simply, 'Be the father and the oppressor of the people; be just and unjust, moderate and rapacious.'[12] (My emphasis)

To describe these texts as 'despatches of hypocrisy'[13] as Macaulay has done, is to moralize both the intention of writing and the object of government. To talk of duplicity is to fail to read the specific discursive doubleness that Macaulay insists exists only between the lines; to fail to see that form of multiple and contradictory belief that emerges as an effect of the ambivalent, deferred address of colonialist governance. Such a split in enunciation can no longer be contained with the 'unisonance' of civil discourse – although it must be spoken by it – nor written in what Walter Benjamin calls the 'homogeneous empty time'[14] of the Western nationalist discourse which normalizes its own history of colonial expansion and exploitation by inscribing the history of the other in a fixed hierarchy of civil progress. What is articulated in the doubleness of colonial discourse is not simply the violence of one powerful nation writing out the history of another. 'Be the father and the oppressor . . . just and unjust' is a mode of contradictory utterance that ambivalently reinscribes, across differential power relations, both colonizer and colonized. For it reveals an agonistic uncertainty contained in the incompatibility of empire and nation; it puts on trial the very discourse of civility within which representative government claims its liberty and empire its ethics. Those substitutive objects of colonialist governmentality – be they systems of recordation, or 'intermediate bodies' of political and administrative control – are strategies of surveillance that cannot maintain their civil authority once the colonial supplementarity, or excess of their address is revealed.

Recordation is faced, 'between-the-lines', with its double existence in the discursive practice of a board of directors or a colonial civil service. This produces a strange irony of reference. For if the primary impulse and address of government emanates not from the democratic representatives of a *people*, but from the members of a *service*, or as Mill describes it, a system that must be calculated to form its agents of government, then, in asserting

the natural rights of empire, Mill's proposal implicitly erases all that is taken as 'second nature' within Western civility. It separates the customary association of a territory with a people; not least, it breaks with any assumption of a natural link between democracy and discussion. The representative nineteenth-century discourse of liberal individualism loses both its power of speech and its politics of individual choice when it is confronted with an aporia. In a figure of repetition, there emerges the uncanny double of democracy itself: 'to govern one country under responsibility to the people of another . . . is despotism,' Mill writes.

> The only choice the case admits is a choice of despotisms. . . .
> There are, as we have already seen, conditions of society in which a vigorous despotism is in itself the best mode of government for training the people in what is specifically wanting to render them capable of a higher civilization.[15]

To be the father and the oppressor; just and unjust; moderate and rapacious; vigorous and despotic: these instances of contradictory belief, doubly inscribed in the deferred address of colonial discourse, raise questions about the symbolic space of colonial authority. What is the image of authority if it is civility's supplement and democracy's despotic double? How is it exercised if, as Macaulay suggests, it must be read between the lines, within the interdictory borders of civility itself? Why does the spectre of eighteenth-century despotism – that regime of primordial fixity, repetition, historylessness, and social death – haunt these vigorous nineteenth-century colonial practices of muscular Christianity and the civilizing mission? Can despotism, however vigorous, inspire a colony of individuals when the dread letter of despotic law can only instil the spirit of servitude?

To ask these questions is to see that the subject of colonial discourse – splitting, doubling, turning into its opposite,

projecting – is a subject of such affective ambivalence and discursive disturbance, that the narrative of English history can only ever beg the 'colonial' question. Deprived of its customary 'civil' reference, even the most traditional historical narrative accedes to the language of fantasy and desire. The modern colonizing imagination conceives of its dependencies as a *territory*, never as a *people*, wrote Sir Herman Merivale in 1839 in his influential Oxford lectures on colonization[16] which led to his appointment as Under Secretary of State for India. The effect of this distinction, he concludes, is that colonies are not conducive to disinterested control. Too often, their governance is overwhelmed by a feeling of national pride expressed in an exciting pleasure, an imaginary sense of power in extensive possessions which might turn into a Cyclopean policy. If such passion be political, then I suggest that we should pose the question of the ambivalence of colonialist authority in the language of the vicissitudes of the narcissistic demand for colonial objects, which intervenes so powerfully in the nationalist fantasy of boundless, extensive possessions.

What threatens the authority of colonial command is the ambivalence of its address – father and oppressor or, alternatively, the ruled and reviled – which will not be resolved in a dialectical play of power. For these doubly inscribed figures face two ways without being two-faced. Western imperialist discourse continually puts under erasure the civil state, as the colonial text emerges uncertainly within its narrative of progress. Between the civil address and its colonial signification – each axis displaying a problem of recognition and repetition – shuttles the signifier of authority in search of a strategy of surveillance, subjection, and inscription. Here there can be no dialectic of the master-slave for where discourse is so disseminated can there ever be the passage from trauma to transcendence? From alienation to authority? Both colonizer and colonized are in a process of miscognition where each point of identification is

always a partial and double repetition of the *otherness* of the self – democrat and despot, individual *and* servant, native and child.

It is around the 'and' – that conjunction of infinite repetition – that the ambivalence of civil authority circulates as a 'colonial' signifier that is *less than one and double*.[17] The position of authority is alienated at the point of civil enunciation – less than liberty, in Mill's case – and doubles at the point of colonialist address – just and unjust or the doubling of democracy as vigorous despotism. Such is the devious strategy of Montesquieu's idea of despotism which authoritatively shaped the eighteenth and nineteenth centuries' image of Mughal and Brahmin India. For Montesquieu, it is in the difference between monarchy and absolute monarchy (that is, sovereignty without honour) that despotism emerges as a textualization of the Turk and faces Versailles and the Court with its uncanny horrifying double.[18] Alexander Dow's *History of Hindustan* (1768), Sir Charles Grant's influential 'Observations' (1794), James Mill's monumental *History of India* (1816), Macaulay's 'Minute on Indian education' (1835), Duff's authoritative *India and India Missions* (1839): in all these, the strategic splitting of the colonial discourse – less than one and double – is contained by addressing the other as despot. For despite its connotations of death, repetition and servitude, the despotic configuration is a monocausal system that relates all differences and discourses to the absolute, undivided, boundless body of the despot. It is this image of India as a primordial fixity – as a narcissistic inverted other – that satisfies the self-fulfilling prophecy of Western progress and stills, for a while, the supplementary signifier of colonial discourse.

But what of the other 'native' scene of colonialist intervention where the ambivalence of authority – be it moderate and rapacious – is required, Macaulay suggests, as a strategy of surveillance and exploitation? If the idea of despotism homogenizes India's past, the colonialist present requires a strategy of calculation in relation to its native subjects. This need is addressed in a

vigorous *demand for narrative*, embodied in the utilitarian or evo-
lutionary ideologies of reason and progress; a demand which is,
nonetheless, in Derrida's words, a matter for the police:

> an inquisitorial insistence, an order, a petition. . . . To demand
> the narrative of the other, to extort it from him like a secretless
> secret, something that they call the truth about what has taken
> place, 'Tell us exactly what happened.'[19]

The narratorial voice articulates the narcissistic, colonialist
demand that it should be addressed directly, that the Other
should authorize the self, recognize its priority, fulfil its outlines,
replete, indeed repeat, its references and still its fractured gaze.

From the journals of the missionary C. T. E. Rhenius, 1818:

> RHENIUS What do you want?
> INDIAN PILGRIM Whatever you give I take.
> R What then do you want?
> IP I have already enough of everything.
> R Do you know God?
> IP I know he is in me. When you put rice into a mortar and
> stamp it with a pestle, the rice gets clean. So, God is known to
> me [the comparisons of the Heathen are often
> incomprehensible to a European]. . . .
> IP But tell me in what shape do you like to see him?
> R In the shape of the Almighty, the Omniscient, the
> Omnipresent, the Eternal, the Unchangeable, the Holy One,
> the Righteous, the Truth, the Wisdom and the Love.
> IP I shall show him to you: but first you must learn all that I have
> learned – then you will see God.[20]

And this from a sermon by Archdeacon Potts in 1818:

> If you urge them with their gross and unworthy misconceptions

of the nature and the will of God, or the monstrous follies of their fabulous theology, they will turn it off with a *sly civility* perhaps, or with a popular and careless proverb. You may be told that 'heaven is a wide place, and has a thousand gates'; and that their religion is one by which they hope to enter. Thus, together with their fixed persuasions, they have their sceptical conceits. By such evasions they can dismiss the merits of the case from all consideration; and encourage men to think that the vilest superstition may serve to every salutary purpose, and be accepted in the sight of God as well as truth and righteousness.[21]

In the native refusal to satisfy the colonizer's narrative demand, we hear the echoes of Freud's sabre-rattling strangers, with whom I began this chapter. The natives' resistance represents a frustration of that nineteenth-century strategy of surveillance, the *confession*, which seeks to dominate the 'calculable' individual by positing the truth that the subject *has* but does not know. The incalculable native produces a problem for civil representation in the discourses of literature and legality. This uncertainty impressed itself on Nathanael Halhed whose *A Code of Gentoo Laws* (1776) was the canonical colonialist codification of Indian 'native' law, but he was only able to read this resistance to calculation and testimony as native 'folly' or 'temporary frenzy . . . something like the madness so inimitably delineated in the hero of Cervantes'.[22] The native answers display the continual slippage between civil inscription and colonial address. The uncertainty generated by such resistance changes the narratorial demand itself. What was spoken within the orders of civility now accedes to the colonial signifier. The question is no longer Derrida's 'Tell us exactly what happened.' From the point of view of the colonizer, passionate for unbounded, unpeopled possession, the problem of truth turns into the troubled political and psychic question of boundary and territory: *Tell us why you, the*

native, are there. Etymologically unsettled, 'territory' derives from both *terra* (earth) and *terrēre* (to frighten) whence *territorium*, 'a place from which people are frightened off'.[23] The colonialist demand for narrative carries, within it, its threatening reversal: *Tell us why we are here*. It is this echo that reveals that the *other* side of narcissistic authority may be the paranoia of power; a desire for 'authorization' in the face of a process of cultural differentiation which makes it problematic to fix the native objects of colonial power as the moralized 'others' of truth.

The native refusal to unify the authoritarian, colonialist address within the terms of civil engagement gives the subject of colonial authority − father *and* oppressor − another turn. This ambivalent 'and', always less than one *and* double, traces the times and spaces between civil address and colonial articulation. The authoritarian demand can now only be justified if it is contained in the language of paranoia. The refusal to return and restore the image of authority to the eye of power has to be reinscribed as implacable aggression, assertively coming from without: *He hates me*. Such justification follows the familiar conjugation of persecutory paranoia. The frustrated wish 'I want him to love me,' turns into its opposite 'I hate him' and thence through projection and the exclusion of the first person, 'He hates me.'[24]

Projection is never a self-fulfilling prophecy; never a simple 'scapegoat' fantasy. The other's aggressivity from without, that justifies the subject of authority, makes that very subject a frontier station of joint occupation, as the psychoanalyst Robert Waelder has written.[25] Projection may compel the native to address the master, but it can never produce those effects of 'love' or 'truth' that would centre the confessional demand. If, through projection, the native is partially aligned or reformed in discourse, the fixed hate which refuses to circulate or reconjugate, produces the repeated fantasy of the native as in-between legality and illegality, endangering the boundaries of truth itself.

The litigious, lying native became a central object of nineteenth-century colonial, legal regulation. Each winter an Indian magistrate was dispatched to the Caribbean to adjudicate over the incalculable indentured Indian coolies. That the process of colonial intervention, its institutionalization and normalization, may itself be an *Entstellung*, a *displacement*, is the symbolic reality that must be disavowed. It is this ambivalence that ensues within paranoia as a play between eternal vigilance and blindness, and estranges the image of authority in its strategy of justification. For, excluded as the first-person subject and addressed by an aggressivity prior to itself, the figure of authority must always be belated; after and outside the event if it wants to be virtuous, and yet master of the situation, if it wants to be victorious:

> The English in India are part of a belligerent civilisation . . . they are the representatives of peace compelled by force. No country in the world is more orderly, more quiet or more peaceful than British India as it is, but if the vigour of the government should ever be relaxed, if it should lose its essential unity of purpose . . . chaos would come again like a flood.[26]

Delusions of 'the end of the world' – as Judge Schreber confessed to Freud – are the common tropes of paranoia, and it is with that in mind that we should reread Fitzjames Stephen's famous apocalyptic formulation that I've quoted above. In the oscillation between apocalypse and chaos, we see the emergence of an anxiety associated with the narcissistic vision and its two-dimensional space. It is an anxiety which will not abate because the empty third space, the other space of symbolic representation, at once bar and bearer of difference, is closed to the paranoid position of power. In the colonial discourse, that space of the other is always occupied by an *idée fixe*: despot, heathen, barbarian, chaos, violence. If these symbols are always the same, their ambivalent repetition makes them the signs of a much

deeper crisis of authority that emerges in the lawless writing of the colonial sense. There, the hybrid tongues of the colonial space make even the repetition of the *name* of God uncanny: 'every native term which the Christian missionary can employ to communicate the Divine truth is already appropriated as the chosen symbol of some counterpart deadly error' writes Alexander Duff, the most celebrated of nineteenth-century Indian missionaries, with trepidation.

> You vary your language and tell [the natives that] there must be *a second birth*. Now it so happens that this and all similar phraseology is preoccupied.
>
> The communication of the *Gayatri*, or the most sacred verse in the Vedas . . . constitutes religiously and metaphorically the natives' second birth. . . . Your improved language might only convey that all must become famous Brahmans ere they can see God.[27] (My emphasis)

6

SIGNS TAKEN FOR WONDERS

Questions of ambivalence and authority under a tree outside Delhi, May 1817

A remarkable peculiarity is that they (the English) always write the personal pronoun I with a capital letter. May we not consider this Great I as an unintended proof how much an Englishman thinks of his own consequence?

Robert Southey, *Letters from England*[1]

There is a scene in the cultural writings of English colonialism which repeats so insistently after the early nineteenth century – and, through that repetition, so triumphantly *inaugurates* a literature of empire – that I am bound to repeat it once more. It is the scenario, played out in the wild and wordless wastes of colonial India, Africa, the Caribbean, of the sudden, fortuitous discovery of the English book. It is, like all myths of origin, memorable for its balance between epiphany and enunciation. The discovery of the book is, at once, a moment of originality and authority. It is,

as well, a process of displacement that, paradoxically, makes the presence of the book wondrous to the extent to which it is repeated, translated, misread, displaced. It is with the emblem of the English book – 'signs taken for wonders' – as an insignia of colonial authority and a signifier of colonial desire and discipline, that I want to begin this chapter.

In the first week of May 1817, Anund Messeh, one of the earliest Indian catechists, made a hurried and excited journey from his mission in Meerut to a grove of trees just outside Delhi.

> He found about 500 people, men, women and children, seated under the shade of the trees, and employed, as had been related to him, in reading and conversation. He went up to an elderly looking man, and accosted him, and the following conversation passed.
>
> 'Pray who are all these people? and whence come they?' 'We are poor and lowly, and we read and love this book.' – 'What is that book?' 'The book of God!' – 'Let me look at it, if you please.' Anund, on opening the book, perceived it to be the Gospel of our Lord, translated into the Hindoostanee Tongue, many copies of which seemed to be in the possession of the party: some were PRINTED, others WRITTEN by themselves from the printed ones. Anund pointed to the name of Jesus, and asked, 'Who is that?' 'That is God! He gave us this book.' – 'Where did you obtain it?' 'An Angel from heaven gave it us, at Hurdwar fair.' – 'An Angel?' 'Yes, to us he was God's Angel: but he was a man, a learned Pundit.' (Doubtless these translated Gospels must have been the books distributed, five or six years ago, at Hurdwar by the Missionary.) 'The written copies we write ourselves, having no other means of obtaining more of this blessed word.' – 'These books,' said Anund, 'teach the religion of the European Sahibs. It is THEIR book; and they printed it in our language, for our use.' 'Ah! no,' replied the stranger, 'that cannot be, for they eat flesh.' – 'Jesus Christ,'

said Anund, 'teaches that it does not signify what a man eats or drinks. EATING is nothing before God. *Not that which entereth into a man's mouth defileth him, but that which cometh out of the mouth, this defileth a man*: for vile things come forth from the heart. *Out of the heart proceed evil thoughts, murders, adulteries, fornications, thefts; and these are the things that defile.*'

'That is true; but how can it be the European Book, when we believe that it is God's gift to us? He sent it to us at Hurdwar.' 'God gave it long ago to the Sahibs, and THEY sent it to us.' ... The ignorance and simplicity of many are very striking, never having heard of a printed book before; and its very appearance was to them miraculous. A great stir was excited by the gradual increasing information hereby obtained, and all united to acknowledge the superiority of the doctrines of this Holy Book to every thing which they had hitherto heard or known. An indifference to the distinctions of Caste soon manifested itself; and the interference and tyrannical authority of the Brahmins became more offensive and contemptible. At last, it was determined to separate themselves from the rest of their Hindoo Brethren; and to establish a party of their own choosing, four or five, who could read the best, to be the public teachers from this newly-acquired Book. ... Anund asked them, 'Why are you all dressed in white?' 'The people of God should wear white raiment,' was the reply, 'as a sign that they are clean, and rid of their sins.' – Anund observed, 'You ought to be BAPTIZED, in the name of the Father, and of the Son, and of the Holy Ghost. Come to Meerut: there is a Christian Padre there; and he will shew you what you ought to do.' They answered, 'Now we must go home to the harvest; but, as we mean to meet once a year, perhaps the next year we may come to Meerut.' ... I explained to them the nature of the Sacrament and of Baptism; in answer to which, they replied, 'We are willing to be baptized, but we will never take the

Sacrament. To all the other customs of Christians we are willing to conform, but not to the Sacrament, because the Europeans eat cow's flesh, and this will never do for us.' To this I answered, 'This WORD is of God, and not of men; and when HE makes your hearts to understand, then you will PROPERLY comprehend it.' They replied, 'If all our country will receive this Sacrament, then will we.' I then observed, 'The time is at hand, when all the countries will receive this WORD!' They replied, 'True!'[2]

Almost a hundred years later, in 1902, Joseph Conrad's Marlow, travelling in the Congo, in the night of the first ages, without a sign and no memories, cut off from the comprehension of his surroundings, desperately in need of a deliberate belief, comes upon Towson's (or Towser's) *Inquiry into some Points of Seamanship*.

Not a very enthralling book; but at the first glance you could see there a singleness of intention, an honest concern for the right way of going to work, which made these humble pages, thought out so many years ago, luminous with another than a professional light. . . . I assure you to leave off reading was like tearing myself away from the shelter of an old and solid friendship. . . .

'It must be this miserable trader – this intruder,' exclaimed the manager, looking back malevolently at the place we had left. 'He must be English,' I said.[3]

Half a century later, a young Trinidadian discovers that same volume of Towson's in that very passage from Conrad and draws from it a vision of literature and a lesson of history. 'The scene', writes V. S. Naipaul,

answered some of the political panic I was beginning to feel.

To be a colonial was to know a kind of security; it was to inhabit a fixed world. And I suppose that in my fantasy I had seen myself coming to England as to some purely literary region, where, untrammeled by the accidents of history or background, I could make a romantic career for myself as a writer. But in the new world I felt that ground move below me. - . . . Conrad . . . had been everywhere before me. Not as a man with a cause, but a man offering . . . a vision of the world's half-made societies . . . where always 'something inherent in the necessities of successful action . . . carried with it the moral degradation of the idea.' Dismal but deeply felt: a kind of truth and half a consolation.[4]

Written as they are in the name of the father and the author, these texts of the civilizing mission immediately suggest the triumph of the colonialist moment in early English Evangelism and modern English literature. The discovery of the book installs the sign of appropriate representation: the word of God, truth, art creates the conditions for a beginning, a practice of history and narrative. But the institution of the Word in the wilds is also an *Entstellung*, a process of displacement, distortion, dislocation, repetition[5] – the dazzling light of literature sheds only areas of darkness. Still the idea of the English book is presented as universally adequate: like the 'metaphoric writing of the West', it communicates 'the immediate vision of the thing, freed from the discourse that accompanied it, or even encumbered it.'[6]

Shortly before the discovery of the book, Marlow interrogates the odd, inappropriate, 'colonial' transformation of a textile into an uncertain textual sign, possibly a fetish:

Why? Where did he get it? Was it a badge – an ornament – a charm – a propitiatory act? Was there any idea at all connected with it? It looked startling round his black neck, this bit of white thread from beyond the seas.[7]

Such questions of the historical act of enunciation, which carry a political intent, are lost, a few pages later, in the myth of origins and discovery. The immediate vision of the book figures those ideological correlatives of the Western sign – empiricism, idealism, mimeticism, monoculturalism (to use Edward Said's term) – that sustain a tradition of English 'cultural' authority. They create a revisionary narrative that sustains the discipline of Commonwealth history and its epigone, Commonwealth literature. The conflictual moment of colonialist intervention is turned into that constitutive discourse of exemplum and imitation, that Friedrich Nietzsche describes as the monumental history beloved of 'gifted egoists and visionary scoundrels'.[8] For despite the accident of discovery, the repetition of the emergence of the book represents important moments in the historical transformation and discursive transfiguration of the colonial text and context.

Anund Messeh's riposte to the natives who refuse the sacrament – 'The time is at hand, when all countries will receive this WORD' (my emphasis) – is both firmly and timely spoken in 1817. For it represents a shift away from the 'Orientalist' educational practice of, say, Warren Hastings and the much more interventionist and 'interpellative' ambition of Charles Grant for a culturally and linguistically homogeneous English India. It was with Grant's election to the board of the East India Company in 1794 and to Parliament in 1802, and through his energetic espousal of the Evangelical ideals of the Clapham sect, that the East India Company reintroduced a 'pious clause' into its charter for 1813. By 1817 the Church Missionary Society ran sixty-one schools, and in 1818 it commissioned the Burdwan Plan, a central plan of education for instruction in the English language. The aim of the plan anticipates, almost to the word, Thomas Macaulay's infamous 1835 'Minute on Education': 'to form a body of well instructed labourers, competent in their proficiency in English to act as Teachers, Translators, and Compilers of useful

works for the masses of the people.'[9] Anund Messeh's lifeless repetition of chapter and verse, his artless technique of translation, participate in one of the most artful technologies of colonial power. In the same month that Anund Messeh discovered the miraculous effects of the book outside Delhi – May 1817 – a correspondent of the Church Missionary Society wrote to London describing the method of English education at Father John's mission in Tranquebar:

> The principal method of teaching them the English language would be by giving them English phrases and sentences, with a translation for them to commit to memory. These sentences might be so arranged as to teach them whatever sentiments the instructor should choose. They would become, in short, attached to the Mission; and though first put into the school from worldly motives alone, should any of them be converted, accustomed as they are to the language, manners and climate of the country, they might soon be prepared for a great usefulness in the cause of religion. . . . In this way the Heathens themselves might be made the instruments of pulling down their own religion, and of erecting in its ruins the standards of the Cross.
>
> (*MR*, May 1817, p. 187)

Marlow's ruminative closing statement, 'He must be English', acknowledges at the heart of darkness, in Conrad's *fin de siècle* malaise, the particular debt that both Marlow and Conrad owe to the ideals of English 'liberty' and its liberal-conservative culture.[10] Caught as he is – between the madness of 'prehistoric' Africa and the unconscious desire to repeat the traumatic intervention of modern colonialism within the compass of a seaman's yarn – Towson's manual provides Marlow with a singleness of intention. It is the book of work that turns delirium into the discourse of civil address. For the ethic of work, as

Conrad was to exemplify in 'Tradition' (1918), provides a sense of right conduct and honour achievable only through the acceptance of those 'customary' norms which are the signs of culturally cohesive 'civil' communities.[11] These aims of the civilizing mission, endorsed in the 'idea' of British imperialism and enacted on the red sections of the map, speak with a peculiarly English authority derived from the *customary practice* on which both English common law and the English national language rely for their effectivity and appeal.[12] It is the ideal of English civil discourse that permits Conrad to entertain the ideological ambivalences that riddle his narratives. It is under its watchful eye that he allows the fraught text of late nineteenth-century imperialism to implode within the practices of early modernism. The devastating effects of such an encounter are not only contained in an (un)common yarn; they are concealed in the propriety of a civil 'lie' told to the Intended (the complicity of the customary?): 'The horror! The horror!' must not be repeated in the drawing-rooms of Europe.

Naipaul 'translates' Conrad from Africa to the Caribbean in order to transform the despair of postcolonial history into an appeal for the autonomy of art. The more fiercely he believes that 'the wisdom of the heart ha[s] no concern with the erection or demolition of theories,' the more convinced he becomes of the unmediated nature of the Western book – 'the words it pronounces have the value of acts of integrity.'[13] The values that such a perspective generates for his own work, and for the once colonized world it chooses to represent and evaluate, are visible in the hideous panorama that some of his titles provide: *The Loss of El Dorado, The Mimic Men, An Area of Darkness, A Wounded Civilization, The Overcrowded Barracoon.*

The discovery of the English book establishes both a measure of mimesis and a mode of civil authority and order. If these scenes, as I have narrated them, suggest the triumph of the writ of colonialist power, then it must be conceded that the wily letter

of the law inscribes a much more ambivalent text of authority. For it is in-between the edict of Englishness and the assault of the dark unruly spaces of the earth, through an act of repetition, that the colonial text emerges uncertainly. Anund Messeh disavows the natives' disturbing questions as he returns to repeat the now questionable 'authority' of Evangelical dicta. Marlow turns away from the African jungle to recognize, in retrospect, the peculiarly 'English' quality of the discovery of the book. Naipaul turns his back on the hybrid half-made colonial world to fix his eye on the universal domain of English literature. What we witness is neither an untroubled, innocent dream of England nor a 'secondary revision' of the nightmare of India, Africa, the Caribbean. What is 'English' in these discourses of colonial power cannot be represented as a plenitudinous presence; it is determined by its belatedness. As a signifier of authority, the English book acquires its meaning *after* the traumatic scenario of colonial difference, cultural or racial, returns the eye of power to some prior, archaic image or identity. Paradoxically, however, such an image can neither be 'original' – by virtue of the act of repetition that constructs it – nor 'identical' – by virtue of the difference that defines it.

Consequently, the colonial presence is always ambivalent, split between its appearance as original and authoritative and its articulation as repetition and difference. It is a disjunction produced within the act of enunciation as a specifically colonial articulation of those two disproportionate sites of colonial discourse and power: the colonial scene as the invention of historicity, mastery, mimesis or as the 'other scene' of *Entstellung*, displacement, fantasy, psychic defence, and an 'open' textuality. Such a display of difference produces a mode of authority that is agonistic (rather than antagonistic). Its discriminatory effects are visible in those split subjects of the racist stereotype – the simian Negro, the effeminate Asiatic male – which ambivalently fix identity as the fantasy of difference.[14] To recognize the *différance* of

the colonial presence is to realize that the colonial text occupies that space of double inscription, hallowed – no, hollowed – by Jacques Derrida:

> whenever any writing both marks and goes back over its mark with an undecidable stroke . . . [this] double mark escapes the pertinence or authority of truth: it does not overturn it but rather inscribes it within its play as one of its functions or parts. This displacement does not take place, has not taken place once as an *event*. It does not occupy a simple place. It does not take place *in* writing. This dis-location (is what) writes/is written.
>
> (*D*, p. 193)

How can the question of authority, the power and presence of the English, be posed in the interstices of a double inscription? I have no wish to replace an idealist myth – the metaphoric English book – with a historicist one – the colonialist project of English civility. Such a reductive reading would deny what is obvious, that the representation of colonial authority depends less on a universal symbol of English identity than on its productivity as a sign of difference. Yet in my use of 'English' there is a transparency of reference that registers a certain obvious presence: the Bible translated into Hindi, propagated by Dutch or native catechists, is still the English book; a Polish émigré, deeply influenced by Gustave Flaubert, writing about Africa, produces an English classic. What is there about such a process of visibility and recognition that never fails to be an authoritative acknowledgement without ceasing to be a 'spacing between desire and fulfilment, between perpetuation and its recollection . . . [a] medium [which] has nothing to do with a center' (*D*, p. 212)?

This question demands a departure from Derrida's objectives in 'The double session'; a turning away from the vicissitudes of interpretation in the mimetic act of reading to the question of

the effects of power, the inscription of strategies of individuation and domination in those 'dividing practices' which construct the colonial space – a departure from Derrida which is also a return to those moments in his essay when he acknowledges the problematic of 'presence' as a certain quality of discursive transparency which he describes as 'the production of *mere* reality-effects' or 'the effect of content' or as the problematic relation between the 'medium of writing and the determination of each textual unit'. In the rich ruses and rebukes with which he shows up the 'false appearance of the present', Derrida fails to decipher the specific and determinate system of *address* (not referent) that is signified by the 'effect of content' (see D, pp. 173–85). It is precisely such a strategy of address – the *immediate presence* of the English – that engages the questions of authority that I want to raise. When the ocular metaphors of presence refer to the process by which content is fixed as an 'effect of the present', we encounter not plenitude but the structured gaze of power whose objective is authority, whose 'subjects' are historical.

The reality effect constructs a mode of address in which a complementarity of meaning produces the moment of discursive transparency. It is the moment when, 'under the false appearance of the present', the semantic seems to prevail over the syntactic, the signified over the signifier. Contrary to current avant-garde orthodoxy, however, the transparent is neither simply the triumph of the 'imaginary' capture of the subject in realist narrative nor the ultimate interpellation of the individual by ideology. It is not a proposal that you cannot positively refuse. It is better described, I suggest, as a form of the *disposal* of those discursive signs of presence/the present within the strategies that articulate the range of meanings from 'dispose to disposition'.

Transparency is the action of the distribution and arrangement of differential spaces, positions, knowledges in relation to each other, relative to a discriminatory, not inherent, sense of

order. This effects a regulation of spaces and places that is authoritatively assigned; it puts the addressee into the proper frame or condition for some action or result. Such a mode of governance addresses itself to a form of conduct that equivocates between the sense of disposal, as the bestowal of a frame of reference, and disposition, as mental inclination, a frame of mind. Such equivocation allows neither an equivalence of the two sites of disposal nor their division as self/other, subject/object. Transparency achieves an effect of authority in the present (and an authoritative presence) through a process similar to what Michel Foucault describes as 'an effect of finalisation, relative to an objective', without its necessary attribution to a subject that makes a prohibitory law, thou shalt or thou shalt not.[15]

The place of difference and otherness, or the space of the adversarial, within such a system of 'disposal' as I've proposed, is never entirely on the outside or implacably oppositional. It is a pressure, and a presence, that acts constantly, if unevenly, along the entire boundary of authorization, that is, on the surface between what I've called disposal-as-bestowal and disposition-as-inclination. The contour of difference is agonistic, shifting, splitting, rather like Freud's description of the system of consciousness which occupies a position in space lying on the border-line between outside and inside, a surface of protection, reception and projection.[16] The power play of presence is lost if its transparency is treated naively as the nostalgia for plenitude that should be flung repeatedly into the abyss – mise en abîme – from which its desire is born. Such theoreticist anarchism cannot intervene in the agonistic space of authority where

> the true and the false are separated and specific effects of power [are] attached to the true, it being understood also that it is not a matter of a battle 'on behalf' of the truth, but of a battle

about the status of truth and the economic and political role it plays.[17]

It is precisely to intervene in such a battle for the *status* of the truth that it becomes crucial to examine the *presence* of the English book. For it is this *surface* that stabilizes the agonistic colonial space; it is its *appearance* that regulates the ambivalence between origin and *displacement*, discipline and desire, mimesis and repetition.

Despite appearances, the text of transparency inscribes a double vision: the field of the 'true' emerges as a visible sign of authority only after the regulatory and displacing division of the true and the false. From this point of view, discursive 'transparency' is best read in the photographic sense in which a transparency is also always a negative, processed into visibility through the technologies of reversal, enlargement, lighting, editing, projection, not a source but a re-source of light. Such a bringing to light is a question of the provision of visibility as a capacity, a strategy, an agency.

This is the question that brings us to the ambivalence of the presence of authority, peculiarly visible in its colonial articulation. For if transparency signifies discursive closure – intention, image, author – it does so through a disclosure of its *rules of recognition* – those social texts of epistemic, ethnocentric, nationalist intelligibility which cohere in the address of authority as the 'present', the voice of modernity. The acknowledgement of authority depends upon the immediate – unmediated – visibility of its rules of recognition as the unmistakable referent of historical necessity. In the doubly inscribed space of colonial representation where the presence of authority – the English book – is also a question of its repetition and displacement, where transparency is *technē*, the immediate visibility of such a regime of recognition is resisted. Resistance is not necessarily an oppositional act of political intention, nor is it the simple negation or

exclusion of the 'content' of another culture, as a difference once perceived. It is the effect of an ambivalence produced within the rules of recognition of dominating discourses as they articulate the signs of cultural difference and reimplicate them within the deferential relations of colonial power – hierarchy, normalization, marginalization and so forth. For colonial domination is achieved through a process of disavowal that denies the chaos of its intervention as *Entstellung*, its dislocatory presence in order to preserve the authority of its identity in the teleological narratives of historical and political evolutionism.

The exercise of colonialist authority, however, requires the production of differentiations, individuations, identity effects through which discriminatory practices can map out subject populations that are tarred with the visible and transparent mark of power. Such a mode of subjection is distinct from what Foucault describes as 'power through transparency': the reign of opinion, after the late eighteenth century, which could not tolerate areas of darkness and sought to exercise power through the mere fact of things being known and people seen in an immediate, collective gaze.[18] What radically differentiates the exercise of colonial power is the unsuitability of the enlightenment assumption of collectivity and the eye that beholds it. For Jeremy Bentham (as Michel Perrot points out), the small group is representative of the whole society – the part is *already* the whole.[19] Colonial authority requires modes of discrimination (cultural, racial, administrative . . .) that disallow a stable unitary assumption of collectivity. The 'part' (which must be the colonialist foreign body) must be representative of the 'whole' (conquered country), but the right of representation is based on its radical difference. Such doublethink is made viable only through the strategy of disavowal just described, which requires a theory of the 'hybridization' of discourse and power that is ignored by theorists who engage in the battle for 'power' but do so only as the purists of difference.

The discriminatory effects of the discourse of cultural coloni-
alism, for instance, do not simply or singly refer to a 'person', or
a dialectical power struggle between self and other, or to a
discrimination between mother culture and alien cultures.
Produced through the strategy of disavowal, the *reference* of
discrimination is always to a process of splitting as the condition
of subjection: a discrimination between the mother culture and
its bastards, the self and its doubles, where the trace of what is
disavowed is not repressed but repeated as something *different* – a
mutation, a hybrid. It is such a partial and double force that is
more than the mimetic but less than the symbolic, that disturbs
the visibility of the colonial presence and makes the recognition
of its authority problematic. To be authoritative, its rules of rec-
ognition must reflect consensual knowledge or opinion; to be
powerful, these rules of recognition must be reached in order to
represent the exorbitant objects of discrimination that lie
beyond its purview. Consequently, if the unitary (and essential-
ist) reference to race, nation or cultural tradition is essential to
preserve the presence of authority as an immediate mimetic
effect, such essentialism must be exceeded in the articulation of
'differentiatory', discriminatory identities. (For a related argu-
ment see the description of the pedagogical and the performative
in Chapter 8.)

To demonstrate such an 'excess' is not merely to celebrate the
joyous power of the signifier. Hybridity is the sign of the prod-
uctivity of colonial power, its shifting forces and fixities; it is the
name for the strategic reversal of the process of domination
through disavowal (that is, the production of discriminatory
identities that secure the 'pure' and original identity of author-
ity). Hybridity is the revaluation of the assumption of colonial
identity through the repetition of discriminatory identity effects.
It displays the necessary deformation and displacement of all
sites of discrimination and domination. It unsettles the mimetic
or narcissistic demands of colonial power but reimplicates its

identifications in strategies of subversion that turn the gaze of the discriminated back upon the eye of power. For the colonial hybrid is the articulation of the ambivalent space where the rite of power is enacted on the site of desire, making its objects at once disciplinary and disseminatory – or, in my mixed metaphor, a negative transparency.

If discriminatory effects enable the authorities to keep an eye on them, their proliferating difference evades that eye, escapes that surveillance. Those discriminated against may be instantly recognized, but they also force a re-cognition of the immediacy and articulacy of authority – a disturbing effect that is familiar in the repeated hesitancy afflicting the colonialist discourse when it contemplates its discriminated subjects: the *inscrutability* of the Chinese, the *unspeakable* rites of the Indians, the *indescribable* habits of the Hottentots. It is not that the voice of authority is at a loss for words. It is, rather, that the colonial discourse has reached that point when, faced with the hybridity of its objects, the *presence* of power is revealed as something other than what its rules of recognition assert.

If the effect of colonial power is seen to be the *production* of hybridization rather than the noisy command of colonialist authority or the silent repression of native traditions, then an important change of perspective occurs. The ambivalence at the source of traditional discourses on authority enables a form of subversion, founded on the undecidability that turns the discursive conditions of dominance into the grounds of intervention. It is traditional academic wisdom that the presence of authority is properly established through the non-exercise of private judgement and the exclusion of reasons in conflict with the authoritative reason. The recognition of authority, however, requires a validation of its source that must be immediately, even intuitively, apparent – 'You have that in your countenance which I would fain call master' – and held in common (rules of recognition). What is left unacknowledged is the paradox of such a

demand for proof and the resulting ambivalence for positions of authority. If, as Steven Lukes rightly says, the acceptance of authority excludes an evaluation of the content of an utterance, and if its source, which must be acknowledged, disavows both conflicting reasons and personal judgement, then can the 'signs' or 'marks' of authority be anything more than 'empty' presences of strategic devices?[20] Need they be any the less effective because of that? Not less effective but effective in a different form, would be our answer.

Tom Nairn reveals a basic ambivalence between the symbols of English imperialism which would not help 'looking universal' and a 'hollowness [that] sounds through the English imperialist mind in a thousand forms: in Rider Haggard's necrophilia, in Kipling's moments of gloomy doubt, . . . in the gloomy cosmic truth of Forster's Marabar caves'.[21] Nairn explains this 'imperial delirium' as the disproportion between the grandiose rhetoric of English imperialism and the *real* economic and political situation of late Victorian England. I would like to suggest that these crucial moments in English literature are not simply crises of England's own making. They are also the signs of a discontinuous history, an estrangement of the English book. They mark the disturbance of its authoritative representations by the uncanny forces of race, sexuality, violence, cultural and even climatic differences which emerge in the colonial discourse as the mixed and split texts of hybridity. If the appearance of the English book is read as a production of colonial hybridity, then it no longer simply commands authority. It gives rise to a series of questions of authority that, in my bastardized repetition, must sound strangely familiar:

> Was it a badge – an ornament – a charm – a propitiatory act? Was there any idea at all connected with it? It looked startling in this black neck of the woods, this bit of white writing from beyond the seas.

In repeating the scenario of the English book, I hope I have succeeded in representing a colonial difference: it is the effect of uncertainty that afflicts the discourse of power, an uncertainty that estranges the familiar symbol of English 'national' authority and emerges from its colonial appropriation as the sign of its difference. Hybridity is the name of this displacement of value from symbol to sign that causes the dominant discourse to split along the axis of its power to be representative, authoritative. Hybridity represents that ambivalent 'turn' of the discriminated subject into the terrifying, exorbitant object of paranoid classification – a disturbing questioning of the images and presences of authority.

To grasp the ambivalence of hybridity, it must be distinguished from an inversion that would suggest that the originary is, really, only an 'effect'. Hybridity has no such perspective of depth or truth to provide: it is not a third term that resolves the tension between two cultures, or the two scenes of the book, in a dialectical play of 'recognition'. The displacement from symbol to sign creates a crisis for any concept of authority based on a system of recognition: colonial specularity, doubly inscribed, does not produce a mirror where the self apprehends itself; it is always the split screen of the self and its doubling, the hybrid.

These metaphors are very much to the point, because they suggest that colonial hybridity is not a *problem* of genealogy or identity between two *different* cultures which can then be resolved as an issue of cultural relativism. Hybridity is a problematic of colonial representation and individuation that reverses the effects of the colonialist disavowal, so that other 'denied' knowledges enter upon the dominant discourse and estrange the basis of its authority – its rules of recognition. Again, it must be stressed, it is not simply the *content* of disavowed knowledges – be they forms of cultural otherness or traditions of colonialist treachery – that return be acknowledged as counter-authorities. For the resolution of conflicts between authorities,

civil discourse always maintains an adjudicative procedure. What is irremediably estranging in the presence of the hybrid – in the revaluation of the symbol of national authority as the sign of colonial difference – is that the difference of cultures can no longer be identified or evaluated as objects of epistemological or moral contemplation: cultural differences are not simply *there* to be seen or appropriated.

Hybridity reverses the *formal* process of disavowal so that the violent dislocation of the act of colonization becomes the conditionality of colonial discourse. The presence of colonialist authority is no longer immediately visible; its discriminatory identifications no longer have their authoritative reference to this culture's cannibalism or that people's perfidy. As an articulation of displacement and dislocation, it is now possible to identify 'the cultural' as a disposal of power, a negative transparency that comes to be agonistically constructed *on the boundary* between frame of reference/frame of mind. It is crucial to remember that the colonial construction of the cultural (the site of the civilizing mission) through the process of disavowal is authoritative to the extent to which it is structured around the ambivalence of splitting, denial, repetition – strategies of defence that mobilize culture as an open-textured, warlike strategy whose aim 'is rather a continued agony than a total disappearance of the pre-existing culture'.[22]

To see the cultural not as the *source* of conflict – *different* cultures – but as the *effect* of discriminatory practices – the production of cultural *differentiation* as signs of authority – changes its value and its rules of recognition. Hybridity intervenes in the exercise of authority not merely to indicate the impossibility of its identity but to represent the unpredictability of its presence. The book retains its presence, but it is no longer a representation of an essence; it is now a partial presence, a (strategic) device in a specific colonial engagement, an appurtenance of authority.

This partializing process of hybridity is best described as a

metonymy of presence. It shares Sigmund Freud's valuable insight into the strategy of disavowal as the persistence of the narcissistic demand in the acknowledgement of difference.[23] This, however, exacts a price, for the existence of two contradictory knowledges (multiple beliefs) splits the ego (or the discourse) into two psychical attitudes, and forms of knowledge, towards the external world. The first of these takes reality into consideration while the second replaces it with a product of desire. What is remarkable is that these two contradictory objectives always represent a 'partiality' in the construction of the fetish object, at once a substitute for the phallus and a mark of its absence. There is an important difference between fetishism and hybridity. The fetish reacts to the change in the value of the phallus by fixing on an object *prior to the perception of difference*, an object that can metaphorically substitute for its presence while registering the difference. So long as it fulfils the fetishistic ritual, the object can look like anything (or nothing!).

The hybrid object, on the other hand, retains the actual semblance of the authoritative symbol but revalues its presence by resisting it as the signifier of *Entstellung — after the intervention of difference*. It is the power of this strange metonymy of presence to so disturb the systematic (and systemic) construction of discriminatory knowledges that the cultural, once recognized as the medium of authority, becomes virtually unrecognizable. Culture, as a colonial space of intervention and agonism, as the trace of the displacement of symbol to sign, can be transformed by the unpredictable and partial desire of hybridity. Deprived of their full presence, the knowledges of cultural authority may be articulated with forms of 'native' knowledges or faced with those discriminated subjects that they must rule but can no longer represent. This may lead, as in the case of the natives outside Delhi, to questions of authority that the authorities — the Bible included — cannot answer. Such a process is not the deconstruction of a cultural system from the margins of its own aporia

nor, as in Derrida's 'Double session', the mime that haunts mimesis. The display of hybridity – its peculiar 'replication' – terrorizes authority with the *ruse* of recognition, its mimicry, its mockery.

Such a reading of the hybridity of colonial authority profoundly unsettles the demand that figures at the centre of the originary myth of colonialist power. It is the demand that the space it occupies be unbounded, its reality *coincident* with the emergence of an imperialist narrative and history, its discourse *non-dialogic*, its enunciation *unitary*, unmarked by the trace of difference. It is a demand that is recognizable in a range of justificatory Western 'civil' discourses where the presence of the 'colony' often alienates its own language of liberty and reveals its universalist concepts of labour and property as particular, post-Enlightenment ideological and technological practices. Consider, for example: Locke's notion of the wasteland of Carolina – 'Thus in the beginning all the World was *America*'; Montesquieu's emblem of the wasteful and disorderly life and labour in despotic societies – 'When the savages of Louisiana are desirous of fruit, they cut the tree to the root, and gather the fruit'; Grant's belief in the impossibility of law and history in Muslim and Hindu India – 'where treasons and revolutions are continual; by which the insolent and abject frequently change places'; or the contemporary Zionist myth of the neglect of Palestine – 'of a *whole* territory', Said writes, 'essentially unused, unappreciated, misunderstood . . . to *be made* useful, appreciated, understandable'.[24]

The voice of command is interrupted by questions that arise from these heterogeneous sites and circuits of power which, though momentarily 'fixed' in the authoritative alignment of subjects, must continually be re-presented in the production of terror or fear. The paranoid threat from the hybrid is finally uncontainable because it breaks down the symmetry and duality of self/other, inside/outside. In the productivity of power, the

boundaries of authority – its reality effects – are always besieged by 'the other scene' of fixations and phantoms.

We can now understand the link between the psychic and political that is suggested in Frantz Fanon's figure of speech: the colonialist is an exhibitionist, because his *preoccupation* with security makes him 'remind the native out loud that there he alone is master'.[25] The native, caught in the chains of colonialist command, achieves a 'pseudo-petrification' which further incites and excites him, thus making the settler–native boundary an anxious and ambivalent one. What then presents itself as the subject of authority in the discourse of colonial power is, in fact, a desire that so exceeds the original authority of the book and the immediate visibility of its metaphoric writing that we are bound to ask: what does colonial power want? My answer is only partially in agreement with Lacan's *vel* or Derrida's veil. For the desire of colonial discourse *is* a splitting of hybridity that is *less than one and double*; and if that sounds enigmatic, it is because its explanation has to wait upon the authority of those canny questions that the natives put, so insistently, to the English book.

The native questions quite literally turn the origin of the book into an enigma. First: *how can the word of God come from the flesh-eating mouths of the English?* – a question that faces the unitary and universalist assumption of authority with the cultural difference of its historical moment of enunciation. And later: *how can it be the European Book, when we believe that it is God's gift to us? He sent it to us at Hurdwar.* This is not merely an illustration of what Foucault would call the capillary effects of the microtechnics of power. It reveals the penetrative power – *both* psychic and social – of the technology of the printed word in early nineteenth-century rural India. Imagine the scene: the Bible, perhaps translated into a north Indian dialect like Brigbhasha, handed out free or for one rupee within a culture where usually only caste Hindus would possess a copy of the Scriptures, received in awe by the natives as both a novelty and a household deity. Contemporary missionary

records reveal that, in Middle India alone, by 1815 we could have witnessed the spectacle of the Gospel 'doing its own work', as the Evangelicals put it, in at least eight languages and dialects, with a first edition of between one thousand and ten thousand copies in each translation.[26] It is the force of these colonialist practices that produce that discursive tension between Anund Messeh, whose address *assumes* its authority, and the natives who question the English presence, revealing the hybridity of authority and inserting their insurgent interrogations in the interstices.

The subversive character of the native questions will be realized only once we recognize the strategic disavowal of cultural/historical difference in Anund Messeh's Evangelical discourse. Having introduced the *presence* of the English and their *intercession* – 'God gave [the Book] long ago to the Sahibs, and THEY sent it to us' – he then disavows that political/linguistic 'imposition' by attributing the intervention of the Church to the power of God and the received authority of chapter and verse. What is being disavowed is not entirely visible in Anund Messeh's contradictory statements, at the level of the 'enounced'. What he, as well as the English Bible-in-disguise, must conceal are their particular enunciatory conditions – that is, the design of the Burdwan Plan to deploy 'natives' to destroy native culture and religion. This is done through the repeated production of a teleological narrative of Evangelical witness: eager conversions, bereft Brahmins, and Christian gatherings. The descent from God to the English is both linear and circular: 'This WORD is of God, and not of men; and when HE makes your hearts to understand, then you will PROPERLY comprehend it.'

This historical 'evidence' of Christianity is plain for all to see, Evangelists would have argued, with the help of William Paley's *Evidences of Christianity* (1791), the most influential missionary manual throughout the nineteenth century. The miraculous authority of colonial Christianity, they would have held, lies precisely in its being both English and universal, empirical and

uncanny, for 'ought we not rather to expect that such a Being on occasions of peculiar importance, may interrupt the order which he had appointed?'[27] The Word, no less theocratic than logocentric, would have certainly borne absolute witness to the gospel of Hurdwar had it not been for the rather tasteless fact that most Hindus were vegetarian!

By taking their stand on the grounds of dietary law, the natives resist the miraculous equivalence of God and the English. They introduce the practice of colonial cultural differentiation *as an indispensable enunciative function* in the discourse of authority – a function Foucault describes as linked to

> a 'referential' that . . . forms the place, the condition, the field of emergence, the *authority to differentiate* between individuals or objects, states of things and relations that are brought into play by the statement itself; it defines the possibilities of appearance and delimitation.[28]

Through the natives' strange questions, it is possible to see, with historical hindsight, what they resisted in questioning the presence of the English – as religious mediation and as a cultural and linguistic medium. What is the value of English in the offering of the Hindi Bible? It is the creation of a print technology calculated to produce a visual effect that will not 'look like the work of foreigners'; it is the decision to produce simple, abridged tracts of the plainest narrative that may inculcate the habit of 'private, solitary reading', as a missionary wrote in 1816, so that the natives may resist the Brahmin's 'monopoly of knowledge' and lessen their dependence on their own religious and cultural traditions; it is the opinion of the Reverend Donald Corrie that 'on learning English they acquire ideas quite new, and of the first importance, respecting God and his government' (MR, July 1816, p. 193; November 1816, pp. 444–5; March 1816, pp. 106–7). It is the shrewd view of an unknown native, in 1819:

For instance, I take a book of yours and read it awhile and whether I become a Christian or not, I leave the book in my family: after my death, my son, conceiving that I would leave nothing useless or bad in my house, will look into the book, understand its contents, consider that his father left him the book, and become a Christian.

(*MR*, January 1819, p. 27)

When the natives demand an Indianized Gospel, they are using the powers of hybridity to resist baptism and to put the project of conversion in an impossible position. Any adaptation of the Bible was forbidden by the evidences of Christianity, for, as the bishop of Calcutta preached in his Christmas sermon in 1715:

I mean that it is a Historical Religion: the History of the whole dispensation is before us from the creation of the world to the present hour: and it is throughout consistent with itself and with the attributes of God.

(*MR*, January 1817, p. 31)

The natives' stipulation that only mass conversion would persuade them to take the sacrament touches on a tension between missionary zeal and the East India Company Statutes for 1814 which strongly advised against such proselytizing. When they make these intercultural, hybrid demands, the natives are both challenging the boundaries of discourse and subtly changing its terms by setting up another specifically colonial space of the negotiations of cultural authority. And they do this under the eye of power, through the production of 'partial' knowledges and positionalities in keeping with my earlier, more general explanation of hybridity. Such objects of knowledges make the signifiers of authority enigmatic in a way that is 'less than one and double'. They change their conditions of recognition while

maintaining their visibility; they introduce a lack that is then represented as a doubling of mimicry. This mode of discursive disturbance is a sharp practice, rather like that of the perfidious barbers in the bazaars of Bombay who do not mug their customers with the blunt Lacanian *vel*, 'Your money or your life', leaving them with nothing. No, these wily oriental thieves, with far greater skill, pick their clients' pockets and cry out, 'How the master's face shines!' and then, in a whisper, 'But he's lost his mettle!'

And this traveller's tale, told by a native, is an emblem of that form of splitting – less than one and double – that I have suggested for the reading of the ambivalence of colonial cultural texts. In estranging the word of God from the English medium, the natives' questions contest the logical order of the discourse of authority – 'These books . . . teach the religion of the European Sahibs. It is THEIR book; and they printed it in our language, for our use.' The natives expel the copula, or middle term, of the Evangelical 'power = knowledge' equation, which then disarticulates the structure of the God–Englishman equivalence. Such a crisis in the positionality and propositionality of colonialist authority destablizes the sign of authority. The Bible is now ready for a specific colonial appropriation. On the one hand, its paradigmatic presence as the Word of God is assiduously preserved: it is only to the direct quotations from the Bible that the natives give their unquestioning approval – 'True!' The expulsion of the copula, however, empties the presence of its syntagmatic supports – codes, connotations and cultural associations that give it contiguity and continuity – that make its presence culturally and politically authoritative.

In this sense, then, it may be said that the *presence* of the book has acceded to the logic of the signifier and has been 'separated', in Lacan's use of the term, from 'itself'. If, on one side, its authority, or some symbol or meaning of it, is maintained – willy-nilly, *less than one* – then, on the other, it fades. It is at the

point of its fading that the metonymy of presence gets caught up in an alienating strategy of doubling or repetition. Doubling repeats the fixed and empty presence of authority by articulating it syntagmatically with a range of differential knowledges and positionalities that both estrange its 'identity' and produce new forms of knowledge, new modes of differentiation, new sites of power.

In the case of the colonial discourse, these syntagmatic appropriations of presence confront it with those contradictory and threatening differences of its enunciative function that had been disavowed. In their repetition, these disavowed knowledges return to make the presence of authority uncertain. They may take the form of multiple or contradictory belief, as in some forms of native knowledges: 'We are willing to be baptized, but we will never take the Sacrament.' Or they may be forms of mythic explanation that refuse to acknowledge the agency of the Evangelicals: 'An Angel from heaven gave it [the Bible] us, at Hurdwar fair.' Or they may be the fetishistic repetition of litany in the face of an unanswerable challenge to authority: for instance, Anund Messeh's 'Not that which entereth into a man's mouth defileth him, but that which cometh out of the mouth.'

In each of these cases we see a colonial doubling which I have described as a strategic displacement of value through a process of the metonymy of presence. It is through this partial process, represented in its enigmatic, inappropriate signifiers – stereotypes, jokes, multiple and contradictory belief, the 'native' Bible – that we begin to get a sense of a specific space of cultural colonial discourse. It is a 'separate' space, a space of *separation* – less than one and double – which has been systematically denied by both colonialists and nationalists who have sought authority in the authenticity of 'origins'. It is precisely as a separation from origins and essences that this colonial space is constructed. It is separate, in the sense in which the French psychoanalyst Victor Smirnoff describes the separateness of the fetish as a

'separateness that makes the fetish easily available, so that the subject can make use of it in his own way and establish it in an order of things that frees it from any subordination.'[29]

The metonymic strategy produces the signifier of colonial mimicry as the affect of hybridity – at once a mode of appropriation and of resistance, from the disciplined to the desiring. As the discriminated object, the metonym of presence becomes the support of an authoritarian voyeurism, all the better to exhibit the eye of power. Then, as discrimination turns into the assertion of the hybrid, the insignia of authority becomes a mask, a mockery. After our experience of the native interrogation, it is difficult to agree entirely with Fanon that the psychic choice is to 'turn white or disappear.'[30] There is the more ambivalent, third choice: camouflage, mimicry, black skins/white masks. Lacan writes:

> Mimicry reveals something in so far as it is distinct from what might be called an *itself* that is behind. The effect of mimicry is camouflage, in the strictly technical sense. It is not a question of harmonizing with the background but, against a mottled background, of being mottled – exactly like the technique of camouflage practised in human warfare.[31]

Read as a masque of mimicry, Anund Messeh's tale emerges as a question of colonial authority, an agonistic space. To the extent to which discourse is a form of defensive warfare, mimicry marks those moments of civil disobedience within the discipline of civility: signs of spectacular resistance. Then the words of the master become the site of hybridity – the warlike, subaltern sign of the native – then we may not only read between the lines but even seek to change the often coercive reality that they so lucidly contain. It is with the strange sense of a hybrid history that I want to end this chapter.

Despite Anund Messeh's miraculous evidence, 'native

Christians were never more than vain phantoms' as J. A. Dubois wrote in 1815, after twenty-five years in Madras. Their parlous partial state caused him particular anxiety,

> for in embracing the Christian religion they never entirely renounce their superstitions towards which they always keep a secret bent ... there is no *unfeigned, undisguised* Christian among these Indians.
>
> (*MR*, November 1816, p. 212)

And what of the native discourse? Who can tell?

The Reverend Mr Corrie, the most eminent of the Indian Evangelists, warned that

> till they came under the English Government, they have not been accustomed to assert the nose upon their face their own. - ... This temper prevails, more or less, in the converted.
>
> (*MR*, March 1816, pp. 106–7)

Archdeacon Potts, in handing over charge to the Reverend J. P. Sperch-neider in July 1818, was a good deal more worried:

> If you urge them with their gross and unworthy misconceptions of the nature and will of God or the monstrous follies of their fabulous theology, they will turn it off with a sly civility perhaps, or with a popular and careless proverb.
>
> (*MR*, September 1818, p. 375)

Was it in the spirit of such sly civility that the native Christians parried so long with Anund Messeh and then, at the mention of baptism, politely excused themselves: 'Now we must go home to the harvest ... perhaps the next year we may come to Meerut.'

And what is the significance of the Bible? Who knows?

Three years before the native Christians received the Bible at Hurdwar, a schoolmaster named Sandappan wrote from southern India, asking for a Bible:

> Rev. Fr. Have mercy upon me. I am amongst so many craving beggars for the Holy Scriptures the chief craving beggar. The bounty of the bestowers of this treasure is so great I understand, that even this book is read in rice and salt-markets.
>
> (*MR*, June 1813, pp. 221–2)

But in 1817, the same year as the miracle outside Delhi, a much-tried missionary wrote in some considerable rage:

> Still everyone would gladly receive a Bible. And why? That he may store it up as a curiosity; sell it for a few pice; or use it for waste paper. . . . Some have been bartered in the markets. . . . If these remarks are at all warranted then an indiscriminate distribution of the scriptures, to everyone who may say he wants a Bible, can be little less than a waste of time, a waste of money and a waste of expectations. For while the public are hearing of so many Bibles distributed, they expect to hear soon of a correspondent number of conversions.
>
> (*MR*, May 1817, p. 186)

7

ARTICULATING THE ARCHAIC

Cultural difference and colonial nonsense

> How can the mind take hold of such a country? Generations of invaders have tried, but they remain in exile. The important towns they build are only retreats, their quarrels the malaise of men who cannot find their way home. India knows of their trouble. . . . She calls 'Come' through her hundred mouths, through objects ridiculous and august. But come to what? She has never defined. She is not a promise, only an appeal.
>
> E. M. Forster, *A Passage to India*[1]

> The Fact that I have said that the effect of interpretation is to isolate in the subject a kernel, a *kern* to use Freud's own term, of *non-sense*, does not mean that interpretation is in itself nonsense.
>
> Jacques Lacan, 'The field of the other'[2]

I

There is a conspiracy of silence around the colonial truth, whatever that might be. Around the turn of the century there emerges

a mythic, masterful silence in the narratives of empire, what Sir Alfred Lyall called 'doing our Imperialism quietly', Carlyle celebrated as the 'wisdom of the Do-able – Behold ineloquent Brindley . . . he has chained the seas together,' and Kipling embodied, most eloquently, in the figure of Cecil Rhodes – 'Nations not words he linked to prove/His faith before the crowd.'[3] Around the same time, from those dark corners of the earth, there comes another, more ominous silence that utters an archaic colonial 'otherness', that speaks in riddles, obliterating proper names and proper places. It is a silence that turns imperial triumphalism into the testimony of colonial confusion and those who hear its echo lose their historic memories. This is the Voice of early modernist 'colonial' literature, the complex cultural memory of which is made in a fine tension between the melancholic homelessness of the modern novelist, and the wisdom of the sage-like storyteller whose craft takes him no further afield than his own people.[4] In Conrad's *Heart of Darkness*, Marlow seeks Kurtz's Voice, his words, 'a stream of light or the deceitful flow from the heart of an impenetrable darkness' and in that search he loses 'what is in the *work* – the chance to find yourself'.[5] He is left with those two unworkable words, 'the Horror, the Horror!' Nostromo embarks on the most desperate mission of his life with the silver tied for safety around his neck 'so that it shall be talked about when the little children are grown up and the grown men are old', only to be betrayed and berated in the silence of the Great Isabel, mocked in the owl's deathcall 'Ya-acabo! Ya-acabo! it is finished, it is finished.'[6] And Aziz, in *A Passage to India*, who embarks jauntily, though no less desperately, on his Anglo-Indian picnic to the Marabar caves is cruelly undone by the echo of the Kawa Dol: 'Boum, ouboum is the sound as far as the human alphabet can express it . . . if one spoke silences in that place or quoted lofty poetry, the comment would have been the same ou-boum.'[7]

As one silence uncannily repeats the other, the sign of identity

and reality found in the work of empire is slowly undone. Eric Stokes, in *The Political Ideas of English Imperialism*,[8] describes the mission of work – that medium of recognition for the colonial subject – as a distinctive feature of the imperialist mind which, from the early nineteenth century, effected 'the transference of religious emotion to secular purposes'. But this transference of affect and object is never achieved without a disturbance, a displacement in the representation of empire's work itself. Marlow's compulsive search for those famous rivets, to get on with the work, to stop the hold, gives way to the compulsive quest for the Voice, the words that are half-lost, lied about, repeated. Kurtz is just a word, not the man with the name; Marlow is just a name, lost in the narrative game, in the 'terrific suggestiveness of words heard in dreams, of phrases spoken in nightmares'.[9]

What emerges from the dispersal of work is the language of a colonial nonsense that displaces those dualities in which the colonial space is traditionally divided: nature/culture, chaos/civility. Ouboum or the owl's deathcall – the horror of these words! – are not naturalized or primitivistic descriptions of colonial 'otherness', they are the inscriptions of an uncertain colonial silence that mocks the social performance of language with their non-sense; that baffles the communicable verities of culture with their refusal to translate. These hybrid signifiers are the intimations of colonial otherness that Forster describes so well in the beckoning of India to the conquerors: 'She calls "Come" . . . But come to what? She has never defined. She is not a promise, only an appeal.'[10] It is from such an uncertain invitation to interpret, from such a question of desire, that the echo of another significant question can be dimly heard, Lacan's question of the alienation of the subject in the Other: 'He is saying this to me, but what does he want?'[11]

'Yacabo! Yacabo! It is finished . . . finished': these words stand not for the plenitudinous place of cultural diversity, but at the point of culture's 'fading'. They display the alienation between

the transformational myth of culture as a language of universality and social generalization, and its tropic function as a repeated 'translation' of incommensurable levels of living and meaning. The articulation of nonsense is the recognition of an anxious contradictory place between the human and the not-human, between sense and non-sense. In that sense, these 'senseless' signifiers pose the question of cultural choice in terms similar to the Lacanian *vel*, between being and meaning, between the subject and the other, 'neither the one nor the other'. Neither, in our terms, 'work' nor 'word' but precisely the work of the colonial word that leaves, for instance, the surface of Nostromo strewn with the detritus of silver – a fetish, Emilia calls it; an evil omen, in Nostromo's words; and Gould is forever silent. Bits and pieces of silver recount the tale that never quite adds up either to the narcissistic, dynastic dream of imperial democracy, or to Captain Mitchell's banal demand for a narrative of 'historical events'.

The work of the word impedes the question of the transparent assimilation of cross-cultural meanings in a unitary sign of 'human' culture. In-between culture, at the point of its articulation of identity or distinctiveness, comes the question of signification. This is not simply a matter of language; it is the question of culture's representation of difference – manners, words, rituals, customs, time – inscribed *without* a transcendent subject that knows, outside of a mimetic social memory, and across the – ouboum – kernel of non-sense. What becomes of cultural identity, the ability to put the right word in the right place at the right time, when it crosses the colonial non-sense?

Such a question impedes the language of relativism in which cultural difference is usually disposed of as a kind of ethical naturalism, a matter of cultural diversity. 'A fully individual culture is at best a rare thing,' Bernard Williams writes in his interesting work *Ethics and the Limits of Philosophy*.[12] Yet, he argues, the very structure of ethical thought seeks to apply its principles to the whole world. His concept of a 'relativism of distance', which

is underwritten by an epistemological view of society as a given whole, seeks to inscribe the totality of other cultures in a realist and concrete narrative that must beware, he warns, the fantasy of projection. Surely, however, the very project of ethical naturalism or cultural relativism is spurred precisely by the repeated threat of the *loss* of a 'teleologically significant world', and it is the compensation of that loss in projection or introjection which then becomes the *basis* of its ethical judgement. From the margins of his text, Williams asks, in parenthesis, a question not dissimilar to Forster's India question or Lacan's question of the subject; 'What is this talk of projection [in the midst of naturalism] really saying? What is the screen?' He makes no answer.

The problematic enunciation of cultural difference becomes, in the discourse of relativism, the perspectival problem of temporal and spatial distance. The threatened 'loss' of meaningfulness in cross-cultural interpretation, which is as much a problem of the structure of the signifier as it is a question of cultural codes (the *experience* of other cultures), then becomes a hermeneutic project for the restoration of cultural 'essence' or authenticity. The issue of interpretation in colonial cultural discourse is not, however, an epistemological problem that emerges because colonial objects appear *before* (in both senses) the eye of the subject in a bewildering diversity. Nor is it simply a quarrel between preconstituted holistic cultures, that contain within themselves the codes by which they can legitimately be read. The question of cultural difference as I want to cast it, is not what Adela Quested quaintly identified as an 'Anglo-Indian difficulty', a problem caused by cultural plurality. And to which, in her view, the only response could be the sublation of cultural differentiation in an ethical universalism: 'That's why I want Akbar's "universal religion" or the equivalent to keep me decent and sensible.'[13] Cultural difference, as Adela experienced it, in the nonsense of the Marabar caves, is not the acquisition or accumulation of additional cultural knowledge; it is the

momentous, if momentary, extinction of the recognizable object of culture in the disturbed artifice of its signification, at the edge of experience.

What happened in the Marabar caves? *There*, the loss of the narrative of cultural plurality; *there* the implausibility of conversation and commensurability; *there* the enactment of an undecidable, uncanny colonial present, an Anglo-Indian difficulty, which repeats but is never itself fully represented: 'Come . . . But come to what?'; remember India's invocation. Aziz is uncurably inaccurate about the events, because he is sensitive, because Adela's question about polygamy has to be put from his mind. Adela, obsessively trying to think the incident out, somatizes the experience in repeated, hysterical narratives. Her body, Sebatian-like, is covered in colonies of cactus spines, and her mind which attempts to disavow the body – hers, his – returns to it obsessively: 'Now, everything transferred to the surface of my body. - . . . He never actually touched me once. . . . It all seems such nonsense . . . a sort of shadow.' It is the echochamber of memory:

> 'What a handsome little oriental . . . beauty, thick hair, a fine skin . . . there was nothing of the vagrant in her blood . . . he might attract women of his own race and rank: Have you one wife or many? . . . Damn the English even at their best,' he says . . . 'I remember, remember scratching the wall with my fingernail to start the echo . . .' she says. . . . And then the echo . . . 'Ouboum'.[14]

In this performance of the text, I have attempted to articulate the enunciatory disorder of the colonial present, the writing of cultural difference. It lies in the staging of the colonial signifier in the narrative uncertainty of culture's in-between: between sign and signifier, neither one nor the other, neither sexuality nor race, neither, simply, memory nor desire. The articulated

opening in-between that I am attempting to describe, is well brought out in Derrida's placing or spacing of the hymen. In the context of the strange play of cultural memory and colonial desire in the Marabar caves, Derrida's words are uncannily resonant.

> It is neither desire nor pleasure but between the two. Neither future nor present, but between the two. It is the hymen that desire dreams of piercing, of bursting in an act of violence that is (at the same time or somewhere between) love and murder. If either one *did* take place, there would be no hymen. . . . It is an operation that *both* sows confusion *between* opposites *and* stands *between* the opposites 'at once'.[15]

It is an undecidability that arises from a certain culturalist substitution that Derrida describes as anti-ethnocentrism thinking itself as ethnocentrism while 'silently imposing its standard concepts of speech and writing.'[16]

II

In the epistemological language of cultural description, the object of culture comes to be inscribed in a process that Richard Rorty describes as that confusion between justification and explanation, the priority of knowledge 'of' over knowledge 'that': the priority of the visual relation between persons and objects above the justificatory, textual relationship between propositions. It is precisely such a priority of eye over inscription, or Voice over writing, that insists on the 'image' of knowledge as confrontation between the self and the object of belief seen through the mirror of Nature. Such an epistemological visibility disavows the metonymy of the colonial moment, because its narrative of ambivalent, hybrid, cultural knowledges – neither 'one' nor 'other' – is ethnocentrically elided in the search for

cultural commensurability, as Rorty describes it: 'to be rational is to find the proper set of terms into which all contributions should be translated if agreement is to become possible.'[17] And such agreement leads inevitably to a transparency of culture that must be thought outside of the signification of difference; what Ernest Gellner has simplistically resolved in his recent work on relativism, as the diversity of man in a unitary world. A world which, if read as 'word' in the following passage, illustrates the impossibility of signifying, within its evaluative language, the values of anteriority and alterity that haunt the colonial non-sense.

Gellner writes:

> Assume the regularity of nature, the systematic nature of the world, not because it is demonstrable, but because anything which eludes such a principle also eludes real knowledge; if cumulative and communicable knowledge is to be possible at all, then the principle of orderliness must apply to it. . . . Unsymmetrical, idiosyncratic explanations are worthless – they are not explanations.[18]

It is the horizon of holism, towards which cultural authority aspires, that is made ambivalent in the colonial signifier. To put it succinctly, it turns the dialectical 'between' of culture's disciplinary structure – *between* unconscious and conscious motives, *between* little indigenous categories and conscious rationalizations, *between* little acts and grand traditions, in James Boon's[19] words – into something closer to Derrida's '*entre*', that sows confusion between opposites and stands between the oppositions at once. The colonial signifier – neither one nor other – is, however, an act of ambivalent signification, literally splitting the difference between the binary oppositions or polarities through which we think cultural difference. It is in the enunciatory act of splitting that the colonial signifier creates its strategies of

differentiation that produce an undecidability between contraries or oppositions.

Marshall Sahlins's 'symbolic synapses'[20] produce homologous differentiations in the conjunction of oppositions from different cultural planes. James Boon's cultural operators produce the *Traviata* effect – when Amato del Passato turns into the sublime duet Grandio – as a moment that recalls, in his words, the genesis of signification. It is a moment that matches the right phones to the language system, producing from different orders or oppositions a burst of cross-referencing significance in the 'on-going' cultural performance. In both these influential theories of the culture-concept, cultural generalizability is effective to the extent to which differentiation is homologous, the genesis of signification recalled in the performance of cross-referencing.

What I have suggested above, for the colonial cultural signifier, is precisely the radical loss of such a homologous or dialectical assemblage of part and whole, metaphor and metonymy. Instead of cross-referencing there is an effective, productive cross-cutting across sites of social significance, that erases the dialectical, disciplinary sense of cultural reference and relevance. It is in this sense that the culturally unassimilable words and scenes of nonsense, with which I started – the Horror, the Horror, the owl's deathcall, the Marabar caves – suture the colonial text in a hybrid time and truth that survives and subverts the generalizations of literature and history. It is to the ambivalence of the on-going colonial present, and its contradictory articulations of power and cultural knowledge, that I now want to turn.

III

The enunciatory ambivalence of colonial culture cannot, of course, be derived directly from the 'temporal pulsation' of the signifier; the rule of empire must not be allegorized in the misrule of writing. There is, however, a mode of enunciation that

echoes through the annals of nineteenth-century Indian colonial history where a strange discursive figure of undecidability arises within cultural authority, between the knowledge of culture and the custom of power. It is a negation of the traviata moment; it is a moment when the impossibility of naming the difference of colonial culture alienates, in its very form of articulation, the colonialist cultural ideals of progress, piety, rationality and order.

It is heard in the central paradox of missionary education and conversation, in Alexander Duff's monumental *India and India Missions* (1839): 'Do not send men of compassion here for you will soon break their hearts; do send men of compassion here, where millions perish for lack of knowledge.'[21] It can be heard in the aporetic moment of Sir Henry Maine's Rede Lecture (1875) and is repeated again in his contribution to Humphry Ward's definitive commemorative volume on the reign of Queen Victoria:

> As has been truly said, the British rulers of India are like men bound to keep true time in two longitudes at once. Nevertheless, the paradoxical position must be accepted in the most extraordinary experiment, the British Government of India, the virtually despotic government of a dependency by a free people.[22]

The paradox is finally fully exposed in Fitzjames Stephen's important essay on 'The foundations of the government of India', in his opposition to the Ibert Bill – an opportunity which he uses to attack the utilitarian and liberal governance of India.

> A barrel of gunpowder may be harmless or may explode, but you cannot educate it into household fuel by exploding little bits of it. How can you possibly teach great masses of people that they ought to be rather dissatisfied with a foreign ruler, but

not much; that they should express their discontent in words and in votes, but not in acts; that they should ask from him this and that reform (which they neither understand nor care for), but should on no account rise in insurrection against him.[23]

These statements must not be dismissed as imperialism's doublethink; it is, in fact, their desperate acknowledgement of an aporia in the inscription of empire that makes them notable. It is their performance of a certain uncertain writing in the anomalous discourse of the 'present' of colonial governmentality that is of interest to me. And not to me alone. For these enunciations represent what I take to be that split-second, that ambivalent temporality that demonstrates the turn from evolutionism to diffusionism in the culturalist discourse of colonial governmentality; an ambiguity that articulated the otherwise opposed policies of the utilitarians and comparativists in the mid-nineteenth-century debate on colonial cultural 'progress' and policy. According to John Burrow, such an ambivalence was signally representative of cultural governance, for, as he writes in *Evolution and Society*

when [they] want to emphasise the fact of continuity, the similarity between barbaric institutions and those of the European past, or even present, they speak in an evolutionary manner. But almost equally often they speak in terms of a straight dichotomy: status and contract, progressive and non-progressive, barbarous and civilized.[24]

In these gnomic, yet crucial, historical utterances, are displayed the margins of the disciplinary idea of culture enacted in the colonial scene: British/India, Nostromo, ouboum – each cultural naming represents the impossibility of cross-cultural identity or symbolic synapses; each time there repeats the incompletion of translation. It is such a figure of doubt that

haunts Henry Maine's naming of India: in his essay on the 'Observation of India', India is a figure of profound intellectual uncertainty and governmental ambivalence.

If India is a reproduction of the common Aryan origin, in Maine's discourse it is also a perpetual repetition of that origin as a remnant of the past; if that remnant of India is the symbol of an archaic past, it is also the signifier of the production of a discursive past-in-the-present; if India is the imminent object of classical, theoretical knowledge, India is also the sign of its dispersal in the exercise of power; if India is the metaphoric equivalence, authorizing the appropriation and naturalization of other cultures, then India is also the repetitive process of metonymy recognized only in its remnants that are, at once, the signs of disturbance and the supports of colonial authority. If India is the originary symbol of colonial authority, it is the sign of a dispersal in the articulation of authoritative knowledge; if India is a runic reality, India is also the ruin of time; if India is the seed of life, India is a monument to death. India is the perpetual generation of a past-present which is the disturbing, uncertain time of the colonial intervention and the ambivalent truth of its enunciation.

These moments of undecidability must not be seen merely as contradictions in the idea or ideology of empire. They do not effect a symptomatic repression of domination or desire that will eventually either be sublated or will endlessly circulate in the dereliction of an identificatory narrative. Such enunciations of culture's colonial difference are closer in spirit to what Foucault has sketchily, but suggestively, described as the material repeatability of the statement. As I understand the concept – and this is my tendentious reconstruction – it is an insistence on the *surface of emergence* as it structures the present of its enunciation: the historical caught outside the hermeneutic of historicism; meaning grasped not in relation to some un-said or polysemy, but in its production of an *authority to differentiate*. The meaning of the

statement is neither symptomatic nor allegorical. It is a status of the subject's authority, a performative present in which the statement becomes both appropriate and an object of appropriation; repeatable, reasonable, an instrument of desire, the elements of a strategy. Such a strategic repetition at the enunciative level requires neither simply formal analysis nor semantic investigation nor verification but, and I quote, 'the analysis of the relations between the statement and the spaces of differentiation, in which the statement itself reveals the differences.'[25] Repeatability, in my terms, is always the repetition in the very act of enunciation, something other, a difference that is a little bit uncanny, as Foucault comes to define the representability of the statement: 'Perhaps it is like the over-familiar that constantly eludes one', he writes, like 'those famous transparencies which, although they conceal nothing in their density, are nevertheless not entirely clear. The enunciative level emerges in its very proximity.'[26]

If at first sight the statements by Duff, Maine and Fitzjames Stephen are the uncommon commonplaces of colonial or imperial history, then, doubly inscribed, their difference emerges quite clearly between-the-lines; the temporal in-between of Maine's past-present that will only name India as a mode of discursive uncertainty. From the impossibility of keeping true time in two longitudes and the inner incompatibility of empire and nation in the anomalous discourse of cultural progressivism, emerges an ambivalence that is neither the contestation of contradictories nor the antagonism of dialectical opposition. In these instances of social and discursive alienation there is no recognition of master and slave, there is only the matter of the enslaved master, the unmastered slave.

What is articulated in the enunciation of the colonial present – in-between the lines – is a splitting of the discourse of cultural governmentality at the moment of its enunciation of authority. It is, according to Frantz Fanon, a 'Manichaean' moment that

divides the colonial space: a Manichaean division, two zones that are opposed but not in the service of a 'higher unity'.[27] Fanon's Manichaean metaphors resonate with something of the discursive and affective ambivalence that I have attributed to the archaic nonsense of colonial cultural articulation, as it emerges with its significatory edge, to disturb the disciplinary languages and logics of the culture-concept itself. 'The symbols of the social – the police, the bugle calls in the barracks, military parades and the waving flags – are at one and the same time inhibitory and stimulating: "Don't dare to budge. . . . Get ready to attack".'[28] If Fanon sets the scene of splitting around the uncanny and traumatic fetishes of colonial power, then Freud, in describing the social circumstances of splitting in his essay on 'Fetishism', echoes the political anxiety of my examples of colonial nonsense. 'A grown man', Freud writes, 'may experience a similar panic when the cry goes up that throne and Altar are in danger, and similar *illogical consequences* will ensue.'[29]

Splitting constitutes an intricate strategy of defence and differentiation in the colonial discourse. Two contradictory and independent attitudes inhabit the *same place*, one takes account of reality, the other is under the influence of instincts which detach the ego from reality. This results in the production of multiple and contradictory belief. The enunciatory moment of multiple belief is both a defence against the anxiety of difference, and itself *productive* of differentiations. Splitting is then a form of enunciatory, intellectual uncertainty and anxiety that stems from the fact that disavowal is not merely a principle of negation or elision; it is a strategy for articulating contradictory and coeval statements of belief. It is from such an enunciatory space, where the work of signification *voids* the act of meaning in articulating a split-response – 'Ouboum', 'true time in two longitudes' – that my texts of colonial nonsense and imperial aporia have to negotiate their discursive authority.

Ambivalence, at the point of disavowal (*Verleugnung*), Freud

describes as the vicissitude of the idea, as distinct from the vicissitude of affect, repression (*Verdrängung*). It is crucial to understand – and not often noted – that the process of disavowal, even as it negates the visibility of difference, produces a strategy for the negotiation of the knowledges of differentiation. These knowledges make sense of the trauma and substitute for the absence of visibility. It is precisely such a vicissitude of the idea of culture in its colonial enunciation, culture articulated at the point of its erasure, that makes a non-sense of the disciplinary meanings of culture itself. A colonial non-sense, however, that is productive of powerful, if ambivalent, strategies of cultural authority and resistance.

There occurs, then, what we may describe as the 'normalizing' strategy of discursive splitting, a certain anomalous containment of cultural ambivalence. It is visible in Fitzjames Stephen's attack on the undecidability of liberal and utilitarian colonial governance. What structures his statement is the threatening production of uncertainty that haunts the discursive subject and taunts the enlightened liberal subject of culture itself. But the threat of meaninglessness, the reversion to chaos, is required to maintain the vigilance towards Throne and Altar; to reinforce the belligerence of British civilization, which if it is to be authoritative, Fitzjames Stephen writes, must not shirk from the open, uncompromising, straightforward assertion of the anomaly of the British government of India. This insoluble anomaly preoccupied enlightened opinion throughout the nineteenth century; in Mill's words: 'the government of a people by itself has a meaning and a reality; but such a thing as government of one people by another does not and cannot exist.'[30] The open assertion of the anomalous produces an impossible cultural choice: civilization or the threat of chaos – either one or the other – whereas the discursive choice continually requires both and the practice of power is imaged, anomalously yet again, as 'the virtually despotic government of

a dependency by a free people' – once more neither one nor the other.

IV

If this mistranslation of democratic power repeats the 'anomaly' of colonial authority – the colonial space without a proper name – then Evangelical pedagogy in the 1830s turns the 'intellectual uncertainty', between the Bible and Hinduism, into an anomalous strategy of interpellation. With the institution of what was termed 'the intellectual system' in 1829, in the mission schools of Bengal, there developed a mode of instruction which set up – on our model of the splitting of colonial discourse – contradictory and independent textualities of Christian piety and heathen idolatry in order to elicit, between them, in an uncanny doubling, undecidability. It was an uncertainty between truth and falsehood whose avowed aim was conversion, but whose discursive and political strategy was the production of doubt; not simply a doubt in the content of beliefs, but a doubt, or an uncertainty in the native place of enunciation; at the point of the colonizer's demand for narrative, at the moment of the master's interrogation. This is Duft writing in 1835:

> When asked whether it is not an imperative ordinance of his faith that, during the great festival of Ramadan, everyone of the faithful should fast from sunrise to sunset – [the Mohammedan] unhesitatingly, and without qualification, admits that this is a command which dare not be broken – an act of contempt against Mohammed. . . . You then appeal to the indisputable geographical fact that in the Arctic and Antarctic regions, the period from sunrise to sunset annually extends to several months . . . either his religion was not designed to be universal, therefore not Divine, or he who framed the Koran was unacquainted with the geographical fact . . . and therefore

an ignorant imposter. So galled does the Mohammedan feel
... that he usually cuts the Gordian Knot by boldly denying the
geographical fact ... and many, many are the glosses and
ingenious subterfuges to which he feels himself impelled to
resort.[31]

The Brahmans treat with equal contempt, not only the dem-
onstrations of modern science but 'the very testimony of their
eyes'. The avowed aim of this systematic mistranslation, of 'this
drawing from the metaphysics of the Koran its physical dog-
mata' is to institutionalize a narrative of 'verisimilitude of the
whole statement' for in Duff's words, 'no sooner was the iden-
tity of the two sets of phenomena announced as a fact, than the
truth of the given theory was conceded.' The normalizing strat-
egy is, however, a form of subjection that requires precisely the
anomalous enunciation – the archaic nonsense of the banal mis-
reading of mythology as geographical fact – so that, as Duff
writes, 'there was a sort of silent warfare incessantly maintained
... self-exploding engines that lurked unseen and unsuspected. -
... When the wound was once inflicted, honourable retreat for
the native was impossible.'[32]

The aim is the separation of the heathen soul from the subter-
fuge of its 'subtile system'. The strategy of splitting is the pro-
duction of a space of contradictory and multiple belief, even
more sly and subtle, between Evangelical verisimilitude and the
poetry of the Vedas or the Koran. A strategic space of enunciation
is produced – neither the one nor the other – whose truth is to
place the native in that moment of enunciation which both
Benveniste and Lacan describe, where to say 'I am lying' is
strangely to tell the truth or vice versa. Who, in truth, is
addressed in the verisimilitude of such translation, which must
be a mistranslation? In that subtle warfare of colonial discourse
lurks the fear that in speaking in two tongues, language itself
becomes doubly inscribed and the intellectual system uncertain.

The colonizer's interrogation becomes anomalous, 'for every term which the Christian missionary can employ to communicate divine truth is already appropriated as the chosen symbol of some counterpart deadly error.'[33] If the word of the master is already appropriated and the word of the slave is undecidable, where does the truth of colonial nonsense lie?

Underlying the intellectual uncertainty generated by the anomaly of cultural difference is a question of the displacement of truth that is at once between and beyond the hybridity of images of governance, or the undecidability between codes and texts, or indeed the impossibility of Sir Henry Maine's colonial problematic: the attempt to keep true time in two longitudes, at once. It is a displacement of truth in the very identification of culture, or an uncertainty in the structure of 'culture' as the identification of a certain discursive human truth. A truth of the human which is culture's home; a truth which 'differentiates' cultures, affirms its human significance, the authority of its address. When the Mohammedan is forced to deny the logical demonstration of geographical fact and the Hindu turns away from the evidence of his eyes, we witness a form of ambivalence, a mode of enunciation, a coercion of the native subject in which no truth can exist. It is not simply a question of the absence of rationality or morality: it leads through such historical and philosophical distinctions of cultural differences, to rest in that precariously empty discursive space where the question of the human capacity of culture lies. To put it a little grandly, the problem now is of the question of culture itself as it comes to be represented and contested in the colonial imitation – not identity – of man. As before, the question occurs in culture's archaic undecidability.

On the eve of Durgapuja in the mid-1820s, the Reverend Duff walks through the quarter of Calcutta where the image-makers are at work. A million images of the goddess Durga affront his eyes; a million hammers beating brass and tin assault his ears; a

million dismembered Durgas, eyes, arms, heads, some unpainted, others unformed, assail him as he turns to reverie:

> The recollections of the past strangely blend with the visible exhibitions of the present. The old settled convictions of home experience are suddenly counterpoised by the previously unimagined scene. To incline [your quivering judgement] in one way or other, to determine the 'dubious propendency' you again and again watch the movements of those before you. You contemplate their form and you cannot doubt that they are men. . . . Your wonder is vastly increased; but the grounds of your decision have multiplied too.[34]

My final argument interrogates, from the colonial perspective, this cultural compulsion to 'be, become, or be seen to be human'.[35] It is a problem caught in the vacillatory syntax of the entire passage; heard finally in the 'cannot' in 'you cannot doubt that they are men.' I will suggest that the coercive image of the colonized subject produces a loss or lack of truth that articulates an uncanny truth about colonialist cultural authority and its figurative space of the human. The infinite variety of man fades into insignificance when, in the moment of the discursive splitting, it oversignifies; it says something beside the point, something beside the truth of culture, something *abseits*. A meaning that is culturally alien not because it is spoken in many tongues but because the colonial compulsion to truth is always an effect of what Derrida has called the babelian performance, in the act of translation, as a figurative transference of meaning across language systems. I quote from Derrida:

> When God imposes and opposes his name he ruptures the rational transparency but interrupts also the . . . linguistic imperialism. He destines them to the law of translation both necessary and impossible . . . forbidden transparency,

> impossible univocity. Translation becomes law, duty and debt,
> but the debt one can no longer discharge.[36]

It is a performance of truth or the lack of it that, in translation, impedes the dialectical process of cultural generality and communicability. In its stead, where there is the threat of over-interpretation, there can be no ethically or epistemologically commensurate subject of culture. There is, in fact, the survival across culture of a certain interesting, even insurgent, madness that subverts the authority of culture in its 'human' form. It will hardly surprise you then, at this juncture, if having glimpsed the problem in those dismembered images of the goddess Durga, I now turn to that other living doll, Olympia, from Hoffmann's *The Sandman*, on which Freud bases his essay on 'The "uncanny" ', to explicate this strategy of cultural splitting: human/non-human; society/ouboum.

In keeping with our taste for contraries, I suggest that we read the fable of the Double uncannily, in-between Freud's analytic distinctions between 'intellectual uncertainty' and 'castration', between 'surmounting' and 'repression'. Such doubts bedevil the essay to the point at which Freud half-suggests an analytic distinction between 'repression proper' as appropriate to psychical reality, and 'surmounting' – which extends the term repression beyond its legitimate meaning – as more appropriate to the repressive workings of the cultural unconscious.[37] It is through Freud's own 'intellectual uncertainity', at the point of his exposition of psychic ambivalence that, I believe, the cultural argument of the uncanny double emerges.

The figure of Olympia stands between the human and the automaton, between manners and mechanical reproduction, embodying an aporia: a living doll. Through Durga and Olympia, the ghostly magical spirit of the double embraces, at one time or another, my entire colonial concert party: Marlow, Kurtz, Adela, Aziz, Nostromo, Duff, Maine, the owl, the Marabar caves,

Derrida, Foucault, Freud, master and slave alike. All these comedians of culture's 'non-sense' have stood, for a brief moment, in that undecidable enunciatory space where culture's authority is undone in colonial power – they have taught culture's double lesson. For the uncanny lesson of the double, as a problem of intellectual uncertainty, lies precisely in its double-inscription. The authority of culture, in the modern *epistēmē*, requires at once imitation and identification. Culture is *heimlich*, with its disciplinary generalizations, its mimetic narratives, its homologous empty time, its seriality, its progress, its customs and coherence. But cultural authority is also *unheimlich*, for to be distinctive, significatory, influential and identifiable, it has to be translated, disseminated, differentiated, interdisciplinary, intertextual, international, inter-racial.

In-between these two plays the time of a colonial paradox in those contradictory statements of subordinate power. For the repetition of the 'same' can in fact be its own displacement, can turn the authority of culture into its own non-sense precisely in its moment of enunciation. For, in the psychoanalytic sense, to 'imitate' is to cling to the denial of the ego's limitations; to 'identify' is to assimilate conflictually. It is from between them, where the letter of the law will not be assigned as a sign, that culture's double returns uncannily – neither the one nor the other, but the imposter – to mock and mimic, to lose the sense of the masterful self and its social sovereignty. It is at this moment of intellectual and psychic 'uncertainty' that representation can no longer guarantee the authority of culture; and culture can no longer guarantee to author its 'human' subjects as the signs of humanness. Freud neglected the cultural uncanny but Hoffmann was far more canny.

If I started with colonial nonsense, I want to end with metropolitan bourgeois burlesque. I quote from Hoffmann's *The Sandman*, a passage Freud failed to note.

> The history of the automaton had sunk deeply into their souls, and an absurd mistrust of human figures began to prevail. Several lovers, in order to be fully convinced that they were not paying court to a wooden puppet required that their mistress should sing and dance a little out of time, should embroider or knit or play with her little pug etc. when being read to, but above all things else that she should frequently speak in such a way as to really show that her words presupposed as a condition some thinking and feeling. . . . Spalanzani was obliged, as has been said, to leave the place in order to escape a criminal charge of having fraudulently imposed an automaton upon human society.[38]

We are now almost face to face with culture's double bind – a certain slippage or splitting between human artifice and culture's discursive agency. To be true to a self one must learn to be a little untrue, out-of-joint with the signification of cultural generalizability. As Hoffmann suggests, sing a little out of tune; just fail to hit that top E in James Boon's *Aida* effect; speak in such a way to show that words presuppose feeling, which is to assume that a certain nonsense always haunts and hinders them. But how untrue must you be to fail to be happily, if haphazardly human? That is the colonial question; that, I believe, is where the truth lies – as always a little beside the point.

Native 'folly' emerged as a quasi-legal, cultural category soon after the establishment of the Supreme Court in Calcutta in the 1830s, almost as the uncanny double of the demand for verisimilitude and testimony – the establishment of the Law. Folly is a form of perjury for which Halhed assures us, in his preface to the *Code of Gentoo Laws*, no European form of words exists. To our delight and horror, however, we find that its structure repeats that enunciatory splitting that I have been attempting to describe. It consists, Halhed writes,

in falsehoods totally incompatible with each other and utterly
contrary to their own opinion, knowledge and conviction. . . . It
is like the madness so inimitably delineated in Cervantes,
sensible enough upon some occasions and at the same time
completely wild and unconscious of itself.[39]

Despite adequate contemporary juridical and sociological
explanations for perjury, the myth of the lie persists in the pages
of power, even down to District Officers' reports in the 1920s.
What is the truth of the lie?

When the Muslim is coerced into speaking a Christian truth
he denies the logic of his senses; the Hindu denies the evidence
of his eyes; the Bengalee denies his very name as he perjures
himself. Or so we are told. Each time what comes to be textual-
ized as the truth of the native culture is a part that becomes
ambivalently incorporated in the archives of colonial know-
ledge. A part like the geographical detail that is specious and
beside the point. A part like 'folly' that is untranslatable,
inexplicable, unknowable yet endlessly repeated in the name of
the native. What emerges in these lies that never speak the
'whole' truth, come to be circulated from mouth to mouth,
book to book, is the institutionalization of a very specific
discursive form of paranoia, that must be authorized at the point
of its dismemberment. It is a form of persecutory paranoia that
emerges from cultures' own structured demand for imitation
and identification. It is the archaic survival of the 'text' of cul-
ture, that is the demand and desire of its translations, never the
mere authority of its originality. Its strategy, as Karl Abrahams
has described it, is a partial incorporation; a form of incorpor-
ation that deprives the object of a part of its body in that its
integrity may be attacked without destroying its existence. 'We
are put in mind of a child,' the psychoanalyst Karl Abraham
writes, 'who catches a fly and having pulled off a leg, lets it go
again.'[40] The existence of the disabled native is required for the

next lie and the next and the next – 'The Horror! the Horror!' Marlow, you will remember, had to lie as he moved from the heart of darkness to the Belgian boudoir. As he replaces the words of horror for the name of the Intended we read in that palimpsest, neither one nor the other, something of the awkward, ambivalent, unwelcome truth of empire's lie.

8

DISSEMINATION

Time, narrative and the margins of the modern nation[1]

THE TIME OF THE NATION

The title of this chapter – DissemiNation – owes something to the wit and wisdom of Jacques Derrida, but something more to my own experience of migration. I have lived that moment of the scattering of the people that in other times and other places, in the nations of others, becomes a time of gathering. Gatherings of exiles and *émigrés* and refugees; gathering on the edge of 'foreign' cultures; gathering at the frontiers; gatherings in the ghettos or cafés of city centres; gathering in the half-life, half-light of foreign tongues, or in the uncanny fluency of another's language; gathering the signs of approval and acceptance, degrees, discourses, disciplines; gathering the memories of underdevelopment, of other worlds lived retroactively; gathering the past in a ritual of revival; gathering the present. Also the

gathering of people in the diaspora: indentured, migrant, interned; the gathering of incriminatory statistics, educational performance, legal statutes, immigration status – the genealogy of that lonely figure that John Berger named the seventh man. The gathering of clouds from which the Palestinian poet Mahmoud Darwish asks 'where should the birds fly after the last sky?'[2]

In the midst of these lonely gatherings of the scattered people, their myths and fantasies and experiences, there emerges a historical fact of singular importance. More deliberately than any other general historian, Eric Hobsbawm[3] writes the history of the modern Western nation from the perspective of the nation's margin and the migrants' exile. The emergence of the later phase of the modern nation, from the mid-nineteenth century, is also one of the most sustained periods of mass migration within the West, and colonial expansion in the East. The nation fills the void left in the uprooting of communities and kin, and turns that loss into the language of metaphor. Metaphor, as the etymology of the word suggests, transfers the meaning of home and belonging, across the 'middle passage', or the central European steppes, across those distances, and cultural differences, that span the imagined community of the nation-people.

The discourse of nationalism is not my main concern. In some ways it is the historical certainty and settled nature of that term against which I am attempting to write of the Western nation as an obscure and ubiquitous form of living the *locality* of culture. This locality is more *around* temporality than *about* historicity: a form of living that is more complex than 'community'; more symbolic than 'society'; more connotative than 'country'; less patriotic than *patrie*; more rhetorical than the reason of State; more mythological than ideology; less homogeneous than hegemony; less centred than the citizen; more collective than 'the subject'; more psychic than civility; more hybrid in the articulation of cultural differences and identifications than can

be represented in any hierarchical or binary structuring of social antagonism.

In proposing this cultural construction of nationness as a form of social and textual affiliation, I do not wish to deny these categories their specific histories and particular meanings within different political languages. What I am attempting to formulate in this chapter are the complex strategies of cultural identification and discursive address that function in the name of 'the people' or 'the nation' and make them the immanent subjects of a range of social and literary narratives. My emphasis on the temporal dimension in the inscription of these political entities – that are also potent symbolic and affective sources of cultural identity – serves to displace the historicism that has dominated discussions of the nation as a cultural force. The linear equivalence of event and idea that historicism proposes, most commonly signifies a people, a nation, or a national culture as an empirical sociological category or a holistic cultural entity. However, the narrative and psychological force that nationness brings to bear on cultural production and political projection is the effect of the ambivalence of the 'nation' as a narrative strategy. As an apparatus of symbolic power, it produces a continual slippage of categories, like sexuality, class affiliation, territorial paranoia, or 'cultural difference' in the act of writing the nation. What is displayed in this displacement and repetition of terms is the nation as the measure of the liminality of cultural modernity.

Edward Said aspires to such secular interpretation in his concept of 'wordliness' where 'sensuous particularity as well as historical contingency . . . exist *at the same level of surface particularity* as the textual object itself' (my emphasis).[4] Fredric Jameson invokes something similar in his notion of 'situational consciousness' or national allegory, 'where the telling of the individual story and the individual experience cannot but ultimately involve the whole laborious telling of the collectivity itself.'[5] And Julia Kristeva speaks perhaps too hastily of the pleasure of

exile – 'How can one avoid sinking into the mire of common sense, if not by becoming a stranger to one's own country, language, sex and identity?'[6] – without realizing how fully the shadow of the nation falls on the condition of exile – which may partly explain her own later, labile identifications with the images of other nations: 'China', 'America'. The entitlement of the nation is its metaphor: *Amor Patria; Fatherland; Pig Earth; Mother-tongue; Matigari; Middlemarch; Midnight's Children; One Hundred Years of Solitude; War and Peace; I Promessi Sposi; Kanthapura; Moby-Dick; The Magic Mountain; Things Fall Apart.*

There must be a tribe of interpreters of such metaphors – the translators of the dissemination of texts and discourses across cultures – who can perform what Said describes as the act of secular interpretation.

> To take account of this horizontal, secular space of the crowded spectacle of the modern nation ... implies that no single explanation sending one back immediately to a single origin is adequate. And just as there are no simple dynastic answers, there are no simple discrete formations or social processes.[7]

If, in our travelling theory, we are alive to the metaphoricity of the peoples of imagined communities – migrant or metropolitan – then we shall find that the space of the modern nation-people is never simply horizontal. Their metaphoric movement requires a kind of 'doubleness' in writing; a temporality of representation that moves between cultural formations and social processes without a centred causal logic. And such cultural movements disperse the homogeneous, visual time of the horizontal society. The secular language of interpretation needs to go beyond the horizontal critical gaze if we are to give 'the nonsequential energy of lived historical memory and subjectivity' its appropriate narrative authority. We need another time of writing that will be able to inscribe the ambivalent and chiasmatic intersections

of time and place that constitute the problematic 'modern' experience of the Western nation.

How does one write the nation's modernity as the event of the everyday and the advent of the epochal? The language of national belonging comes laden with atavistic apologues, which has led Benedict Anderson to ask: 'But why do nations celebrate their hoariness, not their astonishing youth?'[8] The nation's claim to modernity, as an autonomous or sovereign form of political rationality, is particularly questionable if, with Partha Chatterjee, we adopt the postcolonial perspective:

> Nationalism . . . seeks to represent itself in the image of the Englightenment and fails to do so. For Enlightenment itself, to assert its sovereignty as the universal ideal, needs its Other; if it could ever actualise itself in the real world as the truly universal, it would in fact destroy itself.[9]

Such ideological ambivalence nicely supports Gellner's paradoxical point that the historical necessity of the idea of the nation conflicts with the contingent and arbitrary signs and symbols that signify the affective life of the national culture. The nation may exemplify modern social cohesion but

> Nationalism is not what it seems, and *above all not what it seems to itself.* . . . The cultural shreds and patches used by nationalism are often arbitrary historical inventions. Any old shred would have served as well. But in no way does it follow that the principle of nationalism . . . is itself in the least contingent and accidental.[10] (My emphasis)

The problematic boundaries of modernity are enacted in these ambivalent temporalities of the nation-space. The language of culture and community is poised on the fissures of the present becoming the rhetorical figures of a national past. Historians

transfixed on the event and origins of the nation never ask, and political theorists possessed of the 'modern' totalities of the nation – 'homogeneity, literacy and anonymity are the key traits'[11] – never pose, the essential question of the representation of the nation as a temporal process.

It is indeed only in the disjunctive time of the nation's modernity – as a knowledge caught between political rationality and its impasse, between the shreds and patches of cultural signification and the certainties of a nationalist pedagogy – that questions of nation as narration come to be posed. How do we plot the narrative of the nation that must mediate between the teleology of progress tipping over into the 'timeless' discourse of irrationality? How do we understand that 'homogeneity' of modernity – the people – which, if pushed too far, may assume something resembling the archaic body of the despotic or totalitarian mass? In the midst of progress and modernity, the language of ambivalence reveals a politics 'without duration', as Althusser once provocatively wrote: 'Space without places, time without duration.'[12] To write the story of the nation demands that we articulate that archaic ambivalence that informs the time of modernity. We may begin by questioning that progressive metaphor of modern social cohesion – the many as one – shared by organic theories of the holism of culture and community, and by theorists who treat gender, class or race as social totalities that are expressive of unitary collective experiences.

Out of many one: nowhere has this founding dictum of the political society of the modern nation – its spatial expression of a unitary people – found a more intriguing image of itself than in those diverse languages of literary criticism that seek to portray the great power of the idea of the nation in the disclosures of its everyday life; in the telling details that emerge as metaphors for national life. I am reminded of Bakhtin's wonderful description of a national vision of emergence in Goethe's Italian Journey, which represents the triumph of the Realistic component over the

Romantic. Goethe's realist narrative produces a national-historical time that makes visible a specifically Italian day in the detail of its passing time: 'The bells ring, the rosary is said, the maid enters the room with a lighted lamp and says: *Felicissima notte! . . . If one were to force a German clockhand on them, they would be at a loss.*'[13] For Bakhtin, it is Goethe's vision of the microscopic, elementary, perhaps random, tolling of everyday life in Italy that reveals the profound history of its locality (*Lokalität*), the spatialization of historical time, 'a creative humanization of this locality, which transforms a part of terrestrial space into a place of historical life for people'.[14]

The recurrent metaphor of landscape as the inscape of national identity emphasizes the quality of light, the question of social visibility, the power of the eye to naturalize the rhetoric of national affiliation and its forms of collective expression. There is, however, always the distracting presence of another temporality that disturbs the contemporaneity of the national present, as we saw in the national discourses with which I began. Despite Bakhtin's emphasis on the realist vision in the emergence of the nation in Goethe's work, he acknowledges that the origin of the nation's visual *presence* is the effect of a narrative struggle. From the beginning, Bakhtin writes, the Realist and Romantic conceptions of time coexist in Goethe's work, but the ghostly (*Gespenstermässiges*), the terrifying (*Unerfreuliches*), and the unaccountable (*Unzuberechnendes*) are consistently surmounted by the structuring process of the visualization of time: 'the necessity of the past and the necessity of its place in a line of continuous development . . . finally the aspect of the past being linked to the necessary future'.[15] National time becomes concrete and visible in the chronotype of the local, particular, graphic, from beginning to end. The narrative structure of this historical surmounting of the 'ghostly' or the 'double' is seen in the intensification of narrative synchrony as a graphically visible position in space: 'to grasp the most elusive course of pure

historical time and fix it through unmediated contempla-
tion'.[16] But what kind of 'present' is this if it is a consistent
process of surmounting the ghostly time of repetition? Can
this national time–space be as fixed or as immediately visible as
Bakhtin claims?

If in Bakhtin's 'surmounting' we hear the echo of another use
of that word by Freud in his essay on 'The "uncanny" ', then we
begin to get a sense of the complex time of the national narra-
tive. Freud associates surmounting with the repressions of a 'cul-
tural' unconscious; a liminal, uncertain state of cultural belief
when the archaic emerges in the midst of margins of modernity
as a result of some psychic ambivalence or intellectual
uncertainty. The 'double' is the figure most frequently associated
with this uncanny process of 'the doubling, dividing and inter-
changing of the self'.[17] Such 'double-time' cannot be so simply
represented as visible or flexible in 'unmediated contemplation';
nor can we accept Bakhtin's repeated attempt to read the
national space as achieved only in the fullness of time. Such an
apprehension of the 'double and split' time of national represen-
tation, as I am proposing, leads us to question the homogeneous
and horizontal view associated with the nation's imagined
community. We are led to ask whether the emergence of a national
perspective – of an élite or subaltern nature – within a culture of
social contestation, can ever articulate its 'representative' author-
ity in that fullness of narrative time and visual synchrony of the
sign that Bakhtin proposes.

Two accounts of the emergence of national narratives seem to
support my suggestion. They represent the diametically opposed
world views of master and slave which, between them, account
for the major historical and philosophical dialectic of modern
times. I am thinking of John Barrell's[18] splendid analysis of the
rhetorical and perspectival status of the 'English gentleman'
within the social diversity of the eighteenth-century novel; and
of Houston Baker's innovative reading of the 'new national modes

of sounding, interpreting and speaking the Negro in the Harlem Renaissance'.[19]

In his concluding essay Barrell demonstrates how the demand for a holistic, representative vision of society could only be represented in a discourse that was *at the same time* obsessively fixed upon, and uncertain of, the boundaries of society, and the margins of the text. For instance, the hypostatized 'common language' which was the language of the gentleman whether he be Observer, Spectator, Rambler, 'Common to all by virtue of the fact that it manifested the peculiarities of none'[20] – was primarily defined through a process of negation – of regionalism, occupation, faculty – so that this centred vision of 'the gentleman' is so to speak 'a condition of empty potential, one who is imagined as being able to comprehend everything, and yet who may give no evidence of having comprehended anything.'[21]

A different note of liminality is struck in Baker's description of the 'radical maroonage' that structured the emergence of an insurgent Afro-American expressive culture in its expansive, 'national' phase. Baker's sense that the 'discursive project' of the Harlem Renaissance is modernist is based less on a strictly literary understanding of the term, and more on the agonistic enunciative conditions within which the Harlem Renaissance shaped its cultural practice. The transgressive, invasive structure of the black 'national' text, which thrives on rhetorical strategies of hybridity, deformation, masking, and inversion, is developed through an extended analogy with the guerilla warfare that became a way of life for the maroon communities of runaway slaves and fugitives who lived dangerously, and insubordinately, 'on the frontiers or margins of *all* American promise, profit and modes of production'.[22] From this liminal, minority position where, as Foucault would say, the relations of discourse are of the nature of warfare, the force of the people of an Afro-American nation emerge in the extended metaphor of maroonage. For 'warriors' read writers or even 'signs':

> these highly adaptable and mobile warriors took maximum advantage of local environments, striking and withdrawing with great rapidity, making extensive use of bushes to catch their adversaries in cross-fire, fighting only when and where they chose, depending on reliable intelligence networks among non-maroons (both slave and white settlers) and often communicating by horns.[23]

Both gentleman and slave, with different cultural means and to very different historical ends, demonstrate that forces of social authority and subversion or subalternity may emerge in displaced, even decentred strategies of signification. This does not prevent these positions from being effective in a political sense, although it does suggest that positions of authority may themselves be part of a process of ambivalent identification. Indeed the exercise of power may be both politically effective and psychically *affective* because the discursive liminality through which it is signified may provide greater scope for strategic manoeuvre and negotiation.

It is precisely in reading between these borderlines of the nation-space that we can see how the concept of the 'people' emerges within a range of discourses as a double narrative movement. The people are not simply historical events or parts of a patriotic body politic. They are also a complex rhetorical strategy of social reference: their claim to be representative provokes a crisis within the process of signification and discursive address. We then have a contested conceptual territory where the nation's people must be thought in double-time; the people are the historical 'objects' of a nationalist pedagogy, giving the discourse an authority that is based on the pre-given or constituted historical origin *in the past*; the people are also the 'subjects' of a process of signification that must erase any prior or originary presence of the nation-people to demonstrate the prodigious, living principles of the people as contemporaneity: as that sign

of the *present* through which national life is redeemed and iterated as a reproductive process.

The scraps, patches and rags of daily life must be repeatedly turned into the signs of a coherent national culture, while the very act of the narrative performance interpellates a growing circle of national subjects. In the production of the nation as narration there is a split between the continuist, accumulative temporality of the pedagogical, and the repetitious, recursive strategy of the performative. It is through this process of splitting that the conceptual ambivalence of modern society becomes the site of *writing the nation*.

THE SPACE OF THE PEOPLE

The tension between the pedagogical and the performative that I have identified in the narrative address of the nation, turns the reference to a 'people' – from whatever political or cultural position it is made – into a problem of knowledge that haunts the symbolic formation of modern social authority. The people are neither the beginning nor the end of the national narrative; they represent the cutting edge between the totalizing powers of the 'social' as homogeneous, consensual community, and the forces that signify the more specific address to contentious, unequal interests and identities within the population. The ambivalent signifying system of the nation-space participates in a more general genesis of ideology in modern societies that Claude Lefort has described. For him too it is 'enigma of language', at once internal and external to the speaking subject, that provides the most apt analogue for imagining the structure of ambivalence that constitutes modern social authority. I shall quote him at length, because his rich ability to represent the *movement* of political power *beyond* the binary division of the blindness of Ideology or the insight of the Idea, brings him to that liminal site of modern society

from which I have attempted to derive the narrative of the nation and its people.

> In Ideology the representation of the rule is split from the effective operation of it. . . . The rule is thus extracted from experience of language; it is circumscribed, made fully visible and assumed to govern the conditions of possibility of this experience. . . . The enigma of language – namely that it is both internal and external to the speaking subject, that there is an articulation of the self with others which marks the emergence of the self and which the self does not control – is concealed by the representation of a place 'outside' – language from which it could be generated. . . . We encounter the ambiguity of the representation as soon as the rule is stated; for its very exhibition undermines the power that the rule claims to introduce into practice. This exorbitant power must, in fact, be shown, and at the same time it must owe nothing to the movement which makes it appear. . . . To be true to its image, the rule must be abstracted from any question concerning its origin; thus it goes beyond the operations that it controls. . . . Only the authority of the master allows the contradiction to be concealed, but he is himself an object of representation; presented as possessor of the knowledge of the rule, he allows the contradiction to appear through himself.
>
> The ideological discourse that we are examining has no safety catch; it is rendered vulnerable by its attempt to make visible the place from which the social relation would be conceivable (both thinkable and creatable) by its inability to define this place without letting its contingency appear, without condemning itself to slide from one position to another, without hereby making apparent the instability of an order that it is intended to raise to the status of essence. . . . [The ideological] task of the implicit generalization of knowledge and the implicit homogenization of experience could fall apart in the face of the

> unbearable ordeal of the collapse of certainty, of the vacillation
> of representations of discourse and as a result of the splitting
> of the subject.[24]

How do we conceive of the 'splitting' of the national subject?
How do we articulate cultural differences within this vacillation
of ideology in which the national discourse also participates,
sliding ambivalently from one enunciatory position to another?
What are the forms of life struggling to be represented in that
unruly 'time' of national culture, which Bakhtin surmounts in
his reading of Goethe, Gellner associates with the rags and
patches of everyday life, Said describes as 'the non-sequential
energy of lived historical memory and subjectivity' and Lefort
re-presents as the inexorable *movement of signification* that both con-
stitutes the exorbitant image of power and deprives it of the
certainty and stability of centre or closure? What might be the
cultural and political effects of the liminality of the nation,
the margins of modernity, which come to be signified in the
narrative temporalities of splitting, ambivalence and vacillation?

Deprived of that unmediated visibility of historicism – 'look-
ing to the legitimacy of past generations as supplying cultural
autonomy'[25] – the nation turns from being the symbol of mod-
ernity into becoming the symptom of an ethnography of the
'contemporary' within modern culture. Such a shift in perspec-
tive emerges from an acknowledgement of the nation's inter-
rupted address articulated in the tension between signifying the
people as an a priori historical presence, a pedagogical object;
and the people constructed in the performance of narrative, its
enunciatory 'present' marked in the repetition and pulsation of
the national sign. The pedagogical founds its narrative authority
in a tradition of the people, described by Poulantzas[26] as a
moment of becoming designated by *itself*, encapsulated in a suc-
cession of historical moments that represents an eternity pro-
duced by self-generation. The performative intervenes in the

sovereignty of the nation's *self-generation* by casting a shadow *between* the people as 'image' and its signification as a differentiating sign of Self, distinct from the Other of the Outside.

In place of the polarity of a prefigurative self-generating nation 'in-itself' and extrinsic other nations, the performative introduces a temporality of the 'in-between'. The boundary that marks the nation's selfhood interrupts the self-generating time of national production and disrupts the signification of the people as homogeneous. The problem is not simply the 'selfhood' of the nation as opposed to the otherness of other nations. We are confronted with the nation split within itself, articulating the heterogeneity of its population. The barred Nation *It/Self*, alienated from its eternal self-generation, becomes a liminal signifying space that is *internally* marked by the discourses of minorities, the heterogeneous histories of contending peoples, antagonistic authorities and tense locations of cultural difference.

This double-writing or dissemi-*nation*, is not simply a theoretical exercise in the internal contradictions of the modern liberal nation. The structure of cultural liminality *within the nation* would be an essential precondition for deploying a concept such as Raymond Williams's crucial distinction between residual and emergent practices in oppositional cultures which require, he insists, a 'non-metaphysical, non-subjectivist' mode of explanation. The space of cultural signification that I have attempted to open up through the intervention of the performative, would meet this important precondition. The liminal figure of the nation-space would ensure that no political ideologies could claim transcendent or metaphysical authority for themselves. This is because the subject of cultural discourse – the agency of a people – is split in the discursive ambivalence that emerges in the contest of narrative authority between the pedagogical and the performative. This disjunctive temporality of the nation would provide the appropriate time-frame for representing

those residual and emergent meanings and practices that
Williams locates in the margins of the contemporary experience
of society. Their emergence depends upon a kind of social
ellipsis; their transformational power depends upon their being
historically displaced:

> But in certain areas, there will be in certain periods, practices
> and meanings which are not reached for. There will be areas of
> practice and meaning which, almost by definition from its own
> limited character, or in its profound deformation, the dominant
> culture is unable in any real terms to recognize.[27]

When Edward Said suggests that the question of the nation
should be put on the contemporary critical agenda as a hermen-
eutic of 'worldliness', he is fully aware that such a demand can
only now be made from the liminal and ambivalent boundaries
that articulate the signs of national culture, as 'zones of control or
of abandonment, or recollection *and* of forgetting, of force *or* of
dependence, of exclusiveness *or* of sharing' (my emphasis).[28]

Counter-narratives of the nation that continually evoke and
erase its totalizing boundaries – both actual and conceptual –
disturb those ideological manoeuvres through which 'imagined
communities' are given essentialist identities. For the political
unity of the nation consists in a continual displacement of the
anxiety of its irredeemably plural modern space – representing
the nation's modern territoriality is turned into the archaic, atav-
istic temporality of Traditionalism. The difference of space
returns as the Sameness of time, turning Territory into Tradition,
turning the People into One. The liminal point of this ideo-
logical displacement is the turning of the differentiated spatial
boundary, the 'outside', into the authenticating 'inward' time of
Tradition. Freud's concept of the 'narcissism of minor differ-
ences'[29] – reinterpreted for our purposes – provides a way of
undertanding how easily the boundary that secures the cohesive

limits of the Western nation may imperceptibly turn into a contentious *internal* liminality providing a place from which to speak both of, and as, the minority, the exilic, the marginal and the emergent.

Freud uses the analogy of feuds that prevail between communities with adjoining territories – the Spanish and the Portuguese, for instance – to illustrate the ambivalent identification of love and hate that binds a community together: 'it is always possible to bind together a considerable number of people in love, so long as there are other people left to receive the manifestation of their aggressiveness.'[30] The problem is, of course, that the ambivalent identifications of love and hate occupy the same psychic space; and paranoid projections 'outwards' return to haunt and split the place from which they are made. So long as a firm boundary is maintained between the territories, and the narcissistic wound is contained, the aggressivity will be projected on to the Other or the Outside. But what if, as I have argued, the people are the articulation of a doubling of the national address, an ambivalent *movement* between the discourses of pedagogy and the performative? What if, as Lefort argues, the subject of modern ideology is split between the iconic image of authority and the movement of the signifier that produces the image, so that the 'sign' of the social is condemned to slide ceaselessly from one position to another? It is in this space of liminality, in the 'unbearable ordeal of the collapse of certainty' that we encounter once again the narcissistic neuroses of the national discourse with which I began. The nation is no longer the sign of modernity under which cultural differences are homogenized in the 'horizontal' view of society. The nation reveals, in its ambivalent and vacillating representation, an ethnography of its own claim to being the norm of social contemporaneity.

The people turn *pagan* in that disseminatory act of social narrative that Lyotard defines, against the Platonic tradition, as the privileged pole of the narrated:

where the one doing the speaking speaks from the place of the referent. As narrator she is narrated as well. And in a way she is already told, and what she herself is *telling* will not undo that somewhere else she is *told*.[31] (My emphasis)

This narrative inversion or circulation – which is in the spirit of my splitting of the people – makes untenable any supremacist, or nationalist claims to cultural mastery, for the position of narrative control is neither monocular nor monologic. The subject is graspable only in the passage between telling/told, between 'here' and 'somewhere else', and in this double scene the very condition of cultural knowledge is the alienation of the subject.

The significance of this narrative splitting of the subject of identification is borne out in Lévi-Strauss's description of the ethnographic act.[32] The ethnographic demands that the observer himself is a part of his observation and this requires that the field of knowledge – the total social fact – must be appropriated from the outside like a thing, but like a thing which comprises within itself the subjective understanding of the indigenous. The transposition of this process into the language of the outsider's grasp – this entry into the area of the symbolic of representation/ signification – then makes the social fact 'three-dimensional'. For ethnography demands that the subject has to split itself into object and subject in the process of identifying its field of knowledge. The ethnographic object is constituted 'by dint of the subject's capacity for indefinite self-objectification (without ever quite abolishing itself as subject) for projecting outside itself ever-diminishing fragments of itself'.

Once the liminality of the nation-space is established, and its signifying difference is turned from the boundary 'outside' to its finitude 'within', the threat of cultural difference is no longer a problem of 'other' people. It becomes a question of otherness of the people-as-one. The national subject splits in the ethnographic perspective of culture's contemporaneity and provides

both a theoretical position and a narrative authority for marginal voices or minority discourse. They no longer need to address their strategies of opposition to a horizon of 'hegemony' that is envisaged as horizontal and homogeneous. The great contribution of Foucault's last published work is to suggest that people emerge in the modern state as a perpetual movement of 'the marginal integration of individuals'. 'What are we to-day?'[33] Foucault poses this most pertinent ethnographic question to the West itself to reveal the alterity of its political rationality. He suggests that the 'reason of state' in the modern nation must be derived from the heterogeneous and differentiated limits of its territory. The nation cannot be conceived in a state of *equilibrium* between several elements co-ordinated and maintained by a 'good' law.

> Each state is in permanent competition with other countries, other nations . . . so that each state has nothing before it other than an indefinite future of struggles. Politics has now to deal with an irreducible multiplicity of states struggling and competing in a limited history . . . the State is its own finality.[34]

What is politically significant is the effect of this finitude of the State on the liminal representation of the people. The people will no longer be contained in that national discourse of the teleology of progress; the anonymity of individuals; the spatial horizontality of community; the homogeneous time of social narratives; the historicist visibility of modernity, where 'the present of each level [of the social] coincides with the present of all the others, so that the present is an *essential* section which makes the essence *visible*'.[35] The finitude of the nation emphasizes the impossibility of such an expressive totality with its alliance between a plenitudinous present and the eternal visibility of a past. The liminality of the people – their double-inscription as pedagogical objects and performative subjects – demands a

'time' of narrative that is disavowed in the discourse of historicism where narrative is only the agency of the event, or the medium of a naturalistic continuity of Community or Tradition. In describing the marginalistic integration of the individual in the social totality. Foucault provides a useful description of the rationality of the modern nation. Its main characteristic, he writes,

> is neither the constitution of the state, the coldest of cold monsters, nor the rise of bourgeois individualism. I won't even say it is the constant effort to integrate individuals into the political totality. I think that the main characteristic of our political rationality is the fact that this integration of the individuals in a community or in a totality results from a constant correlation between an increasing individualisation and the reinforcement of this totality. From this point of view we can understand why modern political rationality is permitted by the antinomy between law and order.[36]

From Foucault's *Discipline and Punish* we have learned that the most individuated are those subjects who are placed on the margins of the social, so that the tension between law and order may produce the disciplinary or pastoral society. Having placed the people on the limits of the nation's narrative, I now want to explore forms of cultural identity and political solidarity that emerge from the disjunctive temporalities of the national culture. This is a lesson of history to be learnt from those peoples whose histories of marginality have been most profoundly enmeshed in the antinomies of law and order – the colonized and women.

OF MARGINS AND MINORITIES

The difficulty of writing the history of the people as the insurmountable agonism of the living, the incommensurable

experiences of struggle and survival in the construction of a national culture, is nowhere better seen than in Frantz Fanon's essay 'On national culture'.[37] I start with it because it is a warning against the intellectual appropriation of the 'culture of the people' (whatever that may be) within a representationalist discourse that may become fixed and reified in the annals of History. Fanon writes against that form of nationalist historicism that assumes that there is a moment when the differential temporalities of cultural histories coalesce in an immediately readable present. For my purposes, he focuses on the time of cultural representation, instead of immediately historicizing the event. He explores the space of the nation without immediately identifying it with the historical institution of the State. As my concern here is not with the history of nationalist movements, but only with certain traditions of writing that have attempted to construct narratives of the social imaginary of the nation-people, I am indebted to Fanon for liberating a certain, uncertain time of the people.

The knowledge of the people depends on the discovery, Fanon says, 'of a much more fundamental substance which itself is continually being renewed', a structure of repetition that is not visible in the translucidity of the people's customs or the obvious objectivities which seem to characterize the people. 'Culture abhors simplification,' Fanon writes, as he tries to locate the people in a performative time: 'the fluctuating movement that the people are just giving shape to'. The present of the people's history, then, is a practice that destroys the constant principles of the national culture that attempt to hark back to a 'true' national past, which is often represented in the reified forms of realism and stereotype. Such pedagogical knowledges and continuist national narratives miss the 'zone of occult instability where the people dwell' (Fanon's phrase). It is from this instability of cultural signification that the national culture comes to be articulated as a dialectic of various temporalities – modern, colonial,

postcolonial, 'native' – that cannot be a knowledge that is stabilized in its enunciation: 'it is always contemporaneous with the act of recitation. It is the present act that on each of its occurrences marshalls in the ephemeral temporality inhabiting the space between the "I have heard" and "you will hear".'[38]

Fanon's critique of the fixed and stable forms of the nationalist narrative makes it imperative to question theories of the horizontal, homogeneous empty time of the nation's narrative. Does the language of culture's 'occult instability' have a relevance outside the situation of anticolonial struggle? Does the incommensurable act of living – so often dismissed as ethical or empirical – have its own ambivalent narrative, its own history of theory? Can it change the way we identify the symbolic structure of the Western nation?

A similar exploration of political time has a salutary feminist history in 'Women's time'.[39] It has rarely been acknowledged that Kristeva's celebrated essay of that title has its conjunctural, cultural history, not simply in psychoanalysis and semiotics, but in a powerful critique and redefinition of the nation as a space for the emergence of feminist political and psychic identifications. The nation as a symbolic denominator is, according to Kristeva, a powerful repository of cultural knowledge that erases the rationalist and progressivist logics of the 'canonical' nation. This symbolic history of the national culture is inscribed in the strange temporality of the future perfect, the effects of which are not dissimilar to Fanon's occult instability.

The borders of the nation Kristeva claims, are constantly faced with a double temporality: the process of identity constituted by historical sedimentation (the pedagogical); and the loss of identity in the signifying process of cultural identification (the performative). The time and space of Kirsteva's construction of the nation's finitude is analogous to my argument that the figure of the people emerges in the narrative ambivalence of disjunctive

times and meanings. The concurrent circulation of linear, cursive and monumental time, in the same cultural space, constitutes a new historical temporality that Kristeva identifies with psycho-analytically informed, feminist strategies of political identification. What is remarkable is her insistence that the gendered sign can hold together such exorbitant historical times.

The political effects of Kristeva's multiple women's time leads to what she calls the 'demassification of difference'. The cultural moment of Fanon's 'occult instability' signifies the people in a fluctuating movement which they are just giving shape to, so that post-colonial time questions the teleological traditions of past and present, and the polarized historicist sensibility of the archaic and the modern. These are not simply attempts to invert the balance of power within an unchanged order of discourse. Fanon and Kristeva seek to redefine the symbolic process through which the social imaginary – nation, culture or community – becomes the subject of discourse, and the object of psychic identification. These feminist and postcolonial temporalities force us to rethink the sign of history within those languages, political or literary, which designate the people 'as one'. They challenge us to think the question of community and communication without the moment of transcendence: how do we understand such forms of social contradiction?

Cultural identification is then poised on the brink of what Kristeva calls the 'loss of identity' or Fanon describes as a profound cultural 'undecidability'. The people as a form of address emerge from the abyss of enunciation where the subject splits, the signifier 'fades', the pedagogical and the performative are agonistically articulated. The language of national collectivity and cohesiveness is now at stake. Neither can cultural homo-geneity, or the nation's horizontal space be authoritatively repre-sented within the familiar territory of the public sphere: social causality cannot be adequately understood as a deterministic or overdetermined effect of a 'statist' centre; nor can the rationality

of political choice be divided between the polar realms of the private and the public. The narrative of national cohesion can no longer be signified, in Anderson's words, as a 'sociological solidity'[40] fixed in a 'succession of *plurals*' – hospitals, prisons, remote villages – where the social space is clearly bounded by such repeated objects that represent a naturalistic, national horizon.

Such a pluralism of the national sign, where difference returns as the same, is contested by the signifier's 'loss of identity' that inscribes the narrative of the people in the ambivalent, 'double' writing of the performative and the pedagogical. The movement of meaning *between* the masterful image of the people and the movement of its sign interrupts the succession of plurals that produce the sociological solidity of the national narrative. The nation's totality is confronted with, and crossed by, a supplementary movement of writing. The heterogeneous structure of Derridean supplementarity in *writing* closely follows the agonistic, ambivalent movement between the pedagogical and performative that informs the nation's narrative address. A supplement, according to one meaning, 'cumulates and accumulates presence. It is thus that art, *technē*, image, representation, convention, etc. come as supplements to nature and are rich with this entire cumulating function'[41] (pedagogical). The *double entendre* of the supplement suggests, however, that

> [It] intervenes or insinuates itself *in-the-place-of.* . . . If it represents and makes an image it is by the *anterior* default of a presence . . . the supplement is an adjunct, a subaltern instance. . . . As substitute, it is not simply added to the positivity of a presence, it produces no relief. . . . Somewhere, something can be filled up of *itself* . . . only by allowing itself to be filled through sign and proxy.[42] (performative)

It is in this supplementary space of doubling – *not plurality* – where the image is presence and proxy, where the sign

supplements and empties nature, that the disjunctive times of Fanon and Kristeva can be turned into the discourses of emergent cultural identities, within a non-pluralistic politics of difference.

This supplementary space of cultural signification that opens up – and holds together – the performative and the pedagogical, provides a narrative structure characteristic of modern political rationality: the marginal integration of individuals in a repetitious movement between the antinomies of law and order. From the liminal movement of the culture of the nation – at once opened up and held together – minority discourse emerges. Its strategy of intervention is similar to what British parliamentary procedure recognizes as a supplementary question. It is a question that is supplementary to what is stated on the 'order paper' for the minister's response. Coming 'after' the original, or in 'addition to' it, gives the supplementary question the advantage of introducing a sense of 'secondariness' or belatedness into the structure of the original demand. The supplementary strategy suggests that adding 'to' need not 'add up' but may disturb the calculation. As Gasché has succinctly suggested, 'supplements . . . are pluses that compensate for a minus in the origin.'[43] The supplementary strategy interrupts the successive seriality of the narrative of plurals and pluralism by radically changing their mode of articulation. In the metaphor of the national community as the 'many as one', the *one* is now both the tendency to totalize the social in a homogenous empty time, and the repetition of that minus in the origin, the less-than-one that intervenes with a metonymic, iterative temporality.

One cultural effect of such a metonymic interruption in the representation of the people, is apparent in Julia Kristeva's political writings. If we elide her concepts of women's time and female exile, then she seems to argue that the 'singularity' of woman – her representation as fragmentation and drive – produces a dissidence, and a distanciation, within the symbolic

bond itself which demystifies 'the community of language as a universal and unifying tool, one which totalises and equalises'.[44] The minority does not simply confront the pedagogical, or powerful master-discourse with a contradictory or negating referent. It interrogates its object by initially withholding its objective. Insinuating itself into the terms of reference of the dominant discourse, the supplementary antagonizes the implicit power to generalize, to produce the sociological solidity. The questioning of the supplement is not a repetitive rhetoric of the 'end' of society but a meditation on the disposition of space and time from which the narrative of the nation must begin. The power of supplementarity is not the negation of the preconstituted social contradictions of the past or present; its force lies – as we shall see in the discussion of *Handsworth Songs* that follows – in the renegotiation of those times, terms and traditions through which we turn our uncertain, passing contemporaneity into the signs of history.

Handsworth Songs[45] is a film made by the Black Audio and Film Collective during the uprisings of 1985, in the Handsworth district of Birmingham, England. Shot in the midst of the uprising, it is haunted by two moments: the arrival of the migrant population in the 1950s, and the emergence of a black British peoples in the diaspora. And the film itself is part of the emergence of a black British cultural politics. Between the moments of the migrants' arrival and the minorities' emergence spans the filmic time of a continual displacement of narrative. It is the time of oppression and resistance; the time of the performance of the riots, cut across by the pedagogical knowledges of State institutions. The racism of statistics and documents and newspapers is interrupted by the perplexed living of Handsworth songs.

Two memories repeat incessantly to translate the living perplexity of history into the time of migration: first, the arrival of the ship laden with immigrants from the ex-colonies, just stepping off the boat, always just emerging – as in the

fantasmatic scenario of Freud's family romance – into the land where the streets are paved with gold. This is followed by another image of the perplexity and power of an emergent peoples, caught in the shot of a dreadlocked rastafarian cutting a swathe through a posse of policemen during the uprising. It is a memory that flashes incessantly through the film: a dangerous repetition in the present of the cinematic frame; the edge of human life that translates what will come next and what has gone before in the writing of History. Listen to the repetition of the time and space of the peoples that I have been trying to create:

> In time we will demand the impossible in order to wrestle from it that which is possible, In time the streets will claim me without apology, In time I will be right to say that there are no stories . . . in the riots only the ghosts of other stories.

The symbolic demand of cultural difference constitutes a history in the midst of the uprising. From the desire of the possible in the impossible, in the historic present of the riots, emerge the ghostly repetitions of other stories, the record of other uprisings of people of colour: Broadwater Farm; Southall; St Paul's, Bristol. In the ghostly repetition of the black woman of Lozells Rd, Handsworth, who sees the future in the past. There are no stories in the riots, only the ghosts of other stories, she told a local journalist: 'You can see Enoch Powell in 1969, Michael X in 1965.' And from the gathering repetition she builds a history.

From across the film listen to another woman who speaks another historical language. From the archaic world of metaphor, caught in the movement of the people she translates the time of change into the ebb and flow of language's unmastering rhythm: the successive time of instantaneity, battening against the straight horizons, and then the flow of water and words:

> I walk with my back to the sea, horizons straight ahead
> Wave the sea way and back it comes,
> Step and I slip on it.
> Crawling in my journey's footsteps
> When I stand it fills my bones.

The perplexity of the living must not be understood as some existential, ethical anguish of the empiricism of everyday life in 'the eternal living present', that gives liberal discourse a rich social reference in moral and cultural relativism. Nor must it be too hastily associated with the spontaneous and primordial presence of the people in the liberatory discourses of populist ressentiment. In the construction of this discourse of 'living perplexity' that I am attempting to produce we must remember that the space of human life is pushed to its incommensurable extreme; the judgement of living is perplexed; the topos of the narrative is neither the transcendental, pedagogical idea of History nor the institution of the State, but a strange temporality of the repetition of the one in the other – an oscillating movement in the governing present of cultural authority.

Minority discourse sets the act of emergence in the antagonistic in-between of image and sign, the accumulative and the adjunct, presence and proxy. It contests genealogies of 'origin' that lead to claims for cultural supremacy and historical priority. Minority discourse acknowledges the status of national culture – and the people – as a contentious, performative space of the perplexity of the living in the midst of the pedagogical representations of the fullness of life. Now there is no reason to believe that such marks of difference cannot inscribe a 'history' of the people or become the gathering points of political solidarity. They will not, however, celebrate the monumentality of historicist memory, the sociological totality of society, or the homogeneity of cultural experience. The discourse of the minority reveals the insurmountable ambivalence that structures the

equivocal movement of historical time. How does one encounter the past as an anteriority that continually introduces an otherness or alterity into the present? How does one then narrate the present as a form of contemporaneity that is neither punctual nor synchronous? In what historical time do such configurations of cultural difference assume forms of cultural and political authority?

SOCIAL ANONYMITY AND CULTURAL ANOMIE

The narrative of the modern nation can only begin, Benedict Anderson suggests in *Imagined Communities*, once the notion of the 'arbitrariness of the sign' fissures the sacral ontology of the medieval world and its overwhelming visual and aural imaginary. By 'separating language from reality', Anderson suggests, the arbitrary signifier enables a national temporality of the 'meanwhile', a form of homogeneous empty time. This is the time of cultural modernity that supersedes the prophetic notion of simultaneity-along-time. The narrative of the 'meanwhile' permits 'transverse, cross-time, marked not by prefiguring and fulfilment but by temporal coincidence, and measured by clock and calendar.'[46] Such a form of temporality produces a symbolic structure of the nation as 'imagined community' which, in keeping with the scale and diversity of the modern nation, works like the plot of a realist novel. The steady onward clocking of calendrical time, in Anderson's words, gives the imagined world of the nation a sociological solidity; it links together diverse acts and actors on the national stage who are entirely unaware of each other, except as a function of this synchronicity of time which is not prefigurative but a form of civil contemporaneity realized in the *fullness* of time.

Anderson historicizes the emergence of the arbitrary sign of language – and here he is talking of the process of signification rather than the progress of narrative – as that which had to come

before the narrative of the modern nation could begin. In decentring the prophetic visibility and simultaneity of medieval systems of dynastic representation, the homogeneous and horizontal community of modern society can emerge. The people-nation, however divided and split, can still assume, in the function of the social imaginary, a form of democratic 'anonymity'. There is, however, a profound ascesis in the anonymity of the modern community and its temporality, the *meanwhile* that structures its narrative consciousness, as Anderson explains it. It must be stressed that the narrative of the imagined community is constructed from two incommensurable temporalities of meaning that threaten its coherence.

The space of the arbitrary sign, its separation of language and reality, enables Anderson to emphasize the imaginary or mythical nature of the society of the nation. However, the differential time of the arbitrary sign is neither synchronous nor serial. In the separation of language and reality – in the *process* of signification – there is no epistemological equivalence of subject and object, no possibility of the mimesis of meaning. The sign temporalizes the iterative difference that circulates within language, of which meaning is made, but cannot be represented thematically within narrative as a homogeneous empty time. Such a temporality is antithetical to the alterity of the sign which, in keeping with my account of the 'supplementary question' of cultural signification, alienates the synchronicity of the imagined community. From the place of the 'meanwhile', where cultural homogeneity and democratic anonymity articulate the national community, there emerges a more instantaneous and subaltern voice of the people, minority discourses that speak betwixt and between times and places.

Having initially located the imagined community of the nation in the homogeneous time of realist narrative, towards the end of his work Anderson abandons the 'meanwhile' – his pedagogical temporality of the people. In order to represent the

people as a performative discourse of public identification, a process he calls 'unisonance', Anderson resorts to another time of narrative. Unisonance is 'that special kind of contemporaneous community which language alone suggests',[47] and this patriotic speech-act is not written in the synchronic, novelistic 'meanwhile', but inscribed in a sudden primordiality of meaning that 'looms up *imperceptibly* out of a horizonless past' (my emphasis).[48] This movement of the sign cannot simply be historicized in the emergence of the realist narrative of the novel.

It is at this point in the narrative of national time that the unisonant discourse produces its collective identification of the people, not as some transcendent national identity, but in a language of doubleness that arises from the ambivalent splitting of the pedagogical and the performative. The people emerge in an uncanny moment of their 'present' history as 'a ghostly intimation of simultaneity across homogeneous empty time'. The weight of the words of the national discourse comes from an '*as it were* – Ancestral Englishness'.[49] It is precisely this repetitive *time* of the alienating anterior – rather than origin – that Lévi-Strauss writes of, when, in explaining the 'unconscious unity' of signification, he suggests that 'language can only have arisen all at once. Things cannot have begun to *signify* gradually' (my emphasis).[50] In that sudden timelessness of 'all at once', there is no synchrony but a temporal break, no simultaneity but a spatial disjunction.

The 'meanwhile' is the sign of the processual and performative, not a simple present continuous, but the present as succession without synchrony – the iteration of the sign of the modern nation-space. In embedding the *meanwhile* of the national narrative, where the people live their plural and autonomous lives within homogeneous empty time, Anderson misses the alienating and iterative time of the sign. He naturalizes the momentary 'suddenness' of the arbitrary sign, its pulsation, by making it

part of the historical emergence of the novel, a narrative of synchrony. But the suddenness of the signifier is incessant; instantaneous rather than simultaneous. It introduces a signifying space of iteration rather than a progressive or linear seriality. The 'meanwhile' turns into quite another time, or ambivalent sign, of the national people. If it is the time of the people's anonymity it is also the space of the nation's anomie.

How are we to understand this anteriority of signification as a position of social and cultural knowledge, this time of the 'before' of signification, which will not issue harmoniously into the present like the continuity of tradition – invented or otherwise? It has its own national history in Renan's 'Qu'est ce qu'une nation?' which has been the starting point for a number of the most influential accounts of the modern emergence of the nation – Kamenka, Gellner, Benedict Anderson, Tzvetan Todorov. In Renan's argument the pedagogical function of modernity – the will to be a nation – introduces into the enunciative present of the nation a differential and iterative time of reinscription that interests me. Renan argues that the non-naturalist principle of the modern nation is represented in the will to nationhood – not in the prior identities of race, language or territory. It is the will that unifies historical memory and secures present-day consent. The will is, indeed, the articulation of the nation-people:

> A nation's existence is, if you will pardon the metaphor, a daily plebiscite, just as an individual's existence is a perpetual affirmation of life. . . . The wish of nations is, all in all, the sole legitimate criteria, the one to which one must always return.[51]

Does the will to nationhood circulate in the same temporality as the desire of the daily plebiscite? Could it be that the iterative plebiscite decentres the totalizing pedagogy of the will? Renan's will is itself the site of a strange forgetting of the history of the nation's past: the violence involved in establishing the nation's

writ. It is this forgetting – the signification of a minus in the origin – that constitutes the *beginning* of the nation's narrative. It is the syntactical and rhetorical arrangement of this argument that is more illuminating than any frankly historical or ideological reading. Listen to the complexity of this form of forgetting which is the moment in which the national will is articulated: 'yet every French citizen has to have forgotten [*is obliged to have forgotten*] Saint Bartholomew's Night's Massacre, or the massacres that took place in the Midi in the thirteenth century.'[52]

It is through this syntax of forgetting – or being obliged to forget – that the problematic identification of a national people becomes visible. The national subject is produced in that place where the daily plebiscite – the unitary number – circulates in the grand narrative of the will. However, the equivalence of will and plebiscite, the identity of part and whole, past and present, is cut across by the 'obligation to forget', or forgetting to remember. The anteriority of the nation, signified in the will to forget, entirely changes our understanding of the pastness of the past, and the synchronous present of the will to nationhood. We are in a discursive space similar to that moment of unisonance in Anderson's argument when the homogeneous empty time of the nation's 'meanwhile' is cut across by the ghostly simultaneity of a temporality of doubling. To be obliged to forget – in the construction of the national present – is not a question of historical memory; it is the construction of a discourse on society that *performs* the problem of totalizing the people and unifying the national will. That strange time – forgetting to remember – is a place of 'partial identification' inscribed in the daily plebiscite which represents the performative discourse of the people. Renan's pedagogical return to the will to nationhood is both constituted and confronted by the circulation of numbers in the plebiscite. This breakdown in the identity of the will is another instance of the supplementary narrative of nationness that 'adds to' without 'adding up'. May I remind you of Lefort's suggestive

description of the ideological impact of suffrage in the nine-teenth century, where the danger of numbers was considered almost more threatening than the mob: 'the idea of number as such is opposed to the idea of the substance of society. Number breaks down unity, destroys identity.'[53] It is the repetition of the national sign as numerical succession rather than synchrony that reveals that strange temporality of disavowal implicit in the national memory. Being obliged to forget becomes the basis for remembering the nation, peopling it anew, imagining the possi-bility of other contending and liberating forms of cultural identification.

Anderson fails to locate the alienating time of the arbitrary sign in his naturalized, nationalized space of the imagined com-munity. Although he borrows his notion of the homogeneous empty time of the nation's modern narrative from Walter Benjamin, he misses that profound ambivalence that Benjamin places deep within the utterance of the narrative of modernity. Here, as the pedagogies of life and will contest the perplexed histories of the living people, their cultures of survival and resistance, Benjamin introduces a non-synchronous, incom-mensurable gap in the midst of storytelling. From this split in the utterance, from the unbeguiled, belated novelist there emerges an ambivalence in the narration of modern society that repeats, uncounselled and unconsolable, in the midst of plenitude:

> The novelist has isolated himself. The birthplace of the novel is the solitary individual, who is no longer able to express himself by giving examples of his most important concerns, is himself uncounselled and cannot counsel others. To write a novel means to carry the incommensurable to extremes in the repre-sentation of human life. In the midst of life's fullness, and through the representation of this fullness, the novel gives evidence of the profound perplexity of the living.[54]

It is from this incommensurability in the midst of the everyday that the nation speaks its disjunctive narrative. From the margins of modernity, at the insurmountable extremes of storytelling, we encounter the question of cultural difference as the perplexity of living and writing the nation.

CULTURAL DIFFERENCE

Cultural difference must not be understood as the free play of polarities and pluralities in the homogeneous empty time of the national community. The jarring of meanings and values generated in the process of cultural interpretation is an effect of the perplexity of living in the liminal spaces of national society that I have tried to trace. Cultural difference, as a form of intervention, participates in a logic of supplementary subversion similar to the strategies of minority discourse. The question of cultural difference faces us with a disposition of knowledges or a distribution of practices that exist beside each other, *abseits* designating a form of social contradiction or antagonism that has to be negotiated rather than sublated. The difference between disjunctive sites and representations of social life have to be articulated without surmounting the incommensurable meanings and judgements that are produced within the process of transcultural negotiation.

The analytic of cultural difference intervenes to transform the scenario of articulation – not simply to disclose the rationale of political discrimination. It changes the position of enunciation and the relations of address within it; not only what is said but where it is said; not simply the logic of articulation but the *topos* of enunciation. The aim of cultural difference is to rearticulate the sum of knowledge from the perspective of the signifying position of the minority that resists totalization – the repetition that will not return as the same, the minus-in-origin that results in political and discursive strategies where adding *to* does not add up but serves to disturb the calculation of power and

knowledge, producing other spaces of subaltern signification. The subject of the discourse of cultural difference is dialogical or transferential in the style of psychoanalysis. It is constituted through the locus of the Other which suggests both that the object of identification is ambivalent, and, more significantly, that the agency of identification is never pure or holistic but always constituted in a process of substitution, displacement or projection.

Cultural difference does not simply represent the contention between oppositional contents or antagonistic traditions of cultural value. Cultural difference introduces into the process of cultural judgement and interpretation that sudden shock of the successive, non-synchronic time of signification, or the interruption of the supplementary question that I elaborated above. The very possibility of cultural contestation, the ability to shift the ground of knowledges, or to engage in the 'war of position', marks the establishment of new forms of meaning, and strategies of identification. Designations of cultural difference interpellate forms of identity which, because of their continual implication in other symbolic systems, are always 'incomplete' or open to cultural translation. The *uncanny* structure of cultural difference is close to Lévi-Strauss's understanding of 'the unconscious as providing the common and specific character of social facts . . . not because it harbours our most secret selves but because . . . it enables us to coincide with forms of activity which are both *at once ours and other*' (my emphasis).[55]

It is not adequate simply to become aware of the semiotic systems that produce the signs of culture and their dissemination. Much more significantly, we are faced with the challenge of reading, into the present of a specific cultural performance, the traces of all those diverse disciplinary discourses and institutions of knowledge that constitute the condition and contexts of culture. As I have been arguing throughout this chapter, such a critical process requires a cultural temporality that is both

disjunctive and capable of articulating, in Lévi-Strauss's words, 'forms of activity which are both at once ours and other'.

I use the word 'traces' to suggest a particular kind of inter-disciplinary discursive transformation that the analytic of cultural difference demands. To enter into the interdisciplinarity of cultural texts means that we cannot contextualize the emergent cultural form by locating it in terms of some pre-given discursive casuality or origin. We must always keep open a supplementary space for the articulation of cultural knowledges that are adjacent and adjunct but not necessarily accumulative, teleological or dialectical. The 'difference' of cultural knowledge that 'adds to' but does not 'add up' is the enemy of the implicit generalization of knowledge or the implicit homogenization of experience, which Claude Lefort defines as the major strategies of containment and closure in modern bourgeois ideology.

Interdisciplinarity is the acknowledgement of the emergent sign of cultural difference produced in the ambivalent movement between the pedagogical and performative address. It is never simply the harmonious addition of contents or contexts that augment the positivity of a pre-given disciplinary or symbolic presence. In the restless drive for cultural translation, hybrid sites of meaning open up a cleavage in the language of culture which suggests that the similitude of the symbol as it plays across cultural sites must not obscure the fact that repetition of the sign is, in each specific social practice, both different and differential. This disjunctive play of symbol and sign makes interdisciplinarity an instance of the borderline moment of translation that Walter Benjamin describes as the 'foreignness of languages'.[56] The 'foreignness' of language is the nucleus of the untranslatable that goes beyond the transferral of subject matter between cultural texts or practices. The transfer of meaning can never be total between systems of meaning, or within them, for 'the language of translation envelops its content like a royal robe with ample folds . . . [it] signifies a more exalted language than its

own and thus remains unsuited to its content, overpowering and alien.'[57]

Too often it is the slippage of signification that is celebrated in the articulation of difference, at the expense of this disturbing process of the overpowering of content by the signifier. The erasure of content in the invisible but insistent structure of linguistic difference does not lead us to some general, formal acknowledgement of the function of the sign. The ill-fitting robe of language alienates content in the sense that it deprives it of an immediate access to a stable or holistic reference 'outside' itself. It suggests that social significantions are themselves being constituted in the very act of enunciation, in the disjunctive, non-equivalent split of *énoncé* and *enonciation*, thereby undermining the division of social meaning into an inside and outside. Content becomes the alienating *mise-en-scène* that reveals the signifying structure of linguistic difference: a process never seen for itself, but only glimpsed in the gap or the gaping of Benjamin's royal robe, or in the brush between the similitude of the symbol and the difference of the sign.

Benjamin's argument can be elaborated for a theory of cultural difference. It is only by engaging with what he calls the 'purer linguistic air' – the sign as anterior to any *site* of meaning – that the reality-effect of content can be overpowered which then makes all cultural languages 'foreign' to themselves. And it is from this foreign perspective that it becomes possible to inscribe the specific locality of cultural systems – their incommensurable differences – and through that apprehension of difference, to perform the act of cultural translation. In the act of translation the 'given' content becomes alien and estranged; and that, in its turn, leaves the language of translation *Aufgabe*, always confronted by its double, the untranslatable – alien and foreign.

THE FOREIGNNESS OF LANGUAGES

At this point I must give way to the *vox populi*: to a relatively unspoken tradition of the people of the pagus – colonials, post-colonials, migrants, minorities – wandering peoples who will not be contained within the *Heim* of the national culture and its unisonant discourse, but are themselves the marks of a shifting boundary that alienates the frontiers of the modern nation. They are Marx's reserve army of migrant labour who by speaking the foreignness of language split the patriotic voice of unisonance and become Nietzsche's mobile army of metaphors, metonyms and anthropomorphisms. They articulate the death-in-life of the idea of the 'imagined community' of the nation; the worn-out metaphors of the resplendent national life now circulate in another narrative of entry-permits and passports and work-permits that at once preserve and proliferate, bind and breach the human rights of the nation. Across the accumulation of the history of the West there are those people who speak the encrypted discourse of the melancholic and the migrant. Theirs is a voice that opens up a void in some ways similar to what Abraham and Torok describe as a radical *anti-metaphoric*: 'the destruction in fantasy, of the very act that makes metaphor possible – the act of putting the original oral void into words, the act of introjection'.[58] The lost object – the national *Heim* – is repeated in the void that at once prefigures and pre-empts the 'unisonant' which makes it *unheimlich*; analogous to the incorporation that becomes the daemonic double of introjection and identification. The object of loss is written across the bodies of the people, as it repeats in the silence that speaks the foreignness of language. A Turkish worker in Germany, in the words of John Berger:

> His migration is like an event in a dream dreamt by another. The migrant's intentionality is permeated by historical

necessities of which neither he nor anybody he meets is aware. That is why it is as if his life were dreamt by another. . . . Abandon the metaphor. . . . They watch the gestures made and learn to imitate them . . . the repetition by which gesture is laid upon gesture, precisely but inexorably, the pile of gestures being stacked minute by minute, hour by hour is exhausting. The rate of work allows no time to prepare for the gesture. The body loses its mind in the gesture. How opaque the disguise of words. . . . He treated the sounds of the unknown language as if they were silence. To break through his silence. He learnt twenty words of the new language. But to his amazement at first, their meaning changed as he spoke them. He asked for coffee. What the words signified to the barman was that he was asking for coffee in a bar where he should not be asking for coffee. He learnt girl. What the word meant when he used it, was that he was a randy dog. Is it possible to see through the opaqueness of the words?[59]

Through the opaqueness of words we comfront the historical memory of the Western nation which is 'obliged to forget'. Having begun this chapter with the nation's need for metaphor, I want to turn now to the desolate silences of the wandering people; to that 'oral void' that emerges when the Turk abandons the metaphor of a *heimlich* national culture: for the Turkish immigrant the final return is mythic, we are told, 'It is the stuff of longing and prayers . . . as imagined it never happens. There is no final return.'[60]

In the repetition of gesture after gesture, the dream dreamt by another, the mythical return, it is not simply the figure of repetition that is *unheimlich*, but the Turk's desire to survive, to name, to fix – which is unnamed by the gesture itself. The gesture continually overlaps and accumulates, without adding up to a knowledge of work or labour. Without the language that bridges knowledge and act, without the objectification of the social

process, the Turk leads the life of the double, the automaton. It is not the struggle of master and slave, but in the mechanical reproduction of gestures a mere imitation of life and labour. The opacity of language fails to translate or break through his silence and 'the body loses its mind in the gesture'. The gesture repeats and the body returns now, shrouded not in silence but eerily untranslated in the racist site of its enunciation: to say the word 'girl' is to be a randy dog, to ask for coffee is to encounter the colour bar.

The image of the body returns where there should only be its trace, as sign or letter. The Turk as dog is neither simply hallucination or phobia; it is a more complex form of social fantasy. Its ambivalence cannot be read as some simple racist/sexist projection where the white man's guilt is projected on the black man; his anxiety contained in the body of the white woman whose body screens (in both senses of the word) the racist fantasy. What such a reading leaves out is precisely the axis of identification – the desire of a man (white) for a man (black) – that underwrites that utterance and produces the paranoid 'delusion of reference', the man-dog that confronts the racist language with its own alterity, its foreignness.

The silent Other of gesture and failed speech becomes what Freud calls that 'haphazard member of the herd',[61] the Stranger, whose languageless presence evokes an archaic anxiety and aggressivity by impeding the search for narcissistic love-objects in which the subject can rediscover himself, and upon which the group's *amour propre* is based. If the immigrants' desire to 'imitate' language produces one void in the articulation of the social space – making present the opacity of language, its untranslatable residue – then the racist fantasy, which disavows the ambivalence of its desire, opens up another void in the present. The migrant's silence elicits those racist fantasies of purity and persecution that must always return from the Outside, to estrange the present of the life of the metropolis; to make it

strangely familiar. In the process by which the paranoid position finally voids the place from where it speaks, we begin to see another history of the German language.

If the experience of the Turkish *Gastarbeiter* represents the radical incommensurability of translation, Salman Rushdie's *The Satanic Verses* attempts to redefine the boundaries of the Western nation, so that the 'foreignness of languages' becomes the inescapable cultural condition for the enunciation of the mother-tongue. In the 'Rosa Diamond' section of *The Satanic Verses* Rushdie seems to suggest that it is only through the process of dissemiN*ation* – of meaning, time, peoples, cultural boundaries and historical traditions – that the radical alterity of the national culture will create new forms of living and writing: 'The trouble with the Engenglish is that their hiss hiss history happened overseas, so they do do don't know what it means.'[62]

S. S. Sisodia the soak – known also as Whisky Sisodia – stutters these words as part of his litany of 'what's wrong with the English'. The spirit of his words fleshes out the argument of this chapter. I have suggested that the atavistic national past and its language of archaic belonging marginalize the present of the 'modernity' of the national culture, rather like suggesting that history happens 'outside' the centre and core. More specifically I have argued that appeals to the national past must also be seen as the anterior space of signification that 'singularizes' the nation's cultural totality. It introduces a form of alterity of address that Rushdie embodies in the double narrative figures of Gibreel Farishta/Saladin Chamcha, or Gibreel Farishta/Sir Henry Diamond, which suggests that the national narrative is the site of an ambivalent identification; a margin of the uncertainty of cultural meaning that may become the space for an agonistic minority position. In the midst of life's fullness, and through the representation of this fullness, the novel gives evidence of the profound perplexity of the living.

Gifted with phantom sight, Rosa Diamond, for whom

repetition had become a comfort in her antiquity, represents the English *Heim* or homeland. The pageant of 900-year-old history passes through her frail translucent body and inscribes itself, in a strange splitting of her language, 'the well-worn phrases, *unfinished business, grandstand view,* made her feel solid, unchanging, sempiternal, instead of the creature of cracks and absences she knew herself to be.'[63] Constructed from the well-worn pedagogies and pedigrees of national unity – her vision of the Battle of Hastings is the anchor of her being – and, at the same time, patched and fractured in the incommensurable perplexity of the nation's living, Rosa Diamond's green and pleasant garden is the spot where Gibreel Farishta lands when he falls out from the belly of the Boeing over sodden, southern England.

Gibreel masquerades in the clothes of Rosa's dead husband, Sir Henry Diamond, ex-colonial landowner, and through his postcolonial mimicry, exacerbates the discursive split between the image of a continuist national history and the 'cracks and absences' that she knew herself to be. What emerges, at one level, is a popular tale of secret, adulterous Argentinian amours, passion in the pampas with Martin de la Cruz. What is more significant and in tension with the exoticism, is the emergence of a hybrid national narrative that turns the nostalgic past into the disruptive 'anterior' and displaces the historical present – opens it up to other histories and incommensurable narrative subjects. The cut or split in enunciation emerges with its iterative temporality to reinscribe the figure of Rosa Diamond in a new and terrifying avatar. Gibreel, the migrant hybrid in masquerade, as Sir Henry Diamond, mimics the collaborative colonial ideologies of patriotism and patriarchy, depriving those narratives of their imperial authority. Gibreel's returning gaze crosses out the synchronous history of England, the essentialist memories of William the Conqueror and the Battle of Hastings. In the middle of an account of her punctual domestic routine with Sir Henry – sherry always at six – Rosa Diamond is overtaken by another

time and memory of narration and through the 'grandstand view' of imperial history you can hear its cracks and absences speak with another voice:

> Then she began without bothering with once upon atime and whether it was all true or false he could see the fierce energy that was going into the telling . . . this memory jumbled rag-bag of material was in fact the very heart of her, her self-portrait. . . . So that it was not possible to distinguish memories from wishes, guilty reconstructions from confessional truths, because even on her deathbed Rosa Diamond did not know how to look her history in the eye.[64]

And what of Gibreel Farishta? Well, he is the mote in the eye of history, its blind spot that will not let the nationalist gaze settle centrally. His mimicry of colonial masculinity and mimesis allows the absences of national history to speak in the ambivalent, rag-bag narrative. But it is precisely this 'narrative sorcery' that established Gibreel's own re-entry into contemporary England. As the belated postcolonial he marginalizes and singularizes the totality of national culture. He is the history that happened elsewhere, overseas; his postcolonial, migrant presence does not evoke a harmonious patchwork of cultures, but articulates the narrative of cultural difference which can never let the national history look at itself narcissistically in the eye.

For the liminality of the Western nation is the shadow of its own finitude: the colonial space played out in the imaginative geography of the metropolitan space; the repetition or return of the postcolonial migrant to alienate the holism of history. The postcolonial space is now 'supplementary' to the metropolitan centre; it stands in a subaltern, adjunct relation that doesn't aggrandize the presence of the West but redraws its frontiers in the menacing, agonistic boundary of cultural difference that never quite adds up, always less than one nation and double.

From this splitting of time and narrative emerges a strange, empowering knowledge for the migrant that is at once schizoid and subversive. In his guise as the Archangel Gibreel he sees the bleak history of the metropolis: 'the angry present of masks and parodies, stifled and twisted by the insupportable, unrejected burden of its past, staring into the bleakness of its impoverished future'.[65] From Rosa Diamond's decentred narrative 'without bothering with once upon atime' Gibreel becomes – however insanely – the principle of avenging repetition:

> These powerless English! – Did they not think that their history would return to haunt them? – 'The native is an oppressed person whose permanent dream is to become the persecutor' (Fanon). . . . He would make this land anew. He was the Archangel, Gibreel – *And I'm back.*[66]

If the lesson of Rosa's narrative is that the national memory is always the site of the hybridity of histories and the displacement of narratives, then through Gibreel, the avenging migrant, we learn the ambivalence of cultural difference: it is the articulation through incommensurability that structures all narratives of identification, and all acts of cultural translation.

> He was joined to the adversary, their arms locked around one another's bodies, mouth to mouth, head to tail. . . . No more of these England induced ambiguities: those Biblical-satanic confusions . . . Quaran 18:50 there it was as plain as the day. . . . How much more practical, down to earth comprehensible. . . . Iblis/Shaitan standing for darkness; Gibreel for the light. . . . O most devilish and slippery of cities. . . . Well then the trouble with the English was their, Their – In a word Gibreel solemnly pronounces, that most naturalised sign of cultural difference. - . . . The trouble with the English was their . . . in a word . . . their weather.[67]

THE ENGLISH WEATHER

To end with the English weather is to invoke, at once, the most changeable and immanent signs of national difference. It encourages memories of the 'deep' nation crafted in chalk and limestone; the quilted downs; the moors menaced by the wind; the quiet cathedral towns; that corner of a foreign field that is forever England. The English weather also revives memories of its daemonic double: the heat and dust of India; the dark emptiness of Africa; the tropical chaos that was deemed despotic and ungovernable and therefore worthy of the civilizing mission. These imaginative geographies that spanned countries and empires are changing, those imagined communities that played on the unisonant boundaries of the nation are singing with different voices. If I began with the scattering of the people across countries, I want to end with their gathering in the city. The return of the diasporic; the postcolonial.

Handsworth Songs; Rushdie's tropicalized London, grotesquely renamed *Ellowen Deeowen* in the migrant's mimicry: it is to the city that the migrants, the minorities, the diasporic come to change the history of the nation. If I have suggested that the people emerge in the finitude of the nation, making the liminality of cultural identity, producing the double-edged discourse of social territories and temporalities, then in the West, and increasingly elsewhere, it is the city which provides the space in which emergent identifications and new social movements of the people are played out. It is there that, in our time, the perplexity of the living is most acutely experienced.

In the narrative graftings of my chapter I have attempted no general theory, only a certain productive tension of the perplexity of language in various locations of living. I have taken the measure of Fanon's occult instability and Kristeva's parallel times into the 'incommensurable narrative' of Benjamin's modern storyteller to suggest no salvation, but a strange cultural survival

of the people. For it is by living on the borderline of history and language, on the limits of race and gender, that we are in a position to translate the differences between them into a kind of solidarity. I want to end with a much translated fragment from Walter Benjamin's essay, 'The task of the translator'. I hope it will now be read from the nation's edge, through the sense of the city, from the periphery of the people, in culture's transnational dissemination:

Fragments of a vessel in order to be articulated together must follow one another in the smallest details although they need not be *like* one another. In the same way a translation, instead of making itself similar to the meaning of the original, it must lovingly and in detail, form itself according to the manner of meaning of the original, to make them *both* recognizable as the broken fragments of the greater language, just as fragments are the broken parts of a vessel.[68]

9

THE POSTCOLONIAL AND THE POSTMODERN

The question of agency

[F]or some of us the principle of indeterminism is what makes the conscious freedom of man fathomable.
Jacques Derrida, 'My chances'/'*Mes chances*'¹

THE SURVIVAL OF CULTURE

Postcolonial criticism bears witness to the unequal and uneven forces of cultural representation involved in the contest for political and social authority within the modern world order. Postcolonial perspectives emerge from the colonial testimony of Third World countries and the discourses of 'minorities' within the geopolitical divisions of East and West, North and South. They intervene in those ideological discourses of modernity that attempt to give a hegemonic 'normality' to the uneven

development and the differential, often disadvantaged, histories of nations, races, communities, peoples. They formulate their critical revisions around issues of cultural difference, social authority, and political discrimination in order to reveal the antagonistic and ambivalent moments within the 'rationalizations' of modernity. To bend Jürgen Habermas to our purposes, we could also argue that the postcolonial project, at the most general theoretical level, seeks to explore those social pathologies – 'loss of meaning, conditions of anomie' – that no longer simply 'cluster around class antagonism, [but] break up into widely scattered historical contingencies'.[2]

These contingencies are often the grounds of historical necessity for elaborating empowering strategies of emancipation, staging other social antagonisms. To reconstitute the discourse of cultural difference demands not simply a change of cultural contents and symbols; a replacement within the same time-frame of representation is never adequate. It requires a radical revision of the social temporality in which emergent histories may be written, the rearticulation of the 'sign' in which cultural identities may be inscribed. And contingency as the signifying time of counter-hegemonic strategies is not a celebration of 'lack' or 'excess' or a self-perpetuating series of negative ontologies. Such 'indeterminism' is the mark of the conflictual yet productive space in which the arbitrariness of the sign of cultural signification emerges within the regulated boundaries of social discourse.

In this salutary sense, a range of contemporary critical theories suggest that it is from those who have suffered the sentence of history – subjugation, domination, diaspora, displacement – that we learn our most enduring lessons for living and thinking. There is even a growing conviction that the affective experience of social marginality – as it emerges in non-canonical cultural forms – transforms our critical strategies. It forces us to confront the concept of culture outside *objects d'art* or beyond the

canonization of the 'idea' of aesthetics, to engage with culture as an uneven, incomplete production of meaning and value, often composed of incommensurable demands and practices, produced in the act of social survival. Culture reaches out to create a symbolic textuality, to give the alienating everyday an aura of selfhood, a promise of pleasure. The transmission of *cultures of survival* does not occur in the ordered *museé imaginaire* of national cultures with their claims to the continuity of an authentic 'past' and a living 'present' – whether this scale of value is preserved in the organicist 'national' traditions of romanticism or within the more universal proportions of classicism.

Culture as a strategy of survival is both transnational and translational. It is transnational because contemporary postcolonial discourses are rooted in specific histories of cultural displacement, whether they are the 'middle passage' of slavery and indenture, the 'voyage out' of the civilizing mission, the fraught accommodation of Third World migration to the West after the Second World War, or the traffic of economic and political refugees within and outside the Third World. Culture is translational because such spatial histories of displacement – now accompanied by the territorial ambitions of 'global' media technologies – make the question of how culture signifies, or what is signified by *culture*, a rather complex issue.

It becomes crucial to distinguish between the semblance and similitude of the symbols across diverse cultural experiences – literature, art, music, ritual, life, death – and the social specificity of each of these productions of meaning as they circulate as signs within specific contextual locations and social systems of value. The transnational dimension of cultural tranformation – migration, diaspora, displacement, relocation – makes the process of cultural translation a complex form of signification. The natural(ized), unifying discourse of 'nation', 'peoples', or authentic 'folk' tradition, those embedded myths of culture's particularity, cannot be readily referenced. The great, though

unsettling, advantage of this position is that it makes you increasingly aware of the construction of culture and the invention of tradition.

The postcolonial perspective – as it is being developed by cultural historians and literary theorists – departs from the traditions of the sociology of underdevelopment or 'dependency' theory. As a mode of analysis, it attempts to revise those nationalist or 'nativist' pedagogies that set up the relation of Third World and First World in a binary structure of opposition. The postcolonial perspective resists the attempt at holistic forms of social explanation. It forces a recognition of the more complex cultural and political boundaries that exist on the cusp of these often opposed political spheres.

It is from this hybrid location of cultural value – the transnational as the translational – that the postcolonial intellectual attempts to elaborate a historical and literary project. My growing conviction has been that the encounters and negotiations of differential meanings and values within 'colonial' textuality, its governmental discourses and cultural practices, have anticipated, *avant la lettre*, many of the problematics of signification and judgement that have become current in contemporary theory – aporia, ambivalence, indeterminacy, the question of discursive closure, the threat to agency, the status of intentionality, the challenge to 'totalizing' concepts, to name but a few.

In general terms, there is a colonial contramodernity at work in the eighteenth- and nineteenth-century matrices of Western modernity that, if acknowledged, would question the historicism that analogically links, in a linear narrative, late capitalism and the fragmentary, simulacral, pastiche symptoms of postmodernity. This linking does not account for the historical traditions of cultural contingency and textual indeterminacy (as forces of social discourse) generated in the attempt to produce an 'enlightened' colonial or postcolonial subject, and it

transforms, in the process, our understanding of the narrative of modernity and the 'values' of progress.

Postcolonial critical discourses require forms of dialectical thinking that do not disavow or sublate the otherness (alterity) that constitutes the symbolic domain of psychic and social identifications. The incommensurability of cultural values and priorities that the postcolonial critic represents cannot be accommodated within theories of cultural relativism or pluralism. The cultural potential of such differential histories has led Fredric Jameson to recognize the 'internationalization of the national situations' in the postcolonial criticism of Roberto Retamar. This is not an absorption of the particular in the general, for the very act of articulating cultural differences 'calls us into question fully as much as it acknowledges the Other . . . neither reduc[ing] the Third World to some homogeneous Other of the West, nor . . . vacuously celebrat[ing] the astonishing pluralism of human cultures' (Foreword xi–xii).[3]

The historical grounds of such an intellectual tradition are to be found in the revisionary impulse that informs many postcolonial thinkers. C. L. R. James once remarked, in a public lecture, that the postcolonial prerogative consisted in reinterpreting and rewriting the forms and effects of an 'older' colonial consciousness from the later experience of the cultural displacement that marks the more recent, postwar histories of the Western metropolis. A similar process of cultural translation, and transvaluation, is evident in Edward Said's assessment of the response from disparate postcolonial regions as a 'tremendously energetic attempt to engage with the metropolitan world in a common effort at re-inscribing, re-interpreting and expanding the sites of intensity and the terrain contested with Europe'.[4]

How does the deconstruction of the 'sign', the emphasis on indeterminism in cultural and political judgement, transform our sense of the 'subject' of culture and the historical agent of change? If we contest the 'grand narratives', then what alternative

temporalities do we create to articulate the differential (Jameson), contrapuntal (Said), interruptive (Spivak) historicities of race, gender, class, nation within a growing transnational culture? Do we need to rethink the terms in which we conceive of community, citizenship, nationality, and the ethics of social affiliation?

Jameson's justly famous reading of Conrad's *Lord Jim* in *The Political Unconscious* provides a suitable example of a kind of reading against the grain that a postcolonial interpretation demands, when faced with attempts to sublate the specific 'interruption', or the interstices, through which the colonial text utters its interrogations, its contrapuntal critique. Reading Conrad's narrative and ideological contradictions 'as a canceled realism . . . like Hegelian *Aufhebung*',[5] Jameson represents the fundamental ambivalences of the ethical (honour/guilt) and the aesthetic (premodern/postmodern) as the allegorical restitution of the socially concrete subtext of late nineteenth-century rationalization and reification. What his brilliant allegory of late capitalism fails to represent sufficiently, in *Lord Jim* for instance, is the specifically colonial address of the narrative aporia contained in the ambivalent, obsessive repetition of the phrase 'He was one of us' as the major trope of social and psychic identification throughout the text. The repetition of 'He was one of us' reveals the fragile margins of the concepts of Western civility and cultural community put under colonial stress; Jim is reclaimed at the moment when he is in danger of being cast out, or made outcast, manifestly 'not one of us'. Such a discursive ambivalence at the very heart of the issue of honour and duty in the colonial service represents the liminality, if not the end, of the masculinist, heroic ideal (and ideology) of a healthy imperial Englishness – those pink bits on the map that Conrad believed were genuinely salvaged by being the preserve of English colonization, which served the larger idea, and ideal, of Western civil society.

Such problematic issues are activated within the terms and

traditions of postcolonial critique as it reinscribes the cultural relations between spheres of social antagonism. Current debates in postmodernism question the cunning of modernity – its historical ironies, its disjunctive temporalities, its paradoxes of progress, its representational aporia. It would profoundly change the values, and judgements, of such interrogations, if they were open to the argument that metropolitan histories of civitas cannot be conceived without evoking the savage colonial antecedents of the ideals of civility. It also suggests, by implication, that the language of rights and obligations, so central to the modern myth of a people, must be questioned on the basis of the anomalous and discriminatory legal and cultural status assigned to migrant, diasporic, and refugee populations. Inevitably, they find themselves on the frontiers between cultures and nations, often on the other side of the law.

The postcolonial perspective forces us to rethink the profound limitations of a consensual and collusive 'liberal' sense of cultural community. It insists that cultural and political identity are constructed through a process of alterity. Questions of race and cultural difference overlay issues of sexuality and gender and overdetermine the social alliances of class and democratic socialism. The time for 'assimilating' minorities to holistic and organic notions of cultural value has dramatically passed. The very language of cultural community needs to be rethought from a postcolonial perspective, in a move similar to the profound shift in the language of sexuality, the self and cultural community, effected by feminists in the 1970s and the gay community in the 1980s.

Culture becomes as much an uncomfortable, disturbing practice of survival and supplementarity – between art and politics, past and present, the public and the private – as its resplendent being is a moment of pleasure, enlightenment or liberation. It is from such narrative positions that the postcolonial prerogative seeks to affirm and extend a new collaborative dimension, both

within the margins of the nation-space and across boundaries between nations and peoples. My use of poststructuralist theory emerges from this postcolonial contramodernity. I attempt to represent a certain defeat, or even an impossibility, of the 'West' in its authorization of the 'idea' of colonization. Driven by the subaltern history of the margins of modernity – rather than by the failures of logocentrism – I have tried, in some small measure, to revise the known, to rename the postmodern from the position of the postcolonial.

NEW TIMES

The enunciative position of contemporary cultural studies is both complex and problematic. It attempts to institutionalize a range of transgressive discourses whose strategies are elaborated around non-equivalent sites of representation where a history of discrimination and misrepresentation is common among, say, women, blacks, homosexuals and Third World migrants. However, the 'signs' that construct such histories and identities – gender, race, homophobia, postwar diaspora, refugees, the international division of labour, and so on – not only differ in content but often produce incompatible systems of signification and engage distinct forms of social subjectivity. To provide a social imaginary that is based on the articulation of differential, even disjunctive, moments of history and culture, contemporary critics resort to the peculiar temporality of the language metaphor. It is as if the arbitrariness of the sign, the indeterminacy of writing, the splitting of the subject of enunciation, these theoretical concepts, produce the most useful descriptions of the formation of 'postmodern' cultural subjects.

Cornel West enacts 'a measure of *synechdochical* thinking' (my emphasis) as he attempts to talk of the problems of address in the context of a black, radical, 'practicalist' culture:

> A tremendous articulateness is syncopated with the African drumbeat ... into an American postmodernist product: there is no subject expressing originary anguish here but a fragmented subject, pulling from past and present, innovatively producing a heterogeneous product. ... [I]t is part and parcel of the subversive energies of black underclass youth, energies that are forced to take a cultural mode of articulation.[6]

Stuart Hall, writing from the perspective of the fragmented, marginalized, racially discriminated against members of a post-Thatcherite underclass, questions the sententiousness of left orthodoxy where

> we go on thinking a unilinear and irreversible political logic, driven by some abstract entity that we call the economic or capital unfolding to its pre-ordained end.[7]

Earlier in his book, he uses the linguistic sign as a metaphor for a more differential and contingent political logic of ideology:

> [T]he ideological sign is always multi-accentual, and Janus-faced – that is, it can be discursively rearticulated to construct new meanings, connect with different social practices, and position social subjects differently. ... Like other symbolic or discursive formations, [ideology] is connective across different positions, between apparently dissimilar, sometimes contradictory, ideas. Its 'unity' is always in quotation marks and always complex, a suturing together of elements which have no necessary or eternal 'belongingness'. It is always, in that sense, organized around arbitrary and not natural closures.[8]

The 'language' metaphor raises the question of cultural difference and incommensurability, not the consensual, ethnocentric notion of the pluralistic existence of cultural diversity. It

represents the temporality of cultural meaning as 'multi-accentual', 'discursively rearticulated'. It is a time of the cultural sign that unsettles the liberal ethic of tolerance and the pluralist framework of multiculturalism. Increasingly, the issue of cultural difference emerges at points of social crises, and the questions of identity that it raises are agonistic; identity is claimed either from a position of marginality or in an attempt at gaining the centre: in both senses, ex-centric. In Britain today this is certainly true of the experimental art and film emerging from the left, associated with the postcolonial experience of migration and diaspora and articulated in the cultural exploration of new ethnicities.

The authority of customary, traditional practices – culture's relation to the historic past – is not dehistoricized in Hall's language metaphor. Those anchoring moments are revalued as a form of anteriority – a before that has no a priori(ty) – whose causality is effective because it returns to displace the present, to make it disjunctive. This kind of disjunctive temporality is of the utmost importance for the politics of cultural difference. It creates a signifying time for the inscription of cultural incommensurability where differences cannot be sublated or totalized because 'they somehow occupy the same space'.[9] It is this liminal form of cultural identification that is relevant to Charles Taylor's proposal for a 'minimal rationality' as the basis for non-ethnocentric, transcultural judgements. The effect of cultural incommensurability is that it 'takes us beyond merely *formal criteria of rationality*, and points us toward the human *activity of articulation* which gives the value of rationality its sense'.[10]

Minimal rationality, as the activity of articulation embodied in the language metaphor, alters the subject of culture from an epistemological function to an enunciative practice. If culture as epistemology focuses on function and intention, then culture as enunciation focuses on signification and institutionalization; if the epistemological tends towards a *reflection* of its empirical

referent or object, the enunciative attempts repeatedly to re-inscribe and relocate the political claim to cultural priority and hierarchy (high/low, ours/theirs) in the social institution of the signifying activity. The epistemological is locked into the her-meneutic circle, in the description of cultural elements as they tend towards a totality. The enunciative is a more dialogic pro-cess that attempts to track displacements and realignments that are the effects of cultural antagonisms and articulations – sub-verting the rationale of the hegemonic moment and relocating alternative, hybrid sites of cultural negotiation.

My shift from the cultural as an epistemological object to culture as an enactive, enunciatory site opens up possibilities for other 'times' of cultural meaning (retroactive, prefigurative) and other narrative spaces (fantasmic, metaphorical). My purpose in specifying the enunciative present in the articulation of culture is to provide a process by which objectified others may be turned into subjects of their history and experience. My theoretical argument has a descriptive history in recent work in literary and cultural studies by African American and black British writers. Hortense Spillers, for instance, evokes the field of 'enunciative possibility' to reconstitute the narrative of slavery:

> [A]s many times as we re-open slavery's closure we are hurtled rapidly forward into the dizzying motions of a symbolic enter-prise, and it becomes increasingly clear that the cultural syn-thesis we call 'slavery' was never homogenous in its practices and conceptions, nor unitary in the faces it has yielded.[11]

Deborah McDowell, in her reading of Sherley Anne Williams's *Dessa Rose*, argues that it is the temporality of the enunciatory ' "present" and its discourses . . . in heterogeneous and messy array', opened up in the narrative, that enables the book to wres-tle vigorously with 'the critique of the subject and the critique of binary oppositions . . . with questions of the politics and

problematics of language and representation'.[12] Paul Gilroy writes of the dialogic, performative 'community' of black music – rap, dub, scratching – as a way of constituting an open sense of black collectivity in the shifting, changing beat of the present.[13] More recently, Houston A. Baker, Jr, has made a spirited argument against 'high cultural' sententiousness and for the 'very, very sound game of rap (music)', which comes through vibrantly in the title of his essay *Hybridity, the Rap Race, and the Pedagogy of the 1990s*.[14] In his perceptive introduction to an anthology of black feminist criticism, Henry Louis Gates, Jr, describes the contestations and negotiations of black feminists as empowering cultural and textual strategies precisely because the critical position they occupy is free of the 'inverted' polarities of a 'counter-politics of exclusion':

> They have never been obsessed with arriving at any singular self-image; or legislating who may or may not speak on the subject; or policing boundaries between 'us' and 'them'.[15]

What is striking about the theoretical focus on the enunciatory present as a liberatory discursive strategy is its proposal that emergent cultural identifications are articulated at the liminal edge of identity – in that arbitrary closure, that 'unity . . . in quotation marks' (Hall) that the language metaphor so clearly enacts. Postcolonial and black critiques propose forms of contestatory subjectivities that are empowered in the act of erasing the politics of binary opposition – the inverted polarities of a counter-politics (Gates). There is an attempt to construct a theory of the social imaginary that requires no subject expressing originary anguish (West), no singular self-image (Gates), no necessary or eternal belongingness (Hall). The contingent and the liminal become the times and the spaces for the historical representation of the subjects of cultural difference in a postcolonial criticism.

It is the ambivalence enacted in the enunciative present — disjunctive and multiaccentual — that produces the objective of political desire, what Hall calls 'arbitrary closure', *like the signifier*. But this arbitrary closure is also the cultural space for opening up new forms of identification that may confuse the continuity of historical temporalities, confound the ordering of cultural symbols, traumatize tradition. The African drumbeat syncopating heterogeneous black American postmodernism, the arbitrary but strategic logic of politics — these moments contest the sententious 'conclusion' of the discipline of cultural history.

We cannot understand what is being proposed as 'new times' within postmodernism — politics at the site of cultural enunciation, cultural signs spoken at the margins of social identity and antagonism — if we do not briefly explore the paradoxes of the language metaphor. In each of the illustrations I've provided, the language metaphor opens up a space where a theoretical disclosure is used to move beyond theory. A form of cultural experience and identity is envisaged in a theoretical description that does not set up a theory–practice polarity, nor does theory become 'prior' to the contingency of social experience. This 'beyond theory' is itself a liminal form of signification that creates a space for the contingent, indeterminate articulation of social 'experience' that is particularly important for envisaging emergent cultural identities. But it is a representation of 'experience' without the transparent reality of empiricism and outside the intentional mastery of the 'author'. Nevertheless, it is a representation of social experience as the contingency of history — the indeterminacy that makes subversion and revision possible — that is profoundly concerned with questions of cultural 'authorization'.

To evoke this 'beyond theory', I turn to Roland Barthes's exploration of the cultural space 'outside the sentence'. In *The Pleasure of the Text* I find a subtle suggestion that beyond theory you do not simply encounter its opposition, theory/practice, but an

'outside' that places the articulation of the two – theory and practice, language and politics – in a productive relation similar to Derrida's notion of supplementarity:

> a non-dialectical middle, a structure of jointed predication, which cannot itself be comprehended by the predicates it distributes. . . . Not that this ability . . . shows a lack of power; rather this inability is constitutive of the very possibility of the logic of identity.[16]

OUTSIDE THE SENTENCE

Half-asleep on his banquette in a bar, of which Tangiers is the exemplary site, Barthes attempts to 'enumerate the stereophony of languages within earshot': music, conversations, chairs, glasses, Arabic, French.[17] Suddenly the inner speech of the writer turns into the exorbitant space of the Moroccan souk:

> [T]hrough me passed words, syntagms, bits of formulae and no sentence formed, as though that were the law of such a language. This speech at once very cultural and very savage, was above all lexical, sporadic; it set up in me, through its apparent flow, a definitive discontinuity: this non-sentence was in no way something that could not have acceded to the sentence, that might have been before the sentence; it was: what is . . . *outside the sentence.*[18]

At this point, Barthes writes, all linguistics that gives an exorbitant dignity to predicative syntax fell away. In its wake it becomes possible to subvert the 'power of completion which defines sentence mastery and marks, as with a supreme, dearly won, conquered *savoir faire*, the agents of the sentence'.[19] The hierarchy and the subordinations of the sentence are replaced by the definitive discontinuity of the text, and what

emerges is a form of writing that Barthes describes as 'writing aloud':

> a text of pulsional incidents, the language lined with flesh, a text where we can hear the grain of the throat . . . a whole carnal stereophony: the articulation of the tongue, not the meaning of language.[20]

Why return to the semiotician's daydream? Why begin with 'theory' as story, as narrative and anecdote, rather than with the history or method? Beginning with the semiotic project – enumerating all the languages within earshot – evokes memories of the seminal influence of semiotics within our contemporary critical discourse. To that end, this *petit récit* rehearses some of the major themes of contemporary theory prefigured in the practice of semiotics – the author as an enunciative space; the formation of textuality after the fall of linguistics; the agonism between the sentence of predicative syntax and the discontinuous subject of discourse; the disjunction between the lexical and the grammatical dramatized in the liberty (perhaps libertinism) of the signifier.

To encounter Barthes's daydream is to acknowledge the formative contribution of semiotics to those influential concepts – sign, text, limit text, idiolect, *écriture* – that have become all the more important since they have passed into the unconscious of our critical trade. When Barthes attempts to produce, with his suggestive, erratic brilliance, a space for the pleasure of the text somewhere between 'the political policeman and the psychoanalytical policeman' – that is, between 'futility and/or guilt, pleasure is either idle or vain, a class notion or an illusion'[21] – he evokes memories of the attempts, in the late 1970s and mid-1980s, to hold fast the political line while the poetic line struggled to free itself from its post-Althusserian arrest. What guilt, what pleasure.

To thematize theory is, for the moment, beside the point. To reduce this weird and wonderful daydream of the semiotic pedagogue, somewhat in his cups, to just another repetition of the theoretical litany of the death of the author would be reductive in the extreme. For the daydream takes semiotics by surprise; it turns pedagogy into the exploration of its own limits. If you seek simply the sententious or the exegetical, you will not grasp the hybrid moment outside the sentence – not quite experience, not yet concept; part dream, part analysis; neither signifier nor signified. This intermediate space between theory and practice disrupts the disciplinary semiological demand to enumerate all the languages within earshot.

Barthes's daydream is supplementary, not alternative, to acting in the real world, Freud reminds us; the structure of fantasy narrates the subject of daydream as the articulation of incommensurable temporalities, disavowed wishes, and discontinuous scenarios. The meaning of fantasy does not emerge in the predicative or propositional value we might attach to being outside the sentence. Rather, the performative structure of the text reveals a temporality of discourse that I believe is significant. It opens up a narrative strategy for the emergence and negotiation of those agencies of the marginal, minority, subaltern, or diasporic that incite us to think through – and beyond – theory.

What is caught anecdotally 'outside the sentence', in Barthes's concept, is that problematic space – performative rather than experiential, non-sententious but no less theoretical – of which poststructuralist theory speaks in its many varied voices. In spite of the fall of a predictable, predicative linguistics, the space of the non-sentence is not a negative ontology: not *before* the sentence but something that *could have* acceded to the sentence and yet was *outside it*. This discourse is indeed one of indeterminism, unexpectability, one that is neither 'pure' contingency or negativity nor endless deferral. 'Outside the sentence' is not to be opposed to the inner voice; the non-sentence does not relate to

the sentence as a polarity. The timeless capture that stages such epistemological 'confrontations', in Richard Rorty's term, is now interrupted and interrogated in the doubleness of writing – 'at once very cultural and very savage', 'as though that were the law of such a language'.[22] This disturbs what Derrida calls the occidental stereotomy, the ontological, circumscribing space between subject and object, inside and outside.[23] It is the question of agency, as it emerges in relation to the indeterminate and the contingent, that I want to explore 'outside the sentence'. However, I want to preserve, at all times, that menacing sense in which the non-sentence is contiguous with the sentence, near but different, not simply its anarchic disruption.

TANGIERS OR CASABLANCA?

What we encounter outside the sentence, beyond the occidental stereotomy, is what I shall call the 'temporality' of Tangiers. It is a structure of temporality that will emerge only slowly and indirectly, as time goes by, as they say in Moroccan bars, whether in Tangiers or Casablanca. There is, however, an instructive difference between Casablanca and Tangiers. In Casablanca the passage of time preserves the identity of language; the possibility of naming over time is fixed in the repetition:

> You must remember this
> a kiss is still a kiss
> a sigh is but a sigh
> the fundamental things apply
> As times goes by.
>
> (*Casablanca*)

'Play it again, Sam', which is perhaps the Western world's most celebrated demand for repetition, is still an invocation to similitude, a return to the eternal verities.

In Tangiers, as time goes by, it produces an iterative temporality that erases the occidental spaces of language – inside/outside, past/present, those foundationalist epistemological positions of Western empiricism and historicism. Tangiers opens up disjunctive, incommensurable relations of spacing and temporality within the sign – an 'internal difference of the so-called ultimate element (*stoikheion*, trait, letter, seminal mark)'.[24] The non-sentence is not before (either as the past or a priori) or inside (either as depth or presence) but outside (both spatially and temporally ex-centric, interruptive, in-between, on the border-lines, turning inside outside). In each of these inscriptions there is a doubling and a splitting of the temporal and spatial dimensions in the very act of signification. What emerges in this agonistic, ambivalent form of speech – 'at once very cultural and very savage' – is a question about the subject of discourse and the agency of the letter: can there be a social subject of the 'non-sentence'? Is it possible to conceive of historical agency in that disjunctive, indeterminate moment of discourse outside the sentence? Is the whole thing no more than a theoretical fantasy that reduces any form of political critique to a daydream?

These apprehensions about the agency of the aporetic and the ambivalent become more acute when political claims are made for their strategic action. This is precisely Terry Eagleton's recent position, in his critique of the libertarian pessimism of poststructuralism:

> [It is] libertarian because something of the old model of expression/repression lingers on in the dream of an entirely free-floating signifier, an infinite textual productivity, an existence blessedly free from the shackles of truth, meaning and sociality. Pessimistic, because whatever blocks such creativity – law, meaning, power, closure – is acknowledged to be built into it, in a sceptical recognition of the imbrication of authority and desire.[25]

The agency implicit in this discourse is objectified in a structure of the negotiation of meaning that is not a free-floating time lack but a time-lag – a contingent moment – in the signification of closure. Tangiers, the 'sign' of the 'non-sentence' turns retroactively, at the end of Barthes's essay, into a form of discourse that he names 'writing aloud'. The time-lag between the event of the sign (Tangiers) and its discursive eventuality (writing aloud) exemplifies a process where intentionality is negotiated retrospectively.[26] The sign finds its closure retroactively in a discourse that it anticipates in the semiotic fantasy: there is a contiguity, a coextensivity, between Tangiers (as sign) and writing aloud (discursive formation), in that writing aloud is the mode of inscription of which Tangiers is a sign. There is no strict causality between Tangiers as the beginning of predication and writing aloud as the end or closure; but there is no free-floating signifier or an infinity of textual productivity. There is the more complex possibility of negotiating meaning and agency through the time-lag in-between the sign (Tangiers) and its initiation of a discourse or narrative, where the relation of theory to practice is part of what Rodolphe Gasché termed 'jointed predication'. In this sense, closure comes to be effected in the contingent moment of repetition, 'an overlap without equivalence: fort:da'.[27]

The temporality of Tangiers is a lesson in reading the agency of the social text as ambivalent and catachrestic. Gayatri Spivak has usefully described the 'negotiation' of the postcolonial position 'in terms of reversing, displacing and seizing the apparatus of value-coding', constituting a catachrestic space: words or concepts wrested from their proper meaning, 'a concept-metaphor without an adequate referent' that perverts its embedded context. Spivak continues, 'Claiming catechresis from a space that one cannot not want to inhabit [the sentence, sententious], yet must criticize [from outside the sentence] is then, the deconstructive predicament of the postcolonial.'[28]

This Derridean position is close to the conceptual predicament

outside the sentence. I have attempted to provide the discursive temporality, or time-lag, which is crucial to the process by which this turning around – of tropes, ideologies, concept metaphors – comes to be textualized and specified in postcolonial agency: the moment when the 'bar' of the occidental stereotomy is turned into the coextensive, contingent boundaries of relocation and reinscription: the catachrestic gesture. The insistent issue in any such move is the nature of the negotiatory agent realized through the time-lag. How does agency come to be specified and individuated, outside the discourse of individualism? How does the time-lag signify individuation as a position that is an effect of the 'intersubjective': contiguous with the social and yet contingent, indeterminate, in relation to it?[29]

Writing aloud, for Barthes, is neither the 'expressive' function of language as authorial intention or generic determination nor meaning personified.[30] It is similar to the *actio* repressed by classical rhetoric, and it is the 'corporeal exteriorization of discourse'. It is the art of guiding one's body into discourse, in such a way that the subject's accession to, and erasure in, the signifier as individuated is paradoxically accompanied by its remainder, an afterbirth, a double. Its noise – 'crackle, grate, cut' – makes vocal and visible, across the flow of the sentence's communicative code, the struggle involved in the insertion of agency – wound and bow, death and life – into discourse.

In Lacanian terms, which are appropriate here, this 'noise' is the 'leftover' after the *capitonnage*, or positioning, of the signifier for the subject. The Lacanian 'voice' that speaks outside the sentence is itself the voice of an interrogative, calculative agency: '*Che vuoi?* You are telling me that, but what do you want with it, what are you aiming at?' (For a clear explanation of this process, see Zizek, *The Sublime Object of Ideology*.[31]) What speaks in the place of this question, Jacques Lacan writes, is a 'third locus which is neither my speech nor my interlocutor'.[32]

The time-lag opens up this negotiatory space between putting

the question to the subject and the subject's repetition 'around' the neither/nor of the third locus. This constitutes the return of the subject agent, as the interrogative agency in the catechrestic position. Such a disjunctive space of temporality is the locus of symbolic identification that structures the intersubjective realm – the realm of otherness and the social – where 'we identify ourselves with the other precisely at a point at which he is inimitable, at the point which eludes resemblance.'[33] My contention, elaborated in my writings on postcolonial discourse in terms of mimicry, hybridity, sly civility, is that this liminal moment of identification – eluding resemblance – produces a subversive strategy of subaltern agency that negotiates its own authority through a process of iterative 'unpicking' and incommensurable, insurgent relinking. It singularizes the 'totality' of authority by suggesting that agency requires a grounding, but it does not require a totalization of those grounds; it requires movement and manoeuvre, but it does not require a temporality of continuity or accumulation; it requires direction and contingent closure but no teleology and holism. (For elaboration of these concepts, see Chapters 1 and 8.)

The individuation of the agent occurs in a moment of displacement. It is a pulsional incident, the split-second movement when the process of the subject's designation – its fixity – opens up beside it, uncannily *abseits*, a supplementary space of contingency. In this 'return' of the subject, thrown back across the distance of the signified, outside the sentence, the agent emerges as a form of retroactivity, *Nachträglichkeit*. It is not agency as itself (transcendent, transparent) or in itself (unitary, organic, autonomous). As a result of its own splitting in the time-lag of signification, the moment of the subject's individuation emerges as an effect of the intersubjective – as the return of the subject as agent. This means that those elements of social 'consciousness' imperative for agency – deliberative, individuated action and specificity in analysis – can now be thought outside that

epistemology that insists on the subject as always prior to the social or on the knowledge of the social as necessarily subsuming or sublating the particular 'difference' in the transcendent homogeneity of the general. The iterative and contingent that marks this intersubjective relation can never be libertarian or free-floating, as Eagleton claims, because the agent, constituted in the subject's return, is in the dialogic position of calculation, negotiation, interrogation: *Che vuoi?*

AGENT WITHOUT A CAUSE?

Something of this genealogy of postcolonial agency has already been encountered in my expositions of the ambivalent and the multivalent in the language metaphor at work in West's 'synech-dochical thinking' about black American cultural hybridity and Hall's notion of 'politics like a language'. The implications of this line of thinking were productively realized in the work of Spillers, McDowell, Baker, Gates and Gilroy, all of whom emphasize the importance of the creative heterogeneity of the enunciatory 'present' that liberates the discourse of emancipation from binary closures. I want to give contingency another turn – through the Barthesian fantasy – by throwing the last line of the text, its conclusion, together with an earlier moment when Barthes speaks suggestively of closure as agency. Once again, we have an overlap without equivalence. For the notion of a non-teleological and a non-dialectical form of closure has often been considered the most problematic issue for the postmodern agent without a cause:

> [Writing aloud] succeed[s] in shifting the signified a great distance and in throwing, so to speak, the anonymous body of the actor into my ear. . . . And this body of bliss is also *my historical subject*; for it is at the *conclusion* of a very complex process of biographical, historical, sociological, neurotic elements . . . that

I control the contradictory interplay of [cultural] pleasure and [non-cultural] bliss that I write myself as a subject at present out of place.[34]

The contingency of the subject as agent is articulated in a double dimension, a dramatic action. The signified is distanced; the resulting time lag opens up the space between the lexical and the grammatical, between enunciation and enounced, in-between the anchoring of signifiers. Then, suddenly, this in-between spatial dimension, this distancing, converts itself into the temporality of the 'throw' that iteratively (re)turns the subject as a moment of conclusion and control: a historically or contextually specific subject. How are we to think the control or conclusion in the context of contingency?

We need, not surprisingly, to invoke both meanings of *contingency* and then to repeat the difference of the one in the other. Recall my suggestion that to interrupt the occidental stereotomy – inside/outside, space/time – one needs to think, outside the sentence, at once very cultural and very savage. The contingent is contiguity, metonymy, the touching of spatial boundaries at a tangent, and, at the same time, the contingent is the temporality of the indeterminate and the undecidable. It is the kinetic tension that holds this double determination together and apart within discourse. They represent the repetition of the one in or as the other, in a structure of 'abyssal overlapping' (a Derridean term) which enables us to conceive of strategic closure and control for the agent. Representing social contradiction or antagonism in this doubling discourse of contingency – where the spatial dimension of contiguity is reiterated in the temporality of the indeterminate – cannot be dismissed as the arcane practice of the undecidable or aporetic.

The importance of the problematic of contingency for historical discourse is evident in Ranajit Guha's attempt to represent the specificity of rebel consciousness.[35] Guha's argument reveals

the need for such a double and disjunctive sense of the contingent, although his own reading of the concept, in terms of the 'universal-contingent' couple, is more Hegelian in its elaboration.[36] Rebel consciousness is inscribed in two major narratives. In bourgeois-nationalist historiography, it is seen as 'pure spontaneity pitted against the will of the State as embodied in the Raj'. The will of the rebels is either denied or subsumed in the individualized capacity of their leaders, who frequently belong to the elite gentry. Radical historiography failed to specify rebel consciousness because its continuist narrative ranged 'peasant revolts as a succession of events ranged along a direct line of descent . . . as a heritage'. In assimilating all moments of rebel consciousness to the 'highest moment of the series – indeed to an Ideal Consciousness' – these historians 'are ill-equipped to cope with contradictions which are indeed the stuff history is made of'.[37]

Guha's elaborations of rebel contradiction as consciousness are strongly suggestive of agency as the activity of the contingent. What I have described as the return of the subject is present in his account of rebel consciousness as self-alienated. My suggestion that the problematic of contingency strategically allows for a spatial contiguity – solidarity, collectivite action – to be (re)articulated in the moment of indeterminacy is, reading between the lines, very close to his sense of the strategic alliances at work in the contradictory and hybrid sites, and symbols, of peasant revolt. What historiography fails to grasp is indeed agency at the point of the 'combination of sectarianism and militancy . . . [specifically] the *ambiguity* of such phenomena'; causality as the 'time' of indeterminate articulation: 'the *swift* transformation of class struggle into communal strife and vice versa in our countryside'; and ambivalence at the point of 'individuation' as an intersubjective affect:

Blinded by the glare of a perfect and immaculate conscious-

ness the historian sees nothing ... but solidarity in rebel behaviour and fails to notice its Other, namely, betrayal. . . . He understimates the brakes put on [insurgency as a *generalized movement*] by localism and territoriality.[38]

Finally, as if to provide an emblem for my notion of agency in the apparatus of contingency – its hybrid figuring of space and time – Guha, quoting Sunil Sen's *Agrarian Struggle in Bengal*, beautifully describes the 'ambiguity of such phenomena' as the hybridized signs and sites during the Tebhaga movement in Dinajpur:

Muslim peasants [came] to the Kisan Sabha 'sometimes inscribing a hammer and a sickle on the Muslim League flag' and young maulavis '[recited] melodious verses from the Koran' at village meetings 'as they condemned the jotedari system and the practice of charging high interest rates.'[39]

THE SOCIAL TEXT: BAKHTIN AND ARENDT

The contingent conditions of agency also take us to the heart of Mikhail M. Bakhtin's important attempt, in speech genres, to designate the enunciative subject of heteroglossia and dialogism.[40] As with Guha, my reading will be catechrestic: reading between the lines, taking neither him at his word nor me fully at mine. In focusing on how the chain of speech communication comes to be constituted, I deal with Bakhtin's attempt to individuate social agency as an after-effect of the intersubjective. My cross-hatched matrix of contingency – as spatial difference and temporal distance, to turn the terms somewhat – enables us to see how Bakhtin provides a knowledge of the transformation of social discourse while displacing the originating subject and the causal and continuist progress of discourse:

> The object, as it were, has already been articulated, disputed, elucidated and evaluated in various ways. . . . The speaker is not the biblical Adam . . . as simplistic ideas about communication as a logical-psychological basis for the sentence suggest.[41]

Bakhtin's use of the metaphor of the chain of communication picks up the sense of contingency as contiguity, while the question of the 'link' immediately raises the issue of contingency as the indeterminate. Bakhtin's displacement of the author as agent results from his acknowledgement of the 'complex, multiplanar' structure of the speech genre that exists in that kinetic tension in-between the two forces of contingency. The spatial boundaries of the object of utterance are contiguous in the assimilation of the other's speech; but the allusion to another's utterance produces a dialogical turn, a moment of indeterminacy in the act of 'addressivity' (Bakhtin's concept) that gives rise within the chain of speech communion to 'unmediated responsive reactions and dialogic reverberations'.[42]

Although Bakhtin acknowledges this double movement in the chain of the utterance, there is a sense in which he disavows its effectivity at the point of the enunciation of discursive agency. He displaces this conceptual problem that concerns the performativity of the speech-act – its enunciative modalities of time and space – to an empiricist acknowledgement of the 'area of human activity and everyday life to which the given utterance is related'.[43] It is not that the social context does not localize the utterance; it is simply that the process of specification and individuation still needs to be elaborated within Bakhtin's theory, as the modality through which the speech genre comes to recognize the specific as a signifying limit, a discursive boundary.

There are moments when Bakhtin obliquely touches on the tense doubling of the contingent that I have described. When he talks of the 'dialogic overtones' that permeate the agency of

utterance – 'many half-concealed or completely concealed words of others with varying degrees of foreignness' – his metaphors hint at the iterative intersubjective temporality in which the agency is realized 'outside' the author:

> [T]he utterance appears to be furrowed with distant and barely audible echoes of changes of speech subjects and dialogic overtones, greatly weakened utterance boundaries that are completely permeable to the author's expression. The utterance proves to be a very complex and multiplanar phenomenon if considered not in isolation and with respect to its author ... but as a link in the chain of speech communication and with respect to other related utterances. . . .[44]

Through this landscape of echoes and ambivalent boundaries, framed in passing, furrowed horizons, the agent who is 'not Adam' but is, indeed, time-lagged, emerges into the social realm of discourse.

Agency, as the return of the subject, as 'not Adam', has a more directly political history in Hannah Arendt's portrayal of the troubled narrative of social causality. According to Arendt the notorious uncertainty of all political matters arises from the fact that the disclosure of *who* – the agent as individuation – is contiguous with the *what* of the intersubjective realm. This contiguous relation between *who* and *what* cannot be transcended but must be accepted as a form of indeterminism and doubling. The *who* of agency bears no mimetic immediacy or adequacy of representation. It can only be signified outside the sentence in that sporadic, ambivalent temporality that inhabits the notorious unreliability of ancient oracles who 'neither reveal nor hide in words but give manifest signs'.[45] The unreliability of signs introduces a perplexity in the social text:

> The perplexity is that in any series of events that together form

> a story with a unique meaning we can at best isolate the agent who set the whole process into motion; and although this agent frequently remains the subject, the 'hero' of the story, we can never point unequivocally to him as the author of its outcome.[46]

This is the structure of the intersubjective space between agents, what Arendt terms human 'inter-est'. It is this public sphere of language and action that must become at once the theatre and the screen for the manifestation of the capacities of human agency. Tangiers-like, the event and its eventuality are separated; the narrative time-lag makes the *who* and the *what* contingent, splitting them, so that the agent remains the subject, in suspension, outside the sentence. The agent who 'causes' the narrative becomes part of the interest, only because we cannot point unequivocally to that agent at the point of outcome. It is the contingency that constitutes individuation – in the return of the subject as agent – that protects the interest of the intersubjective realm.

The contingency of closure socializes the agent as a collective 'effect' through the distancing of the author. Between the cause and its intentionality falls the shadow. Can we then unquestionably propose that a story has a unique meaning in the first place? To what end does the series of events tend if the author of the outcome is not unequivocally the author of the cause? Does it not suggest that agency arises in the return of the subject, from the interruption of the series of events as a kind of interrogation and reinscription of before and after? Where the two touch is there not that kinetic tension between the contingent as the contiguous and the indeterminate? Is it not from there that agency speaks and acts: *Che vuoi?*

These questions are provoked by Arendt's brilliant suggestiveness, for her writing symptomatically performs the perplexities she evokes. Having brought close together the unique

meaning and the causal agent, she says that the 'invisible actor' is an 'invention arising from a mental perplexity' corresponding to no real experience.[47] It is this distancing of the signified, this anxious fantasm or simulacrum – in the place of the author – that, according to Arendt, indicates most clearly the political nature of history. The sign of the political is, moreover, not invested in 'the character of the story itself but only [in] the *mode* in which it came into existence'.[48] So it is the realm of representation and the process of signification that constitutes the space of the political. What is temporal in the mode of existence of the political? Here Arendt resorts to a form of repetition to resolve the ambivalence of her argument. The 'reification' of the agent can only occur, she writes, through 'a kind of repetition, the imitation of mimesis, which according to Aristotle prevails in all arts but is actually appropriate to the drama'.[49]

This repetition of the agent, reified in the liberal vision of togetherness, is quite different from my sense of the contingent agency for our postcolonial age. The reasons for this are not difficult to find. Arendt's belief in the revelatory qualities of Aristotelian mimesis are grounded in a notion of community, or the public sphere, that is largely consensual: 'where people are with others and neither for nor against them – that is sheer human togetherness'.[50] When people are passionately for or against one another, then human togetherness is lost as they deny the fullness of Aristotelian mimetic time. Arendt's form of social mimesis does not deal with social marginality as a product of the liberal State, which can, if articulated, reveal the limitations of its common sense (inter-est) of society from the perspective of minorities or the marginalized. Social violence is, for Arendt, the denial of the disclosure of agency, the point at which 'speech becomes "mere talk", simply one more means towards the end'.[51]

My concern is with other articulations of human togetherness,

as they are related to cultural difference and discrimination. For instance, human togetherness may come to represent the forces of hegemonic authority; or a solidarity founded in victimization and suffering may, implacably, sometimes violently, become bound against oppression; or a subaltern or minority agency may attempt to interrogate and rearticulate the 'inter-est' of society that marginalizes its interests. These discourses of cultural dissent and social antagonism cannot find their agents in Arendt's Aristotelian mimesis. In the process I've described as the return of the subject, there is an agency that seeks revision and reinscription: the attempt to renegotiate the third locus, the intersubjective realm. The repetition of the iterative, the activity of the time-lag, is not so much arbitrary as interruptive, a closure that is not conclusion but a liminal interrogation outside the sentence.

In 'Where is speech? Where is language?' Lacan describes this moment of negotiation from within the 'metaphoricity' of language while making a laconic reference to the ordering of symbols in the realm of social discourse:

> It is the temporal element ... or the temporal break ... the intervention of a scansion permitting the intervention of something which can take on meaning for a subject. ... There is in fact a reality of signs within which there exists a world of truth entirely deprived of subjectivity, and that, on the other hand there has been a historical development of subjectivity manifestly directed towards the rediscovery of truth which lies in the order of symbols.[52]

The process of reinscription and negotiation – the insertion or intervention of something that takes on new meaning – happens in the temporal break in-between the sign, deprived of subjectivity, in the realm of the intersubjective. Through this time-lag – the temporal break in representation – emerges the process of

agency both as a historical development and as the narrative agency of historical discourse. What comes out so clearly in Lacan's genealogy of the subject is that the agent's intentionality, which seems 'manifestly directed' towards the truth of the order of symbols in the social imaginary, is also an effect of the rediscovery of the world of truth denied subjectivity (because it is intersubjective) at the level of the sign. It is in the contingent tension that results, that sign and symbol overlap and are indeterminately articulated through the 'temporal break'. Where the sign deprived of the subject – intersubjectivity – returns as subjectivity directed towards the rediscovery of truth, then a (re)ordering of symbols becomes possible in the sphere of the social. When the sign ceases the synchronous flow of the symbol, it also seizes the power to elaborate – through the time-lag – new and hybrid agencies and articulations. This is the moment for revisions.

REVISIONS

The concept of reinscription and negotiation that I am elaborating must not be confused with the powers of 'redescription' that have become the hallmark of the liberal ironist or neo-pragmatist. I do not offer a critique of this influential non-foundationalist position here except to point to the obvious differences of approach. Rorty's conception of the representation of difference in social discourse is the consensual overlapping of 'final vocabularies' that allow imaginative identification with the other so long as certain words – 'kindness, decency, dignity' – are held in common.[53] However, as he says, the liberal ironist can never elaborate an empowering strategy. Just how disempowering his views are for the non-Western other, how steeped in a Western ethnocentricism, is seen, appropriately for a non-foundationalist, in a footnote.

Rorty suggests that

> liberal society already contains the institutions for its own improvement [and that] Western social and political thought may have had the last conceptual revolution it needs in J. S. Mill's suggestion that governments should optimize the balance between leaving people's private lives alone and preventing suffering.[54]

Appended to this is the footnote where liberal ironists suddenly lose their powers of redescription:

> This is not to say that the world has had the last political revolution it needs. It is hard to imagine the diminution of cruelty in countries like South Africa, Paraguay, and Albania without violent revolution. . . . But in such countries raw courage (like that of the leaders of COSATU or the signers of Charta 77) is the relevant virtue, not the sort of reflective acumen which makes contributions to social theory.[55]

This is where Rorty's conversation stops, but we must force the dialogue to acknowledge postcolonial social and cultural theory that reveals the limits of liberalism in the postcolonial perspective: 'Bourgeois culture hits its historical limit in colonialism,' writes Guha sententiously,[56] and, almost as if to speak 'outside the sentence', Veena Das reinscribes Guha's thought into the affective language of a metaphor and the body: 'Subaltern rebellions can only provide a night-time of love. . . . Yet perhaps in capturing this defiance the historian has given us a means of constructing the objects of such power as *subjects*.'[57]

In her excellent essay 'Subaltern as perspective', Das demands a historiography of the subaltern that displaces the paradigm of social action as defined primarily by rational action. She seeks a form of discourse where affective and iterative writing develops its own language. History as a writing that constructs the

moment of defiance emerges in the 'magma of significations', for the 'representational closure which presents itself when we encounter thought in objectified forms is now ripped open. Instead we see this order interrogated.'[58] In an argument that demands an enunciative temporality remarkably close to my notion of the time-lag that circulates at the point of the sign's seizure/caesura of symbolic synchronicity, Das locates the moment of transgression in the splitting of the discursive present: a greater attention is required to locate transgressive agency in 'the splitting of the various types of speech produced into statements of referential truth in the indicative present'.[59]

This emphasis on the disjunctive present of utterance enables the historian to get away from defining subaltern consciousness as binary, as having positive or negative dimensions. It allows the articulation of subaltern agency to emerge as relocation and reinscription. In the seizure of the sign, as I've argued, there is neither dialectical sublation nor the empty signifier: there is a contestation of the given symbols of authority that shift the terrains of antagonism. The synchronicity in the social ordering of symbols is challenged within its own terms, but the grounds of engagement have been displaced in a supplementary movement that exceeds those terms. This is the historical movement of hybridity as camouflage, as a contesting, antagonistic agency functioning in the time-lag of sign/symbol, which is a space in-between the rules of engagement. It is this theoretical form of political agency I've attempted to develop that Das beautifully fleshes out in a historical argument:

> It is the nature of the conflict within which a caste or tribe is locked which may provide the characteristics of the historical moment; to assume that we may know a priori the mentalities of castes or communities is to take an essentialist perspective which the evidence produced in the very volumes of *Subaltern Studies* would not support.[60]

Is the contingent structure of agency not similar to what Frantz Fanon describes as the knowledge of the practice of action?[61] Fanon argues that the primitive Manichaeanism of the settler – black and white, Arab and Christian – breaks down in the present of struggle for independence. Polarities come to be replaced with truths that are only partial, limited and unstable. Each 'local ebb of the tide reviews the political question from the standpoint of all political networks.' The leaders should stand firmly against those within the movement who tend to think that 'shades of meaning constitute dangers and drive wedges into the solid block of popular opinion'.[62] What Das and Fanon both describe is the potentiality of agency constituted through the strategic use of historical contingency.

The form of agency that I've attempted to describe through the cut and thrust of sign and symbol, the signifying conditions of contingency, the night-time of love, returns to interrogate that most audacious dialectic of modernity provided by contemporary theory – Foucault's 'Man and his doubles'. Foucault's productive influence on postcolonial scholars, from Australia to India, has not been unqualified, particularly in his construction of modernity. Mitchell Dean, writing in the Melbourne journal Thesis Eleven, remarks that the identity of the West's modernity obsessively remains 'the most general horizon under which all of Foucault's actual historical analyses are landmarked'.[63] And for this very reason, Partha Chatterjee argues that Foucault's genealogy of power has limited uses in the developing world. The combination of modern and archaic regimes of power produces unexpected forms of disciplinarity and governmentality that make Foucault's epistemes inappropriate, even obsolete.[64]

But could Foucault's text, which bears such an attenuated relation to Western modernity, be free of that epistemic displacement – through the (post)colonial formation – that constitutes the West's sense of itself as progressive, civil, modern? Does the disavowal of colonialism turn Foucault's 'sign' of the

West into the symptom of an obsessional modernity? Can the colonial moment ever not be contingent – the contiguous *as* indeterminacy – to Foucault's argument?

At the magisterial end of Foucault's *The Order of Things*, when the section on history confronts its uncanny doubles – the counter-sciences of anthropology and psychoanalysis – the argument begins to unravel. It happens at a symptomatic moment when the representation of cultural difference attenuates the sense of history as the embedding, domesticating 'homeland' of the human sciences. For the finitude of history – its moment of doubling – participates in the conditionality of the contingent. An incommensurable doubleness ensues between history as the 'homeland' of the human sciences – its cultural area, its chronological or geographical boundaries – and the claims of historicism to universalism. At that point, 'the subject of knowledge becomes the nexus of different times, foreign to it and heterogeneous in respect to one another.'[65] In that contingent doubling of history and nineteenth-century historicism the time-lag in the discourse enables the return of historical agency:

> Since *time* comes to him from somewhere other than himself
> he constitutes himself as a subject of history only by the super-
> imposition of . . . the history of things, the history of words. . . .
> But this relation of simple passivity is immediately reversed . . .
> for he too has a right to a development quite as positive as that
> of beings and things, one no less autonomous.[66]

As a result the *heimlich* historical subject that arises in the nineteenth century cannot stop constituting the *unheimlich* knowledge of itself by compulsively relating one cultural episode to another in an infinitely repetitious series of events that are metonymic and indeterminate. The grand narratives of nineteenth-century historicism on which its claims to universalism were founded – evolutionism, utilitarianism, evangelism – were also, in another

textual and territorial time/space, the technologies of colonial and imperialist governance. It is the 'rationalism' of these ideologies of progress that increasingly comes to be eroded in the encounter with the contingency of cultural difference. Elsewhere I have explored this historical process, perfectly caught in the picturesque words of a desperate missionary in the early nineteenth century as the colonial predicament of 'sly civility' (see Chapter 5). The result of this colonial encounter, its antagonisms and ambivalences, has a major effect on what Foucault beautifully describes as the 'slenderness of the narrative' of history in that era most renowned for its historicizing (and colonizing) of the world and the word.[67]

History now 'takes place on the outer limits of the object and subject', Foucault writes,[68] and it is to probe the uncanny unconscious of history's doubling that he resorts to anthropology and psychoanalysis. In these disciplines the cultural unconscious is spoken in the slenderness of narrative – ambivalence, catachresis, contingency, iteration, abyssal overlapping. In the agonistic temporal break that articulates the cultural symbol to the psychic sign, we shall discover the postcolonial symptom of Foucault's discourse. Writing of the history of anthropology as the 'counter-discourse' to modernity – as the possibility of a human science postmodernism – Foucault says:

> There is a certain position in the Western *ratio* that was constituted in its history and provides a foundation for the relation it can have with all other societies, *even with the society in which it historically appeared.*[69]

Foucault fails to elaborate that 'certain position' and its historical constitution. By disavowing it, however, he names it as a negation in the very next line which reads: 'Obviously this does not mean that the colonizing situation is indispensable to ethnology.'

Are we demanding that Foucault should reinstate colonialism as the missing moment in the dialectic of modernity? Do we want him to 'complete' the argument by appropriating ours? Definitely not. I suggest that the postcolonial perspective is subversively working in his text in that moment of contingency that allows the contiguity of his argument – thought following thought – to progress. Then, suddenly, at the point of its closure, a curious indeterminacy enters the chain of discourse. This becomes the space for a new discursive temporality, another place of enunciation that will not allow the argument to expand into an unproblematic generality.

In this spirit of conclusion, I want to suggest a departure for the postcolonial text in the Foucauldian forgetting. In talking of psychoanalysis Foucault is able to see how knowledge and power come together in the enunciative 'present' of transference: the 'calm violence' – as he calls it – of a relationship that constitutes the discourse. By disavowing the colonial moment as an enunciative present in the historical and epistemological condition of Western modernity, Foucault can say little about the transferential relation between the West and its colonial history. He disavows precisely the colonial text as the foundation for the relation the Western ratio can have 'even with the society in which it historically appeared.'[70]

Reading from this perspective we can see that, in insistently spatializing the 'time' of history, Foucault constitutes a doubling of 'man' that is strangely collusive with its dispersal, equivalent to its equivocation, and uncannily self-constituting, despite its game of 'double and splits'. Reading from the transferential perspective, where the Western ratio returns to itself from the time-lag of the colonial relation, then we see how modernity and postmodernity are themselves constituted from the marginal perspective of cultural difference. They encounter themselves contingently at the point at which the internal difference of their own society is reiterated in terms

of the difference of the other, the alterity of the postcolonial site.

At this point of self-alienation postcolonial agency returns, in a spirit of calm violence, to interrogate Foucault's fluent doubling of the figures of modernity. What it reveals is not some buried concept but a truth about the symptom of Foucault's thinking, the style of discourse and narrative that objectifies his concepts. It reveals the reason for Foucault's desire to anxiously play with the folds of Western modernity, fraying the finitudes of human beings, obsessively undoing and doing up the threads of that 'slender narrative' of nineteenth-century historicism. This nervous narrative illustrates and attenuates his own argument; like the slender thread of history, it refuses to be woven in, menacingly hanging loose from the margins. What stops the narrative thread from breaking is Foucault's concern to introduce, at the nexus of his doubling, the idea that 'the man who appears at the beginning of the nineteenth century is dehistoricized.'[71]

The dehistoricized authority of 'Man and his doubles' produces, in the same historical period, those forces of normalization and naturalization that create a modern Western disciplinary society. The invisible power that is invested in this dehistoricized figure of Man is gained at the cost of those 'others' – women, natives, the colonized, the indentured and enslaved – who, at the same time but in other spaces, were becoming the peoples without a history.

10

BY BREAD ALONE

Signs of violence in the mid-nineteenth century

There is often in the Simultaneous, the Coincidental, an apparent uniformity of tendency, which simulates designs, but which so far as human agency is concerned, is wholly fortuitous. We see this in the commonest concerns of life. We see it in events affecting mightily the destinies of empires. Under a pressure of concurrent annoyances and vexations, men often cry out that there is a conspiracy against them, and the historical inquirer often sees a conspiracy, when in reality there is only a coincidence. A great disaster like the massacre at Vellur, acts like iodine upon hidden writings in rice water.

Sir John Kaye, *History of the Indian Mutiny*[1]

How is historical agency enacted in the slenderness of narrative? How do we historicize the event of the dehistoricized? If, as they say, the past is a foreign country, then what does it mean to encounter a past that is your own country reterritorialized, even

terrorized by another? I have suggested in Chapter 9 that the process of historical revision and the production of political and cultural agency emerge through a discursive time-lag; in the contingent tension between the social order of symbols and the 'desubjected' scansion of the sign.[2] This temporality finds its spirit of place in the 'not-there' that Toni Morrison memorializes in her fiction and uses, interrogatively, to establish the presence of a black literary work. The act of 'rememoration' (her concept of the recreation of popular memory) turns the present of narrative enunciation into the haunting memorial of what has been excluded, excised, evicted, and for that very reason becomes the *unheimlich* space for the negotiation of identity and history. 'A void may be empty but it is not a vacuum.' Toni Morrison writes:

> Certain absences are so stressed [that] they arrest us with their intentionality and purpose, like neighbourhoods that are defined by the population held away from them. Where . . . is the shadow of the presence from which the text has fled? Where does it heighten, where does it dislocate?[3]

Intentionality and purpose – the signs of agency – emerge from the 'time-lag', from the stressed absence that is an arrest, a ceasure of time, a temporal break. In so specifying slave history, through an act of communal memory, Toni Morrison negates narrative continuity and the cacophonous comfort of words. In *Beloved* it is the cryptic *circulation* of number as the very first word, as the displacement of the 'personalized' predication of language, that speaks the presence of the slave world: '124 was spiteful. Full of baby's venom. The women in the house knew it and so did the children.'[4]

In the habitus of death and the daemonic, reverberates a form of memory that survives in the sign – 124 – which is the world of truth deprived of subjectivity. And then suddenly from the

space of the not-there, emerges the re-membered historical agency 'manifestly directed towards the rediscovery of truth which lies in the order of symbols' (see pp. 274–5). 124 was spiteful – the act of predication and intention effected by numbers is Morrison's attempt to constitute a form of address that is personalized by its own discursive activity, 'not the pasted on desire for personality'⁵ (what I have called individuation, not individualism). And this creation of historical agency produces the subject from out of the temporality of the contingent: 'snatched as the slaves were from one place to another, from any place to another, without preparation and without defense. . . . The reader is snatched, yanked, thrown into an environment completely foreign.'⁶

It is the caesura of the sign – 124 – that constitutes, according to Morrison, the 'first stroke' of the communal, intersubjective experience of the slave world. The discursive event of 124 remembers death, love, sexuality and slavery; its iterative articulations of those histories of cultural difference produce a community-in-discontinuity, historical revision in diaspora. The community Morrison envisages is inscribed in that slenderness of narrative where social solidarity is wrought through the crises and contingencies of historical survival: of getting, she says, from the 'first to the next and next' where the contiguity of action and narration are linked in the moment of 'not-there' which subverts the synchronous Western sense of time and tradition.

I want to link this circulation of the sign from the 1870s in the world of Beloved, to the circulation of other signs of violence in the 1850s and 60s in northern and central India. I want to move from the tortured history of Abolitionism to the Indian Mutiny. My reckless historical connection is based not on a sense of the contiguity of events, but on the temporality of repetition that constitutes those signs by which marginalized or insurgent subjects create a collective agency. I am interested in cultural strategy and political confrontation constituted in obscure, engimatic

symbols, the manic repetition of rumour, panic as the uncontrolled, yet strategic affect of political revolt. More specifically, I want to tease out the slenderness of narrative that, in the midst of the major agrarian and political causes of the Indian Mutiny, tells the story of those 'chapatis' (unleavened flat bread) that were rapidly circulated across the rural heartlands of the Mutiny, just after the introduction into the Native Infantries of the Enfield rifle and its notorious 'greased' cartridge. In *Elementary Aspects of Peasant Insurgency*, Ranajit Guha uses the chapati story as one of his main illustrations of the 'symbolic' transmission of rebel agency.

Whether we take the chapatis as historical 'myth' or treat them as rumour, they represent the emergence of a form of social temporality that is iterative and indeterminate. The circulation of the chapatis constitutes an interesting problem for the agency of historical discourse. The representation of panic and rumour participates in that complex temporality of social 'contingency' with which I have attempted to stain the clear waters of causality. The chain of communication in the rumour, its semantic content, is transformed in transmission, but despite exaggeration, hyperbole and imprecision, the messages are syntactically 'contiguous' (see p. 267).

The indeterminacy of rumour constitutes its importance as a social discourse. Its intersubjective, communal adhesiveness lies in its enunciative aspect. Its performative power of circulation results in the contagious spreading, 'an almost uncontrollable impulse to pass it on to another person'.[7] The iterative action of rumour, its *circulation* and *contagion*, links it with panic — as one of the *affects* of insurgency. Rumour and panic are, in moments of social crises, double sites of enunciation that weave their stories around the disjunctive 'present' or the 'not-there' of discourse. My point here is close to Ashis Nandy's strictures on Western historicism in his essay 'Towards a Third World Utopia'. The suffering of 'Third World' societies, according to Nandy, creates

an attitude to its history which shares some of the orientations of semiotics and psychoanalysis.

> For the dynamics of history, according to these disciplines [is not] an unalterable past moving towards an inexorable future; it is in the ways of thinking and in the choices of present time . . . anti-memories at that level [that] allow greater play and lesser defensive rigidity.[8]

The indeterminate circulation of meaning as rumour or conspiracy, with its perverse, psychic affects of panic, constitutes the intersubjective realm of revolt and resistance. What kind of agency is constituted in the circulation of the chapati?

Time, I believe, is of the essence. For it is the *circulation* of the chapati that initiates a politics of agency negotiated in the antagonisms of colonial cultural difference.

Let us take Sir John Kaye's description of the phenomenon in his monumental *History of the Indian Mutiny* vol. 1, written in 1864, based on the most extensive research in contemporary sources, including correspondence with participants in the Mutiny. Ranajit Guha draws on Kaye for his exemplary work on rumour in the popular peasant context of the Mutiny. A hundred years later, in Sen's 'official' history of the Indian Mutiny, Kaye's presence is still felt:

> It fixed, too, more firmly in the mind of Lord Canning, the belief that a great fear was spreading itself among the people, *and that there was more danger in such a feeling than in great hatred.* Thinking of this he also thought of another strange story that had come to him from the North-West, and which even the most experienced men about him were incompetent to explain. From village to village, brought by one messenger and sent onward by another, passed a mysterious token in the shape of those flat cakes made from flour and water, and forming the

common bread of the people, which in their language, are called chapatis. All that was known about it was that a messenger appeared, gave the cake to the headman of one village, and requested him to despatch it onward to the next; and that in this way it travelled from place to place; no one refusing, no one doubting, few even questioning in blind obedience to *a necessity felt rather than understood....* The greater number looked upon it as a signal of warning and preparation, designed to tell the people that something great and portentous was about to happen, and to prompt them to be ready for the crisis. One great authority wrote to the Governor-general that he had been told that the chapati was the symbol of men's food, and that its circulation was intended to alarm and to influence men's minds by indicating to them that their means of subsistence would be taken from them, and to tell them therefore, to hold together. Others laughing to scorn this notion of the fiery cross, saw in it only a common superstition of the country. It was said that it was no unwonted thing for a Hindu, in whose family sickness had broken out, to institute this transmission of chapatis, in the belief that it would carry off the disease. Then, again, it was believed by others ... that the purpose attaching to the circulation [of the chapatis] was another fiction, that there was bone dust in them, and that the English had resorted to this supplementary method of defiling the people.... But whatsoever the real history of the movement, it had doubtless the effect of keeping alive much popular excitement in the districts through which the cakes were transmitted.... Some saw in it much meaning; some saw none. Time has thrown no new light upon it. Opinions still differ. And all that History can record with any certainty is, that the bearers of these strange missives went from place to place, and as ever as they went new excitements were engendered, and vague expectations were raised.[9] (My emphasis)

It is the indeterminacy of meaning, unleashed by the contingent

chapati that becomes the totem meal for historians of the Mutiny. They bite the greased bullet and circulate the myth of the chapati. In so doing, they pass on the contagion of rumour and panic into their own serial, sensible narratives that become unsettled in that very act of repetition. Kaye's description of the 'undecidability' that attended the interpretation of the event articulates a temporality of meaning – 'some saw ... much meaning: some saw none' – that would be easy to discount as mere empirical description or reportage. But the rhetorical uncertainty between perspectives, the contingency of meaning that circulates in the compulsive repetition of the chapati, is an expression of a wider historical unease. What accompanies this problem of historical interpretation is the panic unleashed not simply by the 'rural' ritual of the circulation of the chapati but by its inscription as the performative 'present' of the days and nights of the Mutiny, its quotidian mythology, that is also the stuff of historical description.

The discursive figure of rumour produces an infectious ambivalence, an 'abyssal overlapping', of too much meaning and a certain meaninglessness. The semiotic condition of uncertainty and panic is generated when an old and familiar symbol (chapati) develops an unfamiliar social significance as sign through a transformation of the temporality of its representation. The performative time of the chapati's signification, its circulation as 'conspiracy' and/or 'insurgency', turns from the customary and commonplace to the archaic, awesome, terrifying. This re-inscription of a traditional system of organization through the disturbance, or interruption, of the circulation of its cultural codes (whereupon 'new excitements were engendered, and vague expectations were raised'), bears a marked similarity to the conjunctural history of the Mutiny.

The slender narrative of the chapati symbolizes, in its performative rhetoric of circulation/panic, those wider contextual conditions of the 1857 Rebellion that Eric Stokes has suggestively

described as a 'crisis of displacement',[10] in his fine essay on the agrarian context of that Rebellion. The obsessive fear of religious contagion and the extreme suspicion of the Government is symptomatic of a desperate soldiery clinging to its own traditions with a renewed fervour in the face of new regulations for the control and modernization of the native army, of which the Enfield rifle was only the most obvious symbol. The levelling zeal of the Government to liberate the peasant from the taluqdar (landlord) and the infamous annexation of the kingdom of Oudh, amongst other smaller principalities, created a sense of social dislocation that had its effects within an army consisting mainly of high-caste peasant mercenaries. The 20th Bengal Native Infantry that raised the rebellion in Meerut in May 1857 consisted mainly of Rajput and Brahmin petty landholders from southern Oudh. The influx of lower castes and outsiders into their ranks as a result of the radical 'levelling' policies of the Government – as Philip Mason has described[11] – led to such a widespread sense of the confusion of status and reference, that in the midst of the Mutiny, in October 1857, an officer wrote to the Lahore Chronicle publicly warning that 'a ploughman is not a subadar because he is styled so, and an indian nobleman or gentleman is not the less so because we treat him as a tradesman.'[12]

I have prised open, once more, the space between the symbol of the chapati and the sign of its circulation in order to reveal rumour's affect. It is 'panic' that speaks in the temporal caesura between symbol and sign, politicizing the narrative; the agency of politics obscurely contained in the contagion of chapati flour, or in the more revealing castratory fantasies of the former governor-general Ellenborough 'to emasculate all the mutineers and to call Delhi Eunuchabad'.[13] If we read Kaye's account, from its space of undecidability, we find that panic mounts in its phrases, producing the kinetic tension of the contingency of the historical event itself. His narrative attempts to relate the chapatis

contiguously to historical or cultural events in a metonymic series: commonbread: portentous event: deprivation of subsistence (reorganization of army, land resettlement, abrogation of taluqdar's rights and privileges): fiery cross: passing on the malady (ritual peasant practice of *chalawa* or scapegoating an animal in order to rid the community of epidemics): religious defilement (Enfield rifle, greased bullet paper). What articulates these sites of cultural difference and social antagonism, in the absence of the validity of interpretation, is a discourse of panic that suggests that psychic affect and social fantasy are potent forms of political identification and agency for guerilla warfare. So Kaye, citing Canning, can say that 'there was more danger in such a feeling [of the *spreading* of fear] than in great hatred'; that the circulation of the chapatis was 'a necessity *felt* rather than understood'; and, finally, that the circulation was intended to influence *through alarm* and thereby hold together the people. Whatsoever be the real history of the event, the political purpose of rumour, panic and the circulating chapati is to 'keep alive much popular excitement'.

Panic spreads. It does not simply hold together the native people but binds them affectively, if antagonistically – through the process of projection – with their masters. In Kaye's rendering of Canning's account, it is the passages of panic that are written neither simply from the native point of view, nor from the superior interpretative, 'administrative' perspective of Lord Canning. While he largely attributes fear and panic to a 'pre-literate' native mind, its superstition and misapprehensions, its 'pre-formed' psychological and political pliability, the *genre* of 'intelligence gathering' that constitutes the discourse is proof of the fact that the fear was not limited to the peasants. The indeterminacy of the event reveals the panic amongst the bureaucrats, and within the army, which can be read in the anxious, conflicting opinions that Canning musters. By projecting the panic and anxiety on native custom and ethnic particularity, the

British attempted to contain and 'objectify' their anxiety, finding a ready 'native' reference for the undecidable event that afflicted them. This is clearly seen in the rhetorical split in Kaye's passage where the subjects of the narrative (*énoncé*) are natives, but the subjects of the act of enunciation – experienced men, one great authority, others laughing, others believing – are 'British' authorities, whether they are part of the administration or Indian spies. It is at the enunciative level that the humble chapati circulates both a panic of knowledge and power. The great spreading of fear more dangerous than anger, is equivocal, circulating wildly on both sides. It spreads beyond the knowledge of ethnic or cultural binarisms and becomes a new, hybrid space of cultural difference in the negotiation of colonial power-relations. Beyond the barracks and the bungalow opens up an antagonistic, ambiguous area of engagement that provides, in a perverse way, a common battleground that gives the sipahi a tactical advantage.

What lesson does the circulation of panic – the 'time' of the chapati – have for historical agency?

If the chapati is read only for its ontological cultural origins – in the historical order of the symbol – then the result is a cultural binarism that evades the real contagion of the political panic of the Mutiny. This avoids the hybridization of points of reference that create the possibility of a war of nerves and sporadic guerilla action (as the sipahis generally conceived it). To see the chapati as an 'internal', orderly transformation from the symbol of pollution to politics, reproduces the binary between the peasant and the raj, and denies the particular historical agency of the sipahi, which as Stokes has repeatedly shown, succeeded by 'stratagem not arms'. By disavowing the politics of indeterminacy and panic, the collective agency of the insurgent peasant is given a simplistic sense of intentionality. The mutineers are located in a semi-feudal time-warp, the playthings of religious conspiracies. Rewriting Kaye's splendid account of Canning twenty-five years

later, in the fifth volume of the *History*, his prosaic successor Malleson produces the interesting myth of Mohamedan conspiracy and, unwittingly, 'authorizes' the chapatis. The treacherous tracery of the chapatis across the north-west provinces follows the path of the Maulvi of Faizabad, one of the few conspirators known by name. Like the chapati he travelled extensively in the north-west after the annexation of Oudh, 'on a mission which was a mystery to the Europeans'. Like the chapati, the Maulvi's circulation had its ramifications 'at Delhi, at Mirath, at Patna, and at Calcutta'![14]

If, however, we follow the discourse of panic, the *affectivity* of historical understanding, then we encounter a temporal 'speed' of historical events that leads to an understanding of rebel agency. The chapati's circulation bears a contingent relation to the time-lag or temporal break in-between sign and symbol, constitutive of the representation of the intersubjective realm of meaning and action. Contemporary historical accounts stress a similar temporality in suggesting that the spread and solidarity of insurgency was effected with an almost 'timeless' speed; a temporality that cannot be represented except as the 'repetition' of the chapatis and their ensuing uncertainty or panic.

Lieutenant Martineau, the Musketry Inspector at Umballa Rifle Depot, was responsible for training native infantrymen in the use of the Enfield rifle. Having been terrorized by an occurrence of the chapati-flour omen in his own ranks, he writes in desperation to General Belcher about the state of the army on 5 May 1857, just five days before the Mutiny broke at Meerut. His apprehensions have largely been ignored and his demand for a Court of Inquiry to investigate the unusual agitation in the ranks, has been turned down. His is an obscure but representative voice and bears a fine witness to the link between the circulation of panic and its representation as a 'cut' in time or an instant shock:

> Everywhere far and near the army under some maddening impulse are looking out with strained expectation for something, some unseen, invisible agency has caused one *common electric thrill* to run through all. . . . I don't think they know what they will do, or that they have any plan of action except of resistance to invasion of their religion and their faith.[15] (My emphasis)

In retelling the chapati tale as a major instance of the transmission of insurgency, Ranajit Guha associates the speed of the transmission of rebellion with the 'psychosis of dominant social groups'[16] confronted suddenly with the rebellion of those considered loyal. Guha uses this moment, in which he mentions both time and psychic affect, as the basis on which to make an important observation on subaltern agency:

> What the pillars of society fail to grasp is that the organizing principles lies in nothing other than their own dominance. For it is the subjection of the rural masses to a common source of exploitation and oppression that makes them rebel even before they learn to combine in peasant associations. And once a struggle has been engaged in, it is again this *negative condition* of their social existence rather than any revolutionary consciousness which enables the peasantry to rise above localism.[17] (My emphasis)

In locating the emergence of rebel agency in the 'negative condition' of social existence, Guha refers to 'social psychosis' as part of the structure of insurgency. It corroborates my suggestion that the organizing principle of the *sign* of the chapati is constituted in the transmission of fear and anxiety, projection and panic in a form of circulation *in-between* the colonizer and the colonized. Could the agency of peasant rebellion be constituted through the 'partial incorporation' of the fantasy and fear of the

Master? And if that is possible, doesn't the site of rebellion, the subject of insurgent agency, become a site of cultural hybridity rather than a form of negative consciousness?

The link I'm attempting to make between the speedy time of panic and the break-up of a binary sense of political antagonism resonates with an important insight of the psychoanalyst Wilfrid Bion, on the place of panic in the fight–flight group, of which war and the army are examples. The psychosis of the group consists in the reversibility or interchangeability of panic and anger. This ambivalence is part of the group structured within a time-lag similar to the process I described as the 'individuation' of agency (see pp. 271–6): 'His inalienable inheritance as a group animal gives rise to a feeling in the individual that he can *never catch up* with a course of events to which he is always, at any given moment, already committed.'[18] It is this disjunctive structure within and between groups that prevents us from representing oppositionality in the equivalence of a binary structure. Where anger and panic arise they are stimulated by an event, Bion writes, that always falls *outside* the functions of the group.

How are we to understand this notion of falling 'outside' in relation to the discourse of panic? I want to suggest that we understand this 'outside' not in simple spatial terms but as constitutive of meaning and agency. The 'outside event' could also be the unacknowledged liminality or 'margin' of a discourse, the point where it contingently touches the 'other's' discourse *as itself*. This sense of a discursive 'outside' is articulated in the passages of panic in Kaye's account of the chapati. They occupy a space in his narrative where meaning is undecidable, and the 'subject' of discourse split and doubled between native informer and colonial 'enunciator'. What is represented and fixed as native panic at the level of content or propositionality (*énoncé*) is, at the level of narrative positionality (*enunciation*), the spreading, uncontrolled fear and fantasy of the colonizer.

A contingent, borderline experience opens up *in-between*

colonizer and colonized. This is a space of cultural and interpretive undecidability produced in the 'present' of the colonial moment. Such an 'outside' is also visible in my insistence that the chapati's meaning *as circulation* only emerges in the time-lag, or temporal break, *in-between* its social-symbolic ordering and its iterative repetition as the sign of the undecidable, the terrifying. Isn't this Kaye's very predicament when he says that 'all that History can record with any certainty is, that . . . these strange missives went from place to place.' Yet it is this temporal process of the transmission of rebel agency about which he chooses to say nothing. So the moment of political panic, as it is turned into historical narrative, is a *movement* that breaks down the stereotomy of inside/outside. In so doing it reveals the contingent process of the inside turning into the outside and producing another hybrid site or sign. Lacan calls this kind of inside/out/outside/ in space a moment of *extimité*: a traumatic moment of the 'not-there' (Morrison) or the indeterminate or the unknowable (Kaye) around which the symbolic discourse of human history comes to be constituted. In that sense, then, the extimate moment would be the 'repetition' of rumour in the seriality of the historical event (1857), the 'speed' of panic at the site of rebel politics, or indeed, the temporality of psychoanalysis in the writing of history.

The margin of hybridity, where cultural differences 'contingently' and conflictually touch, becomes the moment of panic which reveals the borderline experience. It resists the binary opposition of racial and cultural groups, sipahis and sahibs, as homogeneous polarized political consciousnesses. The political psychosis of panic constitutes the boundary of cultural hybridity across which the Mutiny is fought. The native order of Indian symbols, their indigenous ethnic reference 'inside' are displaced and turned inside-out; they become the circulating signs of an 'English' panic, disavowed by the official discourse of imperial history, represented in the language of indeterminacy. The

chapati then is also a displacement of, and defence against, the Enfield rifle; made of flour contaminated with bone-meal and shaped like 'English ships-biscuits' the chapatis are a heterogeneous, hybrid sign. They suggest, according to the advocate-general, that the conspirators were imputing that army chaplains were trying to impose 'one food one faith'.[19] In these sudden, slender signs of panic, we see a complex cultural writing of rebel agency in 1857 that Eric Stokes has expanded into a wider, more traditional argument:

> Much of what passes for primary resistance occurs at the onset of local crisis when the first phase of collaboration has gone sour. The internal configuration of society has already been altered by the yeast of modernity, so that the local crisis is as much an internal as an external one and reflects the strains of dislocation and displacement.[20]

It is the temporality of the historical event as an internal (psychic, affective) instance and an external (political, institutional, governmental) occurrence that I have been trying to explore within the wider dialectic of the sipahi and the raj. It has been my argument that historical agency is no less effective because it rides on the disjunctive or displaced circulation of rumour and panic. Would such an ambivalent borderline of hybridity prevent us from specifying a political strategy or identifying a historical event?

On the contrary, it would enhance our understanding of certain forms of political struggle. After all my mad talk about group-psychosis and flying chapatis let us take a sober, historical example. In one of the last chapters that Stokes wrote on the Indian Mutiny before his death – 'The sepoy rebels' – he displays an almost hyperreal sense of the contingency of time and event caught like a slow motion replay of the Mutiny itself. Stokes came 'increasingly to emphasize the importance of the

contingent events of military action in his account of the inci-
dence and spread of the revolt', writes C. A. Bayly in his after-
word to *The Peasant Armed*. He came to see the importance of the
'human drama and the mythology of revolt . . . those contin-
gent, almost accidental features of the revolt that also help to
explain the puzzle of its timing in relation to longer-term trends
in north Indian history'.[21] This new emphasis on the contingent
and the symbolic is particularly visible in a fine passage where
Stokes writes:

> An Army wore out like clothing and needed frequent renewal.
> Its tatterdemalion appearance was also of more than symbolic
> significance. In the hour of desperation the British might dis-
> pense with regular uniform and strict puntilio, but once the
> crisis was passed and their regiments multiplied, their military
> practice tightened rather than relaxed. For the sepoys the aban-
> donment of shakos and jackets might have been sensible for
> ease of fighting, but it helps obliterate distinction of company
> and regiment and turned them increasingly from regular
> soldiers into civil insurgents.[22]

Seen from the perspective of the outcome of the rebellion Stokes
is surely right to assert, as he does repeatedly, that the defeat of
the rebels came from the 'absence of a tactical plan or *controlling
mind* and of disciplined organization to press home the assault'.[23]
Stokes is impecable in his understanding of the disciplines of the
regular soldier and the guerilla tactics of the civil insurgent, but
his adherence to a certain notion of the 'controlling mind' does
not permit him to see the doubled, displaced strategy of sepoy-
as/and-civil insurgent. With my taste for in-between states and
moments of hybridity I shall briefly attempt to describe that
inside-out movement when the sepoy and the civil insurgent are
two sites of the subject in the same moment of historical agency.

Of the very few contemporary 'native' narratives available,

written from the scene of battle, Munshee Mohan Lal's account of an overheard conversation between a Mohamedan trooper of the influential 3rd Cavalry and Sir William Nott's sepoy orderly, is the best. Despite his function as a spy with an obvious interest in suggesting a Mohamedan conspiracy, his account provides valuable corroborative evidence. In the attorney-general's account of Mohan Lal's evidence the drama and the 'controlling mind' of the rebel action have been reduced to treachery and conspiracy. If we return to Mohan Lal's original letter written in November 1857, we read quite a different story.

It was on the release of their friends and comrades from the Meerut prison that the mutineers decided on the siege of Delhi. The famous cry of 'Chalo Delhi' – Onwards to Delhi! – does not simply provide 'an immediate loose-knit unity to excited and distracted men'[24] as Stokes describes it. The rebel account makes quite clear that it was only after they tested their strength as a fighting body, and symbolically burned the houses of the 'saheb logue' that they called a meeting to decide what their next move would be. They decided against Rohilcund in the direction of Agra, because they could not take enough defensive positions on the way. 'After clam [sic] and deliberate consideration Delhi was named and resolved to make the headquarters'[25] for tactical military and political reasons: 'the annihilation of the few English and Christian residents . . . the possession of the magazine, and the person of the King'.

It is the 'person' of the king that constitutes the most interesting rebel strategy. To centralize the rebellion in Delhi – a tactic that was to fail in the long run – was a way of providing an affective focus for the Mutiny, to establish it within the public political sphere. 'The name of the king will work like magic and induce the distant states to mutiny,' the soldiers reason. This public affirmation of power is necessary because they (the natives) are aware of the problems of conspiratorial

communication. 'The sepoy said that he had witnessed the artful modes of General Nott to conceal and forward his letters during the Cabool disasters to Sindh and Cabool, such acts of ours will not escape their attention'[26] – which is to say, of course, that General Nott's secret letters were bazaar talk, just as the chapatis became the staple fare of Government House.

The body of the king has another destiny in the political strategy of the mutineers. They contrived to bring out Bahadur Shah in a royal procession to 'restore confidence in the citizens'. Then, surrounded by 'disciplined troops' and 'respectable residents', whether jagirdars or merchants, the king as spectacle becomes that name that can work like magic. This magic is worked by a deliberate narrative strategy – rumour. When the king assumes his public persona, then the mutineers 'excited his ambition' by exaggerated stories of ranged regiments bearing treasures from various stations . . . that all European troops were engaged in Persia . . . that the unsettled state of European politics would hardly permit the home authorities to reach any reinforcement to India. This magic of narrative made the king assume his name, not the other way round: 'made Bahadur Shah to believe that he had been born to restore the lost realm of the great Taimoor in the last days of his life. *He now threw off the mask and took interest in encouraging the rebellion.*'[27]

The sepoy as civil insurgent, that tatterdemalion figure, creates his hybrid narratives from a number of slender tales: the political secrecy of the 'saheb logue'; the late medieval inscription of the body of the king; the Mughal durbar ritual of *khelat*, a gift of clothing through which loyal subjects are 'incorporated'[28] into the body of the king; rumours of English politics; and, of course, the vanity of human wishes and the messianic desires of crowds. I want to tug once more at the ragged coat of the rebel and draw a tattered thread that takes my story from this public political moment to its other slender narrative, panic. From the body of the Mughal I want to move back to the body of the sipahi, by

way of a time-lag; from the Mutiny of 1857 and its chapatis to the Vellore Mutiny of 1806 and its topi.

After the reorganization of the Madras Army in 1796, all the traditional accoutrements of the native soldier's appearance were effaced. Ear-rings and caste-marks were obliterated, the turban forbidden. The sipahi was shaved and dressed 'in a stiff round hat, like a pariah drummer's with a flat top, a leather cockade and a standing feather'.[29] In the eyes of his countrymen the soldier became a 'topiwalla', a hatwearer, synonymous with being a 'firinghi' or Christian. Rumours began to circulate about an imminent conversion of Hindus and Muslims to Christianity through the contagion of the leather hat. In those anxious times wandering mendicants 'with the odour of sanctified filth about them' told strange stories and incredible fables, within the military lines. The unmistakable stirrings of panic could be heard, swiftly carried on the wings of anger, through the bazaars, the countryside, the barracks. Just before the great massacre at Vellore of 10 July 1806 of which the history books tell us, an event occurred that was so common that recent historians seem to have forgotten it.

As the soldiers in their new 'firinghi' topis and uniforms mingled with the palace servants and retainers of the Mysore princes, their traditional protectors, they were jeered and humiliated:

The different parts of their uniform were curiously examined amidst shrugs and other expressive gestures, and significant 'Wah wahs!' and vague hints that everything about them in some way portended Christianity. They looked at the Sipahi's stock and said, 'What is this? It is leather! WELL!' Then they would look at his belt and tell him that it made a cross upon his person. But it was the round hat that most of all was the object of the taunts and warnings of the people of the palace. 'It only needed this to make you altogether a firinghi. Take care or we

> shall all soon be made Christians ... and then the whole country will be ruined.[30]

When the body of the sipahi comes to be hybridized in the circulation of cryptic omens, then new 'firinghi' uniforms become the source of primal fears. The fiery cross turns into a high hat or a flat, unleavened bread. The 'yeast of modernity' causes archaic fears to arise; political signs and contagious portents inhabit the body of the people. Is this panic, written on the sipahi's skin, the omen that sends rumour and rebellion on their flight? Is this the narrative of 'native' hysteria? Beyond these questions you can hear the storm break. The rest is History.

11

HOW NEWNESS ENTERS THE WORLD

Postmodern space, postcolonial times and the trials of cultural translation

> Translation passes through *continua* of transformation, not abstract ideas of identity and similarity.
>
> Walter Benjamin, 'On language as such and the language of man'

I NEW WORLD BORDERS

It is radical perversity, not sage political wisdom, that drives the intriguing will to knowledge of postcolonial discourse. Why else do you think the long shadow of Conrad's *Heart of Darkness* falls on so many texts of the postcolonial pedagogy?[1] Marlow has much in him of the anti-foundationalist, the metropolitan ironist who believes that the neo-pragmatic universe is best preserved by

keeping the conversation of humankind going. And so he does, in that intricate end-game that is best known to readers of the novel as the 'lie' to the Intended. Although the African wilderness has followed him into the lofty drawing-room of Europe, with its spectral, monumental whiteness, despite the dusk that menacingly whispers 'the Horror, the Horror', Marlow's narrative keeps faith with the gendered conventions of a civil discourse where women are blinded because they see too much reality, and novels end because they cannot bear too much fictionality. Marlow keeps the conversation going, suppresses the horror, gives history the lie – the white lie – and waits for the heavens to fall. But, as he says, the heavens do not fall for such a trifle.

The global link between colony and metropolis, so central to the ideology of imperialism, is articulated in Kurtz's emblematic words – 'the Horror, the Horror!' The unreadability of these Conradian runes has attracted much interpretive attention, precisely because their depths contain no truth that is not perfectly visible on the 'outside, enveloping the tale which brought it out only as a glow brings out a haze.'[2] Marlow does not merely repress the 'truth' – however multivocal and multivalent it may be – as much as he enacts a poetics of translation that (be)sets the boundary between the colony and the metropolis. In taking the name of a woman – the Intended – to mask the daemonic 'being' of colonialism, Marlow turns the brooding geography of political disaster – the heart of darkness – into a melancholic memorial to romantic love and historic memory. Between the silent truth of Africa and the salient lie to the metropolitan woman, Marlow returns to his initiating insight: the experience of colonialism is the problem of living in the 'midst of the incomprehensible'.[3]

It is this incomprehensibility in the midst of the locutions of colonization, that echoes with Toni Morrison's insight into the 'chaos'[4] that afflicts the signification of psychic and historical

narratives in racialized societies. It resonates, too, with Wilson Harris's evocation, in the Caribbean context, of 'a certain void of misgiving attending every assimilation of contraries . . . an alien territory and wilderness [that] has become a necessity for one's reason or salvation'.[5] Is this acknowledgement of a necessary anxiety in constructing a transformative, postcolonial knowledge of the 'global' – *at the metropolitan site* – a salutary warning against travelling theory? For as the dusk gathers in that drawing-room of Europe, and Marlow attempts to create a narrative that would link the life of the Intended and Kurtz's dark heart, caught in a split truth or a double frame, he can only tell the infamous, intended lie: yes, Kurtz died with the name of his Intended on his lips. The horror may be averted in the decorum of words – 'It would have been too dark – too dark altogether'[6] – but it avenges the structure of the narrative itself.

Marlow's inward gaze now beholds the everyday reality of the Western metropolis through the veil of the colonial fantasm; the local story of love and its domestic memory can only be told between the lines of history's tragic repressions. The white woman, the Intended, becomes the shadow of the African woman; the street of tall houses takes on the profile of the tribal skulls on staves; the percussive pounding of a heart echoes the deep beat of drums – 'the heart of a conquering darkness'. When this discourse of a daemonic doubling emerges at the very centre of metropolitan life, then the familiar things of everyday life and letters are marked by an irresistible sense of their genealogical difference, a 'postcolonial' provenance.

Writing of the notion of the 'self in moral space', in his book *Sources of the Self*, Charles Taylor sets temporal limits to the problem of personhood: 'the supposition that I could be two temporally succeeding selves is either an overdramatized image, or quite false. It runs against the structural features of a self as a being who exists in a space of concerns.'[7] Such 'overdramatized' images are precisely my concern as I attempt to negotiate

narratives where double-lives are led in the postcolonial world, with its journeys of migration and its dwellings of the diasporic. These subjects of study require the experience of anxiety to be incorporated into the analytic construction of the object of critical attention: narratives of the borderline conditions of cultures and disciplines. For anxiety is the affective address of 'a world [that] reveals itself as caught up in the space between frames; a doubled frame or one that is split',[8] as Samuel Weber describes the symbolic structure of psychic anxiety itself. And the long shadow cast by *Heart of Darkness* on the world of postcolonial studies is itself a double symptom of pedagogical anxiety: a necessary caution against generalizing the contingencies and contours of local circumstance, at the very moment at which a transnational, 'migrant' knowledge of the world is most urgently needed.

Any discussion of cultural theory in the context of globalization would be incomplete without a reading of Fredric Jameson's brilliant, if unruly essay, 'Secondary elaborations',[9] the conclusion to his collected volume *Postmodernism Or, The Cultural Logic of Late Capitalism*. No other Marxist critic has so dauntlessly redirected the movement of the materialist dialectic, away from its centralization in the State and its idealized aesthetic and disciplinary categories, towards the wayward, uncharted spaces of the cityscape, allegorized in its media images and its vernacular visions. This has led Jameson to suggest that the demographic and phenomenological impact of minorities and migrants within the West may be crucial in conceiving of the transnational character of contemporary culture.

The 'postmodern', for Jameson, is a doubly inscribed designation. As the naming of a historical *event* – late multinational capitalism – postmodernity provides the periodizing narrative of the global transformations of capital. But this developmental schema is radically disrupted by the postmodern as an aesthetic-ideological process of signifying the 'subject' of the historical

event. Jameson uses the language of psychoanalysis (the breakdown of the signifying chain in psychosis) to provide a genealogy for the subject of postmodern cultural fragmentation. Inverting the influential Althusserian edict on the 'imaginary' ideological capture of the subject, Jameson insists that it is the schizoid or 'split' subject that articulates, with the greatest intensity, the disjunction of time and being that characterizes the social syntax of the postmodern condition:

> the breakdown of temporality [that] suddenly releases this present of time from all the activities and intentionalities that might focus it and make it a space of praxis . . . engulf[ing] the subject with undescribable vividness, a materiality of perception properly overwhelming. . . . This present of the world or material signifier comes before the subject with heightened intensity, bearing a mysterious charge or affect . . . which one could just as well imagine in the positive terms of euphoria, a high, an intoxicator. (p. 27)

This central passage from an earlier essay, 'The cultural logic of late capitalism',[10] is exemplary amongst Marxist readings of poststructuralism for transforming the 'schizophrenic disjunction' (p. 29) of cultural style, into a politically effective discursive space. The recourse to psychoanalysis has implications that go beyond Jameson's suggestive, metaphoric linkages. Psychoanalytic temporality, I would argue, invests the utterance of the 'present' – its displaced times, its affective intensities – with cultural and political value. Placed in the scenario of the unconscious, the 'present' is neither the mimetic sign of historical contemporaneity (the immediacy of experience), nor is it the visible terminus of the historical past (the teleology of tradition). Jameson repeatedly attempts to turn rhetorical and temporal disjunction into a poetics of praxis. His reading of a poem, 'China', illustrates what it means to establish 'a primacy of the

present sentence in time, ruthlessly disintegrat[ing] the narrative fabric that attempts to reform around it' (p. 28). Even a brief fragment of the poem will convey this sense of the 'signifier of the present' wresting the movement of history to represent the struggle of its making:

> We live on the third world from the sun. Number three. Nobody tells us what to do.
>
> The people who taught us how to count were being very kind.
>
> It's always time to leave.
> If it rains, you either have your umbrella or you don't.

What Jameson finds in these 'sentence(s) in free standing isolation', athwart the disarticulate spaces that utter the present, each time again and anew, is

> the reemergence here across these disjoined sentences of some more unified global meaning. . . . [It] does seem to capture something of the excitement of the immense, *unfinished* social experiment of the New China – unparalleled in world history – the *unexpected* emergence between the two superpowers of 'number three' . . . ; the signal event, above all, of a collectivity which has become a new 'subject of history' and which, after the long subjection of feudalism and imperialism, again speaks in its own voice, for itself, as if for the first time. (p. 29)

The Horror! the Horror! Almost a century after *Heart of Darkness* we have returned to that act of living in the midst of the 'incomprehensible', that Conrad associated with the production of transcultural narratives in the colonial world. From these disjoined postimperial sentences, that bear the anxiety of reference

and representation – 'undescribable vividness . . . a materiality of perception, properly overwhelming' – there emerges the need for a global analysis of culture. Jameson perceives a new international culture in the perplexed passing of modernity into postmodernity, emphasizing the transnational attenuation of 'local' space.

> I take such spatial peculiarities as symptoms and expressions of a new and historically original dilemma, one that involves our insertion as individual subjects into a multidimensional set of radical discontinuous realities, whose frames range from the still surviving spaces of bourgeois private life all the way to the unimaginable decentring of global capital itself . . . the so-called death of the subject . . . the fragmented and schizophrenic decentring [of the Self], . . . the crisis of socialist internationalism, and the enormous tactical difficulties of coordinating local . . . political actions with national or international ones, such urgent political dilemmas are all immediately functions of the new international space in question. (p. 413)

My rendition of Jameson, edited with ellipses that create a Conradian foreboding, reveals the anxiety of enjoining the global and the local; the dilemma of projecting an international space on the trace of a decentred, fragmented subject. Cultural globality is figured in the in-between spaces of double-frames: its historical originality marked by a cognitive obscurity; its decentred 'subject' signified in the nervous temporality of the transitional, or the emergent provisionality of the 'present'. The turning of the globe into a theoretical project splits and doubles the analytic discourse in which it is embedded, as the developmental narrative of late capitalism encounters its fragmented postmodern persona, and the materialist identity of Marxism is uncannily rearticulated in the psychic non-identities of

psychoanalysis. Jameson is, indeed, a kind of Marlow in search of the aura of Ernest Mandel, stumbling upon, not Towson's Almanac, but Lefebvre, Baudrillard and Kevin Lynch. The architecture of Jameson's argument is like a theme-park of an imperilled post-Althusserian phenomenological Marxism of which he is both the master-builder and the most brilliant *bricoleur*, the heroic saviour and the savvy salvage merchant.

Whether it is the emergence of new historical subjects in China or, somewhat later, the new international space in question, the argument moves intriguingly beyond the ken of Jameson's theoretical description of the sign of the 'present'. The radical discontinuity that exists between bourgeois private life and the 'unimaginable' decentring of global capital does not find its scheme of representation in the *spatial position* or the *representational visibility* of the free-standing, disjoined sentences, to which Jameson insistently draws our attention. What must be mapped as a new international space of discontinuous historical realities is, in fact, the problem of signifying the interstitial passages and processes of cultural difference that are inscribed in the 'in-between', in the temporal break-up that weaves the 'global' text. It is, ironically, the disintegrative moment, even movement, of enunciation – that sudden disjunction of the present – that makes possible the rendering of culture's global reach. And, paradoxically, it is only through a structure of splitting and displacement – 'the fragmented and schizophrenic decentring of the self' – that the architecture of the new historical subject emerges at the limits of representation itself, 'to enable a situational representation on the part of the individual to that vaster and *unrepresentable* totality which is the ensemble of society's structures as a whole' (my emphasis) (p. 51).

In exploring this relation to the 'unrepresentable' as a domain of social causality and cultural difference, one is led to question the enclosures and exclusions of Jameson's 'third space'. The space of 'thirdness' in postmodern politics opens up an area of

'interfection' (to use Jameson's term) where the newness of cultural practices and historical narratives are registered in 'generic discordance', 'unexpected juxtaposition', 'the semi-automization of reality', 'postmodern schizo-fragmentation as opposed to modern or modernist anxieties or hysterias' (pp. 371–2). Figured in the disjointed signifier of the present, this supplementary third space introduces a structure of ambivalence into the very construction of Jameson's internationalism. There is, on the one hand, a recognition of the interstitial, disjunctive spaces and signs crucial for the emergence of the new historical subjects of the transnational phase of late capitalism. However, having located the image of the historical present in the signifier of a 'disintegrative' narrative, Jameson disavows the temporality of displacement which is, quite literally, its medium of communication. For Jameson, the possibility of becoming historical demands a containment of this disjunctive social time.

Let me describe what I consider to be the ambivalence that structures both the invention and the interdiction of Jameson's thought, by returning to the primal fantasy of late capitalism that he has located in downtown Los Angeles. The mise-en-scène of the subject's relation to an unrepresentable social totality – the germ of an entire generation of scholarly essays – is to be found in the carnivalesque description of that postmodern panopticon, the Bonaventure Hotel. In a trope that echoes the disorientation of language and location that accompanies Marlow's journey up the Congo, Jameson shoots the rapids in the elevator-gondola and lands in the milling confusion of the lobby. Here, in the hotel's hyperspace, you lose your bearings entirely. This is the dramatic moment when we are faced with the incapacity of our minds to 'map the great global multinational network and decentred communicational network' (p. 44). In this encounter with the global dialectic of the unrepresentable, there is an underlying, prosthetic injunction 'something like an imperative

to grow new organs, to expand our sensorium and our body to some new, yet unimaginable, perhaps impossible, dimensions' (p. 39). What might this cyborg be?

In his concluding meditation on the subject, 'Secondary elaborations', Jameson elaborates this enhanced perceptual capacity as a

> kind of incommensurability-vision that does not pull the eyes back into focus but provisionally entertains the tension of their multiple coordinates. . . . It is their *spatial separation* that is strongly felt as such. Different moments in historical or existential time are here simply filed in different places; the attempt to combine them even locally does not slide up and down a temporal scale . . . but jumps back and forth across a game board that we conceptualize in terms of *distance*. (My emphasis) (pp. 372–3)

Although Jameson commences by elaborating the 'sensorium' of the decentred, multinational network as existing somewhere beyond our perceptual, mappable experience, he can only envisage the representation of global 'difference' by making a renewed appeal to the mimetic visual faculty – this time in the name of an 'incommensurability-vision'. What is manifestly new about this version of international space and its social (in)visibility, is its temporal measure – 'different moments in historical time . . . jumps back and forth'. The nonsynchronous temporality of global and national cultures opens up a cultural space – a third space – where the negotiation of incommensurable differences creates a tension peculiar to borderline existences. In 'The new world (b)order', Guillermo Gomez-Peña, the performance artist who lives between Mexico City and New York, plays with our incommensurability-vision and extends our senses towards the new transnational world and its hybrid names:

> This new society is characterized by mass migrations and
> bizarre interracial relations. As a result new hybrid and tran-
> sitional identities are emerging. . . . Such is the case of the
> crazy *Chica-riricuas*, who are the products of the Puertorican-
> mullato and Chicano-mestizo parents. . . . When a *Chica-riricua*
> marries a Hassidic Jew their child is called *Hassidic vato
> loco*. . . .
>
> The bankrupt notion of the melting pot has been replaced by
> a model that is more germane to the times, that of the *menudo
> chowder*. According to this model, most of the ingredients do
> melt, but some stubborn chunks are condemned merely to
> float. Vergigratia![11]

Such fantastic renamings of the subjects of cultural difference
do not derive their discursive authority from anterior causes –
be it human nature or historical necessity – which, in a second-
ary move, articulate essential and *expressive* identities between
cultural differences in the contemporary world. The problem is
not of an ontological cast, where differences are effects of some
more totalizing, transcendent identity to be found in the past or
the future. Hybrid hyphenations emphasize the incommensur-
able elements – the stubborn chunks – as the basis of cultural
identifications. What is at issue is the performative nature of
differential identities: the regulation and negotiation of those
spaces that are continually, *contingently*, 'opening out', remaking
the boundaries, exposing the limits of any claim to a singular or
autonomous sign of difference – be it class, gender or race. Such
assignations of social differences – where difference is neither
One nor the Other but *something else besides, in-between* – find their
agency in a form of the 'future' where the past is not originary,
where the present is not simply transitory. It is, if I may stretch a
point, an interstitial future, that emerges *in-between* the claims of
the past and the needs of the present.[12]

The present of the world, that appears through the breakdown

of temporality, signifies a historical *intermediacy*, familiar to the psychoanalytic concept of *Nachträglichkeit* (deferred action): 'a transferential function, whereby the past dissolves in the present, so that the future becomes (once again) an *open question*, instead of being specified by the fixity of the past.'[13] The iterative 'time' of the future as *a becoming* '*once again open*', makes available to marginalized or minority identities a mode of performative agency that Judith Butler has elaborated for the representation of lesbian sexuality: 'a specificity . . . to be established, not *outside* or *beyond* that reinscription or reiteration, but in the very modality and effects of that reinscription.'[14]

Jameson dispels the potential of such a 'third' politics of the future-as-open-question, or the 'new world (b)order', by turning social differences into cultural 'distance', and converting interstitial, conflictual temporalities, that may be neither developmental nor linear (*not* 'up and down a temporal scale'), into the topoi of spatial separation. Through the metaphor of spatial distance, Jameson steadfastly maintains the 'frame', if not the face, of the subject-centred perceptual apparatus[15] which, in a counter move, he attempts to displace in the 'virtual reality' of cognitive mapping, or the unrepresentability of the new international space. And the pivot of this regulatory, spatial dialectic – the eye of the storm – is none other than the 'class-subject' itself. If Jameson makes the teleological dimension of the class category retreat in the face of the multiple axes of transnational globality, then the linear, developmental dimension returns in the shape of a spatial typology. The dialectic of the unrepresentable (that frames the incommensurable realities of international space) suddenly becomes all too easily visible, too predictably knowable:

> The three types of spaces I have in mind are all the result of discontinuous expansion of quantum leaps in the enlargement of capital, in the latter's penetration of hitherto uncommodified

areas. A certain unifying and totalizing force is presupposed
here – not the Hegelian Absolute Spirit, nor the party, nor
Stalin, but simply capital itself. (p. 410)

The disjoined signifiers of the present are fixed in the punc-
tual periodizations of market, monopoly and multinational cap-
ital; the interstitial, erratic movements that signify culture's
transnational temporalities are knit back into the teleological
spaces of global capital. And through the framing of the present
within the 'three phases' of capital, the innovative energy of the
'third' space is somehow lost.

Try as he does to suggest, in sympathy with Sartre, that 'total-
izing' is not access to totality but 'a playing with the boundary,
like a loose tooth' (p. 363), there is little doubt that for Jameson
the boundary of knowledge, and the prerequisite of critical
method, is ordered in a binary division of space: there has to be
an 'inside' and an 'outside' for there to be a socially determina-
tive relation. Despite Jameson's fascination with the inside-out
spaces of the Bonaventure Hotel or the Frank Geahry House, for
him the structure of social causality requires the 'base and super-
structure' division which recurs repeatedly in his later work,
shorn of its dogmatism, but nonetheless, as he reminds us, his
methodological starting point: 'a heuristic recommendation
simultaneously to grasp culture (and theory) in and for itself,
but also in relation to its outside, its content and its context, its
space of intervention and effectivity' (p. 409).

If the incommensurable and asynchronic landscape of the
postmodern undermines the possibility of such simultaneity,
then Jameson further evolves the concept of base and super-
structure by rearticulating the binary division through an
analogon:

[I]n the present world system, a media term is always present to
function as an analogon or material interpretant for this or that

> more directly representational social model. Something thereby emerges which looks like a new postmodern version of the base–superstructure formula in which a representation of social relations as such now demands the mediation of this or that interposed communicational structure from which it must be read off indirectly. (p. 416)

Once more the historical difference of the present is articulated in the emergence of a third space of representation which is, just as quickly, reabsorbed into the base–superstructure division. The analogon, required by the new world system as a way of expressing its interstitial cultural temporality – an indirect and interposed communicational structure – is allowed to embellish, but not to interrupt, the base–superstructure formula. What forms of social difference are privileged in the *Aufhebung*, or the transcendence, of the 'unrepresentable'? Who are the new historical subjects that remain unrepresented in the vaster invisibility of this transnational totality?

As the West gazes into the broken mirror of its new global unconscious – 'the extraordinary demographic displacements of mass migrant workers and of global tourists . . . to a degree unparalleled in world history' (p. 363) – Jameson attempts, in a suggestive move, to turn the schizophrenic social imaginary of the postmodern subject into a crisis in the collective ontology of the group faced with the sheer 'number' of demographic pluralism. The perceptual (and cognitive) anxiety[16] that accompanies the loss of 'infrastructural' mapping becomes exacerbated in the postmodern city, where both Raymond Williams's 'knowable community' and Benedict Anderson's 'imagined community' have been altered by mass migration and settlement. Migrant communities are representative of a much wider trend towards the minoritization of national societies. For Jameson this process is part of a historical irony: 'the transitional nature of the new global economy has not yet allowed its classes to form in any

stable way, let alone to acquire a genuine class-consciousness' (p. 348).

The social objectivity of the group-based politics of new social movements – or, indeed, the political groupings of metropolitan minorities – is, in Jameson's argument, to be found in the simulacral superficies of media institutions or in those practices of the culture industry that produce 'libidinal investments of a more narrative kind.' The construction of political solidarities between minorities or special interest groups would then be considered 'pseudo-dialectical' unless their alignment is mediated through the *prior and primal* identification with class identity (as the mode of equivalence between oppressions or exploitations). Racial hierarchies, sexual discriminations, or, for instance, the linkage of both forms of social differentiation in the iniquitous practices of refugee and nationality law – these may be legitimate causes for political action, but the making of the political group for it-self as an effective consciousness could only occur through the mediation of the category of class.

Such a reading of Jameson's class analysis, it may be argued, does little justice to his innovative image of the social actor as a 'third term . . . the non-centred subject that is part of an organic group or collective' (p. 345). We have, by now, learnt that this appeal to a 'thirdness' in the structure of dialectical thought is both an acknowledgement of the disjunctive cultural 'signs' of these (postmodern) times, and a symptom of Jameson's inability to move beyond the binary dialectic of inside and outside, base and superstructure. His innovative conception of the political subject, as a decentred spatial agency, is constrained by his conviction that the moment of History's true recognition – the guarantee of its material objectivity – lies in the ability of the concept of class to become the mirror of social production and cultural representation. He writes:

> Class categories are more material, more impure and
> scandalously mixed, in the way in which their determinants or
> definitional factors involve the production of objects and the
> relations determined by that, along with the forces of the
> respective machinery: we can thus see down through class
> categories to the rocky bottom of the stream. (p. 346)

Would it be fanciful for me to suggest that in this image of
class as the glass of history – an optical ontology that allows a
clear view to the 'bottom of the stream' – there is also a form of
narcissism? Class subsumes the interpellative, affective power of
'race, gender, ethnic culture and the like . . . [which] can always
be shown to involve phantasms of culture as such, in the anthro-
pological sense, . . . authorized and legitimized by notions of
religion' (p. 345). In Jameson's argument, these forms of social
difference are fundamentally reactive and group oriented, lack-
ing the material objectivity of the class relation. It is only when
political movements of race or gender are mediated by the pri-
mary analytic category of class, that these communal identities
are transformed into agencies 'capable of interpellating [them-
selves] and dictating the terms of [their] own specular image[s]'
(p. 346).

If the specularity of class consciousness provides race and
gender with its interpellative structure, then no form of collect-
ive social identity can be designated without its prior naming as a
form of class identity. Class identity is autoreferential, surmount-
ing other instances of social difference. Its sovereignty is also, in
a theoretical sense, an act of surveillance. Class categories that
provide a clear view to the stream's rocky bottom are then
caught in an autotelic disavowal of their own discursive and
epistemic limits. Such a narcissism can articulate 'other' sub-
jects of difference and forms of cultural alterity as either
mimetically secondary – a paler shade of the authenticity and
originality of class relations, now somehow out of place – or

temporally anterior or untimely – archaic, anthropomorphic, compensatory realities rather than contemporary social communities.

If I have described the class category as narcissistic, *tout court*, then I have not done justice to the complexity of Jameson's ambivalence. For it is, perhaps, a wounded narcissus that gazes down to the bottom of the stream. 'In a situation in which, for a time, genuine (or totalising) politics is no longer possible', Jameson concedes, it becomes one's responsibility 'to attend to just such symptoms as the waning of the global dimension, to the ideological resistance to the concept of totality' (p. 330). Jameson's urgent and admirable vigilance is not in doubt. It is the value invested in the visible difference of class that does not allow him to constitute the present moment as the insignia of other interstitial inscriptions of cultural difference. As the autotelic specularity of the class category witnesses the historic loss of its own ontological priority, there emerges the possibility of a politics of social difference that makes no autotelic claims – 'capable of *interpellating itself*'; – but is genuinely articulatory in its understanding that to be discursively represented and socially representative – *to assume an effective political identity or image* – the limits and conditions of specularity have to be exceeded and erased by the inscription of otherness. To revise the problem of global space from the postcolonial perspective is to move the location of cultural difference away from the space of demographic *plurality* to the borderline negotiations of cultural translation.

II FOREIGN RELATIONS

What does the narrative construction of minority discourses entail for the everday existence of the Western metropolis? Let us stay with televisual subjects of channel-switching and psychic splitting – that Jameson deems late capitalist – and enter the

postmodern city as migrants and minorities. Our siren song comes from the Jewish ad-woman Mimi Mamoulian, talking over the phone from New York to Saladin Chamcha, erstwhile London based voice-over artiste, now a Satanic goatman, sequestered in an Indian–Pakistani ghetto in London's Brickhall Street. The scenario comes, of course, from *The Satanic Verses*,[17] and the voice is Mimi's:

> I am conversant with postmodernist critiques of the West, e.g. that we have here a society capable only of pastiche: a flattened world. When I become the voice of a bubble bath, I am entering flatland knowingly, understanding what I am doing and why. . . . Don't teach me about exploitation. . . . Try being jewish, female and ugly sometime. You'll beg to be black. Excuse my french: brown.

At the Shandaar Cafe today all the talk is about Chamcha the Anglophile, famed for his voice-over on the Slimbix ad: '*How's a calorie to earn a salary? Thanks to Slimbix, I'm out of work.*' Chamcha, the great projector of voices, the prestidigitator of personae, has turned into a Goat and has crawled back to the ghetto, to his despised migrant compatriots. In his mythic being he has become the 'borderline' figure of a massive historical displacement – postcolonial migration – that is not only a 'transitional' reality, but also a 'translational' phenomenon. The question is, in Jameson's terms, whether 'narrative invention . . . by way of its very implausibility becomes the figure of a larger possible [cultural] praxis' (p. 369).

For Chamcha stands, quite literally, in-between two border conditions. On the one hand lies his landlady Hind who espouses the cause of gastronomic pluralism, devouring the spiced dishes of Kashmir and the yogurt sauces of Lucknow, turning herself into the wide land mass of the subcontinent itself 'because food passes across any boundary you care to men-

tion'.[18] On Chamcha's other side sits his landlord Sufyan, the secular 'colonial' metropolitan who understands the fate of the migrant in the classical contrast between Lucretius and Ovid. Translated, by Sufyan, for the existential guidance of postcolonial migrants, the problem consists in whether the crossing of cultural frontiers permits freedom from the essence of the self (Lucretius), or whether, like wax, migration only changes the surface of the soul, preserving identity under its protean forms (Ovid).

This liminality of migrant experience is no less a transitional phenomenon than a translational one; there is no resolution to it because the two conditions are ambivalently enjoined in the 'survival' of migrant life. Living in the interstices of Lucretius and Ovid, caught in-between a 'nativist', even nationalist, atavism and a postcolonial metropolitan assimilation, the subject of cultural difference becomes a problem that Walter Benjamin has described as the irresolution, or liminality, of 'translation', the *element of resistance* in the process of transformation, 'that element in a translation which does not lend itself to translation'.[19] This space of the translation of cultural difference *at the interstices* is infused with that Benjaminian temporality of the present which makes graphic a moment of transition, not merely the continuum of history; it is a strange stillness that defines the present in which the very writing of historical transformation becomes uncannily visible. The migrant culture of the 'in-between', the minority position, dramatizes the activity of culture's untranslatability; and in so doing, it moves the question of culture's appropriation beyond the assimilationist's dream, or the racist's nightmare, of a 'full transmissal of subject-matter';[20] and towards an encounter with the ambivalent process of splitting and hybridity that marks the identification with culture's difference. The God of migrants, in *The Satanic Verses*, speaks unequivocally on this point, while of course, fully equivocal between purity and danger:

> Whether We be multiform, plural, representing the union-by-hybridisation of such opposites as Oopar and Neechay, or whether We be pure, stark, extreme, will not be resolved here.[21]

The indeterminacy of diasporic identity, '[that] will not be resolved here' is the secular, social cause for what has been widely represented as the 'blasphemy' of the book. Hybridity is heresy. The fundamentalist charge has not focused on the misinterpretation of the Koran, as much as on the offence of the 'misnaming' of Islam: Mohamed referred to as Mahound; the prostitutes named after the wives of the Prophet. It is the formal complaint of the fundamentalists that the transposition of these sacred names into profane spaces – brothels or magical realist novels – is not simply sacrilegious, but destructive of the very cement of community. To violate the system of naming is to make contingent and indeterminate what Alisdair Macintrye, in his essay on 'Tradition and translation', has described as 'naming for: the institutions of naming as the expression and embodiment of the shared standpoint of the community, its traditions of belief and enquiry'.[22] The conflict of cultures and community around The Satanic Verses has been mainly represented in spatial terms and binary geopolitical polarities – Islamic fundamentalists vs. Western literary modernists, the quarrel of the ancient (ascriptive) migrants and modern (ironic) metropolitans. This obscures the anxiety of the irresolvable, borderline culture of hybridity that articulates its problems of identification and its diasporic aesthetic in an uncanny, disjunctive temporality that is, at once, the time of cultural displacement, and the space of the 'untranslatable'.

To blaspheme is not simply to sully the ineffability of the sacred name. '. . . [B]lasphemy is by no means confined to the Islamic chapters', Sara Suleri writes in her fine reading of The Satanic Verses. '[A] postcolonial desire for deracination, emblematized by the protagonist Saladin Chamcha, is equally represented as cultural heresy. Acts of historical or cultural severance become

those blasphemous moments that proliferate in the narrative . . .'[23] Blasphemy goes beyond the severance of tradition and replaces its claim to a purity of origins with a poetics of relocation and reinscription. Rushdie repeatedly uses the word 'blasphemy' in the migrant sections of the book to indicate a theatrical form of the staging of cross-genre, cross-cultural identities. Blasphemy is not merely a misrepresentation of the sacred by the secular; it is a moment when the subject-matter or the content of a cultural tradition is being overwhelmed, or alienated, in the act of translation. Into the asserted authenticity or continuity of tradition, 'secular' blasphemy releases a temporality that reveals the contingencies, even the incommensurabilities, involved in the process of social transformation.

My theoretical description of blasphemy as a transgressive act of cultural translation, is borne out by Yunus Samad's reading of blasphemy in the context of the real event of the fatwah.[24] It is the *medium* Rushdie uses to reinterpret the Koran that constitutes the crime. In the Muslim world, Samad argues, poetry is the traditional medium of censure. By casting his revisionary narrative in the form of the novel – largely unknown to traditional Islamic literature – Rushdie violates the poetic licence granted to critics of the Islamic establishment. In Samad's words, 'Salman Rushdie's real crime, in the eyes of the clerics, was that he touched on early Islamic history in a critical, imaginative and irreverent fashion but with deep historical insight.' It could be argued, I think, that far from simply misinterpreting the Koran, Rushdie's sin lies in opening up a space of discursive contestation that places the authority of the Koran within a perspective of historical and cultural relativism. It is not that the 'content' of the Koran is directly disputed; rather, by revealing other enunciatory positions and possibilities within the framework of Koranic reading, Rushdie performs the subversion of its authenticity through the act of cultural translation – he relocates the Koran's 'intentionality' by repeating and

reinscribing it in the locale of the novel of postwar cultural migrations and diasporas.

The transposition of the life of Mohamed into the melodramatic theatricality of a popular Bombay movie, *The Message*, results in a hybridized form – the 'theological'[25] – targeted to Western immigrant audiences. Blasphemy, here, is the slippage in-between the intended moral fable and its displacement into the dark, symptomatic figurations of the 'dreamwork' of cinematic fantasy. In the racist psychodrama staged around Chamcha, the Satanic goatman, 'blasphemy' stands for the phobic projections that fuel great social fears, cross frontiers, evade the normal controls, and roam loose about the city turning difference into demonism. The social fantasm of racism, driven by rumour, becomes politically credible and strategically negotiable: 'priests became involved, adding another unstable element – the linkage between the term *black* and the sin *blasphemy* – to the mix.'[26] As the unstable element – the interstice – enables the linkage black/blasphemy, so it reveals, once more, that the 'present' of translation may not be a smooth transition, a consensual continuity, but the configuration of the disjunctive rewriting of the transcultural, migrant experience.

If hybridity is heresy, then to blaspheme is to dream. To dream not of the past or present, nor the continuous present; it is not the nostalgic dream of tradition, nor the Utopian dream of modern progress; it is the dream of translation as 'survival' as Derrida translates the 'time' of Benjamin's concept of the afterlife of translation, as *sur-vivre*, the act of living on borderlines. Rushdie translates this into the migrant's dream of survival: an *initiatory* interstices; an empowering condition of hybridity; an emergence that turns 'return' into reinscription or redescription; an iteration that is not belated, but ironic and insurgent. For the migrant's survival depends, as Rushdie put it, on discovering 'how newness enters the world'. The focus is on making the linkages through the unstable elements of literature and life – the

dangerous tryst with the 'untranslatable' – rather than arriving at ready-made names.

The 'newness' of migrant or minority discourse has to be discovered in *medias res*: a newness that is not part of the 'progressivist' division between past and present, or the archaic and the modern; nor is it a 'newness' that can be contained in the mimesis of 'original and copy'. In both these cases, the image of the new is iconic rather than enunciatory; in both instances, temporal difference is represented as epistemological or mimetic distance from an original source. The newness of cultural translation is akin to what Walter Benjamin describes as the 'foreignness of languages' – that problem of representation native to representation itself. If Paul de Man focused on the 'metonymy' of translation, I want to foreground the 'foreignness' of cultural translation.

With the concept of 'foreignness' Benjamin comes closest to describing the performativity of translation as the staging of cultural difference. The argument begins with the suggestion that though *Brot* and *pain* intend the same object, *bread*, their discursive and cultural *modes of signification* are in conflict with each other, striving to exclude each other. The complementarity of language as communication must be understood as emerging from the constant state of contestation and flux caused by the differential systems of social and cultural signification. This process of complementarity as the agonistic supplement is the seed of the 'untranslatable' – the foreign element in the midst of the performance of cultural translation. And it is this seed that turns into the famous, overworked analogy in the Benjamin essay: unlike the original where fruit and skin form a certain unity, in the act of translation the content or subject matter is made disjunct, overwhelmed and alienated by the form of signification, like a royal robe with ample folds.

Unlike Derrida and de Man, I am less interested in the metonymic fragmentation of the 'original'. I am more engaged with

the 'foreign' element that reveals the interstitial; insists in the textile superfluity of folds and wrinkles; and becomes the 'unstable element of linkage', the indeterminate temporality of the in-between, that has to be engaged in creating the conditions through which 'newness comes into the world'. The foreign element 'destroys the original's structures of reference and sense communication as well'[27] not simply by negating it but by negotiating the disjunction in which successive cultural temporalities are 'preserved in the work of history and *at the same time* cancelled. - . . . The nourishing fruit of the historically understood contains time as a precious but tasteless seed.'[28] And through this dialectic of cultural negation-as-negotiation, this splitting of skin and fruit through the *agency* of foreignness, the purpose is, as Rudolf Pannwitz says, not 'to turn Hindi, Greek, English into German [but] instead to turn German into Hindi, Greek, English'.[29]

Translation is the performative nature of cultural communication. It is language *in actu* (enunciation, positionality) rather than language *in situ* (*énoncé*, or propositionality).[30] And the sign of translation continually tells, or 'tolls' the different times and spaces between cultural authority and its performative practices.[31] The 'time' of translation consists in that *movement* of meaning, the principle and practice of a communication that, in the words of de Man 'puts the original in motion to decanonise it, giving it the movement of fragmentation, a wandering of errance, a kind of permanent exile'.[32]

Chamcha is the discriminatory sign of a performative, projective British culture of race and racism – 'illegal immigrant, outlaw king, foul criminal or race hero'.[33] From somewhere between Ovid and Lucretius, or between gastronomic and demographic pluralisms, he confounds nativist and supremacist ascriptions of national(ist) identities. This migrant movement of social identifications leads to the most devastating parody of Maggie Torture's Britain.

The revenge of the migrant hybrid comes in the Club Hot

Wax sequence,[34] named, no doubt, after Sufyan's translation of Ovid's waxy metaphor for the immutability of the migrant soul. If Gibreel Farishta, later in the book, transforms London into a tropical country with 'increased moral definition, institution of a national siesta, development of vivid and expansive patterns of behaviour',[35] then it is the deejay, prancing Pinkwalla, who stages the revenge of black history in the expressivist cultural practices of toasting, rapping and scratching. In a scene that blends Madame Tussaud's with Led Zepplin, the sepulchral wax figures of an excised black history emerge to dance amidst the migrants of the present in a postcolonial counter-masque of a retrieved and reinscribed history. Waxy Maggie Torture is condemned to a melt-down, accompanied by the Baldwinian chants of 'the fire this time'. And suddenly through this ritual of translation, Saladin Chamcha, the Satanic goatman, is historicized again in the movement of a migrant history, a metropolitan world 'becoming minority'.

Cultural translation desacralizes the transparent assumptions of cultural supremacy, and in that very act, demands a contextual specificity, a historical differentiation *within* minority positions. If the public image of the Rushdie affair has become mired in the righteous indignation of Magus and Mullah, that is because its re-citation within a feminist, anti-fundamentalist public discourse has received little attention. The most productive debates, and political initiatives, in the post-fatwah period, have come from women's groups like Women Against Fundamentalism and Southall Black Sisters[36] in Britain. They have been concerned less with the politics of textuality and international terrorism, and more with demonstrating that the secular, global issue lies uncannily at home, in Britain – in the policies of local government and the race-relations industry; in the 'racialization of religion' in multicultural Britain; in the imposition of homogeneity on 'minority' populations in the name of cultural diversity or pluralism.

Feminists have not fetishized the infamous naming of the prostitutes after Mohamed's wives: rather they have drawn attention to the politicized violence in the brothel and the bedroom, raising demands for the establishment of refuges for minority women coerced into marriages. Their response to the Rushdie affair reveals what they describe as 'the *contradictory* influences of feminist and multi-culturalist policies adopted by the local state (mainly in Labour-led councils)'.[37] From such ambivalent, antagonistic identifications of class, gender, generation and tradition, the British feminist movement of the 1990s has redefined its agenda. The Irish question, post-fatwah, has also been reposed as a *postcolonial* problem of the 'racialization of religion'. The critique of patriarchal fundamentalism and its regulation of gender and sexual desire has become a major issue for minority cultures. Minority artists have questioned the heterosexism that regulates traditional, joint-family based communities, making gay and lesbian relations restrictive and repressive. Such is the tropic movement of cultural translation, as Rushdie spectacularly renames London, in its Indo-Pakistani iteration, as 'Ellowen Deeowen'.

III COMMUNITY MATTERS

Can 'libidinal investments of a more narrative kind'[38] produce a representative discourse of minorities? In other words – *pace* Jameson – how would collective agency be signified in groups that do not have the 'organicist' history and conceptuality of the discourse of 'class'? 'Becoming minor', Abdul Janmohamed and David Lloyd remind us, 'is not a question of essence . . . but a question of subject position.' Such a position articulates 'alternative practices and values that are embedded in the often-damaged, -fragmentary, -hampered, or -occluded work of minorities',[39] and having been 'coerced into a negative, generic subject position, the oppressed individual transforms it into a

positive collective one'.[40] These fragmented, partially occluded values of minority discourse are both continuous and discontinous with Marxism, according to Cornel West. He proposes a genealogical materialism as a way of contesting a 'psycho-sexual racial logic'.[41] It represents a logic of living that cuts across the everyday life of different ideological forms – race, religion, patriarchy, homophobia; it reveals, and contests, the mechanisms by which self-images and self-identities are formed in the realm of cultural styles, aesthetic ideals, psychosexual sensibilities. Both these accounts of the racial, gendered minority positions stage the symbolic form of self-identification represented through fragmentation and occlusion of the sovereignty of the self. Affiliative solidarity is formed through the ambivalent articulations of the realm of the aesthetic, the fantasmatic, the economic and the body political: a temporality of social construction and contradiction that is iterative and interstitial; an insurgent 'intersubjectivity' that is interdisciplinary; an everyday that interrogates the synchronous contemporaneity of modernity.

It is too easy to see the discourses of the minority as symptoms of the postmodern condition. Jameson's claim, that in the absence of a genuine class consciousness, 'the very lively social struggles of the current period are largely dispersed and anarchic' (p. 349), does not sufficiently register the antagonistic displacement that minority discourses initiate, across, or at cross-purposes with, the dialectics of class identities. To seek a 'healthy' sociological holism and philosophical realism (p. 323), as Jameson derives from Georg Lukćs, would hardly be appropriate to those passionate and partial *conditions of communal emergence* which are an integral part of the temporal and historic conditions of postcolonial critique.

'It is not so much the state–civil society opposition but rather the capital–community opposition that seems to be the great unsurpassed contradiction in Western social philosophy.'[42]

From this perspective, Partha Chatterjee, the Indian subaltern scholar, returns to Hegel – crucial to both Lukács and Jameson – to claim that the idea of community articulates a cultural temporality of contingency and indeterminacy at the heart of the discourse of civil society. This 'minority' reading is built on the occluded, partial presence of the idea of community that haunts or doubles the concept of civil society, leading 'a subterranean, potentially subversive life within it because it refuses to go away'.[43] As a category, community enables a division between the private and the public, the civil and the familial; but as a performative discourse it enacts the impossibility of drawing an objective line between the two. The agency of the community-concept 'seeps through the interstices of the objectively constructed, contractually regulated structure of civil society',[44] class-relations and national identities. Community disturbs the grand globalizing narrative of capital, displaces the emphasis on production in 'class' collectivity, and disrupts the homogeneity of the imagined community of the nation. The narrative of community substantializes cultural difference, and constitutes a 'split-and-double' form of group identification which Chatterjee illustrates through a specifically 'anti-colonialist' contradiction of the public sphere. The colonized refuse to accept membership in the civil society of subjects; consequently they create a cultural domain 'marked by the distinctions of the material and the spiritual, the outer and the inner'.[45]

I am less concerned with the conceptual aporia of the community–capital contradiction, than with the genealogy of the idea of community as itself a 'minority' discourse; as the making, or becoming 'minor', of the idea of Society, in the practice of the politics of culture. Community is the antagonist supplement of modernity: in the metropolitan space it is the territory of the minority, threatening the claims of civility; in the transnational world it becomes the border-problem of the diasporic, the migrant, the refugee. Binary divisions of social space neglect

the profound temporal disjunction – the translational time and space – through which minority communities negotiate their collective identifications. For what is at issue in the discourse of minorities is the creation of agency through incommensurable (not simply multiple) positions. Is there a poetics of the 'interstitial' community? How does it name itself, author its agency?

Nowhere in contemporary postcolonial poetry have I found the concept of the right to signify more profoundly evoked than in Derek Walcott's poem on the colonization of the Caribbean as the possession of a space through the power of naming.[46] Ordinary language develops an auratic authority, an imperial persona; but in a specifically postcolonial performance of reinscription, the focus shifts from the nominalism of imperialism to the emergence of another sign of agency and identity. It signifies the destiny of culture as a site, not simply of subversion and transgression, but one that prefigures a kind of solidarity between ethnicities that meet in the tryst of colonial history.

> My race began as the sea began,
> with no nouns, and with no horizon,
> with pebbles under my tongue,
> with a different fix on the stars.
>
>
>
> Have we melted into the mirror
> leaving our souls behind?
> The goldsmith from Benares,
> the stonecutter from Canton,
> the bronzesmith from Benin.
>
> A sea-eagle screams from the rock,
> and my race began like the osprey
> with that cry,
> that terrible vowel,
> that I!

[. . .] this stick
to trace our names on the sand
which the sea erased again, to our indifference.

II

And when they named these bays
bays,
was it nostalgia or irony?

.

Where were the courts of Castille?
Versailles' colonnades
supplanted by cabbage palms
with Corinthian crests,
belittling diminutives,
then, little Versailles,
meant plans for a pigsty,
names for the sour apples
and green grapes
of their exile.

[. . .] Being men they could not live
except they first presumed
the right of everything to be a noun.
The African acquiesced,
repeated and changed them.

Listen, my children, say:
moubain: the hogplum,
cerise: the wild cherry,
baie-la: the bay,
with the fresh green voices
they were once themselves
in the way the wind bends
our natural inflections.

> These palms are greater than Versailles,
> for no man made them,
> their fallen columns greater than Castille,
> no man unmade them
> except the worm who has no helmet,
> but was always the emperor,

There are two myths of history in this poem, each of them related to opposing versions of the place of identity in the process of cultural knowledge. There is the pedagogical process of imperialist naming:

> Being men, they could not live
> except they first presumed
> the right of everything to be a noun.

Opposed to this is the African acquiescence which, in repeating the lesson of the masters, changes their inflections:

> *moubain*: the hogplum
> *cerise*: the wild cherry
> *baie-la*: the bay
> with the fresh green voices
> they were once themselves . . .

Walcott's purpose is not to oppose the pedagogy of the imperialist noun to the inflectional appropriation of the native voice. He proposes to go beyond such binaries of power in order to reorganize our sense of the process of identification in the negotiations of cultural politics. He stages the slaves' right to signify, not simply by denying the imperialist the 'right of everything to be a noun' but by questioning the masculinist, authoritative subjectivity produced in the colonizing process: *Being men they could not live/except they first presumed/the right of everything*

to be a noun. What is 'man' as an effect of, as subjected to, the sign – the noun – of a colonizing discourse? To this end, Walcott poses the problem of 'beginning' outside the question of 'origins', beyond that perspectival field of vision – *the mind halved by the horizon* – that constitutes human consciousness in the mirror of nature, as Richard Rorty has famously described it.[47]

Walcott's history begins elsewhere. He leads us to that moment of undecidability or unconditionality that constitutes the ambivalence of modernity as it executes its critical judgements, or seeks justification for its social facts.[48] Against the possessive, coercive 'right' of the Western noun, Walcott places a different mode of postcolonial speech; a historical time envisaged in the discourse of the enslaved or the indentured. The undecidability from which Walcott builds his narrative opens up his poem to the historical 'present' which Walter Benjamin describes as a 'present which is not a transition, but in which time stands still and has come to a stop'.[49] *For this notion defines the present in which history is being written.* From this discursive space of struggle, the violence of the letter, the terror of the timeless, is negotiated the agency of the goldsmith from Benares, the Benin bronzesmith, the Cantonese stonecutter. It is a collective agency that is, at once, pronomial and postnominalist:

> and my race began like the osprey
> with that cry,
> that terrible vowel,
> that I!

Where does the postcolonial subject lie?

With that *terrible vowel, that* I, Walcott opens up the disjunctive present of the poem's writing of its history. The I as vowel, as the arbitrariness of the signifier, is the *sign* of the interstitial difference through which the identity of meaning is made. The 'I' as pronomial, as the avowal of the enslaved colonial subject is

the repetition of the symbolic agency of history, tracing its name on the shifting sands, constituting a postcolonial, migrant community in-difference: Hindu, Chinese, African. With this disjunctive, double 'I' Walcott writes a history of cultural difference that envisages the production of difference as the political and social definition of the historical present. Cultural differences must be understood as they constitute identities – contingently, indeterminately – in-between the repetition of the vowel I – that can always be reinscribed and relocated – and the restitution of the subject I. Read like this, in-between the I-as-symbol and the I-as-sign, the articulations of difference – race, history, gender – are never singular or binary. Claims to identity are nominative or normative, in a preliminary, passing moment; they are never nouns when they are culturally productive or historically progressive. Like the vowel itself, forms of social identity must be capable of turning up in-and-as an-other's difference and turning the right to signify into an act of cultural translation.

> Pomme arac
> otaheite apple,
> pomme cythère,
> pomme granate,
> moubain,
> z'ananas
> the pineapple's
> Aztec helmet,
> pomme,
> I have forgotten
> what pomme for
> Irish potato,
> cerise,
> the cherry,
> z'aman
> sea-almonds

> by the crisp
> sea-bursts,
> au bord de la ouvrière.
> Come back to me,
> my language.
> Come back,
> cacao,
> grigri,
> solitaire, . . .[50]

Richard Rorty suggests that 'solidarity has to be constructed out of little pieces, rather than found already waiting, in the form of an ur-language which all of us recognise when we hear it'.[51] In the spirit of such solidarity, Walcott's call to language serves a symbolic function. As the poem shuttles between the small acts of nature's naming and the larger performance of a communal tongue, its rhythm registers the 'foreignness' of cultural memory. In forgetting the proper name, in each return of language – its 'coming back' – the disjunctive temporality of translation reveals the intimate differences that lie between genealogies and geographies. It is an interstitial time and space that I have variously described, through this chapter, as living 'in the midst of the incomprehensible', or dwelling with Sufyan at the Shandaar Cafe, on the borderlines between Ovid and Lucretius, in-between Ooopar (above) and Neechay (below). History's *intermediacy* poses the future, once again, as an open question. It provides an agency of initiation that enables one to possess again and anew – as in the movement of Walcott's poem – the signs of survival, the terrain of other histories, the hybridity of cultures. The act of cultural translation works through 'the *continua* of transformation' to yield a sense of culture's belonging:

> generations going,
> generations gone,

> moi c'est gens Ste. Lucie
> C'est la moi sorti:
> is there that I born.[52]

And from the little pieces of the poem, its going and coming, there rises the great history of the languages and landscapes of migration and diaspora.

12

CONCLUSION

'Race', time and the revision of modernity

'Dirty nigger!' Or simply, Look, a Negro!'
Frantz Fanon, *The Fact of Blackness*

I

Whenever these words are said in anger or in hate, whether of the Jew in that *estaminet* in Antwerp, or of the Palestinian on the West Bank, or the Zairian student eking out a wretched existence selling fake fetishes on the Left Bank; whether they are said of the body of woman or the man of colour; whether they are quasi-officially spoken in South Africa or officially prohibited in London or New York, but inscribed nevertheless in the severe staging of the statistics of educational performance and crime, visa violations, immigration irregularities; whenever 'Dirty nigger!' or, 'Look, a Negro!' is not said at all, but you can see it in a gaze, or hear it in the solecism of a still silence; whenever and

wherever I am when I hear a racist, or catch his look, I am reminded of Fanon's evocatory essay 'The fact of blackness' and its unforgettable opening lines.[1]

I want to start by returning to that essay, to explore only one scene in its remarkable staging, Fanon's phenomenological performance of what it means to be *not only a nigger* but a member of the marginalized, the displaced, the diasporic. To be amongst those whose very presence is both 'overlooked' – in the double sense of social surveillance and psychic disavowal – and, at the same time, overdetermined – psychically projected, made stereotypical and symptomatic. Despite its very specific location – a Martinican subjected to the racist gaze on a street corner in Lyons – I claim a generality for Fanon's argument because he talks not simply of the historicity of the black man, as much as he writes in 'The fact of blackness' about the temporality of modernity within which the figure of the 'human' comes to be *authorized*. It is Fanon's temporality of emergence – his sense of the *belatedness of the black man* – that does not simply make the question of ontology inappropriate for black identity, but somehow *impossible* for the very understanding of humanity in the world of modernity:

> *You come too late, much too late, there will always be a world – a white world between you and us.* (My emphasis)

It is the opposition to the ontology of that white world – to its assumed hierarchical forms of rationality and universality – that Fanon turns in a performance that is iterative and interrogative – a repetition that is initiatory, instating a differential history that will not return to the power of the Same. Between *you and us* Fanon opens up an enunciative space that does not simply contradict the metaphysical ideas of progress or racism or rationality; he distantiates them by 'repeating' these ideas, makes them

uncanny by displacing them in a number of culturally contra-
dictory and discursively estranged locations.

What Fanon shows up is the liminality of those ideas – their
ethnocentric margin – by revealing the *historicity* of its most uni-
versal symbol – Man. From the perspective of a postcolonial
'belatedness', Fanon disturbs the *punctum* of man as the signify-
ing, subjectifying category of Western culture, as a unifying
reference of ethical value. Fanon performs the desire of the col-
onized to identify with the humanistic, enlightenment ideal of
Man: 'all I wanted was to be a man among other men. I wanted
to come lithe and young into a world that was ours and build it
together.' Then, in a catachrestic reversal he shows how, despite
the pedagogies of human history, the performative discourse of
the liberal West, its quotidian conversation and comments,
reveal the cultural supremacy and racial typology upon which
the universalism of Man is founded: 'But of course, come in, sir,
there is no colour prejudice among us. . . . Quite, the Negro is a
man like ourselves. . . . It is not because he is black that he is less
intelligent than we are.'

Fanon uses the fact of blackness, of belatedness, to destroy
the binary structure of power and identity: the imperative that
'the Black man must be Black; he must be Black in relation to the
white man.' Elsewhere he has written: 'The Black man is not.
[caesura] Any more than the white man' (my interpolation).
Fanon's discourse of the 'human' emerges from that temporal
break or caesura effected in the continuist, progressivist myth of
Man. He too speaks from the signifying time-lag of cultural
difference that I have been attempting to develop as a structure
for the representation of subaltern and postcolonial agency.
Fanon writes from that temporal caesura, the time-lag of cultural
difference, in a space between the symbolization of the social
and the 'sign' of its representation of subjects and agencies.
Fanon destroys two time schemes in which the historicity of the
human is thought. He rejects the 'belatedness' of the black man

because it is only the opposite of the framing of the white man as universal, normative – *the white sky all around me*: the black man refuses to occupy the past of which the white man is the future. But Fanon also refuses the Hegelian–Marxist dialectical schema whereby the black man is part of a transcendental sublation: a minor term in a dialectic that will emerge into a more equitable universality. Fanon, I believe, suggests another time, another space.

It is a space of being that is wrought from the interruptive, interrogative, tragic experience of blackness, of discrimination, of despair. It is the apprehension of the social and psychic question of 'origin' – and its erasure – in a negative side that 'draws its worth from an almost substantive absoluteness . . . [which has to be] ignorant of the essences and determinations of its being . . . an absolute density . . . an abolition of the ego by desire'. What may seem primordial or timeless is, I believe, a moment of a kind of 'projective past' whose history and signification I shall attempt to explore here. It is a mode of 'negativity' that makes the enunciatory present of modernity disjunctive. It opens up a time-lag at the point at which we speak of humanity through its differentiations – gender, race, class – that mark an excessive marginality of modernity. It is the enigma of this form of temporality which emerges from what Du Bois also called the 'swift and low of human doing',[2] to face Progress with some unanswerable questions, and suggest some answers of its own.

In destroying the 'ontology of man', Fanon suggests that 'there is not merely one Negro, there are *Negroes*'. This is emphatically not a postmodern celebration of pluralistic identities. As my argument will make clear, for me the project of modernity is itself rendered so contradictory and unresolved through the insertion of the 'time-lag' in which colonial and postcolonial moments emerge as sign and history, that I am sceptical of those transitions to postmodernity in Western academic writings which theorize the experience of this 'new

historicity' through the appropriation of a 'Third World' meta-phor; 'the First World . . . in a peculiar dialectical reversal, begins to touch some features of third-world experience. . . . The United States is . . . the biggest third-world country because of unemployment, nonproduction, etc.'[3]

Fanon's sense of social contingency and indeterminacy, made from the perspective of a postcolonial time-lag, is not a celebra-tion of fragmentation, *bricolage*, pastiche or the 'simulacrum'. It is a vision of social contradiction and cultural difference – as the disjunctive space of modernity – that is best seen in a fragment of a poem he cites towards the end of 'The fact of blackness':

> As the contradiction among the features
> creates the harmony of the face
> we proclaim the oneness of the suffering
> and the revolt.

II

The discourse of race that I am trying to develop displays the *problem of the ambivalent temporality of modernity* that is often over-looked in the more 'spatial' traditions of some aspects of post-modern theory.[4] Under the rubric 'the discourse of modernity', I do not intend to reduce a complex and diverse historical moment, with varied national genealogies and different insti-tutional practices, into a singular shibboleth – be it the 'idea' of Reason, Historicism, Progress – for the critical convenience of postmodern literary theory. My interest in the question of mod-ernity resides in the influential discussion generated by the work of Habermas, Foucault, Lyotard and Lefort, amongst many others, that has generated a critical discourse around historical modernity as an epistemological structure.[5] To put it succinctly, the question of ethical and cultural judgement, central to the processes of subject formation and the objectification of social

knowledge, is challenged at its 'cognitivist' core. Habermas characterizes it as a form of Occidental self-understanding that enacts a cognitive reductionism in the relation of the human being to the social world:

> Ontologically the world is reduced to a world of entities *as a whole* (as the totality of objects . . .); epistemologically, our relationship to that world is reduced to the capacity of know[ing] . . . states of affairs . . . in a purposive-rational fashion; semantically it is reduced to fact-stating discourse in which assertoric sentences are used.[6] (My emphasis)

Although this may be a stark presentation of the problem, it highlights the fact that the challenge to such a 'cognitivist' consciousness displaces the problem of truth or meaning from the disciplinary confines of epistemology – the problem of the referential as 'objectivity' reflected in that celebrated Rortyesque trope, the mirror of nature. What results could be figuratively described as a preoccupation not simply with the reflection in the glass – the idea or concept in itself – but with the frameworks of meaning as they are revealed in what Derrida has called the 'supplementary necessity of a parergon'. That is the performative, living description of the writing of a concept or theory, 'a relation to the history of its writing and the writing of its history also'.[7]

If we take even the most cursory view of influential postmodern perspectives, we find that there is an increasing *narrativization* of the question of social ethics and subject formation. Whether it is in the conversational procedures and 'final vocabularies' of liberal ironists like Richard Rorty, or the 'moral fictions' of Alisdair Macintyre that are the sustaining myths 'after virtue'; whether it is the *petits récits* and *phrases* that remain from the fall-out of the grand narratives of modernity in Lyotard; or the projective but ideal speech community that is rescued within

modernity by Habermas in his concept of communicative reason that is expressed in its pragmatic logic or argument and a 'decentred' understanding of the world: what we encounter in all these accounts are proposals for what is considered to be the essential gesture of Western modernity, an 'ethics of self-construction' – or, as Mladan Dolar cogently describes it:

> What makes this attitude typical of modernity is the constant reconstruction and the reinvention of the self. . . . The subject and the present it belongs to have no objective status, they have to be perpetually (re)constructed.[8]

I want to ask whether this synchronous constancy of reconstruction and reinvention of the subject does not assume a cultural temporality that may not be universalist in its epistemological moment of judgement, but may, indeed, be ethnocentric in its construction of cultural 'difference'. It is certainly true, as Robert Young argues, that the 'inscription of alterity within the self can allow for a new relation to ethics';[9] but does that *necessarily* entail the more general case argued by Dolar, that 'the persisting split [of the subject] is the condition of freedom'?

If so, how do we specify the historical conditions and theoretical configurations of 'splitting' in political situations of 'unfreedom' – in the colonial and postcolonial margins of modernity? I am persuaded that it is the catachrestic postcolonial agency of 'seizing the value-coding' – as Gayatri Spivak has argued – that opens up an interruptive time-lag in the 'progressive' myth of modernity, and enables the diasporic and the postcolonial to be represented. But this makes it all the more crucial to specify the discursive and historical temporality that interrupts the enunciative 'present' in which the self-inventions of modernity take place. And it is this 'taking place' of modernity, this insistent and incipient *spatial* metaphor in which the social relations of modernity are conceived, that introduces a

temporality of the 'synchronous' in the structure of the 'split-ting' of modernity. It is this 'synchronous and spatial' represen-tation of cultural difference that must be reworked as a *framework* for cultural otherness *within* the general dialectic of doubling that postmodernism proposes. Otherwise we are likely to find our-selves beached amidst Jameson's 'cognitive mappings' of the Third World, which might work for the Bonaventura Hotel in Los Angeles, but will leave you somewhat eyeless in Gaza.[10] Or if, like Terry Eagleton, your taste is more 'other worldly' than Third World, you will find yourself somewhat dismissive of the 'real' history of the 'other' – women, foreigners, homosexuals, the natives of Ireland – on the basis 'of certain styles, values, life-experiences which can be appealed to now as a form of political critique' because 'the fundamental political question is that of demanding an equal right with others of what one might become, not of assuming some fully-fashioned identity which is merely repressed.'[11]

It is to establish a *sign of the present*, of modernity, that is not that 'now' of transparent immediacy, and to found a form of social individuation where communality is *not predicated on a transcendent becoming*, that I want to pose my questions of a contra-modernity: what is modernity in those colonial conditions where its imposition is itself the denial of historical freedom, civic autonomy and the 'ethical' choice of refashioning?

III

I am posing these questions from within the problematic of modernity because of a shift within contemporary critical tradi-tions of postcolonial writing. There is no longer an influential separatist emphasis on simply elaborating an anti-imperialist or black nationalist tradition 'in itself'. There is an attempt to inter-rupt the Western discourses of modernity through these dis-placing, interrogative subaltern or postslavery narratives and the

critical-theoretical perspectives they engender. For example, Houston Baker's reading of the modernity of the Harlem Renaissance strategically elaborates a 'deformation of mastery', a vernacularism, based on the enunciation of the subject as 'never a simple coming into being, but a release from being possessed'.[12] The revision of Western modernism, he suggests, requires both the linguistic investiture of the subject and a practice of diasporic performance that is metaphorical. The 'public culture' project that Carol Breckenridge and Arjun Appadurai have initiated focuses on the transnational dissemination of cultural modernity. What becomes properly urgent for them is that the 'simultaneous' global locations of such a modernity should not lose sense of the conflictual, contradictory locutions of those cultural practices and products that follow the 'unequal development' of the tracks of international or multinational capital. Any transnational cultural study must 'translate', each time locally and specifically, what decentres and subverts this transnational globality, so that it does not become enthralled by the new global technologies of ideological transmission and cultural consumption.[13] Paul Gilroy proposes a form of populist modernism to comprehend both the aesthetic and political transformation of European philosophy and letters by black writers, but also to 'make sense of the secular and spiritual *popular* forms – music and dance – that have handled the anxieties and dilemmas involved in a response to the flux of *modern life*'.[14]

The power of the postcolonial translation of modernity rests in its *performative, deformative* structure that does not simply revalue the contents of a cultural tradition, or transpose values 'cross-culturally'. The cultural inheritance of slavery or colonialism is brought *before* modernity *not* to resolve its historic differences into a new totality, nor to forego its traditions. It is to introduce another locus of inscription and intervention, another hybrid, 'inappropriate' enunciative site, through that temporal split – or time-lag – that I have opened up (specifically in Chapter 9) for

the signification of postcolonial agency. Differences in culture
and power are constituted through the social conditions of
enunciation: the temporal caesura, *which is also the historically trans-
formative moment*, when a lagged space opens up *in*-between the
*inter*subjective 'reality of signs . . . deprived of subjectivity' and
the historical development of the subject in the order of social
symbols.[15] This transvaluation of the symbolic structure of the
cultural sign is absolutely necessary so that in the renaming of
modernity there may ensue that process of the active agency of
translation – the moment of 'making a name for oneself' that
emerges through 'the undecidability . . . [at work] in a struggle
for the proper name within a scene of genealogical indebted-
ness'.[16] Without such a reinscription of the sign itself – without
a transformation of the site of *enunciation* – there is the danger that
the mimetic contents of a discourse will conceal the fact that the
hegemonic structures of power are maintained in a position of
authority through a *shift in vocabulary* in the position of authority.
There is for instance a kinship between the normative paradigms
of colonial anthropology and the contemporary discourse of aid
and development agencies. The 'transfer of technology' has not
resulted in the transfer of power or the displacement of a neo-
colonial tradition of political control through philanthropy – a
celebrated missionary position.

What is the struggle of translation in the name of modernity?
How do we catachrestically seize the genealogy of modernity
and open it to the postcolonial translation? The 'value' of mod-
ernity is not located, a priori, in the passive fact of an epochal
event or idea – of progress, civility, the law – but has to be
negotiated *within* the 'enunciative' present of the discourse. The
brilliance of Claude Lefort's account of the genesis of ideology
in modern societies is to suggest that the representation of
the rule, or the discourse of generality that symbolizes
authority, is ambivalent because it is split off from its effective
operation.[17] The *new or the contemporary* appear through the

splitting of modernity as event and enunciation, the epochal and the everyday. Modernity as a *sign* of the present emerges in that process of splitting, that *lag*, that gives the practice of everyday life its consistency as *being contemporary*. It is because the present has the value of a 'sign' that modernity is iterative; a continual questioning of the conditions of existence; making problematic its own discourse not simply 'as ideas' but as the position and status of the locus of social utterance.

IV

'It is not enough . . . to follow the teleological thread that makes progress possible; one must isolate, within the history [of modernity], an event that will have the value of a sign.'[18] In his reading of Kant's *Was ist Aufklärung?* Foucault suggests that the sign of modernity is a form of decipherment whose value must be sought in *petits récits*, imperceptible events, in signs apparently *without* meaning and value – empty and excentric – in events that are outside the 'great events' of history.

The sign of history does not consist in an essence of the event itself, nor exclusively in the *immediate consciousness* of its agents and actors, but in its form as a *spectacle*; spectacle that signifies *because of* the distanciation and displacement between the event and those who are its spectators. The indeterminacy of modernity, where the struggle of translation takes place, is not simply around the ideas of progress or truth. Modernity, I suggest, is about the historical construction of a specific position of historical enunciation and address. It privileges those who 'bear witness', those who are 'subjected', or in the Fanonian sense with which I began, historically displaced. It gives them a representative position through the spatial distance, or the *time-lag* between the Great Event and its circulation as a historical sign of the 'people' or an 'epoch', that constitutes the memory and the moral of the event *as a narrative*, a disposition to cultural communality, a form

of social and psychic identification. The discursive address of modernity – its structure of authority – decentres the Great Event, and speaks from that moment of 'imperceptibility', the supplementary space 'outside' or uncannily beside (*abseits*).

Through Kant, Foucault traces 'the ontology of the present' to the exemplary event of the French Revolution and it is there that he stages his sign of modernity. But it is the spatial dimension of 'distance – *the perspectival distance from which the spectacle is seen* – that installs a cultural homogeneity into the sign of modernity. Foucault introduces a Eurocentric perspective at the point at which modernity installs a 'moral disposition in mankind'. The Eurocentricity of Foucault's theory of cultural difference is revealed in his insistent spatializing of the time of modernity. Avoiding the problems of the sovereign subject and linear causality, he nonetheless falls prey to the notion of the 'cultural' as a social formation whose discursive doubleness – the transcendental and empirical dialectic – is contained in a temporal frame that makes differences repetitively 'contemporaneous', regimes of sense-as-synchronous. It is a kind of cultural 'contradictoriness' that always presupposes a correlative spacing. Foucault's *spatial distancing* seals the sign of modernity in 1789 into a 'correlative', overlapping temporality. Progress brings together the three moments of the sign as:

> a *signum rememorativum*, for it reveals that disposition [of progress] which has been present from the beginning; it is a *signum demonstrativum* because it demonstrates the present efficacity of this disposition; and it is also *signum prognosticum* for, although the Revolution may have certain questionable results, one cannot forget the disposition [of modernity] that is revealed through it.[19]

What if the effects of 'certain questionable results' of the Revolution create a disjunction, between the *signum demonstrativum*

and the *signum prognosticum*? What if in the geopolitical space of the colony genealogically (in Foucault's sense) related to the Western metropolis, the symbol of the Revolution is partially visible as an unforgettable, tantalizing promise – a *pedagogy* of the values of modernity – while the 'present efficacy' of the sign of everyday life – its *political performativity* – repeats the archaic aristocratic racism of the *ancien régime*?

The ethnocentric limitations of Foucault's spatial sign of modernity become immediately apparent if we take our stand, in the immediate postrevolutionary period, in San Domingo with the Black Jacobins, rather than Paris. What if the 'distance' that constitutes the meaning of the Revolution as sign, the *signifying lag* between event and enunciation, stretches not across the Place de la Bastille or the rue des Blancs-Monteaux, but spans the temporal difference of the colonial space? What if we heard the 'moral disposition of mankind' uttered by Toussaint L'Ouverture for whom, as C. L. R. James so vividly recalls, the signs of modernity, 'liberty, equality, fraternity . . . what the French Revolution signified, was perpetually on his lips, in his correspondence, in his private conversations.'[20] What do we make of the figure of Toussaint – James invokes Phèdre, Ahab, Hamlet – at the moment when he grasps the tragic lesson that the moral, *modern* disposition of mankind, enshrined in the sign of the Revolution, only fuels the archaic racial factor in the society of slavery? What do we learn from that split consciousness, that 'colonial' disjunction of modern times and colonial and slave histories, where the reinvention of the self and the remaking of the social are strictly out of joint?

These are the issues of the catachrestic, postcolonial translation of modernity. They force us to introduce the question of subaltern agency, into the question of modernity: what is this 'now' of modernity? Who defines this present from which we speak? This leads to a more challenging question: *what is the desire of this repeated demand to modernize? Why does it insist, so compulsively, on its*

contemporaneous reality, its spatial dimension, its spectatorial distance? What happens to the sign of modernity in those repressive places like San Domingo where progress is only heard (of) and not 'seen', is that it reveals the problem of the disjunctive moment of its utterance: the space which enables a postcolonial contramodernity to emerge. For the discourse of modernity is *signified* from the time-lag, or temporal caesura, that emerges in the tension between the epochal 'event' of modernity as the symbol of the continuity of progress, and the interruptive temporality of the sign of the present, the contingency of modern times that Habermas has aptly described as its 'forward gropings and shocking encounters'.[21]

In this 'time' of repetition there circulates a contingent tension within modernity: a tension between the *pedagogy* of the symbols of progress, historicism, modernization, homogeneous empty time, the narcissism of organic culture, the onanistic search for the origins of race, and what I shall call the 'sign of the present': the performativity of discursive practice, the *récits* of the everyday, the repetition of the empirical, the ethics of self-enactment, the iterative signs that mark the non-synchronic *passages* of time in the archives of the 'new'. This is the space in which the question of modernity *emerges as a form of interrogation*: what do I belong to in this present? In what terms do I identify with the 'we', the intersubjective realm of society? This process cannot be represented in the binary relation of archaism/modernity, inside/outside, past/present, because these questions block off the forward drive or teleology of modernity. They suggest that what is read as the 'futurity' of the modern, its ineluctable progress, its cultural hierarchies, may be an 'excess', a disturbing alterity, a process of the marginalization of the symbols of modernity.

Time-lag is not a circulation of nullity, the endless slippage of the signifier or the theoretical anarchy of aporia. It is a concept that does not collude with current fashions for claiming the

heterogeneity of ever-increasing 'causes', multiplicities of subject positions, endless supplies of subversive 'specificities', 'localities', 'territories'. The problem of the articulation of cultural difference is not the problem of free-wheeling pragmatist pluralism or the 'diversity' of the many; it is the problem of the not-one, the minus in the origin and repetition of cultural signs in a doubling that will not be sublated into a similitude. What is in modernity *more* than modernity is this signifying 'cut' or temporal break: it cuts into the plenitudinous notion of Culture splendidly reflected in the mirror of human nature; equally it halts the endless signification of difference. The process I have described as the sign of the present – *within modernity* – erases and interrogates those ethnocentric forms of cultural modernity that 'contemporize' cultural difference: it opposes both cultural pluralism with its spurious egalitarianism – different cultures in the same time ('The Magicians of the Earth', Pompidou Centre, Paris, 1989) – or cultural relativism – different cultural temporalities in the same 'universal' space ('The Primitivism show', MOMA, New York, 1984).

V

This caesura in the narrative of modernity reveals something of what de Certeau has famously described as the non-place from which all historiographical operation starts, the lag which all histories must encounter in order to make a beginning.[22] For the emergence of modernity – as an ideology of *beginning, modernity as the new* – the template of this 'non-place' becomes the colonial space. It signifies this in a double way. The colonial space is the *terra incognita* or the *terra nulla*, the empty or wasted land whose history has to be begun, whose archives must be filled out; whose future progress must be secured in modernity. But the colonial space also stands for the *despotic* time of the Orient that becomes a great problem for the definition of modernity and its

inscription of the history of the colonized from the perspective of the West. Despotic time, as Althusser has brilliantly described it, is 'space without places, time without duration'.[23] In that double-figure which haunted the moment of the enlightenment in its relation to the *otherness* of the Other, you can see the historical formation of the time-lag of modernity. And lest it be said that this disjunctive present of modernity is merely my theoretical abstraction, let me also remind you that a similar, signifying caesura occurs within the invention of progress in the 'long imperialist nineteenth century'. At the mid-point of the century questions concerning the 'origin of races' provided modernity with an ontology of its present and a justification of cultural hierarchy within the West and in the East. In the structure of the discourse, however, there was a recurrent ambivalence between the developmental, organic notion of cultural and racial 'indigenism' as the justification of supremacy, and the notion of evolution as abrupt cultural transition, discontinuous progress, the periodic eruption of invading tribes from somewhere mysterious in Asia, as the guarantee of progress.[24]

The 'subalterns and ex-slaves' who now seize the spectacular event of modernity do so in a catachrestic gesture of reinscribing modernity's 'caesura' and using it to transform the locus of thought and writing in their postcolonial critique. Listen to the ironic naming, the interrogative repetitions, of the critical terms themselves: black 'vernacularism' repeats the minor term used to designate the language of the native and the housebound slave to make demotic the grander narratives of progress. Black 'expressivism' reverses the stereotypical affectivity and sensuality of the stereotype to suggest that 'rationalities are produced *endlessly*' in populist modernism.[25] 'New ethnicity' is used by Stuart Hall in the black British context to create a discourse of cultural difference that marks ethnicity as the struggle against ethnicist 'fixing' and in favour of a wider minority discourse that represents sexuality and class. Cornel West's genealogical

materialist view of race and Afro-American oppression is, he writes, 'both continuous and discontinuous with the Marxist tradition' and shares an equally contingent relation to Nietzsche and Foucault.[26] More recently, he has constructed a prophetic pragmatic tradition from William James, Niebuhr and Du Bois suggesting that 'it is possible to be a prophetic pragmatist and belong to different political movements, e.g. feminist, Black, chicano, socialist, left-liberal ones.'[27] The Indian historian Gyan Prakash, in an essay on postorientalist histories of the Third World, claims that:

> it is difficult to overlook the fact that . . . third world voices . . . speak within and to discourses familiar to the 'West'. . . . The Third World, far from being confined to its assigned space, has penetrated the inner sanctum of the 'First World' in the process of being 'Third Worlded' – arousing, inciting, and affiliating with the subordinated others in the First World . . . to connect with minority voices.[28]

The intervention of postcolonial or black critique is aimed at transforming the conditions of enunciation at the level of the sign – where the intersubjective realm is constituted – not simply setting up new symbols of identity, new 'positive images' that fuel an unreflective 'identity politics'. The challenge to modernity comes in redefining the signifying relation to a disjunctive 'present': staging the past as *symbol*, myth, memory, history, the ancestral – but a past whose iterative *value as sign* reinscribes the 'lessons of the past' into the very textuality of the present that determines both the identification with, and the interrogation of, modernity: what is the 'we' that defines the prerogative of my present? The possibility of inciting cultural translations across minority discourses arises because of the disjunctive present of modernity. It ensures that what *seems* the 'same' within cultures is negotiated in the time-lag of the 'sign'

which constitutes the intersubjective, social realm. Because that lag is indeed the very structure of difference and splitting within the discourse of modernity, turning it into a performative process, then each repetition of the sign of modernity is different, specific to its historical and cultural conditions of enunciation.

This process is most clearly apparent in the work of those 'postmodern' writers who, in pushing the paradoxes of modernity to its limits, reveal the margins of the West.[29] From the postcolonial perspective we can only assume a disjunctive and displaced relation to these works; we cannot accept them until we subject them to a *lagging*: both in the temporal sense of postcolonial agency with which you are now (over)familiar, and in the obscurer sense in which, in the early days of settler colonization, to be lagged was to be transported to the colonies for penal servitude!

In Foucault's Introduction to the *History of Sexuality*, racism emerges in the nineteenth century in the form of an historical retroversion that Foucault finally disavows. In the 'modern' shift of power from the juridical politics of death to the biopolitics of life, race produces a historical temporality of interference, overlapping, and the displacement of sexuality. It is, for Foucault, the great historical irony of modernity that the Hitlerite annihilation of the Jews was carried out in the name of the archaic, premodern signs of race and sanguinity – the oneiric exaltation of blood, death, skin – rather than through the politics of sexuality. What is profoundly revealing is Foucault's complicity with the logic of the 'contemporaneous' within Western modernity. Characterizing the 'symbolics of blood' as being retroverse, Foucault disavows the time-lag of race as the sign of cultural difference and its mode of repetition.

The *temporal* disjunction that the 'modern' question of race would introduce into the discourse of disciplinary and pastoral power is disallowed because of Foucault's spatial critique: 'we must conceptualize the deployment of sexuality on the basis of

the techniques of power that are *contemporary* with it' (my emphasis).[30] However subversive 'blood' and race may be they are in the last analysis merely an 'historical retroversion'. Elsewhere Foucault directly links the 'flamboyant rationality' of Social Darwinism to Nazi ideology, entirely ignoring colonial societies which were the proving grounds for Social Darwinist administrative discourses all through the nineteenth and early twentieth centuries.[31]

If Foucault normalizes the time-lagged, 'retroverse' sign of race, Benedict Anderson places the 'modern' dreams of racism 'outside history' altogether. For Foucault race and blood interfere with modern sexuality. For Anderson racism has its origins in antique ideologies of class that belong to the aristocratic 'pre-history' of the modern nation. Race represents an archaic ahistorical moment outside the 'modernity' of the imagined community: 'nationalism thinks in historical destinies, while racism dreams of eternal contaminations . . . outside history.'[32] Foucault's spatial notion of the conceptual contemporaneity of power-as-sexuality limits him from seeing the double and over-determined structure of race and sexuality that has a long history in the *peuplement* (politics of settlement) of colonial societies; for Anderson the 'modern' anomaly of racism finds its historical modularity, and its fantasmatic scenario, in the colonial space which is a belated and hybrid attempt to 'weld together dynastic legitimacy and national community . . . to shore up domestic aristocratic bastions'.[33]

The racism of colonial empires is then part of an archaic acting out, a dream-text of a form of historical retroversion that 'appeared to confirm on a global, modern stage antique conceptions of power and privilege'.[34] What could have been a way of understanding the limits of Western imperialist ideas of progress within the genealogy of a 'colonial metropolis' – a hybridizing of the Western nation – is quickly disavowed in the language of the *opéra bouffe* as a grimly amusing *tableau vivant* of 'the [colonial]

bourgeois gentilhomme speaking poetry against a backcloth of spacious mansions and gardens filled with mimosa and bougainvillea'.[35] It is in that 'weld' of the colonial site as, contradictorily, both 'dynastic and national', that the modernity of Western national society is confronted by its colonial double. Such a moment of temporal disjunction, which would be crucial for understanding the colonial history of contemporary metropolitan racism in the West, is placed 'outside history'. It is obscured by Anderson's espousal of 'a simultaneity across homogeneous empty time' as the modal narrative of the imagined community. It is this kind of evasion, I think, that makes Partha Chatterjee, the Indian 'subaltern' scholar, suggest, from a different perspective, that Anderson 'seals up his theme with a sociological determinism . . . without noticing the twists and turns, the suppressed possibilities, the contradictions still unresolved'.[36]

These accounts of the modernity of power and national community become strangely symptomatic at the point at which they create a rhetoric of 'retroversion' for the emergence of racism. In placing the representations of race 'outside' modernity, in the space of historical retroversion, Foucault reinforces his 'correlative spacing'; by relegating the social fantasy of racism to an archaic daydream, Anderson further universalizes his homogeneous empty time of the 'modern' social imaginary. Hidden in the disavowing narrative of historical retroversion and its archaism, is a notion of the time-lag that displaces Foucault's spatial analytic of modernity and Anderson's homogeneous temporality of the modern nation. In order to extract the one from the other we have to see how they from a double boundary: rather like the more general intervention and seizure of the history of modernity that has been attempted by postcolonial critics.

Retroversion and archaic doubling, attributed to the ideological 'contents' of racism, do not remain at the ideational or

pedagogical level of the discourse. Their inscription of a structure of retroaction returns to disrupt the enunciative function of this discourse and produce a different 'value' of the sign and time of race and modernity. At the level of content the archaism and fantasy of racism is represented as 'ahistorical', outside the progressive myth of modernity. This is an attempt, I would argue, to universalize the spatial fantasy of modern cultural communities as living their history 'contemporaneously', in a 'homogeneous empty time' of the People-as-One that finally deprives minorities of those marginal, liminal spaces from which they can intervene in the unifying and totalizing myths of the national culture.

However, each time such a homogeneity of cultural identification is established there is a marked disturbance of temporality in the writing of modernity. For Foucault it is the awareness that retroversion of race or sanguinity haunts and doubles the contemporary analytic of power and sexuality and may be subversive of it: we may need to think the disciplinary powers of race as sexuality in a hybrid cultural formation that will not be contained within Foucault's logic of the contemporary. Anderson goes further in acknowledging that colonial racism introduces an awkward weld, a strange historical 'suture', in the narrative of the nation's modernity. The archaism of colonial racism, as a form of cultural signification (rather than simply an ideological content), reactivates nothing less than the 'primal scene' of the modern Western nation: that is, the problematic historical transition between dynastic, lineage societies and horizontal, homogeneous secular communities. What Anderson designates as racism's 'timelessness', its location 'outside history', is in fact that form of time-lag, a mode of repetition and reinscription, that performs the ambivalent historical temporality of modern national cultures – the aporetic coexistence, within the cultural history of the modern imagined community, of both the dynastic, hierarchical, prefigurative 'medieval' traditions

(the past), and the secular, homogeneous, synchronous cross-time of modernity (the present). Anderson resists a reading of the modern nation that suggests – in an iterative time-lag – that the hybridity of the colonial space may provide a pertinent problematic within which to write the history of the 'postmodern' national formations of the West.

To take this perspective would mean that we see 'racism' not simply as a hangover from archaic conceptions of the aristocracy, but as part of the historical traditions of civic and liberal humanism that create ideological matrices of national aspiration, together with their concepts of 'a people' and its imagined community. Such a privileging of ambivalence in the social imaginaries of nationness, and its forms of collective affiliation, would enable us to understand the coeval, often *incommensurable* tension between the influence of traditional 'ethnicist' identifications that coexist with contemporary secular, modernizing aspirations. The enunciative 'present' of modernity, that I am proposing, would provide a political space to articulate and negotiate such culturally hybrid social identities. Questions of cultural difference would not be dismissed – with a barely concealed racism – as atavistic 'tribal' instincts that afflict Irish Catholics in Belfast or 'Muslim fundamentalists' in Bradford. It is precisely such unresolved, transitional moments within the disjunctive present of modernity that are then projected into a time of historical retroversion or an inassimilable place outside history.

The *history* of modernity's antique dreams is to be found in the *writing out* of the colonial and postcolonial moment. In resisting these attempts to normalize the time-lagged colonial moment, we may provide a *genealogy* for postmodernity that is at least as important as the 'aporetic' history of the Sublime or the nightmare of rationality in Auschwitz. For colonial and postcolonial texts do not merely tell the modern history of 'unequal development' or evoke memories of underdevelopment. I have tried

to suggest that they provide modernity with a modular moment of *enunciation*: the locus and locution of cultures caught in the transitional and disjunctive temporalities of modernity. What is in modernity *more* than modernity is the disjunctive 'postcolonial' time and space that makes its presence felt *at the level of enunciation*. It figures, in an influential contemporary fictional instance, as the contingent margin between Toni Morrison's indeterminate moment of the 'not-there' – a 'black' space that she distinguishes from the Western sense of synchronous tradition – which then turns into the 'first stroke' of slave rememory, the *time* of communality and the narrative of a history of slavery (see pp. 274–6 for an elaboration of this issue). This translation of the meaning of time into the discourse of space; this catachrestic seizure of the signifying 'caesura' of modernity's presence and *present*; this insistence that power must be thought in the hybridity of race and sexuality; that nation must be reconceived liminally as the dynastic-in-the-democratic, race-difference doubling and splitting the teleology of class-consciousness: it is through these iterative interrogations and *historical initiations* that the cultural location of modernity shifts to the postcolonial site.

VI

I have attempted, then, to designate a postcolonial 'enunciative' present that moves beyond Foucault's reading of the task of modernity as providing an ontology of the present. I have tried to open up, once again, the cultural space in the temporal doubling of sign and symbol that I described in Chapter 9 (pp. 276–7): from the stroke of the sign that establishes the intersubjective world of truth 'deprived of subjectivity', back to the rediscovery of that moment of agency and individuation in the social imaginary of the order of historic symbols. I have attempted to provide a form of the writing of cultural difference in the midst

of modernity that is inimical to binary boundaries: whether these be between past and present, inside and outside, subject and object, signifier and signified. This spatial-time of cultural difference – with its postcolonial genealogy – erases the Occidental 'culture of common sense' that Derrida aptly describes as 'ontologizing the limit between outside and inside, between the biophysical and the psychic'.[37] In his essay 'The uncolonized mind: Postcolonial India and the East', Ashis Nandy provides a more descriptive illustration of a postcolonial India that is neither modern nor anti-modern but non-modern. What this entails for the 'modern antonyms' of cultural difference between the First and Third Worlds, requires a form of time-lagged signification, for as he writes:

> this century has shown that in every situation of organized oppression the true antonyms are always the exclusive part versus the inclusive whole. . . . [N]ot the past versus the present but either of them versus the rationality which turns them into co-victims.[38]

In splitting open those 'welds' of modernity, a postcolonial contramodernity becomes visible. What Foucault and Anderson disavow as 'retroversion' emerges as a retroactivity, a form of cultural reinscription that moves *back to the future*. I shall call it a 'projective' past, a form of the future anterior. Without the postcolonial time-lag the discourse of modernity cannot, I believe, be written; with the *projective past* it can be inscribed as a historical narrative of alterity that explores forms of social antagonism and contradiction that are not yet properly represented, political identities in the process of being formed, cultural enunciations in the act of hybridity, in the process of translating and transvaluing cultural differences. The political space for such a social imaginary is that marked out by Raymond Williams in his distinction between emergent and residual practices of

oppositionality that require a 'non-metaphysical and non-subjectivist' sociohistorical positionality.[39] This largely unexplored and undeveloped aspect of Williams's work has a contemporary relevance for those burgeoning forces of the 'cultural' left who are attempting to formulate (the unfortunately entitled) 'politics of difference', grounded in the experience and theory of the 'new social movements'. Williams suggests that in certain historical moments, the 'profound deformation' of the dominant culture will prevent it from recognizing 'practices and meanings that are not reached for' and these potentially empowering perspectives, and their political constituencies, will remain profoundly unsignified and silent within the political culture. Stuart Hall takes this argument forward in his attempt to construct an alternative 'modernity' where, he suggests, 'organic' ideologies are neither consistent nor homogeneous and the subjects of ideology are not unitarily assigned to a singular social position. Their 'strangely composite' construction requires a redefinition of the public sphere to take account of the historical transformation by which

> it follows that an alternative conception of socialism must embrace this struggle to democratize power across all the centres of social activity – in private as well as in public life, in personal associations as well as in public obligations. . . . If the struggle for socialism in modern societies is a war of position, then our conception of society must be of a *society of positions* – different places from which we can all begin the reconstruction of society of which the state is only the anachronistic caretaker.[40]

Such a form of the social (or socialist) imaginary 'blocks' the totalization of the site of social utterance. This encounter with the time-lag of representation insists that any form of political emergence must encounter the *contingent place* from where its

narrative *begins* in relation to the temporalities of other marginal 'minority' histories that are seeking their 'individuation', their vivid realization. There is a focus on what Houston Baker has emphasized, for Black Renaissancism, as 'the processual quality [of meaning] . . . not material instantiation at any given moment but the efficacy of passage'. And such a passage of historical experience lived through the time-lag opens up quite suddenly in a poem by the Afro-American poet, Sonia Sanchez:

> life is obscene with crowds
> of black on white
> death is my pulse.
> what might have been
> is not for him/or me
> but what could have been
> floods the womb until I drown[41]

You can hear it in the ambiguity between 'what *might* have been' and 'what *could* have been' — the contingency, the closeness of those rhetorics of indeterminacy. You read it in that considerable shift in historical time between the conditions of an obscene past — *might have been* — and the conditionality of a new birth — *could have been*; you barely see it in the almost imperceptible shift in tense and syntax — *might:could* — that makes all the difference between the pulse of death and the flooded womb of birth. It is the repetition of the 'could-in-the-might' that expresses the marginalized disjunctive experience of the subject of racism — *obscene with crowds/of black on white*: the passage of a 'projective past' in the very time of its performance.

The postcolonial passage through modernity produces that form of repetition — the past as projective. The time-lag of post-colonial modernity moves *forward*, erasing that compliant past tethered to the myth of progress, ordered in the binarisms of its cultural logic: past/present, inside/outside. This *forward* is

neither teleological nor is it an endless slippage. It is the function of the *lag* to slow down the linear, progressive time of modernity to reveal its 'gesture', its *tempi*, 'the pauses and stresses of the whole performance'. This can only be achieved – as Walter Benjamin remarked of Brecht's epic theatre – by damming the stream of real life, by bringing the flow to a standstill in a reflux of astonishment. When the dialectic of modernity is brought to a standstill, then the temporal action of modernity – its progressive, future drive – is *staged*, revealing 'everything that is involved in the act of staging *per se*'.[42] This slowing down, or lagging, *impels* the 'past', *projects* it, gives its 'dead' symbols the circulatory life of the 'sign' of the present, of *passage*, the quickening of the quotidian. Where these temporalities touch contingently, their spatial boundaries metonymically overlapping, at that moment their margins are lagged, sutured, by the indeterminate articulation of the 'disjunctive' present. *Time-lag keeps alive the making of the past.* As it negotiates the levels and liminalities of that spatial time that I have tried to unearth in the postcolonial archaeology of modernity, you might think that it 'lacks' time or history. Don't be fooled!

It may appear 'timeless' only in that sense in which, for Toni Morrison, Afro-American art is 'astonished' by the figure of the ancestor: 'the timelessness is there, this person who represented this ancestor.'[43] And when the ancestor rises from the dead in the guise of the murdered daughter, Beloved, then we see the furious emergence of the projective past. Beloved is not the ancestor as the 'elder' whom Morrison describes as benevolent, instructive and protective. Her presence, which is profoundly time-lagged, moves forward while continually encircling that moment of the 'not-there' which Morrison sees as the stressed, dislocatory absence that is crucial for the rememoration of the narrative of slavery. Ella, a member of the chorus, standing at that very distance from the 'event' from which modernity produces its 'sign', now describes the projective past:

The future was sunset; the past something to leave behind. And if it didn't stay behind you might have to stomp it out. . . . As long as the ghost showed out from its ghostly place. . . . Ella respected it. But if it took flesh and came in her world, well, the shoe was on the other foot. She didn't mind a little communication between the two worlds, but this was an invasion.[44]

Ella bears witness to this invasion of the projective past. Toussaint bears witness to the tragic dissolution, in San Domingo, of the sign of the Revolution. In these forms of witness there is no passivity; there is a violent turning from interrogation to initiation. We have not simply opposed the idea of progress with other 'ideas': the battle has been waged on hybrid territory, in the discontinuity and distanciation between event and enunciation, in the time-lag in-between sign and symbol. I have attempted to constitute a postcolonial, critical discourse that contests modernity through the establishment of other historical sites, other forms of enunciation.

In the figure of the witness of a postcolonial modernity we have another wisdom: it comes from those who have seen the nightmare of racism and oppression in the banal daylight of the everyday. They represent an idea of action and agency more complex than either the nihilism of despair or the Utopia of progress. They speak of the reality of survival and negotiation that constitutes the moment of resistance, its sorrow and its salvation, but is rarely spoken in the heroisms or the horrors of history. Ella says it, plainly: 'What is to be done in a world where even when you were a solution you were a problem.' This is not defeatism. It is an enactment of the limits of the 'idea' of progress, the marginal displacement of the ethics of modernity. The sense of Ella's words, and my chapter, echo in that great prophet of the double consciousness of modern America who spoke across the veil, against what he called 'the colour-line'. Nowhere has the

historical problem of cultural temporality as constituting the 'belatedness' of subjects of oppression and dispossession been spoken more pertinently than in the words of W. E. Du Bois – I like to think that they are the prophetic precursor of my discourse of the time-lag:

> So woefully unorganized is sociological knowledge that the meaning of progress, the meaning of swift and slow in human doing, and the limits of human perfectibility, are veiled, unanswered sphinxes on the shores of science. Why should Aeschylus have sung two thousand years before Shakespeare was born? Why has civilization flourished in Europe and flickered, flamed and died in Africa? So long as the world stands meekly dumb before such questions, shall this nation proclaim its ignorance and unhallowed prejudices by denying freedom of opportunity to those who brought the Sorrow Songs to the Seats of the Mighty?[45]

Du Bois makes a fine answer in the threnody of the Sorrow Songs, their eloquent omissions and silences that 'conceal much of real poetry beneath conventional theology and unmeaning rhapsody'.[46] In the inversion of our catachrestic, critical process, we find that the 'unmeaning', the non-sense of the sign discloses a symbolic vision of a form of progress beyond modernity and its sociology – but not without the enigmatic riddle of the sphinx. To turn Ella's words: what do we do in a world where even when there is a resolution of meaning there is a problem of its performativity? An indeterminacy which is also the condition of its being historical? A contingency which is also the possibility of cultural translation? You heard it in the repetition of Sonia Sanchez as she turned the historical obscenity of 'what might have been' into the projective past, the empowering vision of 'what could have been'. Now you see it in the gaze of the unanswered sphinxes: Du Bois' answer comes through the

rhythm of the swift and slow of human doing itself as he commands the certain shores of 'modern' science to recede. The problem of progress is not simply an unveiling of human perfectibility, not simply the hermeneutic of progress. In the performance of human doing, through the veil, emerges a figure of cultural time where perfectibility is not ineluctably tied to the myth of progressivism. The rhythm of the Sorrow Songs may at times be swift – like the projective past – at other times it may be slow – like the time-lag. What is crucial to such a vision of the future is the belief that we must not merely change the *narratives* of our histories, but transform our sense of what it means to live, to be, in other times and different spaces, both human and historical.

NOTES

PREFACE

1 Parts of this preface have been previously published. Homi K. Bhabha, 'Writing Rights,' in *Globalizing Rights: the Oxford Amnesty Lectures 1999* ed. Matthew J. Gibney (Oxford and New York: Oxford University Press, 2003).

2 A version of the opening section of the preface was published in a collection of essays sponsored by the Arts Council of Great Britain.

3 V.S. Naipaul, *The Middle Passage: Impressions of Five Societies – British, French and Dutch – in the West Indies and South America* (London: Andre Deutsch, 1962), p. 77.

4 V.S. Naipaul.

5 See Kim Scott's lecture, 'Australia's Continuing Neurosis: Identity, Race and History,' at http://www.abc.net.au/rn/deakin/stories/s291485.htm

6 Joseph E. Stiglitz, *Globalization and Its Discontents* (New York: W.W. Norton, 2002), p. 40.

7 ibid., 46.

8 Etienne Balibar, *Masses, Classes, Ideas* trans. James Swenson (New York and London: Routledge, 1994), p. 56.

9 Stiglitz, p. 72.
10 W.E.B. Du Bois 'Human Rights for all Minorities' (November 7, 1945), reprinted in *W.E.B. Du Bois Speaks: Speeches and Addresses 1920–1963*, ed. Philip S. Foner (New York: Pathfinder Press, 1970), p. 183.
11 Adrienne Rich, *An Atlas of the Difficult World: poems, 1988–1991* (New York: W.W. Norton, 1991), p. 44.
12 See Judith Shklar, *American Citizenship: the quest for inclusion* (Cambridge, Mass: Harvard University Press, 1991).
13 *Linguistic Rights of Minorities* ed. Frank Horn (Finland: University of Lapland, 1994).
14 Hannah Arendt, *The Origins of Totalitarianism* (New York: Harcourt, Brace and Company, 1951), p. 297.
15 Salman Rushdie, *Midnight's Children* (London: Picador, 1982), p. 533.
16 Rushdie, *Midnight's Children*.
17 Prakash Jadhav, 'Under Dadar Bridge,' in *Poisoned Bread: translations from modern Marathi Dalit Literature* ed. Arjun Dangle (London: Sangam, 1992), pp. 56–7.
18 Balibar, p. 56.

INTRODUCTION

1 For an interesting discussion of gender boundaries in the *fin de siècle*, see E. Showalter, *Sexual Anarchy: Gender and Culture in the Fin de Siècle* (London: Bloomsbury, 1990), especially 'Borderlines', pp. 1–18.
2 Renée Green interviewed by Elizabeth Brown, from catalogue published by Allen Memorial Art Museum, Oberlin College, Ohio.
3 Interview conducted by Miwon Kwon for the exhibition 'Emerging New York Artists', Sala Mendonza, Caracas, Venezuela (xeroxed manuscript copy).
4 ibid., p. 6.
5 Renée Green in conversation with Donna Harkavy, Curator of Contemporary Art at the Worcester Museum.
6 ibid.
7 W. Benjamin, 'Theses on the philosophy of history', in his *Illuminations* (London: Jonathan Cape, 1970), p. 265.
8 M. Heidegger, 'Building, dwelling, thinking', in *Poetry, Language, Thought* (New York: Harper & Row, 1971), pp. 152–3.
9 S. Rushdie, *The Satanic Verses* (London: Viking, 1988), p. 343.
10 G. Gomez-Pena, *American Theatre*, vol. 8, no. 7, October 1991.

11 T. Ybarra-Frausto, 'Chicano movement/chicano art' in I. Karp and S.D. Lavine (eds) (Washington and London: Smithsonian Institution Press, 1991), pp. 133–4.

12 A. Sekula, *Fish Story*, manuscript, p. 2.

13 ibid., p. 3.

14 F. Fanon, *Black Skin, White Masks*, Introduction by H. K. Bhabha (London: Pluto, 1986), pp. 218, 229, 231.

15 H. James, *The Portrait of a Lady* (New York: Norton, 1975), p. 360.

16 ibid., p. 361.

17 T. Morrison, *Beloved* (London: Chatto & Windus, 1987), pp. 198–9.

18 R. Tagore, *The Home and the World* (Harmondsworth: Penguin, 1985), pp. 70–1.

19 N. Gordimer, *My Son's Story* (London: Bloomsbury, 1990), p. 249.

20 S. Freud, 'The uncanny', Standard Edition XVII, p. 225; H. Arendt, *The Human Condition* (Chicago: Chicago University Press, 1958), p. 72.

21 Morrison, *Beloved*, p. 170.

22 W. H. Auden, 'The cave of making', in his *About the House* (London: Faber, 1959), p. 20.

23 *Goethe's Literary Essays*, J. E. Spingarn (ed.) (New York: Harcourt, Brace, 1921), pp. 98–9.

24 *The Autobiography of Goethe*, J. Oxenford (ed.) (London: Henry G. Bohn, 1948), p. 467.

25 Goethe, 'Note on world literature', p. 96.

26 T. Morrison, *Honey and Rue* programme notes, Carnegie Hall Concert, January 1991.

27 Gordimer, *My Son's Story*, pp. 20–1.

28 ibid., p. 21.

29 ibid., p. 230.

30 ibid.

31 ibid., p. 241.

32 ibid.

33 ibid.

34 ibid., p. 214.

35 ibid., p. 243.

36 ibid., p. 249.

37 E. Levinas, 'Reality and its shadow', in *Collected Philosophical Papers* (Dordrecht: Martinus Nijhoff, 1987), pp. 1–13.

38 ibid.

39 ibid., pp. 6–7.

40 Robert Bernasconi quoted in 'Levinas's ethical discourse, between

individuation and universality', in *Re-Reading Levinas*, R. Bernasconi and S. Critchley, (eds) (Bloomington: Indiana University Press, 1991), p. 90.

41 Morrison, *Beloved*, p. 116.

42 ibid., p. 173.

43 ibid., p. 213.

44 E. Fox-Genovese, *Within the Plantation Household* (Chapel Hill, NC: University of North Carolina Press, 1988), p. 329.

45 ibid., p. 324.

46 Morrison, *Beloved*, Pt II, pp. 200–17.

47 ibid., p. 213.

48 W. Benjamin, *Charles Baudelaire: A Lyric Poet in the Era of High Capitalism* (London: NLB, 1973), p. 171.

1 THE COMMITMENT TO THEORY

1 See C. Taylor, 'Eurocentrics vs new thought at Edinburgh', *Framework*, 34 (1987), for an illustration of this style of argument. See particularly footnote 1 (p. 148) for an exposition of his use of 'larceny' ('the judicious distortion of African truths to fit western prejudices').

2 G. C. Spivak, *In Other Worlds* (London: Methuen, 1987), pp. 166–7.

3 See T. H. Gabriel, 'Teaching Third World cinema' and Julianne Burton, 'The politics of aesthetic distance – São Bernando', both in *Screen*, vol. 24, no. 2 (March–April 1983), and A. Rajadhyaksha, 'Neo-traditionalism: film as popular art in India', *Framework*, 32/33 (1986).

4 S. Hall, 'Blue election, election blues', *Marxism Today* (July 1987), pp. 30–5.

5 M. Foucault, *The Archaeology of Knowledge* (London: Tavistock, 1972), pp. 102–5.

6 J. S. Mill, 'On Liberty', in *Utilitarianism, Liberty, Representative Government* (London: Dent & Sons, 1972), pp. 93–4.

7 For a significant elaboration of a similar argument see E. Laclau and C. Mouffe, *Hegemony and Socialist Strategy* (London: Verso, 1985), ch. 3.

8 For a philosophical underpinning of some of the concepts I am proposing here see R. Gasché, *The Tain of the Mirror* (Cambridge, Mass.: Harvard University Press, 1986), especially ch. 6:

> The Otherness of unconditional heterology does not have the purity of principles. It is concerned with the principles' irreducible impurity, with

the difference that divides them in themselves against themselves. For this reason it is an impure heterology. But it is also an impure heterology because the medium of Otherness – more or less than negativity – is also a mixed milieu, precisely because the negative no longer dominates it.

9 Hall, 'Blue election', p. 33.
10 I owe this point to Martin Thom.
11 Laclau and Mouffe, *Hegemony and Socialist Strategy*, ch. 3.
12 P. Gilroy, *There Ain't No Black in the Union Jack* (London: Hutchinson, 1987), p. 214.
13 F. Fanon, *The Wretched of the Earth* (Harmondsworth: Penguin, 1967 [1961]), p. 168.
14 J.-P. Sartre, *Politics and Literature* (London: Calder & Boyars, 1973 [1948]), pp. 16–17.
15 Rev. A. Duff, *India and India Missions: Including Sketches of the Gigantic System of Hinduism etc.* (Edinburgh: John Johnstone, 1839; London: John Hunter, 1839), p. 560.
16 Fanon, *Wretched of the Earth*, pp. 182–3.
17 B. Williams, *Ethics and the Limits of Philosophy* (London: Fontana, 1985), ch. 9.
18 M. Sahlins, *Culture and Practical Reason* (Chicago: Chicago University Press, 1976), p. 211.
19 B. Anderson, *Imagined Communities* (London: Verso, 1983), ch. 2.
20 W. Harris, *Tradition, the Writer and Society* (London: New Beacon, 1973), pp. 60–3.

2 INTERROGATING IDENTITY

1 F. Fanon, *Black Skin, White Masks*, Introduction by H. K. Bhabha (London: Pluto, 1986), p. 231 (my emphasis).
2 ibid., p. 218.
3 F. Fanon, *Toward the African Revolution* (Harmondsworth: Pelican, 1967), p. 63.
4 Fanon, *Black Skin, White Masks*, pp. 157–8.
5 W. Benjamin, 'Theses on the philosophy of history', in his *Illuminations* (New York: Schocken Books, 1968), p. 257.
6 Fanon, *Black Skin, White Masks*, pp. 110–12.
7 ibid., p. 116.

8 F. Fanon, 'Concerning violence', in his *The Wretched of the Earth* (Harmondsworth: Penguin, 1969).

9 ibid.

10 Fanon, *Black Skin, White Masks*, p. 16.

11 J. Rose, 'The imaginary', in Colin MacCabe (ed.) *The Talking Cure* (London: Macmillan, 1981).

12 Fanon, 'Concerning violence', p. 30.

13 A. Jussawalla, *Missing Person* (Clearing House, 1976), pp. 14–29.

14 M. Jin, 'Strangers on a Hostile Landscape', in R. Cobham and M. Collins (eds) *Watchers and Seekers* (London: The Women's Press, 1987), pp. 126–7.

15 E. Said, *Orientalism* (London: Routledge & Kegan Paul, 1978), pp. 26–7.

16 R. Barthes, 'The imagination of the sign', in his *Critical Essays* (Evanston, Ill.: Northwestern University Press, 1972), pp. 206–7.

17 J. Locke, *An Essay Concerning Human Understanding* (London: Fontana, 1969), pp. 212–13.

18 Barthes, 'Imagination of the sign', p. 207.

19 R. Rorty, 'Mirroring', in his *Philosophy and the Mirror of Nature* (Oxford: Blackwell, 1980), pp. 162–3.

20 Barthes, 'Imagination of the sign', p. 207.

21 Fanon, *Black Skin, White Masks*, p. 112.

22 ibid.

23 J. Lacan, 'Seminar of 21 January 1975', in J. Mitchell and J. Rose (eds) *Feminine Sexuality* (London: Routledge & Kegan Paul, 1982), p. 164.

24 Barthes, 'Imagination of the sign', pp. 209–10.

25 J. Lacan, 'Alienation', in his *The Four Fundamental Concepts of Psychoanalysis* (London: The Hogarth Press, 1977), p. 206.

26 Derrida, 'The double session', in his *Dissemination*, B. Johnson (trans.) (Chicago: University of Chicago Press, 1981), p. 212.

27 Derrida, 'The double session', pp. 212–13.

28 J. Derrida, *Of Grammatology*, G. C. Spivak (trans.) (Baltimore, Md: Johns Hopkins University Press, 1976), p. 145.

29 Lacan, 'Alienation', p. 207.

30 M. Foucault, *The Archaeology of Knowledge*, A. H. Sheridan (trans.) (London: Tavistock, 1972), p. 111.

31 J.-F. Lyotard and J.-L. Thebaud, *Just Gaming*, W. Godzich (trans.) (Minneapolis: University of Minnesota Press, 1985), pp. 34 and 39.

32 Lacan, 'Alienation', p. 88.

33 See Chapters 1 and 6.

34 C. Geertz, 'Native's point of view: anthropological understanding', in his *Local Knowledge* (New York: Basic Books, 1983), p. 70.

35 J. Derrida, *Writing and Difference*, Alan Bass (trans.) (Chicago: University of Chicago Press, 1982), p. 282.

36 Jussawalla, *Missing Person*, p. 15.

37 A. Showstack Sassoon, *Approaches to Gramsci* (London: Writers and Readers, 1982), p. 16.

38 Barthes, 'Imagination of the sign', p. 246.

39 Fanon, *Black Skin, White Masks*, p. 161.

40 ibid., pp. 231–2.

41 ibid.

42 ibid., p. 221.

43 A. Reich.

44 Fanon, *Black Skin, White Masks*, p. 150.

45 ibid., p. 45.

46 ibid., p. 231.

47 J. Lacan, *The Four Fundamental Concepts of Psychoanalysis*, Alan Sheridan (trans.) (New York: Norton, 1981), p. 107.

48 T. F. Eagleton, 'The politics of subjectivity', in L. Appignanesi (ed.) *Identity*, ICA Documents 6 (London: Institute of Contemporary Art, 1988).

3 THE OTHER QUESTION

1 J. Derrida, 'Structure, sign and play in the discourse of the human sciences', in his *Writing and Difference*, Alan Bass (trans.) (Chicago: Chicago University Press, 1978), p. 284.

2 S. Feuchtwang, 'Socialist, feminist and anti-racist struggles', *m/f*, no. 4 (1980), p. 41.

3 S. Heath, 'Film and system, terms of analysis', Part 11, *Screen*, vol. 16, no. 2 (summer 1975), p. 93.

4 *Screen*, vol. 24, no. 2 (January/February 1983).

5 For instance, having decentred the sign, Barthes finds Japan immediately insightful and visible and extends the empire of empty signs universally. Japan can only be the Anti-West:

> in the ideal Japanese house, devoid or nearly so of furniture, there is no place which in any way designates property; no seat, no bed, no table provides a point from which the body may constitute itself as subject (or master) of a space. The very concept of centre is rejected (burning frustration for

Western man everywhere provided with his armchair and his bed, the owner of a domestic position). (R. Barthes, *L'Empire des Signes*, Noël Burch (trans.) *To the Distant Observer* (London: Scolar Press, 1979), pp. 13–14.

For a reading of Kristeva relevant to my argument, see G. Spivak, 'French feminism in an international frame', *Yale French Studies*, no. 62 (1981), pp. 154–84.

6 This concept is further developed in Chapter 6, pp. 108–17.

7 E. Said, *Orientalism* (London: Routledge & Kegan Paul, 1978), p. 72; emphasis added.

8 ibid., p. 206.

9 ibid., p. 273.

10 ibid., pp. 58–9.

11 M. Foucault, 'The confession of the flesh', in his *Power/Knowledge* (Brighton: Harvester Press, 1980), p. 196.

12 ibid., p. 195.

13 See S. Freud, 'Fetishism' (1927) in *On Sexuality*, vol. VII, Pelican Freud Library (Harmondsworth: Penguin Books, 1981), p. 345ff; C. Metz, *Psychoanalysis and Cinema: the Imaginary Signifier* (London: Macmillan, 1982), pp. 67–78. See also S. Neale, 'The same old story: stereotypes and differences', *Screen Education*, nos 32–3 (Autumn–Winter 1979–80), pp. 33–7.

14 F. Fanon, *Black Skin, White Masks* (London: Pluto Press, 1991); 'The Fact of Blackness', pp. 109–40.

15 ibid., see pp. 117, 127.

16 ibid., pp. 111–14.

17 Metz, *Psychoanalysis and Cinema*, pp. 59–60.

18 ibid., pp. 62–3.

19 For the best account of Lacan's concept of the Imaginary see J. Rose, 'The imaginary', in Colin MacCabe (ed.) *The Talking Cure* (London: Macmillan, 1981).

20 F. Fanon, 'Racism and culture', in his *Toward the African Revolution*, H. Chevalier (trans.) (London: Pelican, 1970), p. 44.

21 Fanon, *Black Skin, White Masks*, p. 114.

22 Freud, 'Fetishism', p. 357.

23 F. Fanon, *The Wretched of the Earth* (Harmondsworth: Penguin Books, 1969).

24 P. Abbot, 'Authority', *Screen*, vol. 20, no. 2 (Summer 1979), pp. 15–16.

25 ibid., p. 16.

26 ibid.

27 Fanon, *Black Skins, White Masks*, p. 112.

28 Metz, *Psychoanalysis and Cinema*, p. 70.

29 J. Laplanche and J. B. Pontalis, 'Phantasy (or fantasy)', in their *The Language of Psychoanalysis* (London: Hogarth Press, 1980), p. 318.

30 Fanon, *Black Skins, White Masks*, p. 80.

31 See K. Abraham, 'Transformations of scopophilia', in his *Selected Papers in Psychoanalysis* (London: Hogarth Press, 1978).

32 Fanon, 'Racism and culture, p. 44.

4 OF MIMICRY AND MAN

1 J. Lacan, 'The line and the light', in his *The Four Fundamental Concepts of Psychoanalysis*, Alan Sheridan (trans.) (London: The Hogarth Press and the Institute of Psycho-Analysis, 1977), p. 99.

2 Cited in E. Stokes, *The Political Ideas of English Imperialism* (Oxford: Oxford University Press, 1960), pp. 17–18.

3 E. Said, *Orientalism* (New York: Pantheon Books, 1978), p. 240.

4 S. Weber, 'The sideshow, or: remarks on a canny moment', *Modern Language Notes*, vol. 88, no. 6 (1973), p. 112.

5 C. Grant, 'Observations on the state of society among the Asiatic subjects of Great Britain', *Sessional Papers of the East India Company*, vol. X, no. 282 (1812–13).

6 ibid., ch. 4, p. 104.

7 T. B. Macaulay, 'Minute on education', in W. Theodore de Bary (ed.) *Sources of Indian Tradition*, vol. II (New York: Columbia University Press, 1958), p. 49.

8 Mr Thomason's communication to the Church Missionary Society, 5 September 1819, in *The Missionary Register*, 1821, pp. 54–5.

9 B. Anderson, *Imagined Communities* (London: Verso, 1983), p. 88.

10 ibid., pp. 88–9.

11 J. Conrad, *Nostromo* (London: Penguin, 1979), p. 161.

12 V. S. Naipual, *The Mimic Men* (London: Penguin, 1967), p. 416.

13 F. Fanon, *Black Skin, White Masks* (London: Paladin, 1970), p. 109.

14 A. Césaire, *Discourse on Colonialism* (New York: Monthly Review Press, 1972), p. 21.

15 M. Foucault, 'Nietzche, genealogy, history', in his *Language, Counter-Memory, Practice*, D. F. Bouchard and S. Simon (trans.) (Ithaca: Cornell University Press, 1977), p. 153.

16 E. Stokes, *The English Utilitarians and India* (Oxford: Oxford University Press, 1959), p. xi.

17 S. Freud, 'The unconscious' (1915), *SE*, XIV, pp. 190–1.

18 Fanon, *Black Skin, White Masks*, p. 103.

19 E. Long, *A History of Jamaica*, 1774, vol. II, p. 353.

20 E. Said, 'The Text, the world, the critic', in J. V. Harari (ed.) *Textual Strategies* (Ithaca: Cornell University Press, 1979), p. 184.

21 F. Fanon, 'Racism and culture', in his *Toward the African Revolution*, H. Chevalier (trans.) (London: Pelican, 1967), p. 44.

22 M. Foucault, *The Order of Things* (New York: Pantheon Books, 1971), part II, ch. 9.

23 Long, *History of Jamaica*, p. 364.

24 *The Missionary Register*, May 1817, p. 186.

5 SLY CIVILITY

1 S. Freud, 'Some neurotic mechanisms in jealousy, paranoia and homosexuality' (1922), in *Standard Edition* XVIII, J. Strachey (ed.) (London: The Hogarth Press and the Institute of Psycho-Analysis, 1953–1974), p. 226.

2 J. Derrida, 'The violence of the letter', in his *Of Grammatology*, G. C. Spivak (trans.) (Baltimore: Johns Hopkins University Press, 1976), p. 134.

3 *Parliamentary Papers*, 1852–1853, XXX, testimony of John Stuart Mill to a Select Committee of the House of Lords, 21 June 1852, p. 301.

4 I am using *speech* in the Derridean sense as the expressive sign of the self-presence of voice, the disavowal of the differentiating signifier of writing.

5 J. S. Mill, 'On Liberty', *Utilitarianism, Liberty, Representative Government*, H. B. Acton (ed.) (London: J. M. Dent & Sons, 1972), p. 99.

6 ibid., p. 102.

7 ibid., p. 113.

8 B. Anderson, *Imagined Communities* (London: Verso, 1983), pp. 132–3.

9 Mill, 'On Liberty', p. 97.

10 Mill, *Parliamentary Papers*, 1852–1853, p. 310.

11 Mill, quoted in G. D. Bearce, *British Attitudes Towards India 1784–1858* (London: Oxford University Press, 1961), p. 280.

12 T. B. Macaulay, 'Warren Hastings', *Critical and Historical Essays*, vol. III (London: Methuen, 1903), pp. 85–6.

13 ibid., p. 86.

14 W. Benjamin, 'Theses on the philosophy of history', in his *Illumin-ations*, ed. with an introduction by Hannah Arendt (New York: Schocken Books, 1968), p. 263.

15 Mill, 'On Liberty', p. 382–3.

16 H. Merivale, *Introduction to a Course of Lectures on Colonization and Colonies* (London, 1839), pp. 18–25.

17 For a further elaboration of this concept, see Chapter 6.

18 See L. Althusser, 'Montesquieu: politics and history', in his *Montesquieu, Rousseau, Marx*, Ben Brewster (trans.) (London: Verso, 1982), ch. 4.

19 J. Derrida, 'Living on: border lines', in J. Derrida, P. de Man, J. Hillis Miller, H. Bloom and G. Hartman (eds) *Deconstruction and Criticism* (London: Routledge & Kegan Paul, 1979), p. 87

20 *The Missionary Register*, Church Missionary Society, March 1819, pp. 159–60.

21 ibid., September 1818, pp. 374–5.

22 N. B. Halhed, 'translator's preface', in P.J. Marshall (ed.) *The British Discovery of Hinduism in the Eighteenth Century* (London: Cambridge University Press), 1970, pp. 166–7.

23 *The Compact Edition of the OED*, vol. II, p. 215.

24 S. Freud, 'Psychoanalytic notes on an autobiographical account of a case of paranoia (Schreber)', Pelican Freud Library, vol. IX, pp. 200–3; see also J. Forrester, *Language and the Origins of Psychoanalysis* (London: Macmillan, 1980), pp. 154–7.

25 R. Waelder, 'The structure of paranoid ideas', *International Journal of Psychoanalysis*, vol. 32 (1951).

26 J. F. Stephen, 'Foundations of the government of India', *The Nineteenth Century*, no. LXXX (October 1883), pp. 557–8.

27 Rev. A. Duff, *India and India Missions* (London: John Hunter, 1839), pp. 323–4.

6 SIGNS TAKEN FOR WONDERS

1 R. Southey, *Letters from England* ed. with intro. by J. Simmons (Cresset Press, London, 1952).

2 *The Missionary Register*, Church Missionary Society, London, January 1818, pp. 18–19; all further references to this work, abbreviated *MR*, will be included in the text, with dates and page numbers in parentheses.

3 J. Conrad, *Heart of Darkness*, Paul O'Prey (ed.) (Harmondsworth: Penguin, 1983), pp. 71, 72.

4 V. S. Naipaul, 'Conrad's darkness', in his *The Return of Eva Peron* (Harmondsworth: Penguin, 1974), p. 233.

5 'Overall effect of the dream-work: the latent thoughts are transformed into a manifest formation in which they are not easily recognizable. They are not only transposed, as it were, into another key, but *they are also distorted in such a fashion that only an effort of interpretation can reconstitute them*' (J. Laplanche and J. B. Pontalis, *The Language of Psycho-analysis*, D. Nicholson-Smith (trans.) (London: The Hogarth Press, 1980), p. 124; my emphasis). See also S. Weber's excellent chapter 'Metapsychology set apart', in his *The Legend of Freud* (Minneapolis: University of Minnesota Press, 1982), pp. 32–60.

6 J. Derrida, *Dissemination*, Barbara Johnson (trans.) (Chicago: Chicago University Press, 1981), pp. 189–90; all further references to this work, abbreviated *D*, will be included in the text.

7 Conrad, *Heart of Darkness*, p. 45.

8 F. Nietzsche, *Untimely Meditations*, R. J. Hollingdale (trans.) (Cambridge: Cambridge University Press, 1983), p. 71.

9 T. B. Macaulay, 'Minute on education', quoted in E. H. Cuts, 'The background of Macaulay's Minute', *American Historical Review*, vol. 58 (July 1953), p. 839.

10 See I. Watt, *Conrad in the Nineteenth Century* (Berkeley and Los Angeles: University of California Press, 1979), ch. 4, part i.

11 See Conrad, 'Tradition', in his *Notes on Life and Letters* (London: J. M. Dent, 1925), pp. 194–201.

12 See J. Barrell's excellent chapter, 'The language properly so-called: the authority of common usage', in his *English Literature in History, 1730–1780: An Equal Wide Survey* (London: Hutchinson, 1983), pp. 110–75.

13 Conrad, quoted in Naipaul, 'Conrad's darkness', p. 236.

14 See Chapter 3.

15 M. Foucault, 'The confession of the flesh', in his *Power/ Knowledge: Selected Interviews and Other Writings, 1972–1977*, Colin Gordon (ed.), Gordon *et al.* (trans) (New York: Pantheon Books, 1980), p. 204.

16 See S. Freud, 'Beyond the pleasure principle' (1920), J. Strachey (trans. and ed.) *Standard Edition*, XVIII (London: The Hogarth Press, 1974), pp. 18–25.

17 Foucault, 'Truth and power', *Power/Knowledge*, p. 132.
18 Foucault, 'The eye of power', *Power/Knowledge*, p. 154; and see pp. 152–6.
19 ibid., p. 155.
20 See S. Lukes, 'Power and authority,' in T. Bottomore and R. Nisbet (eds) *A History of Sociological Analysis* (New York: Basic Books, 1978), pp. 633–76.
21 T. Nairn, *The Break-Up of Britain: Crisis and Neo-Nationalism* (London: Verso, 1981), p. 265.
22 F. Fanon, *Toward the African Revolution*, H. Chevalier (trans.) (Harmondsworth: Pelican, 1967), p. 44.
23 See Freud, 'An outline of psychoanalysis' (1940), J. Strachey (trans. and ed.), *SE*, XXIII (London: The Hogarth Press, 1973), pp. 59–61.
24 J. Locke, 'The second treatise of government', in his *Two Treatises of Government* (New York, 1965), p. 343, para. 59; Baron de Montesquieu, *The Spirit of the Laws*, T. Nugent (trans.) (New York: Hafner, 1949), p. 57; C. Grant, 'Observations on the state of society among the Asiatic subjects of Great Britain', *Sessional Papers of the East India Company*, vol. X, no. 282 (1812–13), p. 70; E. Said, *The Question of Palestine* (New York: Routledge & Kegan Paul, 1979), p. 85.
25 F. Fanon, *The Wretched of the Earth*, C. Farrington (trans.) (Harmondsworth: Penguin, 1969), p. 42.
26 *MR*, May 1916, pp. 181–2.
27 William Paley, quoted in D. L. LeMahieu, *The Mind of William Paley: A Philosopher and His Age* (Lincoln, Nebr: Grove Press, 1976), p. 97.
28 M. Foucault, *The Archaeology of Knowledge*, A. M. Sheridan (trans.) (London: Tavistock, 1972), p. 91; my emphasis.
29 V. N. Smirnoff, 'The fetishistic transaction', in S. Levobici and D. Widlocher (eds) *Psychoanalysis in France* (New York: International University Press, 1980), p. 307.
30 See Fanon, 'The Negro and psychopathology', in his *Black Skin, White Masks*, C. Lam Markmann (trans.) (New York, 1967).
31 J. Lacan, *The Four Fundamental Concepts of Psychoanalysis*, J.-A. Miller (ed.), A. Sheridan (trans.) (New York: Norton, 1978), p. 99.

7 ARTICULATING THE ARCHAIC

1 E. M. Forster, *A Passage to India* (Harmondsworth: Penguin, 1979), p. 135.

2 J. Lacan, *The Four Fundamental Concepts of Psychoanalysis* (Harmondsworth: Penguin, 1979), p. 250.

3 A. Lyall; Carlyle, *Essays*; R. Kipling, 'The burial', quoted in E. Stokes, *The Political Ideas of English Imperialism* (Oxford: Oxford University Press, 1960), p. 28. I am indebted to Stokes's suggestive remarks on the value of 'inarticulateness' attributed to the mission of colonial enterprise.

4 W. Benjamin, *Illuminations*, H. Zonh (trans.) (London: Cape, 1970), pp. 98–101.

5 J. Conrad, *Heart of Darkness*, R. Kimbrough (ed.) (New York: W. W. Norton & Co., 1963), p. 28.

6 J. Conrad, *Nostromo* (Harmondsworth: Penguin, 1979), p. 345.

7 Forster, *Passage to India*, p. 145.

8 Stokes, *Political Ideas*, p. 29.

9 Conrad, *Heart of Darkness*, p. 186.

10 Forster, *Passage to India*, p. 135.

11 Lacan, *The Four Fundamental Concepts of Psychoanalysis*, p. 214.

12 B. Williams, *Ethics and the Limits of Philosophy* (London: Fontana, 1985).

13 Forster, *Passage to India*, p. 144.

14 This is a collage of words, phrases, statements made in/around the entry to the Marabar caves. They represent a fictional re-enactment of that crucial moment as an act of memory.

15 J. Derrida, *Dissemination*, B. Johnson (trans.) (Chicago: Chicago University Press, 1981), pp. 212–13.

16 J. Derrida, 'The violence of the letter', in his *Of Grammatology*, G. C. Spivak (trans.) (Baltimore and London: Johns Hopkins University Press, 1974), p. 121.

17 R. Rorty, *Philosophy and the Mirror of Nature* (Princeton: Princeton University Press, 1979), p. 318.

18 E. Gellner, *Relativism and the Social Sciences* (Cambridge: Cambridge University Press, 1985), p. 90.

19 J. Boon, 'Further operations of "culture" in anthropology: a synthesis of and for debate', *Social Science Quarterly*, vol. 52, pp. 221–52.

20 M. Sahlins, *Culture and Practical Reason* (Chicago: Chicago University Press, 1976).

21 Rev. A. Duff, *India and India Missions: Including Sketches of the Gigantic System of Hinduism etc.* (Edinburgh: John Johnstone, 1839), p. 211.

22 Sir H. Maine, 'The Effects of Observation of India on Modern European Thought' (Cambridge: The Rede Lecture, 1875).

23 J. Fitzjames Stephen, 'The foundations of the government of India', *Nineteenth Century*, vol. 14 (October 1883), pp. 551 ff.

24 J. W. Burrow, *Evolution and Society: A Study in Victorian Social Theory* (Cambridge: Cambridge University Press, 1966), p. 159.

25 M. Foucault, *The Archaeology of Knowledge* (London: Tavistock, 1972), p. 92.

26 ibid., p. 111.

27 F. Fanon, *The Wretched of the Earth* (Harmondsworth: Penguin, 1969), p. 29.

28 ibid., p. 41.

29 S. Freud, 'Fetishism' in *On Sexuality* (Harmondsworth: Pelican Freud Library, 1977, vol. 7), p. 352; my italics.

30 J. S. Mill, 'On representative government,' in H. B. Acton (ed.), *Utilitarianism, Liberty, Representative Government* (London: J. M. Dent & Sons, 1972).

31 Duff, *India and India Missions*, p. 564.

32 ibid., p. 563.

33 ibid., p. 323.

34 ibid., p. 225.

35 ibid.

36 J. Derrida, 'Des tours de Babel', *Difference in Translation*, ed. J. F. Graham (ed.) (Ithaca: Cornell University Press, 1985), p. 174.

37 S. Freud, 'The "uncanny" ', in *Art and Literature* (Harmondsworth: Pelican Freud Library, vol. 14), pp. 335–76.

38 E. T. A. Hoffmann, *The Sandman*.

39 N. B. Halhed (trans. and ed.), *A Code of Gentoo Laws, or Ordinations of the Pundits* (London, 1776), pp. li–lii.

40 K. Abraham, *Selected Papers on Psychoanalysis* (London: Karnac, 1988), p. 487.

8 DISSEMINATION

1 In memory of Paul Moritz Strimpel (1914–87): Pforzheim-Paris-Zurich-Ahmedabad-Bombay-Milan-Lugano.

2 Quoted in E. Said, *After the Last Sky* (London: Faber, 1986).

3 I am thinking of Eric Hobsbawm's great history of the 'long nineteenth century', particularly *The Age of Capital 1848–1875* (London: Weidenfeld & Nicolson, 1975) and *The Age of Empire 1875–1914* (London: Weidenfeld & Nicolson, 1987). See especially some of

the suggestive ideas on the nation and migration in the latter volume, ch. 6.

4 E. Said, *The World, The Text and The Critic* (Cambridge, Mass.: Harvard University Press, 1983), p. 39.

5 F. Jameson, 'Third World literature in the era of multinational capitalism', *Social Text* (Fall 1986), p. 69 and *passim*.

6 J. Kristeva, 'A new type of intellectual: the dissident', in T. Moi (ed.) *The Kristeva Reader* (Oxford: Blackwell, 1986), p. 298.

7 E. Said, 'Opponents, audiences, constituencies and community', in H. Foster (ed.) *Postmodern Culture* (London: Pluto, 1983), p. 145.

8 B. Anderson, 'Narrating the nation', *The Times Literary Supplement*, 13 June (1986), p. 659.

9 P. Chatterjee, *Nationalist Thought and the Colonial World: A Derivative Discourse* (London: Zed, 1986), p. 17.

10 E. Gellner, *Nations and Nationalism* (Oxford: Basil Blackwell, 1983), p. 56.

11 ibid., p. 38.

12 L. Althusser, *Montesquieu, Rousseau, Marx* (London: Verso, 1972), p. 78.

13 M. Bakhtin, *Speech Genres and Other Late Essays*, C. Emerson and M. Holquist (eds), V. M. McGee (trans.) (Austin, Texas: University of Texas Press, 1986), p. 31.

14 ibid., p. 34.

15 ibid., p. 36 and *passim*.

16 ibid., pp. 47–9.

17 S. Freud, 'The "uncanny" ', *Standard Edition*, XVII, J. Strachey (ed.) (London: The Hogarth Press, 1974), p. 234. See also pp. 236, 247.

18 J. Barrell, *English Literature in History, 1730–1780* (London: Hutchinson, 1983).

19 H. A. Baker, Jr, *Modernism and the Harlem Renaissance* (Chicago: Chicago University Press, 1987), esp. chs 8–9.

20 Barrell, *English Literature*, p. 78.

21 ibid., p. 203.

22 Baker, *Modernism*, p. 77.

23 R. Price, *Maroon Societies*, quoted in Baker, *Modernism*, p. 77.

24 C. Lefort, *The Political Forms of Modern Society* (Cambridge: Cambridge University Press, 1986), pp. 212–14; my emphasis.

25 A. Giddens, *The Nation State and Violence* (Cambridge: Polity, 1985), p. 216.

26 N. Poulantzas, *State, Power, Socialism* (London: Verso, 1980), p. 113.

27 R. Williams, *Problems in Materialism and Culture* (London: Verso, 1980), p. 43. I must thank Prof. David Lloyd of the University of California, Berkeley, for reminding me of Williams's important concept.

28 E. Said, 'Representing the colonized', *Critical Inquiry*, vol. 15, no. 2 (winter 1989), p. 225.

29 S. Freud, 'Civilization and its discontents', *Standard Edition* (London: The Hogarth Press, 1961), p. 114.

30 ibid.

31 J.-F. Lyotard and J.-L. Thebaud, *Just Gaming*, W. Godzich (trans.) (Manchester: Manchester University Press, 1985), p. 41.

32 C. Lévi-Strauss, *Introduction to the Work of Marcel Mauss*, F. Baker (trans.) (London: Routledge, 1987). Mark Cousins pointed me in the direction of this remarkable text. See his review in *New Formation*, no. 7 (spring 1989). What follows is an account of Lévi-Strauss's argument to be found in section 11 of the book, pp. 21–44.

33 M. Foucault, *Technologies of the Self*, H. Gutman *et al.* (eds) (London: Tavistock, 1988).

34 ibid., pp. 151–4. I have abbreviated the argument for my convenience.

35 L. Althusser, *Reading Capital* (London: New Left Books, 1972), pp. 122–32. I have, for convenience, produced a composite quotation from Althusser's various descriptions of the ideological effects of historicism.

36 Foucault, *Technologies*, pp. 162–3.

37 F. Fanon, *The Wretched of the Earth* (Harmonsdworth: Penguin, 1969). My quotations and references come from pp. 174–90.

38 J.-F. Lyotard, *The Postmodern Condition*, G. Bennington and B. Massumi (trans.) (Manchester: Manchester University Press, 1984), p. 22.

39 J. Kristeva, 'Women's time', in T. Moi (ed.) *The Kristeva Reader* (Oxford: Blackwell, 1986), pp. 187–213. This passage was written in response to the insistent questioning of Nandini and Praminda in Prof. Tshome Gabriel's seminar on 'syncretic cultures' at the University of California, Los Angeles.

40 Anderson, 'Narrating the nation', p. 35.

41 J. Derrida, *Of Grammatology*, G. C. Spivak (trans.) (Baltimore, Md: Johns Hopkins University Press, 1976), pp. 144–5. Quoted in R. Gasché, *The Tain of the Mirror* (Cambridge, Mass.: Harvard University Press, 1986), p. 208.

42 Derrida, *Of Grammatology*, p. 145.

43 Gasché, *Tain of the Mirror*, p. 211.

44 Kristeva, 'Women's time', p. 210. I have also referred here to an argument to be found on p. 296.

45 All quotations are from the shooting script of *Handsworth Songs*, generously provided by the Black Audio and Film Collective.

46 B. Anderson, *Imagined Communities: Reflections on the Origin and Spread of Nationalism* (London: Verso, 1983), p. 30.

47 ibid., p. 132.

48 ibid.

49 ibid.

50 Lévi-Strauss, *Work of Marcel Mauss*, p. 58.

51 E. Renan, 'What is a nation?', in H. K. Bhabha (ed.) *Nation and Narration* (London and New York: Routledge, 1990), p. 19.

52 ibid., p. 11.

53 Lefort, *Political Forms*, p. 303.

54 W. Benjamin, 'The storyteller', in *Illuminations*, H. Zohn (trans.) (London: Cape, 1970), p. 87.

55 Lévi-Strauss, *Work of Marcel Mauss*, p. 35.

56 W. Benjamin, 'The task of the translator', *Illuminations*, H. Zohn (trans.) (London: Cape, 1970), p. 75.

57 ibid. For a most useful survey of the issue see Tejaswini Niranjana, *History, Post-Structuralism and the Colonial Context: Siting Translation* (Berkeley: California University Press, 1992).

58 N. Abraham and M. Torok, 'Introjection – Incorporation', in S. Lebovici and D. Widlocher (eds) *Psychoanalysis in France* (New York: International University Press, 1980), p. 10.

59 J. Berger, *A Seventh Man* (Harmondsworth: Penguin, 1975). I have composed this passage from quotations that are scattered through the text.

60 ibid., p. 216.

61 S. Freud, 'Group psychology and the analysis of the ego', *Standard Edition*, XVIII (London: The Hogarth Press, 1961), p. 119.

62 S. Rushdie, *The Satanic Verses* (New York: Viking, 1988), p. 343. This is a condensed version of this quotation.

63 ibid., p. 130.

64 ibid., p. 145.

65 ibid., p. 320.

66 ibid., p. 353.

67 ibid., p. 354. I have slightly altered the presentation of this passage to fit in with the sequence of my argument.

68 Timothy Bahti and Andrew Benjamin have translated this much-discussed passage for me. What I want to emphasize is a form of the articulation of cultural difference that Paul de Man clarifies in his reading of Walter Benjamin's complex image of amphora.

[Benjamin] is not saying that the fragments constitute a totality, he says that fragments are fragments, and that they remain essentially fragmentary. They follow each other metonymically, and they never constitute a totality. (P. de Man, *The Resistance to Theory* (Manchester: Manchester University Press, 1986), p. 91).

9 THE POSTCOLONIAL AND THE POSTMODERN

1 J. Derrida, 'My chances/*mes chances*', in J. H. Smith and W. Kerrigan (eds) *Taking Chances: Derrida, Psychoanalysis, Literature* (Baltimore: Johns Hopkins University Press, 1984), p. 8.

2 J. Habermas, *The Philosophical Discourse of Modernity: Twelve Lectures*, F. G. Lawrence (trans.) (Cambridge, Mass.: MIT Press, 1987), p. 348.

3 F. Jameson, Foreword to R. Retamar, *Caliban and Other Essays*, trans. E. Baker (Minneapolis: University of Minnesota Press, 1989), pp. vii–xii.

4 E. Said, 'Third World intellectuals and metropolitan culture', *Raritan*, vol. 9, no. 3 (1990), p. 49.

5 F. Jameson, *The Political Unconscious: Narrative as a Socially Symbolic Act* (Ithaca: Cornell University Press, 1981), p. 266.

6 C. West, 'Interview with Cornel West', in A. Ross (ed.) *Univeral Abandon* (Edinburgh: Edinburgh University Press, 1988), pp. 280–1.

7 S. Hall, *The Hard Road to Renewal* (London: Verso, 1988), p. 273.

8 ibid., pp. 9–10.

9 C. Taylor, *Philosophy and the Human Sciences* (Cambridge: Cambridge University Press, 1985), p. 145.

10 ibid., p. 151 (my emphasis).

11 H. Spillers, 'Changing the letter', in D. E. McDowell and A. Rampersad (eds) *Slavery and the Literary Imagination* (Baltimore: Johns Hopkins University Press, 1989), p. 29.

12 D. E. McDowell, 'Negotiations between tenses: witnessing slavery after freedom – *Dessa Rose*', in McDowell and Rampersad, *Slavery*, p. 147.

13 P. Gilroy, *There Ain't No Black in the Union Jack* (London: Hutchinson, 1987), ch. 5.

14 H. A. Baker, Jr, *Hybridity, the Rap Race, and the Pedagogy of the 1990s* (New York: Meridian, 1990).

15 H. L. Gates, Jr, *Reading Black, Reading Feminist: A Critical Anthology* (New York: NAL, 1990), p. 8.

16 R. Gasché, *The Tain of the Mirror* (Cambridge, Mass.: Harvard University Press, 1986), p. 210.

17 I wrote this section in response to Stephen Greenblatt's musing question, put in a bar in Cambridge, Massachusetts: 'What happens in that partial, passing moment in-between the chain of signifiers?' As it turns out, Cambridge is not that far from Tangiers.

18 R. Barthes, *The Pleasure of the Text*, R. Miller (trans.) (New York: Hill, 1975), p. 49 (my emphasis).

19 ibid., p. 50.

20 ibid., pp. 66–7.

21 ibid., p. 57.

22 ibid., p. 49.

23 Derrida, 'My chances', p. 25.

24 ibid., p. 10.

25 T. Eagleton, *Ideology: An Introduction* (London: Verso, 1991), p. 38.

26 J. Forrester, *The Seductions of Psychoanalysis* (Cambridge: Cambridge University Press, 1990), pp. 207–10.

27 J. Derrida, *The Post Card: From Socrates to Freud and Beyond*, A. Bass (trans.) (Chicago: University of Chicago Press, 1987), p. 321.

28 G. C. Spivak, 'Postcoloniality and value', in P. Collier and H. Gaya-Ryan (eds), *Literary Theory Today* (Cambridge: Polity Press, 1990), pp. 225, 227, 228.

29 In an interview, Spivak also talks of the 'irreducible lag-effect' that is not

> what is behind the sign system or after it, which the sign system can't keep up with as the 'real thing' – but you must take into account that what you are tapping in terms of cultural self-representation in order to mobil-ize, or what you are noticing the other side as tapping, also in order to mobilize, must also work with the lag-effect, so that the real task of the political activist is *persistently* to undo the lag-effect. (Quoted in S. Harasym (ed.) *The Postcolonial Critic* (New York: Routledge: 1990), p. 125)

I have argued for a related temporality of political intervention in 'The commitment to theory', *New Formations*, vol. 5 (summer 1988), pp. 5–23.

30 Barthes, *Pleasure of the Text*, pp. 66–7., Mine is a tendentious exploration and reconstitution of Barthes's concept, often read against the grain of Barthes's celebratory, situationist *détournement*. It is not an exposition, as I have made clear repeatedly throughout the chapter.

31 S. Zizek, *The Sublime of Object of Ideology* (Lincoln, Nebr.: University of Nebraska Press, 1986), pp. 104–11.

32 J. Lacan, *Ecrits*, A. Sheridan (trans.) (London: Tavistock, 1977), p. 173.

33 Zizek, *Sublime Object*, p. 109.

34 Barthes, *Pleasure of the Text*, pp. 62, 67 (my emphasis).

35 R. Guha, 'Dominance without hegemony and its historiography', in Guha (ed.) *Subaltern Studies*, vol. 6 (New Delhi: Oxford University Press, 1989), pp. 210–309.

36 ibid., p. 230.

37 R. Guha, 'The prose of counter-insurgency', in Guha (ed.) *Subaltern Studies*, vol. 2 (New Delhi: Oxford University Press, 1983), p. 39.

38 ibid., p. 40.

39 ibid., p. 39.

40 M. M. Bakhtin, *Speech, Genres, and Other Late Essays*, C. Emerson and M. Holquist (eds), V. W. McGee (trans.) (Austin, Texas: University of Texas Press, 1986), pp. 90–5.

41 ibid., p. 93.

42 ibid., p. 94.

43 ibid., p. 93.

44 ibid.

45 H. Arendt, *The Human Condition* (Chicago: Chicago University Press, 1958), p. 185. See also pp. 175–95.

46 ibid., p. 185.

47 ibid., p. 184.

48 ibid., p. 186.

49 ibid., p. 187.

50 ibid., p. 180.

51 ibid.

52 J. Lacan, 'Where is speech? Where is language?', *The Seminars of Jacques Lacan, 1954–55*, J.-A. Miller (ed.), S. Tomaselli (trans.) (Cambridge: Cambridge University Press, 1988), pp. 284–5.

53 R. Rorty, *Contingency, Irony and Solidarity* (Cambridge: Cambridge University Press, 1989), pp. 92, 93.

54 ibid., p. 63.

55 ibid., p. 63, n. 21

56 Guha, 'Dominance', p. 277.

57 ibid. (my emphasis).

58 V. Das, 'Subaltern as perspective', in R. Guha (ed.) *Subaltern Studies*, vol. 6 (New Delhi: Oxford University Press, 1989), p. 313.

59 ibid., p. 316.

60 ibid., p. 320.

61 I have changed the order of Fanon's argument to give an efficient summary of it.

62 F. Fanon, 'Spontaneity: its strength and its weakness', in his *The Wretched of the Earth* (Harmondsworth: Penguin, 1969), pp. 117–18.

63 M. Dean, 'Foucault's obsession with Western modernity', *Thesis Eleven*, vol. 14 (1986), p. 49.

64 See G. C. Spivak, *In Other Worlds: Essays in Cultural Politics* (New York: Methuen, 1987), p. 209.

65 M. Foucault, *The Order of Things: An Archaeology of the Human Sciences*, A. Sheridan (trans.) (London: Tavistock, 1970), p. 369.

66 ibid.

67 ibid., p. 371.

68 ibid., p. 372.

69 ibid., p. 377 (my emphasis).

70 ibid.

71 ibid., p. 369.

10 BY BREAD ALONE

1 J. Kaye and G. B. Malleson, *History of the Indian Mutiny of 1857–8*, vol. 1 (London: W. H. Allen & Co., 1888), p. 179.

2 J. Lacan, 'Where is speech? Where is language?', *The Seminars of Jacques Lacan, 1954–55*, in J. A. Miller (ed.), S. Tomaselli (trans.) (Cambridge: Cambridge University Press, 1988), pp. 284–5.

3 T. Morrison, 'Unspeakable things unspoken', *Michigan Quarterly Review*, vol. 28, no. 1 (winter 1989), pp. 11–12.

4 T. Morrison, *Beloved* (London: Chatto & Windus, 1987), p. 4.

5 Morrison, 'Unspeakable things unspoken', p. 31.

6 ibid., p. 32.

7 I am deeply indebted to Ranajit Guha's reading of the 'chapati' story in

his classic account of rebel politics, *Elementary Aspects of Peasant Insurgency* (New Delhi: Oxford University Press, 1983). See ch. 6, in particular pp. 239–46. Although my analysis of the event differs from his in ways that will become clearer as the argument proceeds, his splendid reading produces an important framework for all successive readings.

8 A. Nandy, *Traditions, Tyranny and Utopias* (New Delhi: Oxford University Press, 1987), pp. 47–8.

9 Kaye and Malleson, *History of the Indian Mutiny*, vol. 1, pp. 416–20.

10 E. Stokes, 'The context of the 1857 Rebellion', in his *The Peasant and the Raj* (Cambridge: Cambridge University Press, 1978); see p. 130 *et passim*.

11 P. Mason, 'Fear and its causes', in *A Matter of Honour: An Account of the Indian Army, Its Officers and Men* (London: Cape, 1974), pp. 247–57.

12 Kaye papers: Home Misc. 725, p. 421.

13 E. Stokes, *The Peasant Armed* (Oxford: Clarendon Press, 1986), p. 92.

14 Kaye and Malleson, *History of the Indian Mutiny*, vol. 5, p. 292.

15 Kaye papers: Home Misc. 725, p. 415.

16 Guha, *Elementary Aspects of Peasant Insurgency*, p. 225.

17 ibid.

18 W. Bion, *Experience in Groups* (London: Tavistock, 1983), p. 91.

19 Kaye and Malleson, *History of the Indian Mutiny*, vol. 5, p. 341.

20 Stokes, *The Peasant Armed.*, p. 124.

21 ibid., pp. 240–1.

22 ibid., p. 66.

23 ibid., p. 82.

24 ibid., p. 50.

25 Kaye papers: Home Misc. 725, pp. 399–407.

26 ibid.

27 ibid.

28 F. W. Buckler, 'The oriental despot', quoted in B. S. Cohn, *The Invention of Tradition*, E. Hobsbawm and T. Ranger (eds) (Cambridge: Cambridge University Press, 1983), p. 168.

29 Kaye and Malleson, *History of the Indian Mutiny*, vol. 1, p. 163.

30 ibid., vol. 1, p. 164.

11 HOW NEWNESS ENTERS THE WORLD

1 Two recent examples. In Edward Said's magisterial *Culture and*

Imperialism (London: Chatto & Windus, 1993) *Heart of Darkness* is the novel that invites the most comment and interpretation. It serves as a resource for many of the central arguments in the book. In Said's early discussions of the complex address and consolidation of the imperial idea as ideology, *Heart of Darkness* features prominently. In the later, postcolonial perspectives that deal with resistance and opposition, Said demonstrates the 'anxiety of influence' generated by the novel on the anti-colonialist fictions of Ngugi wā Thiongo, *The River Between* and Tayeb Salih, *Season of Migration to the North*. In her fine study *The Rhetoric of English India* Sara Suleri gives a contrapuntal reading of *Heart of Darkness* and V. S. Naipaul's *A Bend in the River*.

2 J. Conrad, *Heart of Darkness and Other Tales*, edited with an introduction by Cedric Watts (Oxford: World's Classics, 1990), p. 138.

3 ibid., p. 140.

4 T. Morrison, *Playing in the Dark* (Cambridge, Mass.: Harvard University Press, 1991), *passim*.

5 W. Harris, *Tradition, the Writer, and Society* (New Beacon: 1973), pp. 60–3.

6 Conrad, *Heart of Darkness*, p. 252.

7 C. Taylor, *The Sources of the Self: The Making of the Modern Identity* (Cambridge, Mass.: Harvard University Press, 1989), p. 51.

8 S. Weber, *Return to Freud: Jacques Lacan's Dislocation of Psychoanalysis* (Cambridge: Cambridge University Press, 1991), p. 161.

9 F. Jameson, *Postmodernism Or, The Cultural Logic of Late Capitalism* (Durham: Duke University Press, 1991). All citations are from the conclusion, 'Secondary elaborations' pp. 297–418, and will hereafter be referenced by page numbers.

10 ibid., pp. 1–54.

11 G. Gomez-Pena, 'The new world (b)order', *Third Text*, vol. 21 (winter 1992–3), p. 74.

12 I have described the narrative of such a temporality as a 'projective past' in a reading of Toni Morrison's *Beloved*. See Chapter 12.

13 J. Forrester, 'Dead on Time', in his *The Seductions of Psychoanalysis: Freud, Lacan and Derrida* (Cambridge: Cambridge University Press, 1990), p. 206.

14 J. Butler, 'Decking out: performing identities', in Diana Fuss (ed.) *Inside/Out, Lesbian Theories, Gay Theories* (New York': Routledge, 1991), p. 17.

15 For an argument that might be taken to counter this claim see F. Jameson, 'Modernism and imperialism', in *Nationalism, Colonialism*

and Literature, introduction by Seamus Deane, A Field Day Company Book (Minneapolis: Minnesota University Press, 1990), p. 53.

16 Although Jameson insists that anxiety and alienation form no part of postmodern phenomenology, I would argue that the appeal to affects of disjunction, disorientation and doubling, particularly in the context of 'emergent' knowledges and practices cannot be envisaged without fear and trembling. I have also argued above, all too briefly, for anxiety as a pedagogical address – a theme that I will be extending in the book I am currently working on, The Measure of Dwelling.

17 S. Rushdie, The Satanic Verses (London: Viking, 1988), p. 261.

18 ibid., p. 246.

19 W. Benjamin, Illuminations, H. Zohn (trans.) (New York: Shocken Books, 1968), p. 75.

20 ibid., p. 75.

21 Rushdie, Satanic Verses, p. 319.

22 A. Macintyre, Whose Justice? Which Rationality? (London: Duckworth, 1988), p. 378.

23 Sara Suleri, The Rhetoric of English India (Chicago: Chicago University Press, 1992), p. 192.

24 Y. Samad, 'Book burning and race relations: political mobilisation of Bradford Muslims', New Community, vol. 18, no. 4 (1991), pp. 507–19. My discussion in this paragraph is a paraphrase of Samad's argument and research.

25 Rushdie, Satanic Verses, p. 272.

26 ibid., p. 288.

27 See R. Gasché's brilliant essay on Benjamin's theory of language, 'The saturnine vision and the question of difference: Reflections on Walter Benjamin's theory of language', Studies in 20th Century Literature, vol. II, no. 1, Fall 1986.

28 Benjamin, Illuminations, p. 263.

29 R. Pannwitz, in Benjamin, Illuminations, p. 80.

30 Gasché, 'The saturnine vision', p. 92.

31 It is this disjunctive form of cultural interaction that David Lloyd describes as 'refractive, non-equivalent, translation', in his reading of the emergence of the 'minor' Irish national canon. See D. Lloyd Nationalism and Minor Literature (Berkeley and London: University of California Press, 1987), pp. 110–11.

32 P. de Man, The Resistance to Theory (Minneapolis: Minnesota University Press, 1986), p. 92.

33 Rushdie, *Satanic Verses*, p. 288.

34 ibid., pp. 291–3.

35 ibid., p. 354.

36 See G. Sahgal, 'Fundamentalism and the multiculturalist fallacy', in *Against the Grain: A Celebration of Survival and Struggle* (Middlesex: Southall Black Sisters, 1990).

37 Women Against Fundamentalism Newsletter, no. 4.

38 Jameson, *Postmodernism*, p. 357.

39 A. Janmohamed and D. Lloyd (eds), *The Nature and Context of Minority Discourse* (New York and London: Oxford University Press, 1990), p. 8.

40 ibid., p. 10.

41 C. West, 'Race and social theory', in M. Davis *et al.* (eds), *The Year Left 2: Toward a Rainbow Socialism* (London: Verso, 1987), pp. 85–90.

42 P. Chatterjee, 'A response to Taylor's "Modes of civil society",' *Public Culture*, Fall 1990 (Princeton University Press), p. 130.

43 ibid., p. 130.

44 ibid., p. 127.

45 ibid., p. 131.

46 D. Walcott, 'Names', in his *Collected Poems 1948–1984* (London: Faber, 1992), pp. 305–8.

47 R. Rorty, *Philosophy and the Mirror of Nature* (Princeton: Princeton University Press, 1979).

48 See J. Habermas, *The Philosophical Discourse of Modernity* (Cambridge: Polity, 1990), for a lengthy elaboration of this point.

49 W. Benjamin, 'Theses on the philosophy of history', in his *Illuminations* ed. with intro. by Hannah Arendt, trans. H. Zohn (London: Jonathan Cape, 1970), p. 264.

50 D. Walcott, 'Sainte Lucie', in his *Collected Poems 1948–1984*, p. 310.

51 R. Rorty, *Contingency, Irony and Solidarity* (Cambridge: Cambridge University Press, 1989), pp. 190–1.

52 ibid., p. 314.

12 CONCLUSION

1 All citations from Fanon in the following pages come from 'The fact of blackness', in *Black Skin, White Masks*, Foreword by H. Bhabha (London: Pluto, 1986), pp. 109–40.

2 W. E. Du Bois, *The Souls of Black Folk* (New York: Signet Classics, 1982), p. 275.

3 'A conversation with Fredric Jameson', in A. Ross (ed.) *Universal Abandon: The Politics of Postmodernism* (Edinburgh: Edinburgh University Press, 1988), p. 17.

4 See my reading of Renan in Chapter 8, 'DissemiNation'.

5 Each of these writers has addressed the problem of modernity in a number of works so that selection becomes invidious. However, some of the most directly relevant are the following: J. Habermas, *The Philosophical Discourse of Modernity* (Cambridge: Polity Press, 1990), esp. chs 11 and 12; M. Foucault, *The History of Sexuality. Volume One: An Introduction* (London: Allen Lane, 1979); see also his 'The art of telling the truth', in L. D. Kritzman (ed.) *Politics, Philosophy and Culture* (New York: Routledge, 1990); J.-F. Lyotard, *The Differend* (Minneapolis: University of Minnesota Press, 1988); C. Lefort, *The Political Forms of Modern Society*, J. B. Thomason (ed.) (Cambridge: Polity Press, 1978), especially Part II, 'History, ideology, and the social imaginary'.

6 Habermas, *The Philosophical Discourse of Modernity*, p. 311.

7 J. Derrida, *The Post Card: From Socrates to Freud and Beyond*, A. Bass (trans.) (Chicago: Chicago University Press, 1987), pp. 303–4.

8 M. Dolar, *The Legacy of the Enlightenment: Foucault and Lacan*, unpublished manuscript.

9 R. Young, *White Mythologies: Writing, History and the West* (London: Routledge, 1990), pp. 16–17. Young argues a convincing case against the Eurocentrism of historicism through his exposition of a number of 'totalizing' historical doctrines, particular in the Marxist tradition, while demonstrating at the same time that the spatializing anti-historicism of Foucault remains equally Eurocentric.

10 Cf. Young, *White Mythologies*, pp. 116–17.

11 T. Eagleton, *The Ideology of the Aesthetic* (Oxford: Blackwell, 1990), p. 414.

12 H. A. Baker, Jr, *Modernism and the Harlem Renaissance* (Chicago: Chicago University Press, 1987), p. 56.

13 C. Breckenridge and A. Appadurai, *The Situation of Public Culture*, unpublished manuscript. For the general elaboration of this thesis see various issues of *Public Culture: Bulletin of the Project for Transnational Cultural Studies* (University of Pennsylvania).

14 P. Gilroy, 'One nation under a groove', in D. T. Goldberg (ed.) *Anatomy of Racism* (Minneapolis: University of Minnesota Press, 1990), p. 280.

15 Although I introduce the term 'time-lag' more specifically in Chapters

8 and 9, it is a structure of the 'splitting' of colonial discourse that I have been elaborating and illustrating – without giving it a name – from my very earliest essays.

16 J. Derrida, 'Des Tours de Babel', in *Difference in Translation*, J. F. Graham (ed.) (Ithaca: Cornell University Press, 1985), p. 174.

17 Lefort, *The Political Forms of Modern Society*, p. 212.

18 Foucault, 'The art of telling the truth', p. 90.

19 ibid., p. 93.

20 C. L. R. James, *The Black Jacobins* (London: Allison and Busby, 1980), pp. 290–1.

21 J. Habermas, 'Modernity: an incomplete project', in H. Foster (ed.) *Postmodern Culture* (London: Pluto, 1985).

22 M. de Certeau, 'The historiographical operation', in his *The Writing of History*, T. Conley (trans.) (New York: Columbia University Press, 1988), p. 91.

23 L. Althusser, *Montesquieu, Rousseau, Marx* (London: Verso, 1972), p. 78.

24 P. J. Bowler, *The Invention of Progress* (Oxford: Blackwell, 1990), ch. 4.

25 Gilroy, 'One nation under a groove', p. 278.

26 C. West, 'Race and social theory: towards a genealogical materialist analysis', in M. Davis, M. Marable, F. Pfeil and M. Sprinker (eds) *Towards a Rainbow Socialism* (London: Verso, 1987), pp. 86 ff.

27 C. West, *The American Evasion of Philosophy* (London: Macmillan, 1990), pp. 232–3.

28 G. Prakash, 'Post-Orientalist Third-World histories', *Comparative Studies in Society and History*, vol. 32, no. 2 (April 1990), p. 403.

29 Robert Young, in *White Mythologies*, also suggests, in keeping with my argument that the colonial and postcolonial moment is the liminal point, or the limit-text, of the holistic demands of historicism.

30 Foucault, *The History of Sexuality*, p. 150.

31 M. Foucault, *Foucault Live*, J. Johnstone and S. Lotringer (trans.) (New York: Semiotext(e), 1989), p. 269.

32 B. Anderson, *Imagined Communities* (London: Verso, 1983), p. 136.

33 ibid., p. 137.

34 ibid.

35 ibid.

36 P. Chatterjee, *Nationalist Thought and the Colonial World* (London: Zed, 1986), pp. 21–2.

37 J. H. Smith and W. Kerrigan (eds) *Taking Chances: Derrida, Psychoanalysis, Literature* (Baltimore: Johns Hopkins University Press, 1984), p. 27.

38 A. Nandy, *The Intimate Enemy* (New Delhi: Oxford University Press, 1983), p. 99.

39 R. Williams, *Problems in Materialism and Culture* (London: Verso, 1980), p. 43. See also Chapter 8, p. 149

40 S. Hall, *The Hard Road to Renewal* (London: Verso, 1988), pp. 10–11, 231–2.

41 H. A. Baker, Jr, 'Our Lady: Sonia Sanchez and the writing of a Black Renaissance', in H. L. Gates (ed.) *Reading Black, Reading Feminist* (New York: Meridian, 1990).

42 W. Benjamin, *Understanding Brecht*, S. Mitchell (trans.) (London: New Left Books, 1973), pp. 11–13. I have freely adapted some of Benjamin's phrases and interpolated the problem of modernity in the midst of his argument on epic theatre. I do not think that I have misrepresented his argument.

43 T. Morrison, 'The ancester as foundation', in M. Evans (ed.) *Black Women Writers* (London: Pluto, 1985), p. 343.

44 T. Morrison, *Beloved* (London: Pluto, 1985), pp. 256–7.

45 W. E. Du Bois, *The Souls of Black Folk* (New York: Signet Classics, 1969), p. 275.

46 ibid., p. 271.

INDEX